0 - 9/2017 - "/17

AUG 2 2 2016

NO LONGER PROPERTY OF
SEATTLE PUBLIC LIBRARY

D0044336

BY JEAN STEIN

West of Eden: An American Place

Edie: American Girl
 (edited with George Plimpton)

American Journey: The Times of Robert Kennedy
 (interviews by Jean Stein; edited by George Plimpton)

WEST OF EDEN

RANDOM HOUSE

NEW YORK

WEST OF EDEN

AN AMERICAN PLACE

JEAN STEIN

West of Eden is a work of nonfiction. Some names
and identifying details have been changed.

Copyright © 2016 by Jean Stein

All rights reserved.

Published in the United States by Random House,
an imprint and division of
Penguin Random House LLC, New York.

RANDOM HOUSE and the HOUSE colophon are
registered trademarks of Penguin Random House LLC.

A portion of this work was originally published in different
form in the February 16, 1998, issue of *The New Yorker*.

Text permission credits are located on pages 331–32. Photograph
credits are located on pages 333–34.

LIBRARY OF CONGRESS CATALOGING-IN-PUBLICATION DATA
Names: Stein, Jean.
Title: West of Eden: an American place / Jean Stein.
Description: New York: Random House, 2016.
Identifiers: LCCN 2015022411 | ISBN 9780812998405 (hardback) |
ISBN 9780812998412 (ebook)
Subjects: LCSH: Los Angeles (Calif.)—Biography. | Hollywood (Los Angeles,
Calif.)—Biography. | Beverly Hills (Calif.)—Biography. | Los Angeles (Calif.)—
History. | Hollywood (Los Angeles, Calif.)—History. | Beverly Hills (Calif.)—History. |
Oral history—California—Los Angeles. | Los Angeles (Calif.)—Social life and
customs. | Los Angeles (Calif.)—Social conditions. | BISAC: HISTORY / United
States / State & Local / West (AK, CA, CO, HI, ID, MT, NV, UT, WY). |
BIOGRAPHY & AUTOBIOGRAPHY / Entertainment & Performing Arts. |
PERFORMING ARTS / Film & Video / History & Criticism.
Classification: LCC F869.L853 A275 2016 | DDC 979.4/94—dc23 LC record available
at http://lccn.loc.gov/2015022411

Printed in the United States of America on acid-free paper

randomhousebooks.com

987654321

First Edition

Book design by Barbara M. Bachman

For my daughters,
Katrina and Wendy

CONTENTS

PROLOGUE:
WELCOME TO LOS ANGELES

MIKE DAVIS: When I was a younger man, I made an arrangement with Gray Line Tours that would allow me to drive in the evenings and on weekends (it was called "working the extra board"). Their business included tours of Marineland of the Pacific, Forest Lawn cemetery, Hollywood Park, and Universal Studios, as well as shuttling conventioneers around downtown. Most of the time, however, I was punching the clock on the hugely popular tour of Hollywood and Beverly Hills. We dressed up like airline pilots from a Mel Brooks comedy.

Oddly the company did not provide any information for the tours. There was a fixed route, of course, but otherwise new drivers were expected to purchase celebrity addresses and the tour "rap" from older drivers. But I was a tightwad so I just winged it. I'd pick out a big house and lie about who lived there. Usually this was no problem, but now and then a veteran fan caught me. I remember one time exuding "Here she is—*I Love Lucy*! There's her house. We'll slow down so you can take photos." Then some lady in the back absolutely freaks out. "I've been on this tour enough times to know that's not Lucille Ball's house. She lives three blocks away."

Beverly Hills was no big deal. But driving the tourists from Iowa down Hollywood Boulevard was the most hallucinatory part of the job. This was Hollywood in the early seventies: post–flower-power, post-

Manson. The sidewalks teemed with runaway kids, teenage prostitutes (male and female), people raving, heroin addicts with two weeks to live—the absolute epicenter of human misery. It was an awful place, especially on the Hollywood at Night tour. I used to pull up around the corner from Grauman's Chinese and kick the tourists out to go venerate the footprints. I'd lock myself in the bus. I'd close the windows, saying to myself: "Okay, zombies! You can't get me. Go eat the tourists!" The weird part is that the tourists would get out and, surrounded by misery, gasp, "Ava Gardner's footprints!" I mean there would be someone lying naked or ODing, foaming at the mouth, and they'd walk over the body and say, "Oh! Victor McLaglen, I remember him!" They were ecstatic and I was mortified. Instead of being distressed by the huge moral discrepancy between the myth of Hollywood and its current reality, most of them only saw what already had been fixed in their minds. It was absolutely eerie and sent me right back to *The Day of the Locust*. The point that Nathanael West made, of course, is that the masses ultimately want to kill and devour, to cannibalize their celebrity gods.

Fortunately there were some dramatic exceptions. The Longshoremen's Union used to bring tours of Japanese American, Filipino American sugarcane workers from Hawaii. I'd always get those tours. They were wonderful people and they liked to hear stories and jokes. They were interested in history, including the tidbits of radical history. Then there were the guys I truly despised: the fortysomething drunk white conventioneers with their libidos hanging out of their pants. These leering, hypocritical bastards automatically assumed that every Gray Line driver was a pimp (unfortunately several were) who could set them up with a fifteen-year-old girl. It was all the more disgusting since you knew that most of these Babbitts were upstanding family men and Kiwanis members from some middle-sized city in the Midwest.

Gray Line had two kinds of buses. The normal tour bus was a secondhand American Eagle retired from Greyhound. But for shuttling

conventioneers and the like we used ancient municipal transit buses without a luggage compartment, what we called "flat bottoms." We'd take sometimes six, seven, eight buses up to Universal Studios. Universal was fun because we didn't have to do anything. We just dropped the tourists off in the parking lot. The drivers would hang out together in one bus, sometimes passing a bottle back and forth. Half of them were pimping girls or selling shit out of the back of the buses. So one day we're sitting in my bus, and we see one of these buses slowly rolling by and picking up speed. Now buses, like heavy-duty trucks, have a "maxi brake"—looks like a big red button—that welds your wheels in place when you park. I guess the driver didn't realize that the huge Universal parking lot has a very slight slope. So his bus started rolling backwards, very slowly at first, then gaining speed. "Open the door, Mike!" the drivers shouted. I opened the door, let them out, and we all ran after the bus, but it was too late. We watched in a kind of fascinated horror as that old flat bottom just kept rolling down and then off the embankment onto the Hollywood Freeway.

THE DOHENYS

905 Loma Vista Drive, Beverly Hills

Greystone, built for the son of Edward L. Doheny.

A winding driveway dropped down between retaining walls to the open iron gates. Beyond the fence the hill sloped for several miles. On this lower level faint and far off I could just barely see some of the old wooden derricks of the oilfield from which the Sternwoods had made their money. . . . A little of it was still producing in groups of wells pumping five or six barrels a day. The Sternwoods, having moved up the hill, could no longer smell the stale sump water or the oil, but they could still look out of their front windows and see what had made them rich. If they wanted to. I didn't suppose they would want to.

— RAYMOND CHANDLER, *The Big Sleep*

RICHARD RAYNER: The nature of scandals is that once Pandora's box has been opened, it always ends up murkier, more intestinal, more twisted, and much bigger and longer than anyone could have imagined before they opened the box. And the story of Edward L. Doheny is centered around a Pandora's box that unleashed an extraordinary sequence of events, enthralling the nation for a decade. It involved the fall and death of a president. It involved millions and millions of dollars paid to some of the most gifted lawyers in the country. It involved two slayings intimately connected to Doheny in circumstances that are still very murky. And it ended in the fall from grace for Doheny — at one point the richest man in America — who died in 1935 broken and disgraced, very much by his own actions and his determination to protect himself.

PATRICK "NED" DOHENY: My great-grandfather was shocked at the way that everything spun out. When you think about a guy that strong being broken, you have to wonder what it must have been like to have had to deal with all those elements, who you had to be in order to survive it. It was a tragedy, but the history books have always done a hatchet job on him. It's the heartlessness that I find the most bitter about the interpretation of our family. And it upsets me that someone like my great-grandfather, who was such a seminal figure, gets supplanted by a cardboard stick figure. That's madness.

What my great-grandfather did is almost beyond conception in terms of the amount of money that he made, the success that he enjoyed, and the wildness of his adventure. That whole business with *There Will Be Blood*, however, was completely apocryphal. There's not a shred of truth in it. The only true part of the film was at the beginning, with him in the mine shaft by himself: he did always say he once fell down a mine shaft and broke his legs. But all the rest of it is utter horseshit. All these people—Upton Sinclair with *Oil!* and later the movie people—had a vested interest in furthering their own agendas, and it's ludicrous to confuse those agendas with history. I enjoyed the movie, and I thought Daniel Day-Lewis was outrageously good. But it had nothing to do with my people at all. The actual story itself is so much more interesting than anything they might have come up with.

Shuffle the cards, and deal a new round of poker hands: they differ in every way from the previous round, and yet it is the same pack of cards, and the same game, with the same spirit, the players grim-faced and silent, surrounded by a haze of tobacco-smoke.

—UPTON SINCLAIR, *Oil!*

RICHARD RAYNER: The Doheny saga is central to L.A. history in all sorts of ways. One thinks of Mulholland as being the twisted godfather who summoned L.A. into existence because he brought the water that allowed it to grow. But Doheny symbolizes the other way wealth was acquired in the first thirty years when L.A. was really growing. Between 1900 and 1930, the population went from something like one hundred thousand to one million and a quarter.

MIKE DAVIS: The recent history of Los Angeles had been an exhilarating then terrifying roller-coaster ride. In late 1885 the arrival of the Santa Fe railroad in Southern California broke the decade-long monopoly of the Southern Pacific. By March the most extraordinary rate war in American history began with fares from Chicago dropping to an absurd one dollar then stabilizing at ten dollars. Two hundred thousand curious visitors took advantage of the cheap fares to come visit the Land of Sunshine and dip their toes into the Pacific. First, however, they had to run a gauntlet of realtors and their sandwich-board boys waiting outside the stations to sell them a dream lot in one of the new garden suburbs or in the barren hills around the city. Los Angeles was laying ultramodern concrete sidewalks, but its main streets remained dirt and gravel and too often mud. But an old prospector like Doheny was probably happier with bare rock and exposed ground. He also may have enjoyed the ineradicable wildness everywhere on the city's edges. Los Angeles had little water, no coal, no improved harbor, no manufacturing, a still largely undeveloped hinterland, and a permanent shortage of capital. But these comprehensive disadvantages were the secret of the locals; the newcomers, having seen Eden, were easily convinced to buy a piece of it.

RICHARD RAYNER: The population was driven by oil, and Doheny was the guy who created the L.A. oil industry, even though he made the vast part of his fortune in Mexico. In the 1920s L.A. produced 20 per-

cent of the world's oil. When you look at pictures of the great forests of oil derricks studded all over the city or read Upton Sinclair's *Oil!*, you see it. It's absolutely staggering, and Doheny was responsible for that. But there are all these years of his life before that period about which not much is known, when he was roaming around the West in the 1870s and 1880s. We don't really start to get to know him until he's in his forties. I suspect he was quite desperate by then, because everything had failed. But we do know the story of his first wife, whom he left alone—and it's quite dark.

MaryAnn Bonino: Edward Doheny married his first wife, Carrie Wilkins, in Kingston, New Mexico, in 1883. She never knew her father, a Civil War surgeon who went off to war when she was an infant and didn't come back. She and her mother lived the life of pioneers—and it was a very hard life, in particular for women on their own. In spite of all of that, Carrie seems to have been a woman of considerable sensitivity. She was active in the Episcopal church and also an engaging amateur singer, taking a "large audience by storm" when she and Edward lived in Kingston, and also later in Silver City. After they moved to Los Angeles in 1891, their emotional and financial lives were marked with highs and lows. Their son, Ned, was born in 1893, but their seven-year-old daughter, Eileen, died one year earlier of a rheumatic heart condition. Edward discovered oil in Los Angeles and Orange County, but as he took on new business risks things became financially rocky—which might explain why between 1895 and 1899 they changed their residence every single year. In late April 1899, Carrie decided to take some time away, going to San Francisco and taking Ned with her. It may be that she went north because Edward himself was moving to Kern County, where he had just found oil. But since Carrie never came back, she may have left for another reason. It was during this time that Estelle Betzold, who would later become Edward's second wife, was working as a telephone operator—most likely

in the same building as his office. The story goes that Edward heard Estelle's voice and was charmed by it. She did have a charming voice — everyone said that—and a playful and sassy style. It may be that Carrie's departure coincided with an initial flirtation between Estelle and Edward.

Carrie didn't divorce Edward until eleven months after she left him. Even then, and after moving to Oakland, she must have retained some feelings for him. In late September 1900—about a month after Edward married Estelle, and three weeks after he brought his new bride to San Francisco (and probably across the bay to Oakland)— Carrie killed herself. The published biographies of Doheny suggest strongly that Carrie was in some way disturbed, but the facts suggest otherwise.

CAROLE WELLS DOHENY: Carrie got so despondent over him getting married that she killed herself. The family later got depression from her. It's a very cruel thing that happens to people. But nobody really talks about her.

MARYANN BONINO: She drank battery fluid. According to the women who worked for her, she confused it for a cold medication she had ordered from the pharmacy. She may have staged it to look like a mistake. Ned was probably there. She took the poison during the morning when he was very likely at school, but he would certainly have been around for the aftermath and heard the reports of her "violent screaming," which went on for some hours. And on top of all that, Ned remained in that same house for almost ten months after her death. Perhaps Edward and Estelle thought it would be better to leave Ned in Oakland with familiar staff and a routine he was accustomed to. They themselves were overwhelmed by events. In addition to the shock of Carrie's suicide, their own marriage of barely a month was completely unplanned, they had no home of their own, and Edward faced an

enormous amount of work resulting from his otherwise incredible piece of luck—his discovery of oil in Mexico. But that plan clearly didn't work because Ned was acting up and kicking his governess black and blue. By the end of July 1901, Estelle was in Oakland taking care of him herself, and two weeks later she wrote to Edward, "You and I would've been condemned for murder if we hadn't come to the rescue by this time."

RICHARD RAYNER: The story of Doheny's involvement in Mexico is utterly amazing. It's both this wonderful entrepreneurial swashbuckling adventure and an absolutely naked act of imperial manipulation and theft. Doheny serially bribed his way upwards through the Mexican government until he became friendly with President Porfirio Díaz, from whom he secured exclusive rights to drill for oil in an area near the town of Tampico that held the richest oil deposits in the world at that time. And after the fall of his buddy Díaz in the Mexican Revolution, he managed to maneuver through the various political changes and insurgencies that followed and maintain his holdings.

PATRICK "NED" DOHENY: Regarding the whole business with the oil lands in Mexico, my god, there were whole countries angling for that. The British were in there, and the Germans were in there, too. That's where we get ranchero music, which is basically "oompa" music from Germany. That's why Mexican beer is so good, too. Everybody was trying to back whatever petty tyrant they could, to ensure that they could get their hands on whatever natural resources were there.

RICHARD RAYNER: From 1903 to 1918, Doheny took sixty-five trips to Mexico, suborning and turning a huge area covering 450,000 acres of the countryside into a personal fiefdom with a clear-cut apartheid system. It was a microcosm and an exaggeration of what America tried to

The world's greatest oil well, Cerro Azul No. 4, Mexico, February 1916.

pretend that it wasn't at the time. Not surprisingly, he was resented and hated by a lot of people in Mexico. Reports at that time from the Bureau of Investigation, the precursor to the Federal Bureau of Investigation, note various Mexican revolutionaries hanging around outside Doheny's mansion in L.A. on Chester Place. At least one historian, Dan La Botz, even thinks that Doheny might later have been behind the assassination of Venustiano Carranza, Mexico's constitutional president who had wanted to nationalize the oil industry. True or not, early on Doheny clearly saw that the leftist movement in Mexico could threaten him, so he eventually built a private army to protect his massive holdings, especially when Mexico was in the throes of a revolu-

tion. But his real aim was to get the U.S. Marines to occupy Mexico so that he wouldn't have to protect everything himself. Through it all, Doheny managed to hold on through various means. And he caused a lot of anger down there.

JOHN CREEL: Edward Doheny realized how useful my great-uncle, Enrique Creel, could be for his agenda, since Enrique was a very prominent statesman and banker in Mexico with strong connections to President Díaz. When Enrique was the Mexican ambassador to the United States, Doheny gave a banquet in his honor at the exclusive Alexandria Hotel in Los Angeles. The event, called "one of the most notable ever given in California," by the *Los Angeles Examiner*, featured Caviar Imperiale D'Astrakhan as a starter. Doheny even arranged for special fountains on the elliptical dinner table that spouted streams of red, white, and green, with the voice of Caruso serenading the guests from underneath the table. The event cost easily $150 a plate—in 1907 dollars—and was referred to as "a riot of extravagance" by the *Examiner*'s rival, the *Los Angeles Times*. I would have loved to have been there. They knew how to entertain, didn't they?

RICHARD RAYNER: Perhaps not coincidentally, a week before Doheny threw the banquet for Enrique Creel, private detectives in L.A. under orders from Creel brutally arrested the fugitive Mexican intellectual Ricardo Flores Magón, a leading anarchist who advocated for land reform in Mexico. Doheny managed to hold on to his bit of Mexico through an extraordinary dance of daring and corruption. It's Doheny at his boldest.

PATRICK "NED" DOHENY: Estelle was holding on for dear life then, with these periods of incredible loneliness when she never saw this person she'd married—and then boom, he would come back from Mexico. He was probably the richest man in the United States. Can

you imagine what it would have been like to have found yourself in that situation, in that time? For god's sakes, you go from being a telephone operator to having Steinway make you a piano with a bust of your child on either side of the keyboard? You can go look in the Steinway catalog. They made a piano with Ned's head carved into it. This is not reality—this is an altered state.

CAROLE WELLS DOHENY: Edward and Estelle were in San Francisco at the World's Fair, and she saw this wonderful display from Pompeii with pink-and-black marble pillars. Eighteen of these pillars were in an oblong circle, and she said, "I would love to have that as a ballroom." So he had it all dismantled and taken to Chester Place, where

Edward and Estelle Doheny at their garden party, Los Angeles Times, *June 24, 1915.*

The Pompeian Room in Edward L. Doheny's mansion.

they made it into the ballroom. Wouldn't you love to be able to say, "I'd love to have that," and it was done?

RICHARD RAYNER: Doheny's house doesn't look like the kind of place you could imagine living in, but what they were aspiring to was really some sort of Gilded Age fantasy.

PATRICK "NED" DOHENY: Ned is the missing man in this family, and having his name makes it all the weirder. I have no sense of what this person, my father's father, was like. I would give anything to have met him. I miss him. I do. Not to have met him is to have him consigned to the shadows of someone else's vision of him. Sometimes I think the subconscious reason that my parents called me Ned was to honor him or to connect him to me. It's not been without difficulty, but maybe my relationship to this ancestor about whom I know absolutely nothing provides some form of healing. Because his mother took her own life, and to have your mother go that way, and then be whisked away yourself? I don't know how much he saw, but it's a horrible way to die, to have your insides eaten out that way. My great-grandfather, Pa D., made sure that his first wife, Carrie, was buried in a nice place. The new wife had the same name as Ned's mother, although she was usually called by her middle name, Estelle. It must have just been very surreal.

MARYANN BONINO: Ned had to have missed his mother, but Estelle genuinely and profusely showered him with love, and Ned embraced her almost immediately as Mama. Nonetheless the damage he'd sustained was deep, and he continued to act out. You see the misery in his face in photographs—even as he grew older.

TOPSY DOHENY: In 1914 Ned married Lucy Smith, whom his parents liked and approved of. They had spent a lot of time together: Pa D. and Ma D. even took Ned and Lucy on an extended trip to Europe after he had been in the navy. That's when the romance gelled, on the ship crossing the Atlantic. There's nothing like shipboard romance. My understanding from my husband, Tim, is that's how his parents got together.

RICHARD RAYNER: They clearly hit it off. Lucy's parents were very, very happy for her to go with the Dohenys on this European tour, which was clearly the moment when Doheny allowed himself to say, "I've really arrived, I'm going to take the break, we're going to go to Europe. I'll do some business there, but I'll take Estelle and Ned, and we'll swank it around." William Randolph Hearst gave them his own personal guidebook to Europe. They went on the *Olympic*. Two years earlier when the *Titanic*, coming the other way, went down, Doheny was one of the first people to contact the *Los Angeles Examiner*, the Hearst paper, saying that he'd heard about the sinking ship. He little suspected that his own life, his own empire, would one day hit the iceberg that was Teapot Dome and start to sink beneath the waves.

ANSON LISK: Ned was an only child, and when he and Lucy married, they decided to live in Beverly Hills and build Greystone. I lived right next to them in what was called the Doheny ranch. My father, who was married to Lucy's older sister, managed and ran all the Doheny ranches scattered all over California. Ned and Lucy's children were Dickie Dell and four boys: Larry, Bill, Pat, and Tim. I grew up with all of them. Lucy was kind of a martinet. She wanted to run everybody's life and did. Even my mother and her brothers were under her thumb.

ANN SMITH BLACK: My father was the brother of Lucy Smith Doheny, so as a child, I went with my father every other weekend to Greystone. My grandfather Smith was partly responsible for bringing the Santa Fe railroad west. My grandparents lived originally in Pasadena in a great big house that is still there, and Lucy Doheny and Ned Doheny were married there. Ned was going to USC and wanted to be a doctor.

Lucy was the youngest in her family, but when she married Ned Doheny, everyone began to defer to her. And she wanted them to. She could be tough. She never buffaloed me, but she did everybody else.

LARRY NIVEN: My grandmother ruled with an iron hand. She was smallish, but feisty and quirky. Right from the start, she knew what her nickname ought to be, and she nailed it for us: "Sweetheart." She wasn't one, but she was amusing. She was at a party once, maybe at Greystone, and she ran across a guy whom she recognized. She said to him, "Don't you know me?" He replied, "No, I think we haven't met." So she turned and bared her butt. It was her gynecologist.

TOPSY DOHENY: Her nickname was Sweetheart, but in the immediate family—my husband, Tim, and all the rest of that generation—we all called her Mun. You knew right away she was someone you wouldn't cross, and I was always half scared of her. She was strict. Once she actually broke the back of a hairbrush on Tim. But Tim didn't care; he had a mind of his own and he wasn't intimidated. He was the most rebellious, and nothing she said or did could scare him. One way to humiliate the boys was to put one of his sister Dickie's old dresses on them and threaten to send them to school wearing it. She did this to all the boys growing up. When Tim was older and misbehaving as usual, his mother made him put the dress on. Of course he'd seen it already with the other boys, saw them all cower and give in, and he wasn't going to do that. He didn't cave at all. He started dancing around, saying, "Oh, it fits me so beautifully! This is just wonderful, Mother, I love it, I love it!" She was absolutely beside herself. She never tried that one again. Tim had enough of his mother in him that he just gave it back in spades. There was always a test of wills between Mun and Tim. One day she said, "I've had it," and she shipped him off to Culver Military Academy in Indiana. He didn't like that at all, so he and a friend plotted and strategized for a long time, and they planned the perfect getaway. They ran off and split up because they were worried about being caught. Tim knew that his mother would have the Pinkerton detectives after him, and she did. They spent months trying to find

him, and he stayed one step ahead of them. He worked at a fox farm for a while, stayed at the Salvation Army, hitchhiked around. After months, he finally came home, and she was furious, because she had been worried sick about him all those months out on the road. Nobody knew where he was, not even the Pinkertons. He knew exactly how to get her goat.

She ran the show, though, and she let you know she was in charge. She had a bell and a specific number of rings for each child, based on birth order. All except for Dickie Dell, who didn't have a ring. If the bell only rang once, that would be for Larry, two bells was Bill, three was Pat, four was Tim. Tim said that when the bell started ringing, the kids would freeze and wait and see how many bells there were. Depending on how many, that child would go to see her. She didn't know what to do to get these kids under control. You have to remember when she was born, so maybe they did things like that in those days. I don't think Mun could ever say no to Dickie, basically, although she was pretty tough on her, too. She was tough on all of them.

CAROLE WELLS DOHENY: Dickie Dell and Shirley Temple were friends growing up, and Shirley Temple's mother built her a dollhouse that was the size of a regular house. One of my husband's cousins actually ended up buying it. It's up off of Rockingham up above Sunset. And because Shirley Temple had one, Dickie wanted one, too. It was built on the Greystone property, a three-quarter-size house. Everything, the kitchen and the bathrooms, were all three-quarters size.

ANN SMITH BLACK: The dollhouse of Dickie Dell was just wonderful. We couldn't play in it unless we were invited, and we weren't invited very often. You could look, but not touch. Everything was in miniature, and it was all done beautifully, decorated with silk bedspreads

and silver crystal. It really was quite a thing, a dream, kind of a Hansel and Gretel house, with a swooping roof. You could stand up in it, even if you were a grown-up.

TOPSY DOHENY: Dickie Dell's dollhouse was really a small house, not some little thing. I remember Tim saying he once put a cherry bomb in the dollhouse, and when he didn't hear it go off, he telephoned Dickie in the dollhouse to ask if it had blown up yet. It was a huge place.

CAROLE WELLS DOHENY: Dickie Dell was not a beauty, but she was stunning in her way. She had dark, short hair, and she had the Doheny nose, which is a little protruding, but she had a very kind face. Her first husband was a lawyer—Niven was his name—and he was the "proper" person to marry. He was as boring as a white tablecloth. He was also chintzy. For Christmas, he gave her a refrigerator. This is a woman who could buy and sell him eighteen thousand times, and he gave her a refrigerator. She said, "Why doesn't he go out and buy something fabulous for me?" They just weren't good together. Her second husband, Porter Washington, was a dog trainer and breeder, like her, of keeshonds. He was great-looking—Texan or Oklahoman, part Cherokee Indian—and sexy, especially compared to her first husband, that lawyer prude. He must have banged her a few times in the dog kennels, and he was dashing, fun; why wouldn't she marry him? Sweetheart didn't talk to her for ten years, she was so appalled. She even took Dickie to Europe to get her away from him, but it didn't work. He turned out to be a wonderful husband to her.

LARRY NIVEN: Sweetheart never warmed up to my stepfather, but then again Mom married her dog handler, so come on!

TOPSY DOHENY: Dickie was a very gentle soul, very gentle. I never saw her get mean; she just wanted to laugh and be happy. She didn't have

a mean bone in her. Her nickname came about because her brother Larry couldn't say her real name, Lucy Estelle, a bit of a tongue twister. It came out "Dickie Dell," which just stuck. She had two passions in her life: dogs and jewelry, pretty stones. She'd wear them on any occasion, to go to the doctor's office or to the store, and Tim was always terrified that she'd be mugged.

CAROLE WELLS DOHENY: She once gave me an eighteen-carat faceted pink sapphire. It had two rows of diamonds, maybe a quarter to a third carat each, a huge ring. That was for having my first son. She was very thoughtful. She used to telephone Ruser jewelers on Rodeo Drive and have someone come over if a family member or friend was having a birthday or special occasion. She would call and say, "Bring a few things because my daughter-in-law is having a birthday" or "Christmas is coming," and they'd bring trays of stuff.

She had a house at Hermosa Beach, and we would go there in the summers. Her lunches were like Thanksgiving. The waiters wore white gloves and served things like beef Wellington with all the trimmings or coq au vin. At the beach, for lunch! Everything was fabulous, like you were at the best restaurant. She would come down in an emerald-green bathing suit and have on her emerald earrings and emerald necklace. Her rings. Her bracelets, a pin. She would wear all of her jewelry even if she was just in her swimsuit. She never went swimming; she would just sit around with her girlfriends. But it was gorgeous, and a great example. If she had a red outfit on she'd wear all her rubies, and if she wore blue, she'd have her sapphires and diamonds on. I loved it, because where else should she wear them? Summertime at the beach, why not? Over the swimsuit, she would wear those little jackets and coat tops that you could see through. They would end at her shorts. It was summertime and she had great legs. She'd sit out on the patio and watch all of us swim, have all her jewels on with her friends over and

have cocktails. It was a big drinking group. By noon everyone was getting happy.

Even Groucho Marx was enchanted by her. They met on board a ship to London when her mother was taking her to Europe, trying to distract her from marrying Porter Washington, the dog handler. Groucho was on the ship. He had the best time with her, saying she had such a great sense of humor. He admired her. He was a big celebrity, but he thought she was the cat's meow. So when he and I did a show together years later, I introduced him to my husband, and Groucho said, "Doheny, Doheny, are you Dickie Dell's relative?" My husband answered, "She's my godmother and my aunt," and Groucho regaled us with stories.

LARRY NIVEN: At one point a burglar got away with a fortune in jewels—two fortunes, really—from my mother. He came in through her library window and got stuck in the racks of dog-show ribbons that blocked the window. All the dogs began barking at him, but the servants paid no attention because the dogs were always barking. He finally got through the window and took off with two pillowcases full of jewels. He threw one of them in a garbage can so as not to have to carry it any further, and kept going. He wound up in a bar trying to sell them, and that's how he got caught. He was badly dismayed when he was told how much he had stolen and lost. It was hundreds of thousands of dollars. We got some of it back from the bartender, but not everything was retrieved.

PATRICK "NED" DOHENY: My great-grandfather felt particularly beholden to the well-being and the safety of his family. I've read letters of his that are so sweet and have a level of sentimentality in them that takes you aback, especially when you think that he was as tough as he had to have been to do all that he did. All of his references to his family

are almost cloying, they're so devoted and unabashedly loving. So when he wanted to do something grand for his only child, Ned, he underwrote the building of Greystone. He wanted to be magnanimous.

RICHARD RAYNER: You look at Greystone and you understand that this is what power and money can do. Raymond Chandler mythologizes it in *Farewell, My Lovely*: "The house itself was not so much. It was smaller than Buckingham Palace, rather gray for California, and probably had fewer windows than the Chrysler Building." It's mightily impressive today, and it would have been even more impressive back then—and so inappropriate, in terms of L.A. architecture. An English country mansion, with stone this thick on a hill in Beverly Hills? It would've been like a movie set even back then.

WALLACE NEFF, JR.: The Dohenys were my father's biggest client; they had him design nearly everything they built. He built them a huge home in Ojai, California, and he also designed for Mrs. Doheny the library at St. John's Seminary in Camarillo. But he didn't do Greystone. When Ned Doheny got married and had all these children, he and his wife decided that my father should design a home for them. Ned Doheny told my father that he wanted it to look like a palace. That's the way young Doheny thought. He was sort of grand, wanted a big thing to show off. So some designs were made, but then his wife wanted more of an English house, and I can understand that. A palace is a bit much for a young lady. So she contacted Gordon Kaufmann, and "poof" went my father's design.

MIKE DAVIS: Like everything around the Dohenys, Greystone is a mausoleum: a Gothic, granite/limestone mausoleum. Everything about the family has a sepulcher- or tomb-like quality to it. But maybe that's characteristic of these money houses. The builders of the great

houses set standards for each other; it was an arms race. And Hearst's San Simeon won.

TOPSY DOHENY: Tim told me that the property had its own water. Seven spring caves were dug out, and the water from them was pumped into reservoirs. The work was done by old prospector friends of his grandfather. Pa D. had a lot of old cronies from the old days whom he hired to go into the caves with picks and shovels, dig them out and shore them up so that the water could be caught.

PATRICK "NED" DOHENY: We used to play in the bowling alley a lot when we were kids. It was big fun, that bowling alley. And it was a house you could explore endlessly, a great thing for a kid. But it was a scary place; I mean, it's a big house. My father used to say that he would walk down the halls at night and his brothers would leap out of the curtains to scare white hair into his temples.

TOPSY DOHENY: There were all kinds of people coming and going at Greystone. Mun's father, Pop Smith, loved football, and she used to have the whole USC football team over there. She was also friends with Somerset Maugham, who Tim said once stayed at the house for a few days, and with Auden. There were a lot of people passing through.

JEAN STEIN: I visited Greystone a few times with my parents for tea. It was all very grand, and I was cautioned to be on my best behavior. It was the kind of place where one could never feel comfortable. Like in a museum, one false move and the guards would come after you.

STEFANIA PIGNATELLI WERNER: When I was a girl, I knew Estelle Doheny very well, as this old lady in my life. She wasn't much fun, but Mother liked her, and who didn't like my mother? And I suspect Es-

telle was very taken with the fact that my mother was a descendant of two Spanish land-grant families, the Sepulveda family on her father's side and the de la Guerras on her mother's. We would go over and see Estelle a lot. She had an unbelievable house on Chester Place, with a swimming pool in a greenhouse that was phenomenal. It was long and beautiful, and nobody ever used it, so she let me swim in it.

She looked like somebody's cook, but she was extraordinary. When it came time for me to marry, she wanted me to get married at St. Vincent's, this huge Catholic church that they had built. They didn't build a church, they built a cathedral! I got married there, and that morning she sent her Packard for me, filled with lilies of the valley. It was unbelievable, so beautiful I cannot tell you. She even changed the red carpeting in the church to a soft blue color, all the way from the front door to the altar, added to match the pale blue color of the ridiculous bridesmaids' dresses. And in the corner of the church stood a statue of old man Doheny's patron saint sculpted to resemble Doheny himself.

TOM SITTON: The Dohenys were pillars of L.A. society at the time, except that they were Catholics and Democrats, two things that the rest of the elite of L.A. were not. But they still got along well enough because they were so rich. They were giving a lot of money to the Catholic Church. In 1923, he paid to build St. Vincent de Paul Church, which people used to call "Doheny's Fire Escape." The bishop told him that while everybody sins, rich people sin a lot more than poor people do, so he needed to give a lot of money. So the church was his "fire escape" to keep him from going to hell.

PATRICK "NED" DOHENY: The family was really very, very rich. Not just in the financial sense, but also in the sense of great personalities. We want people to be archetypal, to be larger than life, to live up to our expectations. We expect people to inhabit a certain space fully, for us,

whether or not it's the truth. That is the case with history's judgment on my great-grandfather, although he always felt that he was a patriot.

LARRY NIVEN: The Teapot Dome period was a nightmare, I gather, though the family didn't talk about it. They definitely didn't talk about the scandal to the kids. But Mom always felt that my great-grandfather had done no wrong.

RICHARD RAYNER: As early as the beginning of World War I, Doheny began to advise the U.S. government about how to ensure the naval oil supply. In the first years of the twentieth century, control of certain oil-rich lands in Wyoming and California had been given to the Department of the Navy as an oil reserve, since naval vessels had recently been converted to run on oil rather than coal. By the outbreak of the Great War, Doheny had begun talking to the government about building a base in Hawaii, with tanks to hold oil. Hovering around all this was the question of what to do with this oil-rich land controlled by the navy. Who was going to exploit it? Doheny then held out the threat of drainage, the nightmare that if you leave the oil in the ground, ruthless people are going to buy the land next to it and suck the oil out. Paul Thomas Anderson obviously picked up on this for *There Will Be Blood.* So Doheny presented a case for friendly people like himself to be given the job of getting the oil out on the navy's behalf. When Harding was elected in 1920, low and behold, Doheny's old poker playing partner, Albert Fall, from their harum-scarum days in New Mexico in the 1880s, was appointed secretary of the interior. Shortly thereafter—presumably at Doheny's behest, but certainly in Doheny's interest—control of these two oil naval reserves, Elk Hills and Teapot Dome, passed from the secretary of the navy to the secretary of the interior, i.e., to Albert Fall. The right to exploit these oil leases was then given to two of the most powerful oil men in the country: Harry Sinclair, who received

Teapot Dome in Wyoming, and Edward Doheny landed Elk Hills in California.

PATRICK "NED" DOHENY: I don't know who did what with respect to Teapot Dome. My great-grandfather had a lot of integrity, but every era has its own zeitgeist, its own personality. Whether it's socially acceptable levels of racism or chauvinism, or a tolerance for kinds of deviant behavior, or a cavalier disregard for rules—each era is marked by its own set of circumstances. And you can't have a historical perspective if you look back at the past with the values of the contemporary era. But the consensus view within the family, at least, is that the bid my great-grandfather made and the deal he struck with the government for the oil storage depots in Pearl Harbor was, in fact, the lowest bid.

RICHARD RAYNER: Eventually it came out that Harry Sinclair had plied Fall with gifts and that Doheny himself in 1921 had sent his son, Ned, along with Ned's friend-secretary-chauffeur, Hugh Plunkett, to New York, where they withdrew a hundred thousand dollars in cash from Ned's bank account and then traveled down by train to Washington, where they handed over the money in a black leather satchel to Albert Fall in a Washington hotel. All of this was exposed later in an excruciating series of hearings, investigations, and eventually court trials.

The unraveling began when Albert Fall, strapped for cash and the owner of the Three Rivers Ranch in New Mexico that he was desperate to expand, was seen in 1922, 1923 spending money ostentatiously. His enemies in New Mexico started poking around and brought it to the attention of Senator Thomas Walsh of Montana. An Inspector Javert figure, Walsh called Doheny and Fall to appear before a Senate committee in late 1923 to account for the money and the leases. During the hearings, both denied that anything improper had occurred, although Fall admitted that he had granted the leases without com-

petitive bids, and Doheny could not resist boasting about the size of the deal, saying it would be "bad luck if we do not get one hundred million dollars profit."

ANN SMITH BLACK: Pa D. created pipelines in Hawaii to receive oil from various places, as well as a shipping process for it, and when World War II started, they used those pipelines to keep our navy going. My father always said, "Don't forget that. He may have been involved in a scandal and all, but nevertheless the things that he created, like the pipelines in Hawaii, were of great benefit to the United States."

RICHARD RAYNER: When the first round of hearings ended with no revelation about where Fall received his money, Fall and Doheny concocted a plan to make a patsy of Ned McLean, the millionaire socialite and playboy owner of *The Washington Post* and *The Cincinnati Enquirer* who traveled around in a private railway car named the Enquirer and gave baubles like the Hope Diamond to his flamboyant wife, Evalyn Walsh McLean. It's hard not to see McLean as another rich boy who ended up strangled by his silver spoon. His father created a great newspaper in Cincinnati, bought *The Washington Post*, turned it into a great paper, and amassed a fortune, leaving it to his only child, who, like young Ned Doheny, was not the man his father was. Yet because Ned McLean had played poker and bridge with Fall in smoke-filled rooms with President Harding, he went along with Fall and Doheny's strategy to say that he had loaned Fall the money. It was easy to pin it all on Ned. It was a stupid and failed cover-up that Walsh saw through quickly.

In early 1924, only a few months after Harding's sudden death in August of the previous year, Doheny took the witness chair twice more, determined to protect his oil company, his family, his position, his money. He testified that while he did indeed give his dear old friend Albert Fall the money, one hundred thousand dollars was to him a

*Former secretary
of the interior
Albert B. Fall
and his wife at
the opening of
his trial.*

mere bagatelle, no more than twenty-five or fifty dollars to the ordinary individual, he said. Doheny presented himself as an irresponsible old-time miner who happened to strike oil. His hope was to get out of this without being prosecuted criminally.

Doheny tried every possible angle. In 1925 he even approached Cecil B. DeMille, then the most famous movie director in America, and asked him to film his biography. He expected DeMille to shoot what was essentially a PR film to make him look glamorous and exciting and patriotic. I'm sure that he thought he was a worthy subject for a feature film by DeMille, but he also believed it could be a useful tool in his pesky fight against the government. DeMille was not tempted, merely rather amused by the idea.

The attempt to avoid criminal prosecution failed, and the first trial for conspiracy began in late 1925, just a few months after Doheny sold his holdings in Mexico to Standard Oil. He'd clearly been thinking about how to protect his fortune and leave his family well provided for in the future. But as the first trial started, he was under tremendous

pressure from stockholders who did not believe that they had gotten fair value for their shares. So in addition to criminal proceedings for conspiracy, there was a wave of other lawsuits, and he knew he'd have to spend untold millions on his legal defense. Meanwhile, just before the criminal trial, he wrote a letter to Fall in which he mentioned that Ned Doheny had spent the summer at the Mayo Clinic. You get the sense that everything was proving too much for his son; nevertheless, Ned was called to stand in the trial, testifying to his service during the war and his activity as the messenger carrying one hundred thousand dollars from his father to Fall. When asked why he would send his only son on such a journey, Doheny blithely replied, "I sent my most trusted agent, whom I was endeavoring at that time to work into every phase of the business." What's more astonishing is that Doheny went on to say that even if Ned "had been held up on the way he would have learned something in experience." The implication was that it would have made him more of a man. Of course, Doheny must have believed that Ned's Sancho Panza, Hugh Plunkett, would have protected him on the journey.

PATRICK "NED" DOHENY: Under the circumstances, Pa D.'s son was the only person he felt he could totally trust. My great-grandfather was very particular toward family. I remember one letter in particular that he wrote when he was in London on a war footing for World War I. The windows were blacked out, and the headlights on cars were reduced to really small squares of light, and there was a lot of military in the streets. And his overwhelming concern was how much he missed his family, and how much he cared about them. The well-being of his family was his first priority. Your family becomes that one resource that is undeniably connected to you, when everything else is uncertain at best.

GAYLE CHELGREN: My uncle's full name was Theodore Hugh Plunkett, but my mother, Isabelle, called him Hughie. I never knew him

because he was born in 1896 and died in the late twenties. But my mother idolized him. The Plunketts comprised my mother and her brothers, Hugh, Charles, and Robert. She was the closest to Hugh. He was always kind to her, and she'd tell me about how he'd get a new car and come pick her up first thing to take her for a ride in it. She loved him a lot, and she must have been special to him, too.

I was told that Hugh worked at a gas station as a mechanic and that that's where he met Ned Doheny. I think Ned also worked at the station, although maybe Hugh just worked on his car and that's how they met. Hugh became his chauffeur, then his secretary, and then his best friend. I don't know for sure, but they may have both been gay.

LARRY NIVEN: Every Doheny kid worked as a gas station attendant. Every Doheny male. I don't know whether that's still true or not, but the idea was to give them an idea of what it's like to work. You're not a complete male until you've done that, that's the way people thought—and still do think, I believe. For my brother the gas station was in Beverly Hills, somewhere east of Rodeo. I worked at a gas station in Topeka, Kansas, when I was studying mathematics at Washburn University. And my father worked at a gas station, after he married my mother, and he wasn't even a Doheny—he was a Niven. He once talked about it, saying it was a dumb idea and that spending that many hours cleaning up under dripping cars was just not worth his while. So he became a lawyer. My family had their doubts about me. I was slow getting any kind of a career before I became a writer, so my grandmother Lucy Doheny's second husband, Leigh Battson, had the idea to buy me a gas station and let me run it. He certainly had the money. For that matter, I probably had the money. And running a gas station has got to be easy, right? For a scatterbrain like me, who daydreamed as a kid about flying Wernher von Braun's imaginary vehicles—the winged craft that was supposed to land on Mars. I was always a rabid science fiction fan, but

Leigh Battson didn't see that as an ambition. His offer was well meant, but I turned him down.

PATRICK "NED" DOHENY: Supposedly Ned Doheny met Hugh Plunkett when Ned was working at a gas station, but there are all kinds of wild rumors. One was that Ned was gay. I don't know. Among the ranks of the family it's held to be a spurious idea. I suspect it arose from all the time that Ned spent alone, away from his family. I can't be any more specific than that. I mean, my hands are completely tied.

JOHN CREEL: My mother divorced my father, Henry Creel. Then she married my stepfather, Robert Plunkett. He was born in Fort Scott, Kansas, and from there the family moved to Los Angeles. His brother Hugh was the oldest of the family: there was Hugh, Chick—which stood for Charles—Robert, and Isabelle. My stepfather said that Hugh was the best, a good person who helped people. Everybody loved him. And if Hugh was anything like my stepfather or his sister, Isabelle, he was also very charismatic.

Hugh was good with his hands, and he worked repairing cars. I don't know if he met Ned Doheny in that process, but they became good friends. Hugh worked for Ned for a long time, and he did well, even sending my stepfather to USC to study engineering. He was supporting the family, so it was really dramatic for them when everything happened.

RICHARD RAYNER: When a second criminal trial for bribery began to loom on the horizon for Doheny and Fall in 1929, the pressure on all parties reached a breaking point. Both men had been acquitted of the conspiracy charges in December 1926, and they must have hoped that after Harding's death the Coolidge administration would say, "That's it. We've spent all this money already, enough is enough." But it was

not to be. Plunkett was going to have to testify at the trial, and he didn't have immunity, whereas Ned did from one of the previous trials. This was the first time that the prosecutors had required Plunkett to testify, and he was probably cracking up a bit.

JOHN CREEL: Hugh's former wife later testified that although Hugh was very upset during this period, he certainly wasn't crazy. According to my stepfather, if anyone was disturbed, it was Ned. He was a very unstable person.

LARRY NIVEN: My grandfather and his friend wound up dead. I think there was a fight; the friend may have been something of a parasite, but I don't know. There was probably some meddling with the evidence, too, so the full story of how it happened is lost in the past. They didn't talk about that with the kids at all.

TOPSY DOHENY: My husband, Tim, was only three when his father died, so he had only two memories of his father: once when his father pulled him out of the surf at Hermosa Beach and kept him from drowning, and once carrying him in Greystone to the indoor balcony overlooking the living room where a party was under way. That's it. And in the old days, they discussed the death as little as possible. Any question was quickly discouraged. But once I asked Tim, "What do you think happened?" and he told me his father's secretary had mental problems and finally Ned said to him, "Look, Hugh, you're going to have to go away for a while." They didn't have any real medicines for such things in those days, and I imagine the places where one got sent were not the nicest. So Hugh got very upset, pulled out a gun, shot Tim's father, and then shot himself.

Tim's middle name was Hugh—Timothy Hugh Doheny—and after that incident, of course, his name was changed. Timothy Michael it became. So Hugh had been close to the family. My under-

standing is that Mun, Tim's mother, was in the house at the time. I don't know if Tim was there or not, but if so he was probably upstairs with the nurse or something. It was in the papers, of course, not that you'd get the right story. They were afraid of scandal, so apparently the doctor came first, before it was reported to the police, and then the doctor didn't report everything to the police. In those days families were very low on publicity.

CAROLE WELLS DOHENY: My father-in-law, Larry Doheny, was in the house when it happened. He was only like ten or eleven. It was about nine thirty, so he and Dickie Dell, the two eldest, were still up. I think they'd heard the yelling, so they were up there on the landing, just listening, wanting to know what was going on. They were there before the gun went off. It's fascinating: the family didn't call the police for three hours. They never told the truth about it, that's the amazing thing.

GAYLE CHELGREN: Ned and his father were in on the Teapot Dome scandal, and I read somewhere that my uncle was going to testify against Ned. My mother never told me this, because it hurt her to talk about it—she never talked about any of it—but there were some crooked dealings, and my uncle would have been involved since he was Ned's secretary. And I think he was going to testify against Ned.

RICHARD RAYNER: The Dohenys were trying to persuade Plunkett to rest in a mental hospital. The night that it happened, there was a sequence of altercations among him and Ned and Lucy Doheny about whether he should go. He didn't want to. He left Greystone and then turned back up again around nine o'clock at night. The shootings happened and the next thing the doctor was called. The shootings happened about ten o'clock, but it was way after midnight before the cops got there.

JOHN CREEL: Since Hugh had been the bagman on Ned's trip to Washington and would have known all about Teapot Dome, the Dohenys wanted him to go into an asylum so he wouldn't have to testify in the trial. He said no way. If he went in, who knew if he would ever come out? That's why he was very upset and why he went to meet with the Dohenys that night.

What is never talked about is the fact that Ned lived in a different section of Greystone. The family didn't want his children to see him when he was incapacitated. That's why he lived in a separate part of the mansion, something borne out by the fact that he was not discovered in the family room or in the master bedroom with his wife. He lived in a virtually separate apartment in the mansion.

RICHARD RAYNER: In his pictures Plunkett doesn't look like the smartest guy in the world. I'm sure that he wished to do as right by Ned as he possibly could, but that nonetheless he felt he was being pushed to do something that he didn't want to do. He was afraid that he'd be locked away forever. In Chandler novels, people are always being hidden away in cure homes or locked away by evil doctors in loony bins—in fact, held prisoner by some rich family. It was a way of shuttling off someone, of dealing with inconvenience and messiness. Plunkett clearly resented being used that way.

JOHN CREEL: The Dohenys were belligerent about everything, spreading stories about what happened. My stepfather was really upset because he knew what they were saying was a lie, especially that his brother Hugh was crazy. The purpose was to keep him from testifying. And they spread the lie that Hugh killed Ned. From the very beginning my family never believed that Hugh killed Ned and committed suicide, and they were very, very upset about that. The whole issue of Hugh not being mentally stable was strictly manufactured so that he wouldn't have to testify.

The other thing that would really upset my stepfather was the story that Ned and Hugh were lovers. He said that was totally unfair, although of course he would say that; Hugh was his brother. But he said there was no way, that Hugh was not like that. It was simply Hugh's job to take care of Ned, because no one in the family could deal with him.

PATRICK "NED" DOHENY: One of the things that I really regret is that there wasn't more of an attempt made to bring Ned to life for us, including by my father, who was four or five when my grandfather died. And my grandmother never spoke of my grandfather, absolutely not. She was pretty strong willed and did not take kindly to questions about him because of the tragedy surrounding the situation. Apparently Ned had a great sense of humor and was a lot of fun, but I wouldn't be surprised if there weren't some issues with depression. I have a strong sense that there was loneliness there. With his dad away all the time, and his mom dying like that, I would think there would be some unfinished business. I'd love to know more about who these people were. It's a huge piece to be missing. Huge.

RICHARD RAYNER: Leslie White was a young investigator for the L.A. district attorney's office and one of the first detectives to arrive on the scene the night of the killings. He believed Doheny shot Plunkett. When you see the remarkable crime scene picture that White took and his assessment of it—the way the powder burns appear on the respective head wounds of the two guys—you see why. Raymond Chandler, who had worked in the oil business and was fascinated by Doheny, obviously thought the same as White did, because of the way Chandler incorporates the Doheny-Plunkett story in *The High Window*. He not only borrows a passage from Leslie White's book, *Me, Detective*, that describes going to Greystone, but at one point Chandler has Marlowe describe the killings and then say, "You read it in the papers . . . but it wasn't so. What's more you knew it wasn't so and the D.A. knew it

wasn't so and the D.A.'s investigators were pulled off the case within a matter of hours." The story of a cover-up was clearly bubbling around in the air, and people knew that whatever happened that night, they hadn't been given the straight scoop. At one time I had a fantasy that I'd find the piece of paper that finally solved it. But when I started looking into the Doheny story, there was just nothing; it was all destroyed.

White later became a writer and in the 1930s was more successful than Chandler. He had more vivid street experience than Chandler, and he felt that he could write the inside story of the city's shame, of the corruption of L.A. *Me, Detective* has nothing of the emotional depth or descriptive resonance that you get with Chandler—who may have met White and certainly knew his book—but it's still kind of a great book.

ANSON LISK: Ned committed suicide. We lived close to the Dohenys, and the night that it all happened I recall the phone ringing at two o'clock in the morning and the uproar after that. My father helped Lucy straighten everything out. He went over and kind of managed the whole affair forward, kept it as quiet as possible. He did everything he could to help. He was friendly with the police in Beverly Hills, so he called them, and he steered Lucy through everything. But I think Ned shot his male secretary and shot himself. I think he was having an affair with his secretary and something happened.

RICHARD RAYNER: It is intriguing to look at the newspapers from those few days, when the story explodes so quickly and then is over in a flash. They just bring the shutters down, and all reporting stops. Doheny has clearly called in every favor in town that he can, getting on the phone with L.A. *Times* publisher Harry Chandler, saying, "Okay, after the funerals, that's it, no more." It happens very, very quickly. The shootings were on Saturday night, Ned's funeral was on Tuesday, and Hugh's

the day after. And that's it. It's almost instantaneous. The Plunketts were nobodies, and you get the sense that the parents were bewildered by what happened. They had no wherewithal and were just crushed by the remorselessness of this power and control, the lineaments of which were visible then.

JOHN CREEL: They never truly allowed an investigation, so we'll never know the true story. Everyone was afraid of the Dohenys, so the things published weren't true. The Dohenys were just so powerful. After two days, the district attorney, Buron Fitts, refused to get into the case or investigate further, even though he came into office saying he was going to clean up corruption. My stepfather often went into the police station to try and get information, and he also called on Leslie White but was told that White wasn't allowed to talk about the case while still part of the district attorney's office. My stepfather knew, though, that White was going to write a book and that one of the stories in it would be about the murder. And when you read White's book, there's absolutely no question that Ned Doheny shot my stepfather's brother, Hugh Plunkett. For example, the fact that Hugh had a cigarette in his hand proves that he couldn't have been violent in that moment. He might have been arguing with Ned about going into a sanatorium, but if a smoking cigarette is still in your hand, you're not doing anything violent.

That's why my stepfather was so adamant about finding Leslie White's book. When it was published, he tried to buy it, but he was told there were no copies available. Everywhere he went, people told him the same story. He said that the Dohenys bought up all of the books. He'd been looking for it for years, and finally I found a copy for him in the Los Angeles Library. The library never occurred to him. He probably thought that the Dohenys were so powerful they could even keep it out of the library.

The Dohenys owed back pay to Hugh, and my stepfather was the one who tried to see about some form of settlement, but the family didn't get anything. So he had to leave USC and find work for the family to survive, and the only job he could find during the Depression was moving stone in a quarry for twenty-five cents a week.

GAYLE CHELGREN: My family was not wealthy at all, and the Dohenys were of course very, very wealthy. I don't think they threatened my family, since they saw that my family wasn't gonna put up any battle. My mother always said, "Let's put it away. It's been done, so let's forget it." That's how she handled it. But my uncle Robert fought that; I think he got the maddest about it. If he were here now, he would be patting me on the back, saying, "Good, let's not let this die." But the Dohenys came right away and purchased the cemetery plots for my mother's whole family at Forest Lawn. My grandmother is there, as is Hugh, who is buried not far from Ned Doheny. The rest of the family didn't want anything to do with it, because the Dohenys had given them the plots. My grandfather is not buried there.

My grandfather, a house painter, was a stern, tall man. I never had a lot of fun with him, but once in a while he'd crack a smile. He was very quiet about Hugh's death. Those were tough times for him. I imagine they were all so angry that they just held it in and didn't want to talk about it anymore. Eventually my grandfather had a stroke. He lived at our house for maybe a couple of weeks, and then he died. It was kind of quick for him.

JOHN CREEL: The Dohenys were very religious, and from what I understand they were very upset that Ned didn't receive a Catholic burial. I think the family must have disclosed the truth to the priest, and the priest made that decision. They couldn't lie to a priest. The fact that Ned wasn't buried with the family in the Doheny location at Calvary Cemetery indicates to me that he committed suicide. It also indicates

that people knew this and that there was collusion to keep the truth from the public.

My stepfather really didn't want to talk about it too much, because it was a hurtful part of his life. He never brought it up, although he would talk about it if I asked a question. But he would get very melancholy, and you didn't want him in a melancholy mood. It was really traumatic for him whenever he thought about it, so he just didn't think about it very much. He would go and visit Hugh's grave at Forest Lawn once in a while, but always alone. My mother didn't even go with him.

RICHARD RAYNER: In October 1929, eight months after Ned and Hugh's deaths, Albert Fall was convicted of receiving a bribe from Doheny, so the next year Doheny went on trial for giving the bribe that Fall had been convicted of receiving. As the trial went on, there were teams of lawyers, with Frank Hogan at the top of the pyramid of attorneys, trying to get Doheny off the hook. At one point they were all working out of Chester Place and the bowling alley there, which they dubbed "Hogan's Alley."

Hogan was extraordinary. The L.A. *Examiner* said that he was like Houdini in the courtroom, using any trick or sleight of hand to get his client off the hook. He had a wildly dramatic, compelling flair, and in this trial, he pulled an extraordinary stunt: he sat in the witness chair himself as questions asked of Ned Doheny in the earlier trial were read to him and to which he read Ned's responses, as if he were Ned. He was channeling the tragically dead son of the accused. Poor Ned ends up being used by his father even after he's dead. He was probably more use to his father dead than alive at that moment. It was extremely cynical, awful. Yet it works. The trial concluded on a very cold day in Washington, and incredibly Doheny was acquitted. He was found innocent of giving the very bribe that Fall had been convicted of accepting, a Lewis Carroll legal moment. Doheny gave Hogan a million dollars as a bonus and threw in a Rolls-Royce for good measure,

prompting Hogan to say, "The ideal client is a rich man when he is scared." A great line. But Doheny was kind of gone already, a broken man. He died not long after.

TOPSY DOHENY: Pa D. had a stroke. I don't know the year that it happened, but when Tim's father was killed it just knocked the stuffing out of him. That was virtually the end of his life, the poor man, his only child killed. It was a terrible tragedy.

ANN SMITH BLACK: We'd go to Chester Place for Easter, where they had eggs hidden all over, and we'd have a wonderful Easter egg hunt. Pa D. had had several strokes, and he was sitting drooling in his wheelchair. We were all supposed to kiss him, but everybody tried to escape as fast as they could.

His funeral was very Catholic, and it went on forever. Afterward, Ma D. always had two or three priests who stayed with her at the house, which was a great comfort to her. There was one particular priest that was kind of her confessor, and he was nice.

TOPSY DOHENY: Ma D. was a convert, and those are always the most rabid people of all. When her husband died, she was left in charge, and I'm sure she was lonely and sad. And already a lot of people from the church were coming around and influencing her. I think around that time they made her a papal countess, and eventually, the church got her entire collection of rare books. She had visions of her memory lasting forever, but they auctioned everything off.

PATRICK "NED" DOHENY: She was such a devout Catholic. They were both pillars of generosity to the church, but don't get me started. That's a rant I will keep to myself. But if she hadn't given all that dough to the Catholic Church? She gave a staggering amount of money, to the point of where it's like, "Oh my god." And the day of Pa D.'s funeral,

she burned all his papers. Those weren't hers either. She later said, "I really felt bad about that afterward," as if she had nothing to do with any of it. Not only did you not make any of the money you gave away, but you didn't have anything to do with any of the letters or anything else. You just step in, someone who was not part of the process in any way, shape, or form, and direct everything in whatever manner you think right? What the hell is that? She was pompous and self-important. She thought that she was protecting his memory, but she was a foolish woman.

RICHARD RAYNER: The Doheny family is still present in L.A. What's haunting is that in order to secure his power and position, Doheny ended up sacrificing his own family. It's tragic, and he was obviously destroyed by it. It's an original-sin sort of story. His legacy is forgotten and flawed yet emblematic in its own secret way. Few now remember who Doheny was, yet the name is still significant and present—the Doheny Memorial Library at USC, designed by Wallace Neff, the Doheny Eye Institute, Doheny Drive, Doheny State Beach. And then there is the grand Greystone mansion, which fell into disrepair before being bought and restored by the City of Beverly Hills. It's open to the public now and an amateur theater group even stages murder mystery tours there. Enter Greystone!

LARRY NIVEN: One of my cousins was on a tour at Greystone, and he heard the guide announce that all of the Dohenys were now dead. He set the man straight. I imagine he was polite if supercilious. After that, the tour guides invited the Doheny clan for a special tour of their own, and I went. My grandmother put in some really outré baroque chimneys, although I don't remember them from my childhood. And the bowling alley's real; I used it as a child. There was an Olympic-sized swimming pool, always cold, because it was surrounded by trees. Even in the summer it was too bloody cold, but you swam anyway. There

was a tall diving board and even a tower with a diving board on that. Now it is a swimming pool only a foot deep. In order to avoid lawsuits, they poured a lot of concrete in there when the city took ownership.

GAYLE CHELGREN: I went to a wedding shower at Greystone once. I wanted to go inside and steal something from the bathroom, but I didn't. I was kind of overwhelmed with the whole thing. We were out in the garden, mostly; it was a huge, lovely place. I know they have tours, and some of my friends have gone through it. But I have never had an interest to do so. And you know what? The old family is all gone, and these are the young people that had nothing to do with it. They believe what they want to believe. Still, I resent the Doheny family tremendously, and I wasn't even born when all of this happened.

RICHARD RAYNER: Raymond Chandler famously said that "the law is where you buy it and what you pay for it." He completely saw the way that power works in Los Angeles, which along with corruption became his broadest subject. And he kept going back to the Doheny story. It's glanced at in different ways throughout his work, and it lingered with him as a paradigm for what he saw as the rotten heart of paradise.

II

THE WARNERS

1801 Angelo Drive, Beverly Hills

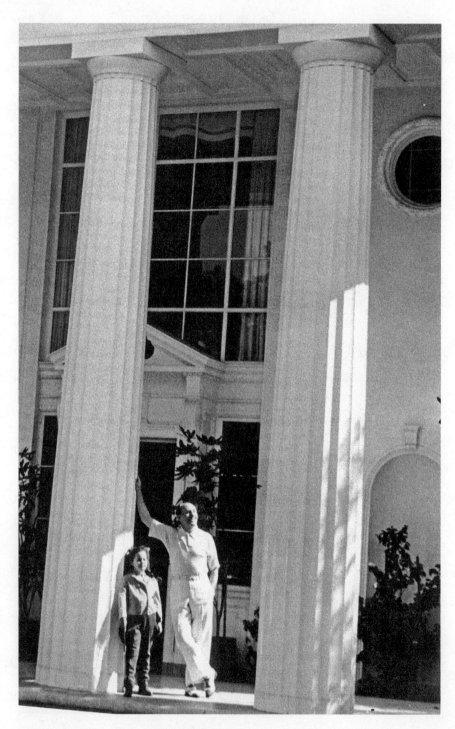

Barbara Warner with her father, Jack Warner, 1942.

ARTHUR MILLER: Jack Warner's generation invented what turned out to be the major world culture—not just American, but a world culture. The world's dream is to escape the dreadful, ordinary, industrial, technological life. And you can understand how it happened if you think of where they came from, a place where there was absolutely no chance for anybody to do anything. They were living in a mud hole, but here the dreams were absolutely feasible. If you could think it, you could do it. It was magic. And they filled the movies with that magic. George Cukor told me once, "Our object was to escape reality. We were quite conscious of all that." It was a never-never land, a construct. These immigrants, these Jews from Eastern Europe, had developed this dream that had blond hair, blue eyes, and a straight nose. It all had to be beautiful. This was a fairy tale, because they were immigrants who saw this country as a fairy tale. It was incredible: it captured the whole country.

DAVID GEFFEN: Jack Warner was a great character, like all of them. They were remarkable guys, but they were monsters. The movie business is a hard business, and you had to be a monster to create this industry.

CY HOWARD: Nobody cares now, but they did. They really liked their business. It was an exciting business, and they cared for it. They loved to get out and hustle. They didn't do it for the money; money was just a by-product. Now, they also loved to get away from the house in the morning, to be around people with perfect tans and straight noses from Texas who'd dance around them and say, "It's so nice to be here!" The

studio was the family, and someone like Loretta Young was the wife. Not a bad wife. Wouldn't you like to think, This is my wife, Ginger Rogers, rather than the wife at home? So they had it both ways.

But I don't know why some new mogul feels he has to move into an older mogul's house. He should have his own identity. I can see why the old moguls came out and needed a new persona. After all, General Motors and Wall Street had not invited any of them in, so they started a new business. They made the rules. But I don't see why a new generation needs a persona from the Old World.

DAVID GEFFEN: One time, a friend and I were driving past Jack Warner's house on Angelo Drive. We noticed that the gates were open and we actually drove in, but guards showed up and stopped us from looking at the house. When I read Ann Warner's obituary in *The Hollywood Reporter* in March 1990, I thought, Hmm, I'll say I want to buy the house just to get a look at it. This time, I was ushered in. It was so grand and so Hollywood. It was a bigger statement than Louis B. Mayer. It was a bigger statement than David O. Selznick. It was the biggest statement that any of the figures of that era had made. It was an homage to an idea about the way people lived in Hollywood. I got caught up in the whole gestalt and I bought it. What's really interesting, though, is that I paid more for the house than Jack Warner sold his studio for in 1956. I think he sold it for thirty-eight million and I bought it for forty-seven.

JACK WARNER, JR.: After he had the success of *The Jazz Singer* in 1927, my father bought some land next door to Harold Lloyd's house. It was wild, filled with wheat and grasses, and they moved in with horses and men with shovels. He built this oppressive Spanish house—what we used to call the Spanish clunker—but a gorgeous one. It was designed and dressed by the studio art department; they were great on building sets, lousy on homes. The studio didn't build the house itself—my fa-

ther had an architect and a contractor—but the studio did the interior design. They must have had a lot of old Spanish furniture they wanted to get rid of, ugly and uncomfortable, heavy stuff. It was like living in a museum, with magnificent pieces of furniture that should be in a gallery somewhere. Or over in the prop department, which is probably where they came from. But parts of the house were magnificent, with flooring from Europe and paneling from England.

My father added a nine-hole golf course, but I don't remember it being used much. Once I brought home some kids, friends of mine from USC's golf team, and my father bawled the hell out of me for mussing up the greens, making divots and so on. He didn't want it touched for golf, but it was a golf course. The only time it really got used was a housewarming party. Harold Lloyd and my father got together—the one and only time they did—and put a bridge over the wall between their houses, and people went back and forth.

BARBARA WARNER HOWARD: Our house was originally built in a Spanish style, but my mother hated it. My father had lived there with his first wife, and Mother was always after him, saying, "Let me just change a few things," but he kept saying no. Then one day Father came home and found that she had arranged through someone at the studio to have a bulldozer tear down the façade of the house. Anything that looked Spanish was gone. So he finally let her redesign the whole front. She was very taken with Monticello and went to study it before they built. With some help from the Hollywood decorator Billy Haines, the house became the Southern antebellum mansion of her dreams. She had grown up in Ferriday, Louisiana, and she had wonderful memories of the plantations down there.

There were big wrought-iron gates at the street entrance and there was always a guard from the studio posted by them. You'd come up the driveway, under a canopy of sycamore trees that were illuminated at night by soft hidden lights, then around a graceful fountain in the

brick courtyard. Then you'd pass through a pair of mahogany doors into an entrance hall that had a curved staircase, a large crystal chandelier, and a Versailles parquet floor, which Mother had found in France. Downstairs, there was a theater with a massive screen that rose out of the floor and, in the next room, a bar with a pale oak counter and leather wall panels. The dining room on the ground floor had Regency chairs and an English dining table that could seat twenty-four. And there was a ladies' room, where the women would go while the men smoked their cigars after dinner, which had a pink-veined marble floor and Venetian blackamoors. In the pantry, there was an old-fashioned telephone switchboard that only the butler could work. My parents' quarters were upstairs, complete with a steam room, and my little bedroom and sitting room, which were done in deep pink—to this day I've hated pink—and lots of chintz. I'd never been particularly attached to the house—I'd always wanted to get out. To this day, I don't completely understand my feelings about it.

JEAN STEIN: Our house seemed modest compared to the Warners'. Theirs was like the Parthenon, complete with golf course and waterfall. The scale of it was dazzling. Barbara's birthday parties were major productions, dozens of children seated at an elegant banquet table. I remember at one party, Mr. Warner stuck his head in when the cake was being brought in. "Happy Birthday, Bunky!" he shouted. And then he quickly shut the door again.

BARBARA WARNER HOWARD: Only about ten days after my mother died, an executor for the estate said, "I have someone who might be interested in the house." It was David Geffen. He came over a few days later, dressed in jeans and a T-shirt and a nice jacket: he looked like someone you would meet at a beach party. He could have been a friend of mine. I thought it would be nice to sell it to someone in the

entertainment business, and my mother might have liked him, though my father would have disapproved. But David said, "I could never live here. What would I do in a place like this?"

Then he came back again. This time, he said he thought he was very interested. My father had a brother named David who had died of sleeping sickness shortly after the First World War, and I said, "David, that's wonderful. Maybe you're the fifth brother come back." He looked at me as if this had clinched the deal.

He showed the house to friends: Steven Spielberg and so forth. In the office, there was a collection of original leather-bound scripts embossed with "From the Library of Ann and Jack Warner." Spielberg saw one that dated from around the time he'd first come to Hollywood: *Rebel Without a Cause* or *East of Eden*. And he said, "Do you think I could touch it?" David asked if he could give it to Spielberg. He hadn't bought the house yet, but he took me so much by surprise that I replied, "Of course, go ahead." They were like children in a candy store. And I felt the mystique for the first time. Here were people I respected who were enthralled. It was a very odd feeling, as if I were living in a wax museum.

Escrow on the house closed just six weeks after Mother's death. It was so fast, but David kept saying, "Why can't this go faster?" He wouldn't take no for an answer. He wanted it now and yesterday.

DAVID GEFFEN: After I bought the house I took my interior designer to see it, and I showed her all the original furnishings. I said, "See this floor? This floor was a gift from Napoleon to his sister." My designer said, "Really? You think people give floors as presents to their family?" We walked into the dining room, and I said, "This wallpaper was from the imperial palace in China." She said, "This is French wallpaper from 1870 or 1880." I pointed to another piece and said, "This is a Chippendale." She said, "You're not going to scream at me, are you?"

I said, "What do you mean, scream at you?" She said, "The original is a Chippendale and is in the Victoria and Albert Museum. This was made at Warner Brothers."

CY HOWARD: After David bought the house, Barbara and I went to the cocktail party the lawyers gave there. David and I greeted each other, and he said, "I don't know why the fuck I bought it. What is a Brooklyn boy doing here?" I said, "You don't always have to be from Brooklyn. You'll enjoy yourself. You can afford it. You'll have a new persona." He said, "You know how Brooklyn is: we sit on the stoop, all huddled together, friendly. How can I make this friendly?" I said, "David, you can make this Brooklyn. You open up two candy stores, and you bring in five Hasidic rabbis and three Koreans to picket. You bring in cops to beat everybody up. Then, for the climax—this might be expensive, but I think it should be done—you build an El, so that you can sit there shivering as the train goes overhead. Then you'll have Brooklyn." Barbara grabbed me and hustled me away and I wasn't allowed to speak anymore.

BETTY WARNER SHEINBAUM: My grandparents were people from the old country, from Krasnocielc, Poland. My grandmother Pearl Warner was a childbearing machine: she had twelve children, seven of whom survived. She wore a long black silk dress every day, and she had no interests that I knew of. She hardly ever spoke. My grandfather was the boss, and she obeyed. He wanted to have a new life in the New World, but at the same time he was not equipped to do anything other than what he had done in the Old World. He was a butcher, then a cobbler, then he ran a store. They wanted better things for their children, and they themselves had no education. But their children weren't able to have much of one because they had to work to keep the family eating food and clothed.

They were constantly moving, changing, taking on new businesses

to try them out, see if they would work. At one point, they took horses and broke them and made them tame. They diversified in a desperate search to find something that they could really make a living at and that was going to make them better off than they were in the old country. The streets were not paved with gold. The kids all had to go to work immediately. They did anything they could do that was available to them, and they worked very hard. Harry, my father, was the oldest son and became the patriarch, the tribal head. The mantle fell on him from day one, and he never knew anything else. He talked about how serious his life was from age seven. Jack, because he was the youngest and the baby, never went through that. And he was cute and funny and wanted to be in show business: he was a pest from the day he was born. Sam—the brother in between—kept peace in the family because everybody loved him. And Albert was a slow-paced sort who avoided as many problems and as much trouble as he could.

JACK WARNER, JR.: I don't think my father found any real warmth in the family as a little boy. They were too busy surviving. It's an old, old story from way back. Plus he had older brothers who tormented him. They didn't intend to be mean, but he interpreted it that way, and it sowed the seeds for what followed.

Harry and Albert and Sam all took after their father. I don't know who my father took after—he was a street Arab, if you want to call it that, a kid who grows up on the streets and gets tough. Today you'd call him a juvenile delinquent. He never went to school and was even thrown out of religious training at Hebrew school. When his teacher rapped him with a ruler because he was a rough little cookie, he yanked the teacher's beard and took off. And that was the last formal education. Harry could read Hebrew. Albert had a knack for figures, so he handled the funds. He could also take a racing form and analyze everything on it. Sam was good at everything: mechanical things and working with his hands, but also had creative ideas and worked with

his mind. And he didn't have to try to be liked and loved, he just was. It came to him. Had he lived I think so much history would have been different.

My father took the name of a minstrel he liked—Leonard—as his middle name. And he wasn't really Jack, he was Jacob, and the last name wasn't Warner. I asked my father once, "What was the real family name?" and he said, "Jack, get me a cigarette." Then he let the smoke curl up, and he looked at me and said, "I don't remember."

BARBARA WARNER HOWARD: The kids grew up in Youngstown, Ohio, where my grandfather had a butcher shop. He kept kosher meat in front and nonkosher in back, and my father used to swap the kosher steaks for the nonkosher ones because they tasted better. They had a horse and buggy to deliver the meat to different clients, and the horse knew the route well enough to stop on its own at the right place. They lived in a Polish neighborhood, and there was some anti-Semitism there at the time. Kids would come by and look in the window, laughing and wanting to see if Jews really had tails.

JACK WARNER, JR.: My parents met in San Francisco, where my mother's father was an attorney. When they married, he was just a young kid from Youngstown, Ohio, who had a film exchange, and her family wasn't happy about him. They were a very well-to-do German Jewish family from way, way back, who'd come across the Isthmus of Panama and up the coast right after the Gold Rush. They'd been there for several generations, and then along came this young squirt one generation out of Poland. My mother, Irma, had never eaten kosher food or heard Yiddish spoken, and suddenly she's propelled into my father's family.

BARBARA WARNER HOWARD: Her family was not taken with my father. He had a fifth-grade education, and she came from very educated peo-

ple. He was very young, twenty-one, and she was pretty, with blond hair and a little bit cross-eyed. But he was very strong, and they got married. After, he took his bride back to Youngstown, Ohio, to meet the family, and it was a disaster. She was very sheltered and hadn't really met people like that. They had a butcher shop, and his mother spoke only Yiddish. If my father was the most refined of them, you can imagine. So right from the beginning things didn't go too well.

JACK WARNER, JR.: My mother was a sweet, warm woman, interested in life with a large circle of friends. She didn't have any specific talent, but she could cook pretty well and run a house nicely. She was a good mother, and I often wondered why they didn't have more children, but I think my father had already had one large family and he wasn't ready for another.

My father was married to my mother for twenty years. In the early years of their marriage, when he was struggling to move up in the movie industry and his big job was to get the actors out in the morning and be sure the cameraman wasn't drunk, my father was a happy guy. The brothers were not yet such wealthy men, and many of their later problems hadn't developed.

BETTY WARNER SHEINBAUM: Once the brothers had founded the studio in L.A. in 1923, Harry went back to New York to work on distribution with Albert and to deal with the banks—he was one of the few Jewish entrepreneurs the bankers trusted in that era. Sam and Jack were left to establish the business, although Harry had to approve whatever they did. Somehow or other they all worked well together. Then Sam died of a cerebral hemorrhage after an operation to relieve a sinus infection, the day before the opening of *The Jazz Singer*, in 1927. He had been responsible for bringing sound to the movies—with another man who worked at Warner Brothers, an army engineer who was a genius with electronics called Major Nathan Levinson.

JACK WARNER, JR.: My father was a lot of fun to be with before he hit it big. In the silent picture days, he would take the companies out and direct. He'd get behind a camera and do everything but act—which is what he wanted to do most of all. Once in a while, you'd even see his back in a shot. He was a ham from way back, a frustrated thespian—although he'd think "thespian" was a dirty word. He shot one-reel and two-reel comedies to start, no scripts. This was before their first big hit, *Rin Tin Tin*. If he needed a crowd, the extras would be friends and family. They'd all be told to bring along overcoats and hats and mufflers and wigs if they owned them. The crew would set up the cameras early in the morning, usually up Sunset Boulevard or on the beach or in the hills where Dodger Stadium is now, and they'd stage chase scenes. The extras, who were paid with a box lunch, would race by the camera and circle around behind it, where they'd change hats and race by again, then change coats or put on a wig and race by another time. When they edited the film later, they'd figure out how it all fit together. When I was eleven or twelve, I was one of the ones running around and around.

We lived close enough at that time that we could walk to the studio together, and those are my happiest memories. I remember walking to the studio one day, and my father was dancing half of the way there. The studio then was in Hollywood, on Sunset Boulevard, but before that, they had a crummy little studio in a place called Poverty Row. These were offices really, because you didn't shoot on a stage then, you went out on location. Those were poor days, but they were happy.

My father was then a different kind of man entirely, a struggling young guy who got on well with everyone. I don't think he had developed the attitude that everybody wanted something from him, which governed his life later. Success ruined my father. Right after *The Jazz Singer* earned all the money, that's when it happened, the metamorphosis.

RICHARD GULLY: Jack wasn't fond of having employees at the house. So many of the people who came didn't work at Warners. He felt much safer with them. He was nervous about people from the studio taking advantage of him. Once, at a sneak preview, I said to him, "Jack, couldn't you be a little more considerate?" He said, "In my line of business, you can't have friends. You obviously can't have friends." If you want to run your business in sort of a tough orthodox way, you just can't do favors for people. It's that simple.

BARBARA WARNER HOWARD: My father loved to play tennis. He was a pretty good player, but he'd always make sure that his doubles partner was either a pro or someone who was very, very good so that he always won. A long time before we met, my husband, Cy, had written a film for my father and was invited to play tennis there. Cy used to be an excellent player, and he beat my father. Richard Gully said, "That's a no-no. You'll never be invited back." And of course, he wasn't. My parents had their tennis parties every Saturday and Sunday and wonderful buffets. And no one could start to eat until my father did. The people around my father were a little scared of him. I didn't realize as a child that people usually didn't act that way, that it was not normal behavior for people to say, "Yes, of course, what time would you like to eat?" when they were starving or always to ask him, "What would you like to do?" and say, "Of course, you're right and everything is the way you see it."

JACK WARNER, JR.: The studio lot had this big black monstrous tower, and whenever my father had an argument with someone and he wanted to end it, he'd go to the window and point outside, saying, "Whose name is on the water tower?" Of course, his name was never up there—it said "Warner Bros." Harry Warner or even I could have said my name was up there. But this was my father's way to shut up

Jack Warner, astride a lion, surrounded by yes-men.

people who disagreed with him. He wanted to stress that he ran this company and by god, he did. Not so much when his brother was alive, but when his brother was gone, he ran it. Supposedly at some point Warren Beatty climbed up the tower—which is a hell of a thing, you've

gotta have a death wish to do it—and signed his name. I admire him for that. I would never have dared do it.

RICHARD GULLY: Jack Warner's dining room at the studio was really like Buckingham Palace. He'd sit at the head of this great table and was really something to see. He was like a monarch. In his office in story conferences or meeting with producers, you never saw the grand manner, but in his private dining room at the studio, Jack Warner would sit there as the king of all he surveyed. The table could seat about twenty people on each side. By comparison, the dining room at his house was big, but you could only put ten or so on each side. The food in the dining room at the studio was superb. He had a French chef, and it was like a gourmet restaurant. He sat at the long table and everyone deferred to him. You would talk when you were given permission to speak.

ARTHUR MILLER: The night I met Jack Warner, he reminded me of no one so much as Victor Moore, a comedian in things like *Of Thee I Sing*—he played in musicals where he could wear a high hat and act absolutely stupid and dopey. The mixture of vanity and gross vulgarity in that man Jack Warner was something to behold. He really had the world in his hands, you could feel it. We laughed. It was terrible, really. But everybody was beholden to him. He sat in a high-backed chair in the sitting room, and everybody was treating him like he was the king of England. That was an education.

JACK WARNER, JR.: When Albert Einstein visited the studio in 1931, my father—who would speak up to anyone even when he didn't know what he was talking about—said, "Doctor, you have your theory of relativity and I have mine: Never hire a relative." I always wanted to add, "Where would you be, Pop, if your brothers hadn't hired you?"

They took Einstein to the process department, where they had a Ford set up on a scaffolding. He and Mrs. Einstein sat in it and the cameramen filmed them while, unbeknownst to the Einsteins, projecting an aerial film of New York, Niagara Falls, Chicago, and Los Angeles behind them. Then they developed this film of the Einsteins flying over America in a Ford and showed it. Einstein stared at it and kept saying in German, "My god, what have they done? I don't understand." My father said, "Relativity he understands!"

I started working in my father's production department when I was still in college. I'd ride a bicycle around the lot and look for problems. I once wrote a fifteen-page critique and gave it to him and to Steve Trilling, his right-hand man at the time. Then the phone rings, and my father says, "Who did you give this to? Find all the copies and destroy them." I'd found fault with certain things that delayed pictures—nothing earth-shattering, too much dependence on committees and so on. I guess I was showing off a little, and he resented it. He never went past the fifth grade, so he wanted me to have a great education, but then once I got it he'd say, "You and your college talk. . . ." I always felt, what the hell, he's a cum laude in his field, he doesn't have to feel negative about it. But he did have a great inferiority complex.

BETTY WARNER SHEINBAUM: Harry took care of the family, and if anybody had a problem they came to him. But he was also very domineering. It was "Do it my way or else." He knew what was right and what was wrong, and he expected everybody to live up to his code. Jack was constantly rebelling, and everything he did was just shocking to my father. He treated Jack as if he were a bad little boy, and they were constantly at odds. It wasn't that their relationship deteriorated—it was always bad. My grandfather Benjamin Warner, who the brothers had moved to Beverly Hills with my grandmother, tried to keep peace in the family: "One for all and all for one" was his credo. But Jack and Harry came from two different planets.

We moved back to California from New York in 1936—largely so that my father could keep an eye on Jack. My dad bought a thousand acres in the San Fernando Valley and built a ranch there. But after a few years he decided to sell it to the studio. They were using part of it for location shots anyway. Jack said, "Look, can you give the studio a break?" So my dad said, "Sure, you can have it for ten thousand dollars." About a year later, he found out that Jack had bought it for himself and turned it into a housing development. I guess he made money on it, but he had no hesitation about lying to my dad.

My dad lived well, but it wasn't important whom he saw socially. He didn't like actors' parties, and he never really connected the faces to the names. There's a story about him going to the Coconut Grove and noticing a beautiful teenager at the next table. Before anyone could stop him, he went over and said, "Young lady, you're really beautiful. You should be in films." She said, "Well, how do you do, Mr. Warner. I'm Shirley Temple."

JACK WARNER, JR.: My father built the house on Angelo Drive while he was still with my mother. There was one feature in the house that I've always been sorry about: it had a central-heating system with big vents, and if my parents had a battle at the other end of the house—because she'd found out that he wasn't at the studio that night—I'd hear the whole damn thing coming through the vent. And my father stayed out a lot of nights. I'm surprised I'm even able to think about it without getting all tightened up. A successful producer in that early period was the worst marriage risk in the world: there were so goddamn many temptations, and my father was exposed to them willingly and happily.

One day he sent his masseur, Abdul, over to pick up all his clothes and then he disappeared from our lives for a year. My mother knew he'd had affairs—Ann wasn't the first—but she hadn't known he wanted a divorce. And suddenly she and I had to pack and leave. Part

of my parents' divorce agreement was, strangely, that neither of them could remarry for one year. As soon as the year was up, my father and Ann got married in upstate New York. We found out because the newspapers reported on it and it was all over town. My mother was very upset because she hadn't yet adjusted to being divorced. She'd been Mrs. Jack Warner and had lived in a mansion, and suddenly she was living in the Beverly Wilshire Hotel.

I was still working at the studio every summer, and there was no real friction between me and my father at that point. He kept saying, "I want you to get to know Ann." All I knew was that she had broken up our home, and it took a while to get my mother to let me meet her. "That woman" and "that bitch" were interchangeable terms in our house.

Then the first time I met Ann she said, "When were you born?" I gave her the date, and she said, "What time?" I said, "My mother says it was at eight in the evening." My father said, "Yeah, that's right, you broke up a movie I was looking at." Ann said right away, "You and I will never get along. My sign is in conflict with yours." I've heard from other people who knew her that she was ruled by astrology. My father looked a little surprised, but what could he say? You'd better recheck your stars?

BETTY WARNER SHEINBAUM: My father had this unrealistic idea that the Warners should always be dignified and avoid scandal. So when Jack came to him and said, "I want to marry this girl, and she's been married, and we have an illegitimate child," and so on, my father went bananas. He said, "Absolutely not. How dare you marry a woman like this?" Ann was not exactly a nice Jewish girl.

GREGORY ORR: My grandmother Ann Warner was born in Ferriday, Louisiana, where her father had run a dry goods store, and he also had a movie theater for a while in the silent-movie days. Then they moved out to California when Ann was twelve.

She met her first husband, the actor Don Page, later Don Alvarado, when she was sixteen and he was twenty-one. She was finishing high school, trying to figure out what to do, when this very good looking young actor came along, and he was her ticket to the exciting life of young Hollywood. It was not the greatest match. She needed someone who could provide a bigger life for her, and he was just a struggling actor. They didn't have much money and lived in a little house near Carthay Circle. Then he didn't do well when sound came in. My grandmother and Jack Warner started having an affair in the early thirties, and she got divorced from Don pretty quickly then. Don ended up leaving acting and becoming a very good assistant director at Warner Brothers. They all knew each other. Jack Warner even supposedly changed Don's name, telling him that since he looked Latin, he should have a Latin name, a "Rudolph Valentino knockoff." They were driving past Alvarado Street one day, and Jack said to him, "Alvarado, that's a good name."

BARBARA WARNER HOWARD: My father first saw my mother when she was dancing the tango at the Coconut Grove. She was very beautiful—she looked like Dolores del Rio—with amazing blue-green eyes and a great sense of rhythm. She loved to dance. And she had an incredible presence, great charm and wit. But they didn't actually meet until later because she was married to her first husband then.

My parents got married in 1936. Years later, when I was about thirty-seven, I met Mae Brussell, the daughter of Rabbi Magnin, who had been the chief rabbi of Los Angeles. She said, "Barbara, the last time I saw you, you were three and it was your adoption party. At least that's what everyone was told, but I said to my father in a rather loud voice that I could tell you were Jack and Ann's daughter because you looked so much like them. And he told me to shut up."

I tried to find out what had happened. I spoke to my father's secretary and a cousin of my mother's, and they both told me that I had

been born before my parents were married so they had had to hide me. I was shunted off to the gatehouse at the edge of our property, where I lived with a close friend of my mother's, and then when I was two and a half I was "adopted" and moved into the house.

I didn't ask Mother about it then. But, about a year later, the night after my father died, I slept over in my mother's room, so she wouldn't be alone. In the middle of the night she forgot I was there and pushed the button to make the automatic bed sit up and woke me up. I thought that was probably a good time to ask about this story. Mother was very touched. She said, "Oh, you should have asked me before. You were a love child. We really wanted you."

JOY ORR: I was Ann's first child, and we were alone together a lot. Before she met Mr. Warner, I was all she had, and she was all I had. We used to have picnics together at Laguna Beach. She was so young and adventurous. I was in love with her. But, of course, she changed. She became a lady of the world.

I first met Mr. Warner when he came with my mother to visit me at the Sacred Heart Academy in L.A., and I loved him on first sight, even though he had a gruff manner. I didn't know anything about him, but I thought, If you make my mother happy, I'll kiss you. I was attracted to him. He was a big polar bear. Then, when I came home, I thought, If I stay out of sight I won't get in trouble. But I had this love for him. I used to wait at the gate for him. Then he started taking me to tennis and polo matches. Still, I never called him "Father" or "Daddy." Finally, when he was passing away, I was just over sixty, and he said, "I am your father, am I not?" And I said, "Yes!" I had always been afraid to say it, but he was sitting there almost blind, and I said for the first time, "I love you." And he said, "We love you, too, baby." Whatever people say about him otherwise, Mr. Warner was a wonderful father. He could have walked away from a lot of things, and he didn't.

Of course, I knew that Barbara wasn't really adopted. One Sunday

afternoon, my mother showed me a picture of a little girl and asked, "Would you like a sister?" The minute I saw the picture, I knew she was my mother's daughter. So I said, "She has to come home right this minute. This is where she belongs."

Life in that house was a fairyland at times. We were protected; we knew nothing of the outside world. I remember looking out my window and seeing all the way down to Benedict Canyon—nothing but trees blowing in the wind. My room was in the upstairs corner of the house, and later, when I was grown up, I'd go back and sit in the dark and pretend no one knew I was there. I wanted to stay there until I left the earth. But my mother would say, "We have to stop this. You have to grow up."

In 1942, when I was seventeen, I went into Mother and Mr. Warner's sitting room to get the funny papers or whatever was around to read, and he handed me a script to look at. I read it and I thought, Oh, it's kind of cheap, but I don't want to say anything, because I don't want to be on the outs. So I said, "Yeah, it's okay." Then he said they wanted to test me for it. It was *Casablanca*. When I first read it, it was just *Everybody Comes to Rick's*, and it sounded kind of corny. It turned out, because of Ingrid Bergman, I guess, to be something unique. Bergman couldn't be cheap, no matter what she did. My scene was done in half a day and Bogart directed it.

BARBARA WARNER HOWARD: I think I never heard Joy say what she really felt about anything. Usually she just loved everything; it was all wonderful and great: her past, our mother, everybody. Especially living at the house. She always said how happy she was there and how she never wanted to leave it. She glorified it all. It was part of her character—and her problem, too.

RICHARD GULLY: I tagged along to Hollywood in 1936 with my cousin Lord Warwick, who had gotten a fabulous contract to act at MGM:

$750 a week. In the thirties, going to Hollywood was not considered the most distinctive thing to do, but it turned out to be a stroke of genius on my part, because I certainly became a far greater success in Hollywood than I would have been in the House of Lords. I was the son of a peer; my father was Lord Selby, and his father had been speaker of Britain's House of Commons. I was never brought up to do a day's work. I always thought that I was going to be a peer of the realm. But when I was sixteen, my father died, and I found out that I had been born out of wedlock, and so I could not succeed to the title. I suddenly had no title, no money, nothing, even though my parents got married a year after my birth. I only found out about it through reading my father's obituary in the newspaper. And that's the reason I left England and came to America in the first place. And Fulk Warwick helped me move to Hollywood. I knew from the day I arrived that I had come to the right place. People have asked me, "How could a man with your upbringing like a place like Hollywood?" But when I looked at the people here, I looked at them as talented people. I'm sure Ginger Rogers never went to school. But what the hell! I watched her dance cheek to cheek with Fred Astaire, and that was all I needed.

Before I started working as Jack Warner's chief of protocol, the three social figures were Jack, Darryl Zanuck, and Sam Goldwyn. They were the inner circle. Jack Warner completely outclassed Louis B. Mayer. Mayer had no social prestige, but at the same time he had the most fabulous roster of stars: Garbo, Joan Crawford, Myrna Loy, all the glamour people. Warners was a more intellectual studio. We had brilliant writers and the greatest musical staff in the world—Selznick had to borrow Max Steiner from Jack Warner to score *Gone with the Wind*—but we couldn't compete where the stars were concerned. Jack took it all in stride. He borrowed people, and he could always get John Wayne or Cary Grant, because they didn't want to be affiliated with one studio. Jack would have friends like Gary Cooper and Greer Gar-

son at the house, but he very rarely invited Warner Brothers' stars over. There were so many disputes with them — they were always on suspension. Bette Davis, for instance, was a real problem. She sued Jack and was disruptive in every way.

I learned about the tremendous intrigues that went on in Hollywood at the time: the battles for success. The plunders were so great if you succeeded. Jules Stein busting in on the agency business and grabbing movie stars — he got hold of Bette Davis at Warner Brothers. Jack was outraged and barred MCA from the lot.

HARRY JOE "COCO" BROWN, JR.: All the players of that generation of the thirties — Louis B. Mayer, Jack Warner, Darryl Zanuck — were people who came with a burst of energy from nowhere and founded a business nobody had heard of before.

Barbara Warner was my age, and we lived in a world of governesses and nannies. It was a society within a society. Now, because we're second-generation Californians, we're looked down on as the old aristocrats.

But when our parents arrived, there was no tradition. When I think of that generation, I think of a style that's gone: a style that went with large houses and invisible children and gaiety of some sort. The rest of the country was in a depression, but in Hollywood after 1930 everybody was rich.

The Warners were always the mythic family. You had normal, run-of-the-mill people, and then you had the Warners. Their gardens were like something out of Versailles, and the projection room was extraordinary. All the up-and-coming actors would have to come over and make an appearance. After dinner, there would always be movies, and everybody would joke about them if they weren't Warner Brothers movies. Sometimes Jack would get up in the middle of it and say, "I have to go to bed, and everybody has to go home." It was just feudal, that kind of power.

BARBARA WARNER HOWARD: My father's butler was named Rocher. Before working for my father he had worked for Douglas Fairbanks, Sr. He was French and was with my father from the 1930s until the 1960s. When my father would travel, he would always take Rocher with him, even to the South of France, where he was also supposedly on vacation, but then he would want to run the house there, too. He was impeccable, a little severe and rather formal, but I liked him. He and my mother had a running battle, a war of place cards. Mother would have the table set a certain way, and he'd find a way to change it at the last moment when it was too late to change it back. He'd always change the flowers when she put roses on the table. She'd go upstairs to dress, and when she'd come back the roses would be gone. He couldn't stand them; they smelled too strongly to be on a dining room table. He ruled the place with an iron hand. The last time I saw him, he was retired and living in Brittany. He showed me pictures of Douglas Fairbanks, Sr., on an elephant in India. He was lovely.

FROM LADY DIANA COOPER'S AUTOBIOGRAPHY:

We had been asked to stay in Los Angeles by Mr. and Mrs. Jack Warner. . . . The house was beautiful, so was the hostess, and our own Rolls Royce had a better Ronald Colman at the wheel. Our rooms, bathed in sunshine, had a private terrace furnished with sofas, tables, cigarettes, books, and gin. Lying on my bed, I had only to press a button to find my room flooded by a Beethoven or Tchaikovsky symphony, not presented to me by Wrigley's chewing gum but coming from the tennis court where Jack Warner was playing. . . . The walls are covered in Chinese paper, the twin Chippendale beds are under a single Chippendale canopy, the carpet is rich and white, every piece of furniture is a museum piece. The lamps are Ming and sheets embroidered from hem to hem. . . .

Duff's fiftieth birthday. He never groans at the passage of time. I can't think why. The night before the Warners threw us a star-scattered party. It was a bit of an orgy, none the worse for that and we enjoyed ourselves hugely. I started in a fine pink brocade Molyneux dress, but Mr. David Selznick told me that my breasts were too flattened and that people were complaining about them, and could I change? So I went back to the old Central European's peasant dress and took a new lease of deep-bosomed life. The morning after, being woken bedside by Ann Warner's enchanting child of five singing, "Happy Birthday, Mr. Cooper," I feel fine. "The climate looks after you here," as George Gordon Moore used to say as he gulped down another demijohn of alcohol. We had lunch with the adorable Vivien Leigh in her caravan. There had been galaxies of kisses the night before, and now we had a birthday bottle of champagne, and more kisses, and back to pack for we must leave these flesh-pots of Ming and jade, these layers of Chippendale and aspho-del and moly, for the desert and the war. I witnessed a fine battle between very "sound" Elsa Maxwell and a hideous Hitler agent, who turned up at Elsa's hotel to book a room and got an ava-lanche of insults from Elsa in front of the manager and clien-tele. "I'll have you run out of the state of California," she said. I never hoped to hear the phrase. She'll be as good as her word.

Duff and I agree we could live in California. It has a radio quality of having the world in this little space. You can tune in and live your day in whatever country, art or grade of intelli-gence or idiocy you feel inclined for.

RICHARD GULLY: I remember around 1940, Jack and Ann gave a fabu-lous dinner party for Duff Cooper. As you know, Sir Duff Cooper was married to Lady Diana Cooper, who was one of England's greatest beauties, and he would become the British ambassador to France. He

himself was a very brilliant and good-looking man. Well, Jack gives this wonderful dinner for him, and afterwards Duff Cooper gets him in a corner. All of a sudden I see Jack beckoning to me, and, of course, I come over. And he says, "Oh, Richard, I want you to join in this conversation, because Duff is telling me all about Talleyrand." And sure enough, Duff Cooper had the biography he'd written on Talleyrand under his arm. He wanted Jack Warner to buy it and produce the picture. Jack had never even heard of Talleyrand. This is what happens. Here you have a famous man—he comes to dinner, and he has a script idea under his arm. And that's the story of Jack's life. It happened to Jack all the time. I mean, never fail.

BARBARA WARNER HOWARD: When I was a child, there was still quite a bit of wilderness in the garden. The property was fourteen acres, and it had not yet been bricked over and bordered up and down. One side of the garden went down onto Angelo Drive: it was steep and full of weeds and trees, and I could disappear in there. One small part of the garden was landscaped into three tiers, with two bridges going over the tiers and a waterfall with pumps to recirculate the water. My mother must have had it built. During the war we kept chickens in little huts, little apartments really—twelve flights up and a chicken in each one. I thought it was very cruel: all they could do was lay eggs, and they'd be in these cages all day. I let a few of them out at one point. My dream was to have a cow there, too. I did get some little ducks, which lived in a pond at the bottom of the waterfall, and I had a rabbit hutch. The fountain outside the front of the house had goldfish and glass balls made out of Venetian glass.

I used to go for walks with my father after dinner. He always carried a flashlight and a big cane with a rubber end to it, not because he limped but because he used it to kill snails. He hated snails. Another time he had a gun, a .22, and he shot a rabbit. He said it had been eat-

ing the lettuce and carrots in our victory garden. I was very disappointed in my father. It took me a long time to trust him again.

During the war, our bomb shelter was behind the projection room. It must have had at least twelve bunk beds, because you couldn't let the servants die—they were hard to find during the war. My father was terribly patriotic, and he was a lieutenant colonel in the air force.

JACK WARNER, JR.: During the war, I wound up as General Bradley's assistant photo officer as a lieutenant colonel. When I got back, I commanded a reserve unit here in Hollywood and was promoted to full colonel. One day I went to the studio in uniform and went into my old man's office and said, "Hey, you were only a lieutenant colonel, you've got to salute me." He said to me, "Around here, I make the jokes."

BARBARA WARNER HOWARD: We had a golf course at our house, and at the end of the course near a little bench was a memorial to someone named Doc Salomon. The memorial had originally been at the studio, but it was moved to the house eventually. It was a large piece of stone, about four feet square, perched on a pedestal and with a beautiful inscription that read, "In memory of Doc Salomon, who served Warner Brothers faithfully for many years and died in the service of this company in the Blitz in London on July 5, 1944." I never knew who he was, but I loved that plaque. My husband, Cy, made up a wonderful story about how Doc Salomon was the studio accountant who kept a double set of books and had been killed trying to get them out of the office during the Blitz. Much later, Jack Warner, Jr. told me the real story. Doc Salomon wasn't a doctor, but his father was and he had been the one who delivered Jack Warner, Jr. The doctor's son was later called "Doc" because in the early days they had to have someone on the set who knew about first aid, and he did. So he became "Doc." During the war, Doc Salomon had a position at the Warner office in London. One

night he came home and found his wife with someone else. As Jack Jr. said, "He forgot to knock." Very disturbed, the poor man left to sleep at the office, where he received a phone call from America saying they needed someone to tape the sound of the German bombers for a movie. So he and a whole sound crew went up on the roof, and they were all wiped out. A nightmare.

Not long after that, there was a labor strike at the studio. Joy's father, Don, was working at Warners at the time and was involved in fighting the strikers and turning the water hoses on them. A note was sent to my family threatening to scatter our bones all over our golf course; a map was enclosed to show where the different pieces would be buried. After that, I always looked at the golf course differently, wondering exactly where which parts would be. Children have a certain cruel streak.

RING LARDNER, JR.: The Conference of Studio Unions, or the CSU—led by Herbert Sorrell and the rival of the IATSE, the International Alliance of Theatrical Stage Employees—started a strike in 1945. A man named Roy Brewer came into the picture as the local leader of the IATSE and was the one trying to help the studios break the strike. Brewer was also a main organizer of the Motion Picture Alliance for the Preservation of American Ideals, and he was pretty fanatical. I had no contact with him, really, but he may have had something to do with bringing people round from the liberal fold.

During the war, we communists opposed any strike because everybody was supposed to be concentrating on the war effort, so there was a no-strike agreement. We were sympathetic to the cause but not to the strike at that time. But as soon as the war was over we supported the strike, as did most of the liberals in Hollywood. This was the issue that really got Jack Warner. He had been a fairly liberal man, a supporter of Roosevelt, but the strike was particularly nasty at Warner Brothers, with the studio police beating up picketers. A lot of us went in sympathy in picket lines outside of Warners. That was the big issue in Hol-

lywood that year, and we were very much in opposition to what Brewer stood for. Those strikes helped lead to HUAC [House Un-American Activities Committee], certainly.

ROY BREWER: I reshaped Reagan's life, though I don't brag about that. He was on the other side, a liberal Democrat, and he was playing right into their hands. They called the strike while he was high up in the guild and I was head of the union. I belonged to the IATSE, really a wonderful organization guided by the principles of the old American Federation of Labor. I took the position that people like Reagan and others in this movement were honest people who were deceived. If they were seduced by a clever program to get them in, and the communists wouldn't let them out, we had an obligation to help them because they were just as much a victim as anybody else was. See, the great tragedy of our day is that we completely underestimated the power of the communist enemy. I really want to make you understand that the real problem is that nobody hardly understands the real nature of the enemy we had.

SETH ROSENFELD: There was a union dispute between the Conference of Studio Unions, Herbert Sorrell's upstart group, and the older IATSE. Reagan was part of a Screen Actors Guild committee that looked into it, and they decided to side with the established IATSE. Reagan viewed Sorrell as under communist influence, and he concluded that the communists were using what he called a "jurisdictional dispute" over which unions would have which territory as a way to disrupt Hollywood—essentially, as part of a communist plot.

HERBERT SORRELL (FROM HERBERT KNOTT SORRELL'S "SCRAP-BOOKS ABOUT LOS ANGELES AND THE HOLLYWOOD STRIKE, 1945–1947"): The Conference of Studio Unions was a group of unions, most of whom were organized by us, who started with the painters and oth-

ers who joined us to benefit in the better working conditions that we had been able to negotiate. . . .

In March 1945, the strike was on in earnest. The producers began to hire scabs. There was a lot of violence, but not enough, and they began to try to make pictures without us. The strike ran into weeks and months, and something had to be done. . . . We decided the next move would be a mass picket line on one of the studios. Just pick out one studio and hammer it good. . . . We finally decided on Warner Brothers.

ROY BREWER: The CSU called a strike. This was not the first penetration of labor by the Communist Party. The communists were behind it all, and Sorrell was the front man. Sorrell said he wasn't a communist and that was technically true, but whether a man has a card in the Communist Party is beside the point because the real communists are hidden. I said to my boss Richard Walsh, the president of the IATSE, "This is a communist strike. The only way you are going to win is to destroy them before they destroy you. And there is no use in trying to do it piecemeal because they will just whittle away at you. So we have to take a stand against the communists in this." I rented a home across the street from Warner Brothers, and I was in communication with the people on the inside. We took our people through that picket line. It was a rough time. The communists planned the violence. About 150 people went to the hospital in one day. The strike never ended really, though there was a settlement made in the latter part of 1945. See, I studied the communist movement and that is how I won this strike.

RING LARDNER, JR.: I saw people who were picketing being beaten and hosed. They were mass picketing, not actually blocking the entrance to the studio but just trying to discourage people from going in. There was quite a lot of violence. The head of the Warner studio police, Blayney Matthews, was an American fascist type, very much against unions, and he led this business of attacking the picket lines

when there was no real cause for it. That made Warner Brothers a particular target of liberals and radicals.

HARRY JOE "COCO" BROWN, JR.: During the strikes, there were stories about the unions throwing acid at the cars of studio executives as they drove through the Warner Brothers gates. The strikes were very bitter. This was a different era, one of industrial America where the two sides were still fighting it out.

JACK WARNER, JR.: My father more or less volunteered to testify; he wasn't subpoenaed. He wanted to be a friendly witness. I think someone got to him and said, "They're going to jump all over Warner Brothers for making *Mission to Moscow* and *Action in the North Atlantic*," which were pictures that portrayed Russia—our ally at the time—in a friendly light. So he went to Washington with a prepared speech, but he got nervous and fell apart. You could see the sweat running off his face. The cameras and the lights were on him, and he knew he was making a fool of himself. He volunteered names—some of which he retracted at a later hearing. He just grabbed at names. He named the Epsteins, Julie and Philip, maybe because they were bald; I'm surprised he didn't name Bette Davis as a communist. We walked out together afterward with a couple of our lawyers, and he said to me, "I didn't do good, did I? I shouldn't have given names. I was a schmuck." I was tempted to say, "Yes, you were," but I didn't. He was taken for one hell of a ride.

It was so easy to look back and say, "We shouldn't have made those movies." But Warners made *Mission to Moscow* because Franklin D. Roosevelt had called my father into the Oval Office and said, "Our allies the Russians think we hate them. We're doing all we can, but can you make a picture that will show them in a light the American people will be friendly toward?" And that's what they did. And Warners led the way in that kind of gutsy, visceral picture. They made *Confessions of a*

Nazi Spy, which was almost prematurely anti-Fascist, and finally had to close up all their offices in Nazi-occupied areas. Their head of distribution in Germany was murdered on the street. And this was before we had even entered the war. You would never have seen Louis B. Mayer making *Confessions of a Nazi Spy.* He was making *Grand Hotel* and frothy things like that. Harry Warner was violently anti-Nazi. His father had taken him and Albert out of Poland/Russia—the countries were mixed up then—because the Cossacks were doing the things the Nazis did later. It was the same feeling.

ARTHUR MILLER: *Mission to Moscow* was made to warm up the American people toward the Russians. Everybody I knew thought it was terrific, because for the first time the Russians were seen in a sympathetic light. Without that sympathy, of course, we never could have collaborated with them in the war, and Hitler would have loved that. I think the movie had an important influence. I'm sure the instructions came from Washington to make that film. The studios normally steered clear of any contentious stuff like that. It was absolutely unprecedented; Hollywood never made films like that. It was unheard-of. We were in never-never land, and if you got out of never-never land with one toe, it would be an amazement.

JACK WARNER, JR.: Harry Warner was an honorable man who did what he could do. He tried to get Roosevelt to open up America to the refugees coming from Europe and he talked to him about opening up Alaska: if they couldn't let them into this country, Alaska was empty, let the Jews settle there, they can adapt to any kind of weather. Nothing happened. The State Department was occupied by a bunch of your average Princeton, Dartmouth, Yale Ivy League types. I won't say they were anti-Semitic, but they weren't anti-Nazi at that point.

I think the family felt pretty secure, as most Jews did once they were

in America. But it's a Jewish tradition: you have to be ready to grab your children and what few possessions you have and get out the back door when the Cossacks come in the front door. They have history. This went on over and over. My god, daughters were grabbed and raped, the sons were put into the army in labor battalions where they'd all be killed. This was not based on fear alone but on experience.

When I think of my father's testimony, though, I don't see fear as much as I see humiliation. It was dreadful what happened to people who got named. They had no chance to refute it. It was a time you couldn't really think straight, just a time of hysteria.

BETTY WARNER SHEINBAUM: I don't know what role my dad played in the HUAC hearings. Jack used to talk to my father about what he thought was the correct thing to do. We were so afraid of HUAC. All our friends were being accused of writing propaganda and being communist and running cells. It was terrifying. The purpose was censorship. If you looked at what HUAC really wanted, they wanted control over the media. So you had to fight them. My dad understood a lot of that, but I don't think Jack did. Jack was not a political person. I think he did what he thought was the politically correct thing to do. They just didn't know what the heck HUAC was about. They always termed it "anti-Semitic." That was always their explanation for anything that happened: it wasn't political, it was anti-Semitic. There was probably some truth in that, too.

JOY ORR: Mr. Warner was frightened by it all; he didn't want to have anything to do with card carriers. The government was after them, so you had to be careful. I don't know whether he thought they could be put in jail or just never allowed to work again. It was a terrible period for a lot of people. But I only knew how serious it was when I saw the newsreel of Mr. Warner. They were scared to death.

BARBARA WARNER HOWARD: I was sent to Europe to get a little culture. I went to a boarding school in Geneva called the International School. When my father found out the name, he pulled me out because he was convinced it was a communist school. It wasn't at all—it was a school with diplomats' children—but my father had a rabid fear of anything or anyone communist. It was the worst thing a person could be. Someone could have been a drug addict, and I don't think my father would have cared as much. He labeled them commies, Reds, or "moody Russians."

I continued to live in Europe for more than twenty years, and I heard about blacklisting, of course, but I didn't realize how tragic it was. The first time I felt it directly was in New York in the mid-seventies. I was at the photographer Milton Greene's house, and he was showing old videotapes of *"Life" Goes to the Movies.* Suddenly my father was on the screen, before the House Un-American Activities Committee, attacking all the supposed communists in Hollywood saying that he and his brothers would send all the communists back to Russia and would happily subscribe to a pest-removal fund to get rid of those termites. I had never seen this videotape, and I was terribly embarrassed. My father was so grateful to have done well as an American citizen that he would have done anything for the government, including things he shouldn't have. Depriving people of their livelihood in that way was the worst thing my father could have done.

ARTHUR MILLER: The only movies at that time with a social conscience were Warner Brothers pictures. They were sentimental and inaccurate, but they were pictures of social consciousness. And that is why Jack Warner had to be so vicious. He felt defensive and had to come out and denounce all these left-wingers that he was going to fire tomorrow morning. Of course he knew damn well who they had been the whole time. But they were making usable movies for him. And just

as he was saying this he was trying to sign Kazan up to a deal. In fact, Warner Brothers wanted to buy *Death of a Salesman*, right after it opened.

When Kazan went before the committee it was terrible. It was god-awful. I was shocked to the bone. But I felt for him. Kazan, like a lot of other people, was totally dependent upon the studio. As I think I wrote in my autobiography, they had told him that he was not going to work making films in America unless he did what the Un-American Activities Committee wanted him to do, period. Now that was a pretty heavy thing to be hanging over your head. It would have meant the end of his film career. He is still the best director I have ever run into for a certain kind of play, realistic work. And you can't take that away from him. I'm sure he didn't want to be put in the position that he was finally put into, a position of cultural leadership. From the little I've observed, he didn't want any kind of power like that. He was probably the most talented of them all as a director, so therefore he became the leader. But he never made a speech as far as I am aware of. He had no political life that I ever heard of after or even during the thirties. So it wasn't as though he wanted that kind of power. But people looked to him nevertheless. There seemed to be no way out for him at that time.

I didn't work with him for quite a while after that. The next play that I did was *The Crucible* — he couldn't very well direct *The Crucible*! And then I did *A View from the Bridge*, which also was about an in-former. Marty Ritt and I were casting *A View from the Bridge*. Marty, who was very militantly anti-Kazan, because he had adored Kazan — Kazan had been his model — and he felt terribly betrayed by him. I said, "Who would be the best man that we know of to play Eddie Car-bone?" And, of course, it was Lee J. Cobb, who had done the same thing as Kazan in front of the Un-American Activities Committee. No-body paid much attention to it. I said, "Why don't we offer it to him? I

don't want to have a blacklist." So we did. Called him up. Lee should have played that part; he would have been marvelous. But he wired back that he couldn't because the American Legion would object. That is how far it had gone. They would have objected to his being in my play.

It was a cloud that never went away. It was terrible. It destroyed a lot of people, more than anybody is ever going to know. It killed them, even when they weren't dead. It struck fear into the hearts of all kinds of people. Lee Cobb was as much of a menace to the United States as a vacuum cleaner is. It was utterly idiotic to connect him with any such plot. The Group Theatre was probably going through a paroxysm of radicalism: everybody was running around going to stop Hitler, or some damn thing, and so they were joining the Communist Party. They would forget about it in six months, but their names were on some roster. That was the size of it. It was unconscionable. It was just brutal and fake from beginning to end.

FROM THE TESTIMONY OF JACK L. WARNER AT THE
HEARINGS REGARDING THE COMMUNIST INFILTRATION OF
THE MOTION PICTURE INDUSTRY, OCTOBER 20, 1947:

Ideological termites have burrowed into many American indus-tries, organizations, and societies. Wherever they may be, I say let us dig them out and get rid of them. My brothers and I will be happy to subscribe generously to a pest-removal fund. We are willing to establish such a fund to ship to Russia the people who don't like our American system of government and prefer the communistic system to ours. . . . Subversive germs breed in dark corners. Let's get light into those corners. That, I believe, is the purpose of this hearing.

RING LARDNER, JR.: We saw Jack Warner at the hearings in 1947 when he spoke about having "termites" in the studio and that he knew several of them. He was quite vehement on the subject. He had to defend *Mission to Moscow*, which he said was a mistake.

All nineteen of us who were subpoenaed attended all of the hearings. I was finally called on the last day. Bertolt Brecht was a witness that day, too. He was great, although afterwards he came to the hotel where we all had a meeting room and apologized because he was asked the question, "Are you now or have you ever been a communist?" and he had said no. We knew his status was special, that he was anxious to get back to Germany, and if he was indicted for contempt he would have to stay in this country. So we forgave him.

Dalton Trumbo and I decided that the only sensible thing to do was not to answer the questions and to try to get the case into the courts. We thought we would probably be cited for contempt but have a fair chance of winning a case. There had been enough Supreme Court decisions about people's rights to their beliefs, so we thought that by challenging the committee's right to ask the question we would get it into the courts. If we had taken the Fifth Amendment, it wouldn't get into the courts at all and there would be no chance of winning the case. Additionally, we didn't want to take the Fifth Amendment because we would be saying it's a crime to be a communist. But the court just decided not to hear the case when it got up there.

Sam Goldwyn was against the whole idea of the blacklists and the hearings. He wasn't the only one. I was under contract to 20th Century–Fox, then run by Darryl Zanuck. When the major producers met in the Waldorf Astoria just after the hearings and decided to blacklist the ten of us and fire the five of us who were then working, Zanuck said he was not going to fire anybody unless his board of directors insisted he do it. His board of directors obliged. They instructed him to fire me.

I was sitting in an office with Otto Preminger when a call came from Zanuck's office wanting to "see Mr. Lardner immediately." Otto rather indignantly said, "What, just Mr. Lardner, not me?" He thought it had to do with the script and that Zanuck was interfering. It turned out it wasn't that. Nevertheless, from 1947 to 1950, we were able to get underground jobs in Hollywood. People were not scared. But when we got out of prison in 1951, nobody would touch us.

PHILIP DUNNE: When they started the blacklist, Ring was the first to go. It was dramatic. When I heard about it on the morning news, I got in the car and went roaring into the studio. I didn't know what I was going to do, but I knew I was furious. I was met at the studio at the gate by the cop who said, "Mr. Zanuck wants to see you right away, and Mr. Lardner wants you to call him right away." Now, this was nine o'clock in the morning, and Zanuck never came in until noon. So he apparently knew where the trouble was going to be, because I went in and he started to scream, "I didn't want to do it. I was forced to do it. I was ordered to do it. I was told it was my share by the money people from New York!" I took him at his word. Ring said to me, "Don't do anything silly because I have legal recourse," but I don't know what good it did him. George Seaton and I were trying to see if we could organize a strike among the writers and directors as a protest. Nobody wanted to play, including people who later were blacklisted. It was frightening to them.

NAOMI KLEIN: My grandfather never recovered from his experience with Disney. It was a crushing event. After he was fired, after the strike—he was blacklisted, came back to New Jersey, where he grew up, and worked in the shipyards. He worked in advertising, too, but never as an artist again. He loved working at Disney and they had an amazing community. He loved working as an animator, then for the rest of his life had to just work for money. The strike was not a victory.

My grandfather's best friend, David Hilberman, his response to getting fired was to do more radical work. But when my grandfather had to leave L.A., he left that side of him behind and did his art on the side, making sculptures in his spare time. We all have some of his work and it is very, very un-Disney: abstract and antithetical. Huge pieces. They're for outdoors and they rust.

One of my grandfather's responsibilities at Disney was Donald Duck continuity. So, when we were little, he used to draw pictures of Donald Duck. He could do one in eight strokes. I always thought it was funny that one of his jobs was to make sure Donald Duck never changed. He worked on *Fantasia*, too, on the dancing hippopotamus scene. And *Dumbo* was in production when they went on strike. It was a love-hate relationship for us all. I grew up with these stories of evil Walt Disney and what he did to my grandfather. But at the same time, I told all my friends that my grandfather drew Donald Duck, and he would draw for all of us. And we went to Disneyland. My grandfather didn't come. It was my father and his brother, Henry, just the two of them and their kids. I was probably six or seven. Growing up, a favorite family story was how my father, at about three years old during the strike, would scream, "Scab!"

My grandfather never changed his politics. For him, religion was the opiate of the masses. When I was married, he wouldn't say "God" at the ceremony. He was a hardcore Marxist and that didn't fade. But it wasn't like he acted on it. It was just his belief. He grew up with it, got fired for it, then just believed in it. It was his identity and his culture. In the acknowledgments of my first book, *No Logo*, I said that he was the person who taught me to always look behind the logo. Growing up in the shadow of Disney, with utter fascination and pride that my own grandfather had worked for the ultimate kids' icon, gave me a double sense. I had a personal connection to the characters my friends were obsessed with. But I also knew that Disney had this sinister side, and that the sides could coexist: we could want to go to Disneyland

and love Donald Duck but hate Walt Disney. This influenced the way I wrote *No Logo* and the way I write about pop culture, which is being critical but leaving space to understand the appeal.

MARSHA HUNT: *Hollywood Fights Back*, a radio network special, stands in history as an epochal event. Never before or since has that number of the very top gifted people in an artistic medium spoken as one. Not only as artists, but as citizens. Our field had suddenly been attacked, and we were outraged. Every newspaper, every newsreel, was obsessed with the story of Hollywood being riddled with Reds, with the screen being subverted with coded messages of communism. It swept the land like a terrible blight, and we felt that something had to be done.

The idea for the show blew up overnight and had to be done very quickly. Lew Wasserman at MCA said, "Listen, we close the office at seven P.M., and the place is yours after that. We'll leave the lights on and the door unlocked. Make free with our typewriters and phones, anything you need." Norman Corwin, Millard Lampell, and my husband, Robert Presnell, Jr., did the writing, and I was conscripted to get the scripts out to the artists. I was the carrier pigeon. I would tear it off the typewriter and drive it to specific stars' homes. A single segment was no longer than a minute, and each one had a different point to make. We wanted as many voices as possible to be heard from and accounted for, all equally outraged and protesting what was happening in Washington. They wrote it all in no more than two nights at breakneck speed.

It was Willie Wyler, John Huston, and Philip Dunne's idea to fly to Washington to counter the headlines across the nation and to defend the industry, free speech, and the right to advocacy and assembly. Those of us who flew to Washington prerecorded our radio spots, with the rest done live. As we were flying across the country to Washington it went on the air, and we were invited into the cockpit, as many of us could crowd in, to listen to ourselves as the nation below us was hear-

ing it. It was one of the most chilling, thrilling times of our lives, to realize that our message—those three words, "Hollywood Fights Back"—was going the length and breadth of the land. It was a dazzling array of the movies' top citizens renouncing the mischief and terrible behavior of this handful of congressmen who called themselves the House Un-American Activities Committee.

Bogie and Bacall were there, but they proved our tragedy. They repented. They ended the entire protest movement, and we never met again. We were the Committee for the First Amendment, we were an expression of outrage and protest throughout the industry, we were the spokespeople that went on the flight and did that broadcast to support the Hollywood Nineteen. And the climate changed while we were in Washington. I think the brothers Warner got to the Bogarts, because within days of our return, they published a statement that the trip had been ill advised and even foolish. It knocked the wind out of everything. Bogie did some article for a fan magazine called "I'm No Communist." Nobody said he was! It was a tragedy for us because he had been the most vociferous of all of us on the flight.

I was there, a political innocent advocating nothing but free speech, and it got me blacklisted. It ended my career, especially my refusal to repent. That combination did it. But because my husband went right on working, I think because of the scarcity of good writers, 20th Century–Fox gave him a loyalty oath to sign, listing movements he might have joined. Whimsical Robert checked all of them—adding at the bottom, "I guess I'm just a joiner." So of course they had to throw it all out, this entire piece of nonsense. He had no fear but was never, in any way that I know of, passed over. It was the weirdest thing, but very lucky, because we did keep eating.

ABRAHAM POLONSKY: I was blacklisted for almost seventeen years, maybe the longest of anybody. So I know why you're here: I'm the only one left.

In Hollywood, they're in business to make money, they're not in business to make works of art or express this or that idea. The wonderful effect of the communists and the liberals was that they introduced social themes into their works and tried to make moderately successful something that was significant. And a great deal of it was. They also wrote for ordinary politicians because you can affect them by writing their speeches. Of course, being writers they were very independent of party control. There was a constant struggle between them and the New York City party. New York City might say that the most important thing now was "to carry on a struggle." And the Hollywood party would think, Who the hell gives a shit about that? There were endless problems with one group wanting to control the intellectual content and the social content of things. Writers won't put up with that. The Communist Party in Hollywood had the brightest people, the best writers, the nicest people. They had parties every week, with dances in their houses. They had a hell of a time. But the blacklists killed that.

The Committee for the First Amendment was founded by John Huston, Philip Dunne, and a few others when HUAC first started putting the pressure on Hollywood. I went to Ira Gershwin's house, and everybody in Hollywood was there. They wanted to get a plane and go to Washington with them and protest against what was happening.

Nobody in the movie industry wants anybody telling them what to do, including the producers, so there was no struggle with the producers over this protest. But after that first meeting in Washington, which was a fiasco for everybody, Harry Truman sent a general out here to talk to a lot of big-shot producers, the ones who owned the studios. He said, "Call these dogs back. They're your dogs, get them in here, and tell them we don't want the Committee for the First Amendment to keep going." I went to the second meeting at Ira Gershwin's house, and nobody was there. Humphrey Bogart was walking around yelling, "Where's everybody?" He had already taken an anti-communist stand himself in Chicago, so anti-communism was in the air and part of

American policy. Between the first meeting at Ira Gershwin's house and the second one, the pressure had come from Washington to end it. People were chased out. They had no choice: the studios controlled their contracts.

Later, I was in France when I found out from a friend of mine who was living in my house that people had been around to serve me with a subpoena. My wife said, "Let's stay in Europe. All you will do is get blacklisted when you go home." I said, in my general romantic way, "They can't tell me where I can go! If I want to go home, I'll go home. Let them serve me with a subpoena." Stupid attitude, but that was mine. So we went home, I got a job at 20th Century–Fox, and a couple of weeks later I got served with a subpoena.

At my hearing Congressman Velde said to me, "You were in the OSS. Can you give me the names of the people you worked with? They may have been communists." I said, "No, I can't give 'em to you." He said, "I can hold you in contempt!" I didn't stand on the Fifth Amendment or anything, I just said, "You're not supposed to know their names, and therefore I'm not going to give them." These guys were agents: if you give their names, you kill them. These guys are in some foreign country, what do you think they're doing there, learning to play the kazoo? But he kept insisting, and I kept saying no. This stupid thing kept going on until a guy from the CIA went up to the chairman, spoke to him, and they stopped Velde asking questions. He got very mad at me and said, "You are a very dangerous citizen." That was the headline in the paper. When I got home my wife said, "I never expected a very dangerous citizen would call on me."

ARTHUR MILLER: I've always been on the left, just sentimentally; everybody I knew was. Around 1950 I had gone to two meetings of communist writers in New York. They were party people, twenty writers, playwrights mostly, some novelists, and it was a purely literary discussion. I knew a lot of the people there. One or two I knew from when I

had written for radio in the forties. That was my involvement. But obviously they must have had some informer there, who told the Un-American Activities Committee. The committee never bothered me all through those years. It was only after I married Marilyn in 1956 that they got interested, because they saw pay dirt. They were already starting to fade: the committee was really losing ground. They were not on the front page anymore, but with me and Marilyn, they thought they would really get back on the front. To show you what the motive was, when I got to Washington, Congressman Walter, the chairman, offered Joe Rauh, my lawyer, that if he could take a picture with Marilyn, he'd call off the hearing. That is how seriously they were involved. A picture of just the two of them, and that would be the end of the whole hearing. The inanity is still hard to take in. Marilyn thought it was an absurdity, too. She wondered, "What kind of people are these?" But she took it much more seriously than the rest of us did. She thought the United States government had to have some kind of validity, compared to Hollywood, which had no validity. She learned fast what this really was. They got elected that way. It was hard to convince people; it would have been hard to convince me.

At some point one of the committeemen, Congressman Scherer, actually asked me, "Would you advocate the right of a poet to write a poem which demanded the destruction of the United States government?" "Yeah," I said, "I think a person has a right to write a poem about anything." At which point he threw up his hands and turned to his fellow committee members and said, "What more do we need to ask this guy?" You see, we have all the makings of a real beautiful dictatorship. And what is holding it back is a tradition stemming out of the Bill of Rights and the Constitution. That's it. And if that center doesn't hold, you will find the sweetest dictatorship you will ever want to look for. Many of them are men of goodwill, and they do not understand the delicacy of liberty, how easily it can be destroyed.

The other questions were very boring. Mainly it was, "Did you sign

this petition?" They had a pile of petitions: there must have been fifty of them. Of course I had signed everything. I'd written a musical about HUAC called *Listen My Children*. When I was called to testify, about twenty foreign journalists showed up at the press table. Well, this never happened, and it threw them off—they hadn't expected that. It rattled them a little bit. So they were dumb enough to begin reading from this musical. The scene they picked was that the Un-American Activities Committee takes a writer, binds his hands and feet, puts a gag on his mouth, then drips water on his head. Now he asked, "Did you write that?" I said, "Yeah, I think I did." Of course, the newspaper guys like I. F. Stone were rolling around, guffawing, and the committee guys were looking over wondering why they were laughing. That is how dumb it all was!

SETH ROSENFELD: Just as the Red Scare was heating up, as HUAC was about to descend on Hollywood, one night in 1946 there was a knock on the door of Reagan's house overlooking Sunset Boulevard. Reagan answered, and some men from the FBI asked if they could speak with him. Reagan invited them in, made them coffee, and they told him that they had information that communists were infiltrating some of the liberal groups that he was involved in. And not only that, but they were saying bad things about him personally. Reagan's response, as he put it in his first memoir, *Where's the Rest of Me?*: "I must confess they opened my eyes to a good many things." In his second memoir, *An American Life*, he recounted the scene a little bit differently: "They [the FBI agents] asked if they could meet with me periodically to discuss some of the things that were going on in Hollywood. I said of course they could." FBI records show that he then became active as an informer in Hollywood and that he informed on fellow actors and actresses, sometimes on the scantest of evidence. Some of these people were his opponents within the Screen Actors Guild, such as Karen Morley, Anne Revere, and Alexander Knox. Reagan was not

only reporting people whom he said he suspected of being communist, he was reporting on his adversaries.

In the years right after that meeting in his home, Reagan met several times with FBI agents and gave them information about fellow actors and actresses who he suspected were Communist Party members, or who were somehow subversive. In one instance an FBI agent asked Reagan if he could help him identify an actor who was involved with the Progressive Citizens of America, which was a broad-based political organization that supported Henry Wallace for president, and which had a nonexclusionary policy, so you could be a Democrat, you could be a Republican, you could be a Communist, it didn't matter. If you wanted to support them, they were open. One of the FBI reports describes how Reagan listened to the agent's description of this actor and said, "I think I know who that is," and he went and got a copy of a movie magazine and showed him a photograph in it of Richard Conte, who later became a film noir star.

BARBARA WARNER HOWARD: The strike was eventually broken, and the union was very angry. We had guards at the house after that. I was always told that was why a guard had to drive me to school and pick me up. I was never really allowed out and about as a little kid.

As a young girl, I'd go to all the sneak previews with my father. They were always held halfway out of town and you could never tell anyone where they were going to take place. Climbing into those black cars, we were like gangsters going to rob a bank. We'd usually stop at a steak house for dinner, where everyone would eat the same thing because we were always late—usually a shrimp cocktail and a steak. And my father would have one drink, a Jack Daniel's, I think. If it was really ultrasecret, he'd drive himself. When we'd stop at a gas station on the way he'd tell the attendants, "You have to go and see" and of course he'd name a Warner Brothers movie.

Almost every night my father would bring the dailies home. The

editor, the director, and my father's secretary would be there. One night when I was eleven, they were running *San Antonio*, which was a Western with Errol Flynn. I saw it two nights in a row, and the second night I noticed that the cattle were stampeding left to right instead of right to left—the two sections of film didn't match. I said, "Daddy, they're going the wrong way!" "Please be quiet, Barbara. We're trying to concentrate. . . . But the kid's right!" Two months later, I was sent to Switzerland. They must have had the idea of sending me away before, but my outspokenness clinched it.

HARRY JOE "COCO" BROWN, JR.: Ann Warner was sort of mysterious; she would come and go. She was always off in another wing, it seemed. She and Jack Warner had a very torrid love affair that ended in marriage. I think he once even shut the gates so she couldn't get back in, and she was banging on them—like a scene out of *Dallas*.

JEAN HOWARD: I think I was Ann's closest friend. She certainly was mine. When I met her, she looked like she did for most of her life: a small woman with lovely, great big green eyes and nice skin. She was a simple woman, and she was very shy, actually, especially when Jack was around. I think she was madly in love with him when she married him, and she was very happy for maybe five years before she even thought of anybody else. Ann was emotional, but she was a brilliant woman, in her way. She didn't really like to go to lunch. She didn't play cards. She was someone who didn't like to go out; she liked people to come to her. She didn't have much in common with the other women, because they hadn't read the books she liked—Robinson Jeffers and other poets. She also read up on the occult, which I didn't really want to know about.

At some point in the early forties, Jack caught Ann with a Warner Brothers actor. She was really stuck on him—he was bright, unlike most Hollywood people in those days. Ann had rented a little house up in the

Hollywood Hills, and one day Jack walked in on her there with him. Ann put herself in the hospital and called me, weeping. And then slowly they made up. The actor was blackballed at Warner Brothers and he didn't work in Hollywood for a long time. Jack had that kind of power.

There was also a rumor around town in that period that Ann and I were having a romance. When she got bored at parties, she'd get hold of me, and I'd sit down with her, because she was more amusing than anybody else there. And in the summers, after dinner at the Warners', the men would start playing cards, and the women would go swimming in the pool. There was always this wonderful Hawaiian music, white gardenias floating by, and rum drinks. Boys were mixed up with it, too: a lot of them fey or gay or whatever. Not undressed—we'd have our bathing suits on. It was all innocent fun. But it was better fun than most wives were having.

Then all this stuff blew up about Ann's affair with the actor, and a few months later Harry Warner walks into his brother's office and says, "Listen, I know how you feel, that you caught Jean and Ann in bed together." Jack Warner, bless his heart, stood up and socked his brother. "You son of a bitch! You don't know what you're talking about." There was always such drama in this town.

GORE VIDAL: It was a totally lesbian scene. Yeah. They were all raging. And I was just a kid who was around. The girls were always off in a corner whispering together. There's a famous story of Salka Viertel. She was coming with Garbo to a party, with Hepburn. And then, suddenly, Dietrich. The four make their entrance. And Dietrich is the only one wearing slacks. And I think it was Garbo who said—she always called her "Ms. Dietrissssh"—and she would hiss the name. "Look at Ms. Dietrissssh giving the game away again."

BARBARA WARNER HOWARD: In the early forties, Mother wrote to Salvador Dalí in New York to ask him to do her portrait. He wrote back

that a portrait with detail in the background would be six thousand dollars; without detail, it would be four thousand. My father circled the "four." The painting of my mother took several months. She and Dalí became such good friends that he threw in the details anyway. I believe it was one of his favorite portraits, but I found it a little bit spooky. She's wearing her cabochon emerald brooch and a hat with feathers that look like snakes—Medusa.

Portrait of Mrs. Jack Warner (*Ann Warner*), *by Salvador Dalí, 1944.*

JEAN STEIN: As a child I was really frightened of that portrait of Mrs. Warner. There was something menacing about it, and when I went over to play with Barbara I'd avoid looking at it, like the painting was possessed.

BARBARA WARNER HOWARD: Mother loved that portrait so much that she wanted him to do one of my father. Of course my father was very impatient and I doubt if he sat for it much. He sent photographs for Dalí to work from. At the time we had a giant schnauzer named Dragon, and the dog came out more lifelike in the portrait than my father. It is probably the worst thing Dalí ever did, terribly stiff. He must have cared very little about this painting. There was something wrong with my father's hand, which was resting on the dog's head, and

Portrait of Colonel Jack Warner, *by Salvador Dalí, 1951.*

my father made him repaint it. I think Dalí gave him a sixth finger. They finally gave away the painting; god knows where it is.

I was six or seven at the time, and I was much darker than I am now. While Dalí was staying with us, whenever I came into the room he'd say, "Here's the little prune."

JEAN HOWARD: Dalí was somebody you liked to watch because he was like a marionette jumping on a stick. For some reason he always painted rich women. Like Mona Harrison Williams, the Countess of Bismarck: in the painting, she's beautifully dressed, but he painted her barefoot, like the country girl she had been. Gore Vidal suspected that she would have been a role model for Ann.

In Ann's portrait, the house is shown crumbling. She hated to see that. Oddly enough, she never realized that it would eventually crum-

From left to right: Ann Warner, Lili Damita, Marlene Dietrich, Jack Warner, and Errol Flynn, 1948.

ble, that it was just a material thing. We all said the picture was terrific, and she kept it because she realized it represented something important. But I know in her heart she thought maybe someday she'd get Dalí to redo it.

BARBARA WARNER HOWARD: I had a very complex relationship with my mother. I think she loved me very much, and it wasn't that she wasn't physically affectionate, she was. But as I got older there was a competitive edge to our relationship. When there was a man present, she wanted to be the one to whom attention was paid. I don't know if she was like that with everyone, but she was with me.

ANNE TERRAIL: What I remember about my grandmother, from my real memories, not from things that I was told but real memories, is having her on the phone when I lived in France with my mother. It was always a big deal then to call overseas—"Okay, Anoushka is calling." I used to have to call her "Gaga"—which I thought was really horrible. It was ridiculous. She was going to call at nine in the evening, so everybody was around waiting for this call. I remember for me it was strange because I had never met this woman and she would say all those nice things to me but it always seemed very remote, very far away. When I was around eight or nine she asked, "Do you love me?" and I said, "How can I love you, you have never seen me." I don't remember how she responded, but I think my mother was pretty happy that I'd said it. I remember that it seemed very weird that this woman would call and be very warm, you know—what does it mean?

She was a mythical figure since I didn't meet her until I went to the States, when I was sixteen. I just knew this woman whose voice was very present. She was like some kind of ghost even. It was very strange. At the same time, she felt like a very strong woman who had power over my mother. But how could she be so strong if she could never

show herself in real life, and hid behind those calls. As a child that is what I felt, not what I saw, but what I felt.

Now, my grandfather, Jack Warner, was much more real, since I went to the South of France to his house every summer. I don't know which age I started to go there, probably four or five. As a little child, I knew that he was very nice. He was funny. He would always make stupid jokes like putting a fork in his mouth and leave it there. I know that when I was very little he would let me drop leaves on his head for an hour and he wouldn't say a thing. He was probably so happy to have some family thing somewhere, you know. In all the pictures that I have with him I am relaxed. He was fun. We never had talks really because when he was in the South of France he had a very big social life and there were people who were maybe not used to being with children or something. But I liked him. I thought he was a nice, warm man. He was put in that film made by the Coen Brothers, Jack Warner was.

BETTY WARNER SHEINBAUM: The first time Jack fired Jack Jr. from Warner Brothers, it was really instigated by Ann. She felt that Jackie was more loyal to his mother than he was to her—which, of course, he was. It also had to do with the fact that the Warner family didn't accept her—she married into a family which had predetermined that it wasn't going to like her, and she vowed vengeance. Jack Jr. just got caught in the middle of everything. He was the kindest person you could possibly meet. And he always wanted his father's approval. At one point, Jack Sr. came to him pleading for money, claiming that his divorce from Irma had left him in financial trouble. So, without any hesitation, Jackie gave him back the million dollars that had been put in trust for him. Jack Sr. took it and ran.

JACK WARNER, JR.: When my father had me fired, the cops who were ordered to throw me off the lot were crushed. But they had to do it, and

I said to them, "Okay, fellas, you're following your orders, now let me buy you some coffee," and I took them to the drugstore across the street. Then I went to several fine attorneys, and they all said the same thing: "Sure, you've got a case, but are you prepared to spend the next ten years and all the money you've got?" But the real thing was why would I sue? For what? Hurt feelings? A father has the right to fire his son, even if he has no real strong, honest reasons. What you do is pick up your shattered pieces and get going with something else. Then later Harry got to my father and said, "It's either you or your son." So my father said, "All right, bring him back."

I should never have gone back, because my father hadn't really changed. He was still married to Ann, and hers was the last voice he heard every night. She hated the idea of two Jack Warners in the world. I would say that my father deserved better, but that's not true. He was a tremendous failure where it counts. Human relationships: zero. He wanted to be loved, and yet he did so much that was unlovable.

Interestingly enough, throughout my father's life he would not personally fire anybody. God help you if you left the room he was in, though. Nobody would leave the executive dining room at Warners before my father, because they knew that he would start throwing barbs and jokes about them and demeaning them in front of everyone. And then, when Harry came to lunch, first the phone would ring and Harry's secretary would tell the headwaiter, "H.M.'s on his way"—"M" was Harry's middle initial—and then the headwaiter would tell my father, "Your brother's coming to lunch." My father would say goodbye and leave before Harry got there. They timed it that way.

What's that saying? Power corrupts, absolute power corrupts absolutely. I always think of my father when I hear that. He was the man who fights to get up the trail to the mountaintop and when he gets there rolls rocks down the trail to keep other people from joining him. But I can't say he was ignorant. The company didn't do what it

did with an idiot at the helm. This man knew how to feel the public pulse.

RICHARD GULLY: Jack just couldn't bear being the younger brother. He wanted to be president of Warner Brothers and officially he was vice president. When he traveled he got to a point where he never even registered in hotels anymore. He used to wave them away. He said, "I'm too important to sign a hotel register." But in the early days I remember he would never put "Vice President of Warner Brothers." He always put "Head of Warner Brothers."

DENNIS HOPPER: I was very young in 1955, when Warner Brothers did *Rebel Without a Cause*—eighteen or nineteen years old. We'd started shooting in black and white, and two weeks into it Jack clearly saw that something was going on with James Dean. He said, "Change this picture to color. The kid's going to be a star." He'd found his new Rin Tin Tin.

Then one day, the next year, Jimmy Dean and I were coming out of the commissary on the Warner Brothers set, and Jack Warner came up to introduce the banker Serge Semenenko to Jimmy: Semenenko put out his hand to shake hands, and Jimmy reached into his pocket, threw a bunch of coins at their feet, and walked off. They looked completely stunned. I followed Jimmy like a puppy dog and said, "What the hell was that all about?" So he told me that Jack had convinced Harry that they should sell the studio, and they sold it to Semenenko; then, the day after, Jack bought back in. All he had really done was to buy his brother out. So that was Jimmy Dean's reply to what Jack had done.

BETTY WARNER SHEINBAUM: I knew that my father and Jack were getting along so badly that it was absolutely necessary that my father

quit. Jack was spending six or eight months at a time gambling in the South of France—he wasn't minding the store—and it drove my father crazy. Dad was giving himself heart palpitations by going to the studio. His blood pressure was up, and the screaming and yelling were absolutely inhuman. So there was a reason to sell, and the understanding was that the brothers would go their separate ways. But Jack came back as the president of Warner Brothers. He'd wanted that title, and he'd wanted to get rid of my dad. My father went crazy; it was such a betrayal. He didn't scream or yell this time: he had a terrible stroke. It was too much to bear. If you look at Hollywood now, that kind of thing happens every six months. But they had lasted, what, almost forty years?

The sad thing was that Jack didn't have friends. He had yes-men. He loved people who lived like kings. But although he sought out society, he always seemed so uneasy and defensive when he was in it.

JACK WARNER, JR.: I was supposed to go to Hawaii the day after Harry's stroke, but I canceled the trip because they thought he might die. When I saw my father at the studio the next day, he said, "Hey, why aren't you in Hawaii?" and I said, "I couldn't leave Uncle Harry so sick." And he looked at me and said, "Why not? He's not your father." There was no answer to that.

When Harry died, in the summer of 1958, I sent a priority cable to my father in the South of France, but he never answered. It was a bitter end to the war between them. Then, a few days later, he had a terrible accident. He came out of the casino one night around two A.M., got in his Bentley, and started driving to his house in Cap d'Antibes. Halfway there, he must have fallen asleep, because his car drifted left and hit a coal truck head-on. My father's door flew open, and he was propelled out onto the pavement. He was in a semi-coma for five or six days. His sister Sadie couldn't wait to get to him and say, "God punished you." She actually said it. I don't know if he threw her out or not, but he

never saw her again. She died not long after that, and he wouldn't even go to her funeral.

BARBARA WARNER HOWARD: After my father's accident, everyone really felt he was dying, so they all came to France—including Jack Jr., who wanted to see him for what he thought was going to be the last time. But when my father saw Jack walk into the hospital room he was really disturbed. He said, "I must be in worse shape than I thought, if he came all the way over." It gave him such a shock that he felt he had to get better. Then Jack Jr. gave a statement to a reporter, saying that my father was close to death, and that was really the end of their relationship. When my father got back to California, he had him fired again from the studio. Jack Jr. probably was rarely welcome at the house.

JEAN HOWARD: Jack and Ann used to have Sunday suppers at a long table with maybe twenty people. I remember one time—I hadn't noticed that Ann was the least bit tipsy—all of a sudden Jack, who was at the other end of the table from her, screamed down through all the guests, "Anna, put that drink down!" It was embarrassing, and even if you weren't drunk it would have made you drunk. Which it did—she fell right on her face. Very cruel. And she was a sensitive woman. What Jack Warner did to Ann destroyed her. I often saw that girl get up from the table and run out of the room crying. I didn't blame Ann for anything, not even for having a lover, which she certainly did. Jack had his own sex where he wanted and when he wanted.

BARBARA WARNER HOWARD: I went with my father to Grace Kelly's wedding because my mother wasn't feeling well. I was twenty-one or twenty-two and had just married. I wore a Balmain dress made especially for the wedding: cream with big circles of embroidery and a little jacket, and a lovely hat with a cream tulle veil. Father wore a top hat and tails. We had a dinner party at the Hôtel de Paris, and I sat next to Aristotle

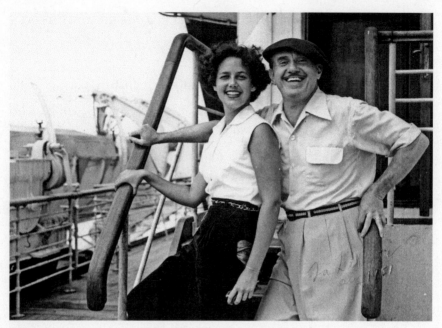

Barbara Warner with her father, Jack Warner, on the SS Liberté.

Onassis. I don't know if Maria Callas was there at the time, but we had a long conversation about Greek mythology, and he was very sweet and thoughtful. I saw Ava Gardner there, since she and Grace were friends.

King Farouk was there, too. Farouk was enormous, a womanizer and an ugly man. He and my father used to gamble together, mostly at the Palm Beach casino in Cannes. They both played baccarat. They were pals, but I don't think they were friends. My father loved gambling. It was a great relaxation for him, and he always lied about what he lost, saying, "I broke even."

RICHARD GULLY: Farouk and Jack had a great liking for each other. They were both expert gamblers and were extremely good baccarat players. They didn't bat an eyelash no matter how great the stakes were. They'd play all night, starting after dinner until daylight, when the three of us would go to breakfast at seven o'clock in the morning. They were both men who liked the good things in life. Jack was an

*Jack Warner (left) and Richard Gully (right) on their way to
Grace Kelly's wedding in Monaco, 1956.*

enormously likeable man away from the studio. He could be very
tough, mean and disagreeable about contracts and things, but socially
he had enormous charm. He was also a little bit of a philanderer, al-
though not as much as Farouk. He didn't pinch girls; Farouk was really
rather vulgar. But they both had an eye for a pretty woman and had
that great social *joie de vivre*. But the main thing that brought them
together was gambling; they made a beeline for the baccarat tables.

When we first met, Farouk was still a good-looking man. He wasn't overweight or as gross as he became in his later years. As a young man he was very good looking, and even when he was middle-aged he was presentable. He was very sharp-witted, intelligent, with a keen analytical mind. He was an interesting man. He was still on the throne when we first knew him, and he always had some kind of lord in waiting with him. Later, after he was kicked out of Egypt, he dismissed the aide, so although he always had a chauffeur he was really by himself. Not even a bodyguard. It was extraordinary.

He never visited Hollywood. The only one who ever visited Jack was the shah of Iran, of whom Ann was very fond. We did entertain Queen Nazli of Egypt, Farouk's mother. She was a very beautiful woman. When he went into exile, she came to Hollywood and even had a house in Beverly Hills for a while. But he never came. Theirs was strictly a gambling friendship. I don't think Ann Warner ever met him. She never went gambling or to the casino, and she didn't want to encourage Jack. But she couldn't stop him. There was no way you could stop Jack Warner gambling. Jack Warner and Charlie Feldman and Zanuck were absolute inveterate gamblers. All three of them were very close friends when they were in Europe.

PATRICK FOULK: I met Ann Warner in New York when I was on leave from the air force—through a friend whose husband was a director. I took one look at her and said, "I don't believe this." That's the way she looked. Ann and I just hit it off, and after that we never looked sideways much. I've met a lot of people, but I've never seen one like her. She was Miss Mercury: she was electric. Some people felt that her magnetism was an affectation, but it wasn't. Anybody who knew her recognized how unusual she was. Even Elsa Maxwell told me, "I've met them all, and there's nobody like Ann."

Our relationship was quite strange. Hardly anyone knew about it, except for Jack. We kept it that way. Jack understood it; he endured it

because he didn't want to lose her. As a matter of fact, on two occasions he offered me a writing job. I sure didn't want to work for him. Nonetheless, he and I had a kind of mutual respect, because I would not take any of that Warner balderdash from him. When I first met him, he would do anything to put Ann down. He was jealous of her, but he adored her basically. She was the only human being he trusted.

RICHARD GULLY: By 1958, Jack and Ann had grown apart. She had no interest in gambling and loathed listening to the baseball games he'd have running through dinner. The three of us would have dinner together about five nights a week at that point, but it was no party. I was the buffer, the referee between them. It had been a great love story for years, and then Ann withdrew.

It wasn't that she didn't like people—she talked on the phone for hours. Basically it was vanity. When you've been a raving beauty and you suddenly begin to put on weight . . . She was also bored. She'd say, "I gave great parties for twenty years, and I've done enough entertaining." She wasn't born to be royalty. To be Mrs. Jack Warner was like being royalty. The Warner house was Buckingham Palace, and she was the queen. But she wasn't born to be a queen, and she certainly wasn't trained. Members of the royal family are trained every day of their lives, for it's a very difficult position. Besides, the world had changed, and Mrs. Warner was really one of the first people to see that.

JACK WARNER, JR.: She never came down then. No one ever saw her. It was strange: a big group would be at the house with hamburgers, and Rocher, the butler, would bring out drinks and we'd play tennis. And my father would look up toward the house at the upstairs drapes, which were closed—she was there. It was peculiar. I came to visit once and drove up that big circular drive and looked up over the front door to a small window that was in her dressing room. It opened and she looked out, saw me, and pulled it shut. That was it. That was all I saw of her.

BETTY WARNER SHEINBAUM: Jack Sr. was a weak man, that was the worst part about it. I don't think he hated Jack, but he never behaved like a father. He would tell Jack to shut up or go away or stop writing, things that were really very hurtful. And all his life Jack tried to show that he was willing to make up with him. But Jack couldn't do it. Every once in a while, they'd ride together in a car; Jack speaks of that as a highlight of their relationship.

JACK WARNER, JR.: I was Jack's only boy. And he named me Jack. But I never felt that I was to be the heir apparent. Growing up I wanted to be like my father: if he ran a studio, I wanted to run a studio. A surgeon's son wants to be a surgeon. It's a normal thing—except for us, it wasn't normal. This virus crept in, and she influenced the brothers, the sisters, and me. I hate like hell to make Ann the villainess in everything, but so much of this happened because he wanted peace at any price. He once said to me, "Look, I'm sorry. When I come home, I've got to have peace in my house." Whenever Ann was in the South of France, I would often be up at the house, but soon as she came back into the country, I would be given notice by him to stay away.

When Albert Warner died, I flew to New York for his interment. I went to the temple and my father came in and sat in the front row. There was a vacant seat next to him, and I said to myself, "You've got to move." So I walked right over and sat next to him and he kind of acknowledged me. After the funeral, he went out and got into a car. No one said anything to me, so I got right in and sat next to him. I figured, Look, nothing's gonna come to you, you've got to chase after it and grab it. I thought my problem was I didn't do enough of that earlier, that I was afraid of banging into things. He said to me, "Feel like a drink?" and I say, "Sure, I could use one." He owned two floors of the Sherry-Netherland tower with a gorgeous view, and the two of us sat there overlooking Central Park. It was winter and snowy, and we

had Chivas Regal. We sat there and didn't talk about anything impor-
tant. He was very warm and friendly. He said, "How are you getting
back home? I'm going out tomorrow morning on TWA." And I said,
"I'll change mine." I got the seat next to him and flew back with him.
I had been writing him letters saying, "Let's work this out," but it was a
labor of Hercules. He said to me on the plane, "Will you quit writing
me those fucking letters?" and the closer we got to Los Angeles, the
more I could sense a coldness. I said to him, "Look, I have my car. I'll
drive you home," but he said, "Forget it, no, no, no, I've got a studio
car." We got to the airport, and he said goodbye, goodbye. I left the
terminal and looked back and then he came down on his own, got in
the car, and was gone. She was there, of course, at home.

RICHARD GULLY: Jack was a man with a great zest for living, and he
wasn't going to live alone. In 1958, he started seeing this Englishwoman
and staying at her suite at the Beverly Carlton hotel instead of going
home. Mrs. Warner was staying in their apartment at the Sherry-
Netherland in New York, but she obviously knew he had this mistress,
and she was waiting to see how serious it would get.

So one weekend Jack went through the motions, as he always did—
"Oh, I miss you so much, darling. Come back soon"—hoping she
wouldn't come back at all. And she said, "Oh, no, I'm getting a new
dress here. I can't possibly get back until Tuesday." Then she came
back, deliberately, in the middle of the night two days early, and there
was no one in the house. When I arrived at the studio Monday morn-
ing, my secretary said, "A lady's been calling you, and I think it's Mrs.
Warner." So I called Jack urgently at the Beverly Carlton and he said,
"Pretend you're at the dentist or something. Don't talk to her until I get
to the studio. And then come up to my office."

Jack didn't get to the studio until eleven o'clock. When I went in,
the studio manager had an envelope full of money, and he said, "Give

the girl this money, put her on a plane, and get her out of the country as quickly as possible." She put up an argument, and it took me the whole goddamn day to get her out of town. By then, Mrs. Warner was livid with me for not taking her calls. She had no intention of divorcing Jack, so she held me responsible for the mistress, which was totally unfair, but she had me fired.

There were ten days where I was almost suicidal because I didn't know what I was going to do. I had no job, and no one was going to antagonize Jack Warner by employing me, let me tell you. I thought the end of the world had come.

JACKIE PARK: I grew up in Philadelphia. I don't know who my father was. My mother used to have different boyfriends and then she abandoned me to the Catholic Charities. I was abused sexually, but I got a good education. We were all given different scripts when we came into the world, and the important thing is to accept that.

When I was sixteen, a nice gentleman took a liking to me, but when he found out my age he got frightened. So he sent me to Hollywood with some money and a letter of introduction to the director Edmund Goulding. My real name is Mary Scarborough, but when I met Edmund he said, "Let's call you Jacqueline Park, after Park Avenue." I stayed at a club for actresses called the Hollywood Studio Club. Marilyn Monroe lived there at some point, and so did Kim Novak and a lot of other starlets. I dated Ronald Reagan for three months and he never once took me out, because he was carrying a torch for Jane Wyman. And I went out with Cary Grant for a while. The first time I ever had a date with him, he was dressed up like a woman. He had on a silk blouse, velvet pants, and gold lamé shoes. You had relationships, you know. Then you met somebody else. It was like watching a movie.

When Jack Warner came along, in 1960, I was dating other people and having a good time, and Warner said, "I want you to be only with me." I told him I'd try it, and he said, "Don't fuck around with love."

My bills were paid and nothing too much was expected of me. But Jack never wanted me to express myself. When I wanted to go to art class, he said, "That's a waste of time. Go work for the Red Cross." He set me up with my own apartment at the Sunset Towers and gave me an allowance of $350 a week. He was so cheap he would always make sure that the bills didn't stick together when he counted them.

But there was a side of Jack that would come out when he was not threatened by anything. He always wanted to be a singer, and one time we were sitting in a restaurant in the Valley and Stanley Holloway, from *My Fair Lady*, walked in, and Jack started singing "Get Me to the Church on Time." He was singing louder and louder, and finally Stanley came over and said, "Jack, you will never make it." Sometimes his soul would come out, but that wasn't very often.

I went to the command performance of *My Fair Lady* in London with him. We didn't have to go through customs—the FBI took us right through, because Hoover was his buddy. And, because my great-grandfather was from aristocracy, Jack started introducing me as Lady Scarborough. He said, "This is Lady Scarborough, and she has a heart of gold and a snatch to match." The next day, all the lords and ladies were looking for me to have tea.

Frank Sinatra said to me one day, "If this old geezer gives you a problem, call me." I put in a couple of calls at some point, but these guys with funny accents answered: "What do you want?" I said, "I have the wrong number." Then, when Frank Sinatra, Jr., was kidnapped, Jack called Frank and said, "Look, if you need a million dollars, Jackie will drive me to the studio and I'll get it from the safe." Then he turned to me and asked, "Is your car big enough to hold a million dollars?" I said, "How big is that?"

The Kennedys used to call Jack, and instead of identifying themselves—in case there was a columnist over—they'd say, "It's code K." One night in August '62, the phone rang, and Jack and I picked it up at the same time. All I heard was, "This is code K, Marilyn is dead."

Then Jack came in and said, "Did you pick up that phone?" I said, "No." The next day the story made headlines in all the papers.

One time Jack called me and said, "You know, I'm tired of all the restaurants I go to. I want to go where I'm not known." So I took him to Barney's Beanery and introduced him as George Anderson. Barney gives me that I-know-who-*he*-is look. We had dinner and the steaks were horrible. So Jack calls me up the next day and says, "I like Barney's, but could you buy the steaks and take them there?" So I bought lettuce, tomatoes, and steaks and said, "Barney, all you have to do is cook these." We went back there all the time, and Jack loved it. He'd say, "Tell Barney we're coming in." Barney would say, "Look, this isn't Chasen's, you don't need a reservation." One time a guy came over to Jack and said, "I know who you are: you're Jack Warner." He said, "No, I'm not. I'm George Anderson. I look like Jack Warner, but I wouldn't want to be that son of a bitch." That is the joy I shared with him. He knew how to live when his demons weren't coming out.

But when they did come out he just wanted to humiliate you. I never asked for anything because I knew I wasn't going to get it. See, Jack Warner could control me, but Mrs. Warner he couldn't control. I think there was a lot of guilt involved. And he was afraid of losing half of his stake in the studio if he tried to divorce her. The studio was his life—he had no other identity. He would have sold his soul to hold on to it.

When we first became lovers, I found out that he was very beaten down—he needed shots from a doctor to make him virile. So I put him under hypnotic autosuggestion and told him, "You can get it up. You can get it up," and I did a lot of nurturing. Then eventually we had a great sex life. He told me that he and Mrs. Warner hadn't had a sexual relationship in thirteen years. In fact she couldn't stand him. It was marriage in name only, but it worked. She had been his mistress for three years, so she knew what that role was.

He used to call me and say, "I am having dinner downstairs, the old

hound dog is upstairs." But he also carried around pictures of her, and every girl he went out with looked like her. She was a drug for him and he was addicted.

He broke up with me in '65 or '66. Then I was in really bad shape. I was drinking, and one night I got a call from Mrs. Warner. "Jack has told me all about you," she said. "You know we wouldn't get a divorce over such a silly thing as you being his mistress. But I have to think of my husband's reputation. If you have anything planned" So I sent her flowers. I said, "To Mrs. Jack Warner, the most understanding woman I know." Then Jack sent word that I should leave California. A friend of his said to me, "You don't want to wind up like Monroe, so you'd better go." Jack never saw me again. The five thousand dollars he gave me didn't last long. I lived off the money from hotel to hotel, and then I was homeless twice.

ANNE TERRAIL: The first time I met my grandmother is when my mother moved back to California, because my grandfather was sick. I must have been fifteen or sixteen, and I was in school in France and dreaming to do theater. I mean, I was in a completely different world, a completely different environment. I was really far, far, far away from all that. And I was very anti-American, wearing a Chinese cap, saying all these things like "China is great!" I had all these big theories of how life should be, of course, at that age. So I went up to my grandparents' house in a car with my mother. She was probably pretty tense and so was I. I knew that my grandfather was sick and I hadn't seen him for several years. We drive up. The fountains are on. This door opens, *squeaaaak*, and there is this woman that I have never seen before standing behind my grandfather, who cannot see me. This is like we are in the movies. She stands behind him. I am just going, Ahh. I say, "Hello, Grandpa," and he doesn't see me. I come up to kiss him. Anoushka is behind him, and that is the first time I see her. She was in a flowered dressing gown made of some kind of muslin. It had frills

and she had slippers on, and she was made up with blue eye shadow and red lipstick. Oh god! And the smell of her. She always wore this perfume, Princess Marcella Borghese. Actually, I have one bottle at home in Paris. I took one when she died. I remember her once and a while doing *spritz, spritz*. It was real strong. Oh god! I'm glad I wasn't their child. So, anyway, that is the first time I saw her. I remember she was looking after him. I remember this power thing mostly that she was controlling everything. Of course, you should say she was a saint. You know, when people have power over another person and people say, "Oh she is so good, she is taking care of him," it is just killing that person. It is always weird.

My grandfather, I always wondered whether he recognized me. Then, when I remember saying hello to him I hardly . . . I think he recognized me but not right away. I am not sure. I know we went inside the house. I don't really remember the rest of it, but I remember them opening the door and them standing at the door. Instead of letting people come in the house and make it normal, she made it this big thing so that it would hide what was going on behind.

This was a really foreign world to me: this huge house, this huge door, and my grandmother made a huge Hollywood performance, a spectacle. She was trying to make something out of her life. I see her as someone who didn't live the life that she would have liked to have lived; she probably imagined it differently. That is what I feel. That is probably all projection. She didn't tell me that. It is hard to make sense of what she invented, what I heard, what she said, and what I felt. It is a big jumble. Personally, I had very strong encounters with her.

JEAN HOWARD: The last time I saw Jack and Ann it was Christmas 1973. Jack was completely senile, and he was wheeled in. Ann had him dressed up for Christmas in red pajamas. She said, "This is Jean." But he didn't know me from Adam. And he didn't really know who or where he was. He was friendlier than I'd ever seen him, just waving his

arms around. And Ann was very sweet with him. She put her arms around him and gave him a kiss good night when they took him out. He had no idea who she was either.

JACKIE PARK: Right to the end, Mrs. Warner was a perfect wife. She took care of Jack. I heard that if you went in to see him you had to wear gloves and a mask. His last years were not good years. Once a friend of mine went to see him. Jack held his hand and said, "Help me."

LOUIS ROSNER: It was 1973 when I was called in to see Mr. Warner at Cedars-Sinai Medical Center. I was in private practice as a neurologist in Beverly Hills, but Jack Warner had been to Scripps Clinic, and they hadn't been able to repair the damage from his stroke. Mainly it involved loss of visual recognition—a condition called cortical blindness, in which the person can see but can't make sense out of what he's seeing.

I was greeted by Mrs. Warner at the hospital room. Before a few weeks had passed, she knew every term on the laboratory chart. She absorbed everything you told her. She was the one who smoothed over Jack's rough edges. When he would curse, she'd say, "Jack, darling, you never talked like that. Don't talk like that in front of the doctor." She had a culture and sophistication that complemented his drive.

She became interested in every religion and the approaches they might have to healing Jack. She called me one day and said, "I've found our savior." For a while, I had been the savior, but then when I didn't cure anything I wasn't the savior. This one was a Tibetan faith healer. She delved into Buddhism, into Hinduism, and finally I said, "Mrs. Warner, I've always wondered, what religion are you? Aren't you Jewish?" She said, "Darling, I'm anything you want me to be."

She had these great little sayings. She'd say, "Give your wife a kiss for me." And I'd say, "Where should I kiss her?" And she'd say, "In all the old familiar places." My wife, Larraine, would call Mrs. Warner to

brag after she'd been out at some affair and say, "Everybody was staring at me. I must have looked really good." And Mrs. Warner would say, "Darling, people will stare at a snake," to bring her down to earth.

LARRAINE ROSNER: I was going through some turmoil with Louis in 1978 and Ann let me stay at the house while she was at the hospital with Jack. She was on the phone with me while he was dying. He was unconscious, and a whole team was trying to revive him, but it was hopeless. She kept saying, "His little foot is going so fast. It's going so fast." He was having some type of spasm, and she was standing in the doorway and that was all she could see. Then, when he died, she asked me to tell everybody at the house. So I did, and even though he had been sick for many years, they were all in complete shock.

The day of Jack's funeral was very painful for Ann. I remember the amount of anxiety it caused her to leave the house after all those years. There was going to be a big crowd, and she would be on public view. Nixon called her twice from San Clemente and said, "You have to do it." She always said, "He is the one who helped me leave the house."

JACK WARNER, JR.: Ann decided to make it a small funeral, with only the nurses and a few others. Then someone must have told her, "If you don't invite his son, he could very well sue you." Suddenly the phone rang, and some man from my father's office said, "Can you be at your father's funeral the day after tomorrow?" And I said, "Certainly." I took my wife and my two daughters, and we went to Rabbi Magnin's Wilshire Boulevard Temple. It was a strange experience. I hadn't seen Ann since my father's car accident. She'd put on a tremendous amount of weight. And she wore muumuus, no dresses anymore. She came up the stairs with her two daughters, and people clustered around her. I went right over to her and said, "I'm so sorry, Ann, about what happened." She didn't say a word, just looked at me, and I stepped aside and let her go in.

BARBARA WARNER HOWARD: I was always told that Jack Jr. was a terrible person and that he was only after money. Which, unfortunately, poor man, he really wasn't. He wanted love. My mother thought he would sue after my father passed away, and of course he didn't. He was left a little money and he accepted that. "Irrational fear" is the only term I can give to her feelings for Jack Jr. All those years she tortured herself with it, and it was sad for both of them. I remember seeing him at my father's funeral, and we acknowledged each other without talking. My mother had the coffin covered with red carnations—which my father used to love. Every morning on his way to the studio he'd pull out one for his boutonnière from a vase by the front door.

ANNE TERRAIL: I didn't go to the funeral because I was back in France. But then my mother moved back to L.A., and I followed her and went to CalArts. Every time I would go and visit my grandmother after that she would be sitting in the same chair, an armchair, in a kind of living room suite upstairs next to her bedroom, where she spent all of her time. I would say, "Oh, hello, Anoushka," and smell this perfume. She was wearing one of those robes, very overweight. I have a feeling that she wasn't that huge actually. She was wearing that blue eye shadow and her face had a lot of heavy pancake makeup on it. Oh god, excuse me, Anoushka.

I liked being with her, though, because for me this was like a special thing. I had this grandmother who was very special, who was called Ann, and on top of that she could tell me many things that nobody else was going to tell me—she never told me anything, but I could ask her things. What she did tell me, though, was about her husband, Jack. She said, "When I met him he was just a little Jewish guy and I made him into what he was. I changed his clothes. I changed his way of dressing. Thanks to me . . ." I tried to get links to my past. I've always been interested in family things. It was a great treat for me to go there. It was like this escapade, and maybe for her, too. I remember, she had

this friend staying with her, it was a writer, and she wanted to show off in front of him, probably because she had this French granddaughter, and I was in my Jewish period, I mean, I was really looking for my Jewish roots, and she asked me, "Who is your favorite writer?" She probably thought that I would answer with the name of a French writer and I said, "Isaac Bashevis Singer." She said, "Oh really?"

Actually, my mother only told me I was Jewish when I was around eleven. I was pretty old by then. I remember playing cards with her and she said, "Oh, by the way, since you are Jewish, this and that . . ." I said, "I am what?" I think she thought I knew. Suddenly, I was very proud. Then I got very scared. I thought, What if Hitler came back? I was a little girl. I don't remember asking her questions. I had probably heard bad things about the Jews. All the things about being a victim and Hitler. You know, all these things when you are little. At the same time, I thought, This is special. At least my mother is giving me something from her. I thought it was really neat in that way. I felt that I was a link to her. I think for her it was not very important. I remember that I was proud about it. To be different.

When my grandmother was younger, there was probably a side of her that was sensitive and liked poetry, all that realm of things. Then she probably wanted to make it also, wanted to become a rich woman. Now why, I don't know. I don't know how poor she was when she was little. She probably wasn't that poor. I have that feeling. But with Jack she probably wasn't happy because he was not poetic at all . . . *Who gives a shit about poetry.* His reasons. She probably was not happy and that is why she got into all this mystic stuff—you know, really she always talked about astrology. She did my sign when I was born because my mother gave it to me. It is not very interesting. She didn't do it herself. She had it done. It is not very accurate actually. The way that she got into astrology was a little . . . it was like, what next? She tried to invent something for herself. From what I understood, she closed herself up

more and more. She hardly went downstairs after she was forty. That is not old. That is pretty strange. She probably wasn't happy. Sometimes I wonder if she didn't drink a little just to make herself feel better. She had intuitions. Now, how real, I don't know. I really asked her to be my grandmother when I saw her. I would ask her questions, you know, "Where did you meet my grandfather?" This and that. She hardly said anything, but I would just look her in the eyes and say, "This is what I want from you." She liked me because of that, I think. At first, I was kind of exotic because I came from France and she didn't have to show herself too much. I didn't ask her for anything. I wouldn't have gotten it anyway. Once I said, "Can I have this little picture of your mother? Oh, I would love a copy of it," and she said, "Oh, yes." And I never got it. So, when she was gone, one thing I took was that picture. I have it in Paris. She told me that I looked like her mother. Her mother was called Sarah. She died when my grandmother was twelve. So it seems like her mother could not have taken care of her because she was dead. I was always really trying with her to get some kind of connection with the past in the family beyond the Hollywood image. It was hard to get past that. I never got anything from her. I think she built up barriers to protect herself so she wouldn't show who she really was, because that was the only way she could move up in the world she chose to move into, marrying my grandfather Jack. She probably wasn't made for that world, I think, since she didn't know how to deal with that sensitivity she had and all that fame. She was also a very powerful woman. She wanted to have power, and you can't have everything. I think she fucked herself over. Sorry to talk like that. She wanted to have power, she got it—on the other hand, at the same time it destroyed something inside of her. It's sad, this woman. She is someone that I would have liked to know better, as a real person, my grandmother—stop the bullshit, stop saying and inventing stories. I really would have liked to know her because she was really interesting. I know her relationship with my mother must

have been really awful. My mother didn't like her, I think. I don't think they liked each other. It probably was hard for my mother that I had a relationship with her, I'm sure it was. She would say no, but I'm sure it was. That's normal. It is often like that, that it goes over generations. I could feel that they did not have that much to say to each other. They probably never had much to say to each other. Also, I felt this, it is a weird thing, I never understood why my mother talked to her so nicely, you know, with these sweet words to this woman that she really didn't like. I always felt that was strange. I did not understand what the point of it was. But I guess, she was protecting herself because she probably felt very scared of her mother and very menaced by her. Anoushka was very power oriented and she must have been a terrible, terrible mother. It must have been really terrible to be their child. I think with Jack, too. I know my mother had a much better relationship with her father, it seems like it anyway. I just feel that she had no family support at all. He was probably very charming. But who cares if someone is charming if they are not there? I feel he didn't want trouble. That is what I feel. It went down three generations. Now, I am trying. Someone has to break it; otherwise it can go on for ten generations.

My grandmother was very moved that I went to Ferriday. She was very surprised, I think. I'd asked her where she was from and she said that when she was growing up her father had a movie theater. I asked around in the town, "Is there an old movie theater?" People told me there was only one, so I took pictures of it. It is an old town. There is nothing . . . the Mississippi River just on the other side of the wall. I'm not sure it was the right theater. That is the thing, I am not certain. And I am not certain either that she told me the truth. That was the problem always with her—that you were not certain, sometimes you felt that she was saying the truth, and sometimes you didn't know.

Once she let me bring my friends over to the house. Usually she would say, "No, not today. I am sick." I was there in a motel in Santa Monica with my ex-boyfriend, James, and my two French friends, and

I called her and said, "Can I come up?" and she said, "Come on up." I thought, This is amazing. So we all drove up there. Of course, she didn't see them. They all stayed downstairs. We went all over the house. She had us brought down a bottle of really good French wine with cookies and stuff. I don't know why. It was really funny. She even gave me some money, a hundred dollars, for us to go and have dinner. Isn't that something? I couldn't believe it. I really couldn't believe it. I think she thought I was going to get married to the man because I told her that I was with my boyfriend. I remember she said, "Which one is it?" She had probably been looking down. When I went back outside, my friends had jumped into the pool, which I would have never dared to do myself. That pool. The woman who worked there came down with robes. She was actually so happy that someone was swimming there. My friends were so excited. They were actors and they took pictures of the Oscars. Then they were in the swimming pool shouting, "Hey, Lauren! Hey, Humphrey!" It was real fun.

I didn't go in my grandmother's bathroom when she was alive. She had a closet in there, and the shoes were all stored by era. There were some high-heeled shoes, some shoes with low heels, then the later shoes were all slippers. I don't know how many there were, like sixty pairs of shoes. Too bad, if I hadn't lived so far away I should have taken them.

GORE VIDAL: Doris Stein's story about her last glimpse of Ann Warner, though, is wonderful. Doris was driving her land yacht down from the heights and came down by Ann's house as she had a couple times. Doris said, "The gates were always shut. Just nothing was going on and no way of getting in touch with her." But this day the gates were open. And Doris said, "I just stopped and I went in."

And there was Ann big as a house watching. She was on a golf cart. That was it. Some kind of golf cart that she was getting herself around in. "And as she whisked past me, she said, 'Hello, Doris.' I said, 'Hello,

Ann.'" She kept going and Doris said, "I turned around and I left." Just whizzing by.

PATRICK FOULK: I was up at the house a few times before Jack went to the hospital. By that time, he wasn't the same jackass he'd been when he was in power. He hated dying. So we became a little closer. Then, after Jack died, Ann had a big house and a squad of people, but she was very alone. I kept going up there, and she suggested that I come there to live. So I lived at her house for the next twelve years.

Once Cary Grant called and said, "Annie, let's get the hell out of this goddamn town. Let's go somewhere where you can just be yourself and have some fun." That was about a year before he died. But Ann was very aware of her role as Mrs. Warner. She was a person who would stay up all night and then sleep in the day. There would be days when I wouldn't see her, but I was always talking to her on the phone. Sometimes I'd sleep upstairs in a room of Jack's, just to be close. There might be an earthquake or it'd be raining, and we'd talk and that would make her feel good, and me, too.

She was incredibly brave, but she liked to feel a kind of security. Over the last year or two, when she was diabetic, the nurses were there around the clock, giving her insulin. But it wasn't like a sickroom: everyone was very cheerful and so was Ann.

JAN IVAL: I worked as a butler and a chauffeur for Mrs. Warner for twelve years. I had a little house in the back, whose windows faced the hill, and you could see deer and coyotes. I come from a very distinguished Spanish family in Chile, much better than the Warners. Mrs. Warner loved that. She would tell stories about her youth on a Southern plantation, but I personally think she made them up. She acted her life like a scene from *Gone with the Wind*. She had an explosive character.

We'd go out to dinner almost every night. Once we were driving to

a little joint she had read about in the newspaper: it was a long way out of town, and she wanted to stop and ask for directions. I said, "We're not lost, and I'm not going to stop." So she opened the door of the car and tried to jump out. I had to grab her by one arm and pull her back in.

In the beginning, she was afraid to have people see what she looked like. Then she saw that no one recognized her, so she didn't care. Sometimes if it was a fancy restaurant or somewhere she didn't want to give her name, I would make the reservation, and she would pass me money under the table to pay.

One day we were driving down Third Street, and Mrs. Warner saw a man with a cook's hat on. She said, "Look! There must be a restaurant somewhere." So we drove back, and there was a little restaurant on the side street. It was kind of shabby and dark but very clean. Every table was taken, and there was a counter at the end with a display case full of chicken wings and mashed potatoes. Mrs. Warner told the man behind the counter that she wanted the chicken wings. He said, "You have to pay first." So I went down to the register, and the woman said, "Let me see your Social Security card." It was a welfare restaurant. So I went back to Mrs. Warner and dragged her out. She said, "But the food looked good, and the people looked so happy eating it." And I told her, "Mrs. Warner, this is a welfare place where you have to leave your Social Security number, and I don't think it would look right to have Mrs. Jack Warner eating here." She said, "I want my wings." So I took her to the car, went back in, passed over my Social Security card, paid a dollar, and took the wings out to her.

When I was driving her to the hospital for the last time, we passed a little coffee shop and she said, "Let's go in." She ordered chili beans and they were very hot. There was a jug of cream for the coffee, and she poured it onto the beans. Then she said to me, "Maybe this is my last dinner." She had humor, even though she knew that she wasn't going to live very long.

LOUIS ROSNER: Mrs. Warner was at Cedars-Sinai in the intensive-care unit with a rare lung disease, and there was a point where the question was, "Is the case salvageable now?" and I wanted to keep fighting for her. But her daughter Barbara had signed a do-not-resuscitate order. So I talked to the doctor in charge, Dr. Mills, and protested it. But he felt that to put tubes in her throat and all of these things in her veins and to keep her respirator going would be torture.

JACK WARNER, JR.: When Ann died, in March 1990, there was an obituary in the *Los Angeles Times*. It was written by someone who had never known her, and they used a picture of some strange lady: I don't know who the hell it was. So I phoned the obituary editor and asked, "Who's that lady you had on Ann Warner's obituary?" She said, "I don't know." "You'd better check, because it's not her." All she said was "Oh, my god."

BARBARA WARNER HOWARD: A couple of months later, I went to visit Mother's grave to see how everything looked. As I was driving out of the Jewish cemetery, I saw a chapel with a huge Nazi flag on it. I thought I was dreaming, and suddenly I felt a little scared, because the cemetery was completely deserted. So I drove around this chapel, and on the other side there were picnic tables and a film crew. They were shooting a movie, and they had just rented the building. I went back to the main office, and I don't think I've ever been so angry in my life. I said, "I don't care how much money they're giving you, you don't let them desecrate a Jewish cemetery by hanging a Nazi flag!" At the same time, it was hilarious. It was better than a Mel Brooks movie.

JANE GARLAND

22368 Pacific Coast Highway, Malibu

ED MOSES: In 1957, I was a graduate student at UCLA and I needed a gig to pick up some living money, so I went over to the job office for students. They had these little card files you'd pick through. I always looked in the medical section, in the crazy section, trying to find something intriguing. I was interested in anything that was more esoteric.

There was one job that looked interesting. You had to report to the neuropsychiatric ward at UCLA and talk to a Dr. Judd Marmor, tell him your credentials and capabilities. I didn't really know anything about him. I arranged to meet this guy and he explained the situation. There was a woman who had been in and out of mental institutions, but it was not a crisis situation and it was time for her to get out of the neuropsychiatric ward. Her history was described in very couched language. Dr. Marmor was giving me as little information as possible. I would be paid two dollars an hour or something like that, which was a good sum compared to any other job you could get at the time. He said, "This girl is very disturbed. Do you think you can handle taking her out to restaurants and staying at the family's place in Malibu at night and on the weekends?" At that time they were experimenting with schizophrenics in England—instead of putting them into a lockup cell, they just let them out so they could socialize, go dancing, interact with the so-called real world. The theory was that if they were introduced to a "normal" or natural family structure by people who were paid to serve in that role, and who didn't make a big deal about it and just did what the patients wanted to do, little by little they would hook up and move back into our reality.

When I was in the navy during World War II, I was trained as a surgical technician at the San Diego naval hospital, and as part of the

training I had to go through various medical areas—psychiatric, urology, general surgery, cranial surgery. I worked on four or five intercranial operations with the Gigli-saw drill and would drill holes in the head. I thought I was hot shit. I could scrub in with any of these guys and know what they were doing before they knew it themselves. I worked in the spinal meningitis ward for a while, and in every manner of ward. I had some slight experience with the psychiatric wards. I thought I knew a lot about everybody—who could better take care of the crazies and the weirdos that everybody else was scared of but me? So that's where I came in. And my cohort, Walter Hopps, too. Sometimes he went by Chico. Only crazies like us could deal with the genuine crazies. I said, "Oh, sure, this is right up my alley." Judd Marmor knew a sucker when he saw one.

CRAIG KAUFFMAN: I knew Ed Moses in college, and a bunch of other artists. You know, Walter and Billy Al Bengston and John Altoon and Bob Irwin, and—and so forth. John Mason and all those people. And then later, Ken Price. We were the guys who went to college—the art school kids. Maybe you know Walter made photographic collages. We would kind of go to the crummy areas, and he would take some photographs. There must have been fifty bars on Fifth Street back then. Bars and prostitutes in the bars and stuff. And in those days, there were sort of soft porn movies shown down on Main Street. We went to some of those. The girls really didn't take their clothes off all the way. Maybe you saw their breasts. And Walter took some photographs in the theaters of these girls. And they were in some of his collages.

ED MOSES: I met Walter through Craig Kauffman, who was a painting student at UCLA at the same time I was. This was in the early fifties. Craig took me over to Syndell Studio, this little gallery that Walter and Jim Newman had opened with another guy named Ben Bartosh. There was this real pretty girl who worked there. Years later, she jumped off

the edge mentally. She committed suicide and it was real tough on all of us. Craig and I both dated her; we all passed everybody around back then—we were very generous—but Jane Garland was never passed around. She was too spooky.

Ed Moses.

JIM NEWMAN: I knew Walter as Chico. We lived in the same dorm freshman year at Stanford. Walter was lean, maybe six feet tall, and wore dark-rimmed glasses. He stood straight and moved slowly but fluidly. He spoke with very carefully chosen words and phrases—actually, he spoke prose that wouldn't have needed editing. He made you feel you were the most important person around.

WALTER HOPPS: I once knew a girl named Dominique. Dominique designed very trendy knitwear for Jax of Beverly Hills—do you remember that place?—and subsequently for customers such as Mrs. Lennie Hayton and Eva Marie Saint, on whom they were quite fetching. Dominique was a super knitter among other things, and she invented the whole style of little knitwear tops. During the Beat period some women wore sleeveless men's undershirts with no bra or anything underneath, which was quite charming for those of us around. You got a pretty good free show, you know what I mean. Dominique was a high-spirited girl in my life in those years. She was dating a guy named Bob Jones who was a good amateur chess player and one day he would counsel me in my games with Marcel Duchamp.

Anyway, Bob Jones also was a graduate student in psychology at UCLA, which I paid little attention to—he was Dominique's boyfriend, always away, always busy with chess or with his graduate studies, and how all this got rolling was that I'd hear reports from Dominique from time to time that Bob had some kind of strange job that was keeping him away even more than usual. It also happened that an artist friend of mine, Ed Moses, who was around the university at the same time, began to speak to me about this amazing job he had. I was to learn it was the same job.

Somehow Ed Moses was the connection to recruit young people who would serve as special psychiatric attendants to a very strange patient under highly unusual circumstances. Ed and Bob were restrained from talking about the patient in any great detail; they just referred to it as "the case." Nevertheless, I learned enough from them to be very interested.

For students in those years, the pay was terrific. Well, terrific was I suppose two or three dollars an hour. Ed said that I should meet the psychiatrist who was the head doctor on the case. He said there was a need for young men, not necessarily with any psychiatric attendant

Walter Hopps.

training or orderly background. I would be screened by a doctor in the UCLA psychiatric unit to see if I measured up, then I would learn more from there. The psychiatrist turned out to be Judd Marmor. I heard all sorts of things about him later on. It turned out that he was considered the most brilliant psychiatrist of his generation, and one of his major causes was to take homosexuality off the list of pathologies.

I called Dr. Marmor, made an appointment, and early one evening I showed up at his house in Bel Air. A young man, his son, let me in. Dr. Marmor appeared and apologized for having been on the phone. We conducted our interview, and he explained the circumstances of the case and what might be expected. Then he also had me talk some

about myself. Having known psychiatrists professionally and person-
ally before this, I knew that I was being given a very sensitive screening
indeed.

My mother and father were both doctors. And for a period of time
when I was a child, my mother was also very sick. My father told me
she was going to die, and he took me in to see her in their bedroom. I
remember her being unconscious or asleep in bed and the whiteness
of it all. The terrible lesson of that for me was that my father had this
kind of life-or-death control over all of us. And that seemed to give him
powers beyond those that came with being a father, with being older
and larger—all those things that are normal to any child. Doctors can
fix your hurts and make you well, but I got a very vivid picture early on
as to how he was, or seemed to be, in charge of the dying.

So, Dr. Marmor explained a little more about the case. It involved
a young woman in her late twenties who had a curious form of schizo-
phrenia. Normally she was the sort of person who would be institution-
alized, and in fact she had already been a patient at Menninger's clinic
in May 1955. But one of the things about her particular syndrome, for
reasons Dr. Marmor didn't go into, was that nurses or anyone of insti-
tutional mien put her in an even more serious state. He explained
there was a danger with this patient that, well, let's put it this way: an
institutional setting with attendants who behaved like they were in a
hospital would put her into an involutional state. He further explained
that she was the daughter of a very wealthy family. It's a real Hollywood
story. William Garland, a railroad builder and owner of real estate in
L.A., encountered a young woman named Grace, who I heard had
been Miss Cleveland of 1912. It seems she had major Hollywood aspi-
rations. She was supposedly brought west by Sam Goldwyn. Garland
married her, and they had a daughter named Jane.

ED MOSES: Grace Garland was a looker. From what I gathered, she
hoped to be in the movies, to be famous, to be rich. Those girls who

came out west dreamt of being famous like Lana Turner or like Ava Gardner, the most fantastic of them all. Grace might even have had a screen test, since she'd been Miss Cleveland. It's hard to know how happy she was. The guys those women find are difficult and she was probably neurotic as hell.

WALTER HOPPS: Grace, the mother, who was a widow by the time I came to know the Garlands, had the means to do something very unusual. This was an experiment, Dr. Marmor explained to me, to try to construct a semblance or version of what life would be like for someone of Jane's age and means if she were not so seriously sick. We were told that Jane's reactions to women, especially young women, were so severe that the people with her needed to be male. They would be given guidance as to how to behave generally and to assure her safety. In the course of this conversation, he explained that all sorts of things might go on—she was very bright, but very crazy, with childlike behavior. The mother lived at home with her daughter, he explained, but she was terrified of her child. One soon learned why.

As it turned out, Dr. Marmor thought I might be the right sort, and further arrangements were made. But the final hurdle would be to see how Jane would take to me. She might reject me, and, if so, it would be unmanageable to try to continue. That would be discerned fairly quickly.

I found out that a program had been devised for around-the-clock attendance at the home, divided into four shifts among five or six young male attendants, I eventually being one of them. There needed to be backups for those who had to miss their shifts and substitutions for weekends. There was always to be in effect at least one psychiatric attendant in the house with her. Not only would we be paid well by the hour, but she, Jane, would be expected to live and be entertained more or less in the style commensurate with her means. Any expenses we incurred when we went out with Jane would be covered by Mrs. Gar-

land. Further it was explained that the attendants should, at the conclusion of their shift, collect any writings or drawings that Jane would do and then write up little reports on how she was behaving. We would meet weekly with one of the two psychiatrists on the case. I came to realize that in a way we were under as much direct care as someone who was himself seeing a psychiatrist. That was standard practice in the best of mental hospitals, that all the attendants, nurses, and doctors had their own sessions to check on their mental health. The situation of such unusual emotional and mental stress in these circumstances affects the very persons who are there to help those most affected. It was quite an extraordinary experiment.

Oh, the important part I forgot—it was explained that I should be on the lookout for the patient developing a variety of relationships with the attendants. There would be a different sort of possibility in her deranged fantasy life with each of the young men who were there. Did I have any qualms about that? Was I willing just to see how it would go? At some point it was explained to me that my own behavior, mores, ethics, and moral standards should guide me as I worked. In other words, in a roundabout way Dr. Marmor was explaining that although you have your job to do, would it be possible to think of her as no different from any other girl one might know? We would be on our own insofar as the rules with her went. It was very clearly said that we had to make our own choices there, even though we were following her lead.

I don't think Dr. Marmor worried that anything would be initiated by one of us. Of course he warned about what in the trade they call "sharps"—that is, dangerous items: knives, scissors, ice picks, broken glass, everything she could hurt herself with would have to be locked up. As a matter of fact, these "sharps" were routinely brought up, but in a way that wouldn't scare you off right away unless you were a nervous type. I'm sure it did scare off some. The terms of the work interested me; it was compelling to think about what one might discover.

By that time, Ed Kienholz and I had opened the Ferus Gallery and Ed was pretty much running it. I was dropping in and out of school trying to earn some money. Whatever I might be up to as far as jobs were concerned didn't seem to worry me too much, so this was the job I took to survive. Thus began what was an extraordinary year of my life.

ED MOSES: When I first met Jane Garland, she was still in the lockup on the top floor of the UCLA psychiatric ward. I would go over there to pick her up around eleven thirty in the morning to take her out to lunch and then bring her back around four. They'd bring her out and she'd see me coming and she'd say, "Hi," and have her hair all twisted and sort of standing up. She could have been a redhead, but I think she was a brunette. I suspect she was no more than twenty-four or twenty-five. She had a vocabulary of behavior and a lot of body language. She had different walks for different things: she took tiny little quick steps; she walked on the toes of her feet, slightly tilted forward, and at other times with a kind of stumpiness. She wasn't hideous, not at all, but she didn't take care of herself either. There were a lot of pore openings around her nose. She had very coarse skin and a ruddy, slightly blotchy complexion, but with a little primping and stuff she'd have been okay. Her nose wasn't perfect, but everything else was pretty okay about her. She was a little bit thick in the ankles, but she was slender, robust, and strong. She didn't like to bathe. Her mother would take her to a salon and get 'em ripped open and waxed. She'd come back and her legs would be riddled with little teeny red dots.

Later on, she was permitted to stay at her mother's house in Malibu on weekends. It was right there on the Pacific Coast Highway. I'd stay out there every other weekend on Friday and Saturday night and come home on Sunday. At first it was fun. Sometimes we'd go someplace and dance. Sometimes we'd go to the movies. Sometimes I'd take her by to see certain of my friends. I'd warn them ahead of time. Craig Kauffman was totally fascinated with Jane, totally fascinated. I would

bring different guys in to sort of mix it up a little bit. I didn't want the full burden of this job and I wanted to see what would happen with the other guys. I explicitly said what was going on, but I was slightly embarrassed by it. These guys just didn't know how I could do anything like that. They said, "Man, you are out there—taking care of that girl!" Walter, of course, loved it.

WALTER HOPPS: It's strange that my memory of my first encounter with the Garland house is almost as vague as remembering the first encounter you might have had with some cousin your own age when you were a teenager. Later there might be a friendship or some kind of relationship that's quite vivid, but that first meeting somehow remains vague. So even under these circumstances—the setting, the mother, the girl—they are all at first more than overshadowed by what followed. I don't recall having any special nervousness going there. I was really intrigued. This I can remember: the long drive up the coast from Santa Monica to just below the Malibu Colony. It was a weekend, undoubtedly, I think that was arranged. There was a large California Spanish beach house, sitting like others in that sector that hug against the Pacific Coast Highway and face the ocean. Spanish tiles, clean plaster walls, bougainvillea coming over walled gardens. Arched doorways, heavy wooden doors, and wrought-iron fittings. Inside the walled gardens of the house, there was something immediately quiet. There always is in the beach houses in that section during the day, a very deep silence between the crash of waves. Another quality that all Californians who have spent any time on the edge of the Pacific are aware of is that the light is different. There's a pressure on the eyes from the light. I've never felt it on the other coast.

The house, which had a curious kind of configuration, was at least three stories high, oddly staggered so that they tapered off—one story moving towards the beach, and the higher stories moving towards the highway. There was a little court with bougainvillea off to the left and

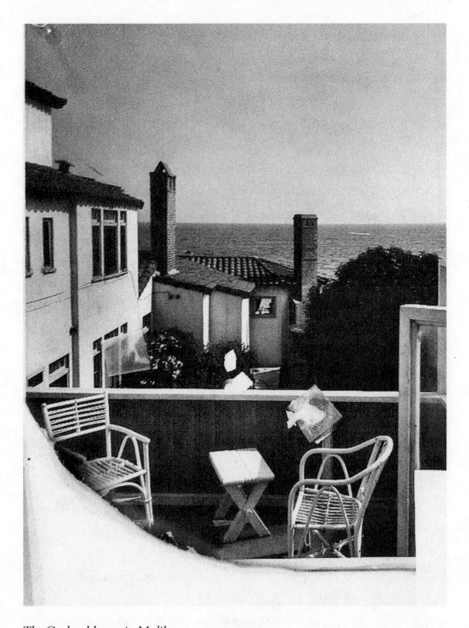

The Garland house in Malibu.

an outdoor fireplace where you could have dinner, but the mother didn't use it. On the ground floor was a sitting room with big windows that looked out over the beach to the ocean. There was also a little sort of library sitting room and then a more interior sitting room with a

baby grand piano. There was a dining room, too. The house was filled
with stuff ranging from the late twenties on, so it had that "in the past"
look to it with big green vases sitting in corners, strange wrought iron,
and what have you. You could've gone through that house and found
all sorts of collectibles that would've been in the shops on Melrose
Avenue. We're not talking antiques or fancy interior decorating, but it
had a retro look and enough money had been spent so that it was well
appointed. Yes, you could say it was gloomy, except that the sun came
in and there were windows that looked out on the ocean. Gloomy was
the vibe in the house, not so much the look. The family was very
Catholic—there was also a strange chapel in that house where I some-
times saw Jane on her knees, praying.

 The mother lived her life in the bedroom suite up on the very top
floor. She had her own sitting room and bedroom and bath up there.
It had some windows with an ocean view. When she turned in at night,
she locked it like a vault and you were alone in the house with Jane.
Where I slept, and Jane slept [and so on], was on the second floor.
Jane's bedroom had a fluffy double bed, overflowing closets, and a
bathroom that the housekeeper was always at pains to try and put back
together.

ED MOSES: There was a little tower at the top of the house, like in a
Spanish castle. It was a money type place but it was very plain and old-
fashioned, and Mrs. Garland had tried to jazz it up a little à la Beverly
Hills renaissance with a lot of froufrou in that sort of chickenshit way
people decorated those places. They had this horrible painting in the
living room above the mantel, a mother holding her child, a senti-
mental snuggling mother-loves-daughter-and-daughter-adores-mama
thing. Walter and I hated that sappy romantic Gainsboroughesque
painting.

 There was a little store on Wilshire Boulevard called Taffy's—did
you ever know that store? It had all these kooky clothes in it, and it was

sort of like powder puffs. Mrs. Garland had powder-puffed Jane's bed-
room. It was mostly pink, ginghamy. It wasn't Jane's room at all. There
wasn't anything personal in it like old dolls or dresses or anything like
that—it was empty, very sterile. It was like going into a hotel room, as
I remember.

Mrs. Garland had a caretaker who drove her around in a station
wagon, probably a Pontiac or an Oldsmobile, something like that. I
had to drive Jane in my own car, an old wreck. I had so many cars over
the years. I had an old Chrysler convertible at one time, I had a '36
Ford, and then I had a '41 Chevy. It might have been the Chevy I had
at that time.

WALTER HOPPS: Grace Garland was a glamour girl and just a hopeless
person; she'd leave Jane in the care of the houseman and the cook.
The mother didn't cook anything—I don't think she could even boil
water for coffee. The cook and the houseman, who was the cook's hus-
band, were there quite a bit of the time, and I think they had some
quarters down on the ground floor somewhere. Sometimes they stayed
overnight, but I think they were happy to get out of there if they could.
They did all the shopping and cooking, and we had to do the driving
for Jane in terms of taking her around for appointments, especially
doctor's appointments, and outings. Jane would have to go to the psy-
chiatrist like twice a week. Sometimes the doctors would come over.

We were supposed to take her out as though she were one of us—
here we were, young men her age, so it was like going out on benign
dates. For heaven's sakes, we would take her bowling, and that was in-
sane. Crazy things would go on. The first time we took her we were not
even worrying about keeping score or anything, it was just R & R, and
Jane would watch us and occasionally she'd get up to do her thing. She
wouldn't roll the ball down the court. She'd get ahold of it and swing
her arm and let it go way up in the air and come smashing back down.
Whack! The manager of the bowling alley got very upset. I learned

early on that when things got out of hand like that I just had to slip the poor person the twenty bucks I'd been given by the mother for the quote "date," and we'd get her out of there. You know, "What's going on here? Is she crazy?" We'd say, "Look, she's not quite herself today. Here—sorry we've created a disturbance." And then we'd leave. We'd go out for dinner or lunch, hamburgers or whatnot, and suddenly she'd put the plate in her right hand and slam the whole plate of food down hard on the floor. And I'm saying, "Oh god, we gotta leave and try it again at another place."

It was a most unusual situation. Jane had obviously been a very attractive young lady but she'd put on quite a bit of weight. Occasionally she would slip down to the kitchen and eat a whole loaf of bread or an entire pie. They should've locked the icebox. Locked the entire kitchen. But they were trying to get her off all that, trying to get her to live a normal life at home. She was flabby and out of shape. Physically she looked a wreck, older than her years. If you saw her on the street you would have said, "Jesus, that forty-year-old woman is out of shape." Like she must have had a hard life. She had large, full brown eyes. I think her hair was brown, but she had this amazing mop of unkempt dyed blond hair, we're talking brassy blond, bleach blond. She would've been five foot eight at least—she was a big girl. She'd try and dress herself, it'd be kind of eccentric, but she was trying, she was trying. Like she'd be wearing a sundress but then she'd put on black high-heeled shoes that were a little too tight—Jane loved to wear high-heeled shoes for some damned reason. She didn't in the normal way look attractive—she looked like Anna Magnani without the style. Somebody described Magnani once as a big sack of oranges. Something was always off with Jane. You knew when she was agitated. She would slap her hands down on her legs, not hard, but sort of whack herself, or stomp in some way. Sometimes when she'd put on makeup and she was not in a great mood she'd smear the lipstick way beyond her lips and, poor thing, she'd cry and we'd encourage her to wash her face and

give it another shot. You're trying to be like a sympathetic friend. One of the women who worked there had the dubious distinction of having to help her bathe, and that was tough—her personal hygiene was not something wonderful, but it didn't bother me that much, you sort of got used to it.

ED MOSES: I thought I was ready for anything, but Jane would do more and more outrageous things and it got heavier and heavier. She liked to play around and then she'd get very seductive. She was very serious about that, and if I rejected her, she'd get upset.

She'd taken a pair of scissors one day and cut all her hair off, so her mother had this wig person make this hairpiece so that she could clip it to the back of her head like a little pigtail. One time she was mad at

Ed Moses.

me and she went into the ladies' room and when she came back she had this big shitty smile on her face. She had clipped the ponytail to the front of her head, hanging down over her eyes, and she was just proud as punch. Another time she came out of the bathroom with lips painted on her forehead. With her lipstick she'd painted her mouth on her forehead. I wasn't going along with the gag, and the gag was that she was obsessed with sex. And obsessed with me. If she was mad at me she might throw a nice little wad of ice cream across the room and paste somebody with it. You know, hit them with a little ice cream ball, flinging it across the room and whack them with it. And then she'd look the other way and sort of smile. If you weren't responsive at that point, she'd stand on her head in the restaurant in her little summer dress with no undergarments on. She'd get up, look at me, and say, "Well, what did you think of this one?" The person at the front desk and the waiters would walk by and she'd be standing on her head with no panties on, sort of doing scissor kicks to keep her balance. The waiters didn't say anything, and I'd say, "Wow! That's pretty impressive, Jane, that you could stand on your head without any drawers on!" She'd just sort of smirk. Sometimes she'd get that smirk on her face like she'd just cut a good one. Jane had these wonderful enigmatic smiles. She had her own kind of mirth.

Walter was always very low-key but intrigued about the whole Garland thing, whereas I was jumping around like a cat on this rubber band, just jumping all over the place. The first comment Jane made when she met Walter was, "Are you a cock, or do you need someone to take care of you, too?" Of course that really whetted Walter's appetite. He was fascinated by her—are you kidding? He was just a half step away himself. Not even half. Jane was really interesting to people like us who like the irrational and who don't place a lot of importance on conventional achievement and rationality. Everybody wants to be reasonable, but Walter didn't like that idea and neither did I. Walter had a real appreciation for the other zones, so Jane was just perfect. He was

very consistent and very thoughtful with her. He genuinely wanted to make contact.

WALTER HOPPS: An awful lot of Jane's regular behavior was childlike. It wasn't like baby goo goo, but a mix of impulsiveness and innocence the way a nine-year-old would be. I can't quite imitate her speech. Sort of stream of consciousness coming off from somewhere, but then she'd slip into these moments of shrewd clarity and would seem normal and just clear as can be.

Jane would go in and out of it. Sometimes we'd draw together, just to get her involved with something so she wasn't sitting there on the sofa rocking, so out of it. There were times when she'd go into an almost autistic kind of world, but drawing would get her going. We'd do crazy drawings together. I'd say, "Let's do monsters" or whatever, you know, it was all like childlike drawing. What I was doing with her was turning the art into something really creepy. That was the exercise. I was interested to see, if she were to draw demons, what would they look like? Mostly, she just did numbers. She would do strange arithmetic or crazy number sequences, just repeating them over and over. Occasionally—oh god, this is sad—occasionally she'd do what looked like a childish drawing of a woman lying down dead, murdered. She'd grab these drawings and hide them in the vases around the place. I think I saved one somewhere. She grabbed some of mine one time while I was dutifully trying to draw monsters and hid them without my knowing it. Ed Moses found a stash of them one day and said, "Can you believe what she's done here? Look at this!" and "Boy, those are terrible, weird-looking things!" Actually I never confessed to him that they were mine. I turned in some of her drawings to the psychiatrists, who wanted to see what she was doing. Mostly it was just sad, it was as though she were somewhere locked away, way inside and not too much could get out.

Occasionally Ed and I would watch television with her. She en-

joyed Elvis Presley on *The Ed Sullivan Show* and things like that. Sometimes she'd play records and we had to dance with her. Dancing for her could be anything from just standing in one place twirling around and around, or doing bizarre versions of the twist, or stomping around the room like a robot. Whatever struck her fancy, you know? If you had a certain imagination, you could sort of get into it. Okay. So, around the house it was drawing, dancing, listening to music, watching television. We'd also try to get her to sit out on the beach and take a little sun because she looked very pasty. We were not to go into the ocean because none of us were up to handling that if she got in trouble out there. I don't think she wanted to go in. I think the sea scared her. She'd wade in the waves but mostly we'd just spread out a blanket and lie on the sand fully dressed, have snacks or something.

Ed and I and one of the other guys, I can't remember who, took her to Disneyland. Moses had brought some grass along, and he and I were smoking it. It's the only time I'd been there, and I don't ever need to go to Disneyland ever again—I'll tell you, for me it was the way to see it. To experience it stoned, in the company of a charming, totally delighted schizophrenic girl—that's the only way to see Disneyland. The whole thing delighted Jane: the people, being out, the cartoon characters walking around so you could meet Mickey Mouse and Donald Duck and Goofy, and they had all these strange rides and places to go to. In her childlike way, she enjoyed it—I don't recall now what rides she liked, but I remember what frightened her. There was a sizable room that was dark and shaped like a hexagon. It had a very sophisticated projection outfit so that we'd sit on benches in the middle of the room while six different movies were projected up on the wall playing simultaneously, so you had a Charlie Chaplin here, W. C. Fields there, whatever, and you could just look around. Of course I loved that fantastic montage. To me that was the most interesting thing in the whole place. It was just nuts to have them all going at once on big screens. I couldn't stay as long as I wanted to, because being there in the dark

room with all this stuff going on was obviously upsetting to Jane. She kept standing up, and she'd go, "Did you hear me stomping my feet?"

CRAIG KAUFFMAN: The three of us took her to Disneyland. And I think there's some photographs of us all there in jail. You know one of those jail photographs. And we were all just plastered on martinis, going on these rides and stuff. But I, I really couldn't take it, because it was—it would be so depressing at times. You know, she'd tear her dress and run into the crowd and stuff. But she loved Walter, and she loved Ed. Walter was like her father, and Ed was like her date. And when she'd go out with me, she always told everybody she was taking care of me. I was kind of nuts in those days. You know, I really liked her. But you know, you'd be driving along, she'd light up a cigarette and turn up an Elvis tune. Blast it all the way up on the radio, right? I mean, oh boy, I embarrass easily. It didn't seem to bother Walter very much. I don't know where those photos are now. I'd love to have one. Maybe Ed Moses has 'em.

ED MOSES: A couple of months after I started the job I picked Jane up and she didn't have any shoes on, so I took her to a shoe store down at the Third Street mall in Santa Monica. Salesmen walked up to her at first just like she was a normal person and then they'd have to sort of step back to reorient themselves. I'd help them along as much as I could by talking to Jane in a fashion to obliquely convey that we're dealing with a mental patient here. They didn't always get it at first, so you'd have to make repeated efforts and little by little they'd settle into it. Since Jane never wore underpants, she'd be sitting there with her legs apart and the guy would be down there and she'd go back and forth with her feet. There was some energy that she had to diffuse somehow, so she made these strange motions. I saw these little boots and pointed them out to her. She just sort of nodded her head and twisted around. I thought they were nice little boots. They were very

soft and they were sort of plum red. They came up just above her an-
kles in a sort of scallop and made her look like a little elf. She could
have worn one of those hats with a feather through it and she would
have been like Robin Hood. I don't know why I wanted to make her
into Robin Hood—that's too perverse a thought. In hindsight I don't
know why I got those boots for her, I just thought it was a cute idea—
I thought it might brighten her up a little bit. Whenever I was at her
home she'd always have them on. She'd wear those fucking red boots
to bed. She wore those things until they were falling off her feet—
'cause I bought them for her. It's excruciating when you get to know
someone whose behavior from the outside just seems goofy, but after a
while you can feel what's twisting and turning inside.

Jane was never a danger to you, only to herself. And there was dan-
ger. The scary part was that she would come creeping in in the middle
of the night. I slept very lightly. At the stir of a mouse I'd wake up—
because of her. I was up in this little room way up at the top and her
bedroom was down below. But she'd wander up in the middle of the
night and stand over me—shuffling from one foot to the other. She'd
be wearing a nightgown or something like that. She wasn't naked. I
don't think she was proud of her body so she wasn't exposing herself.
I'd realize this presence and I'd look up and she'd be looking down at
me. I'd say, "Oh, hi, Jane. Are you just looking for something to eat? A
drink of water? Or can I direct you back to your sleeping quarters?"

Jane had stepped out of the territory where most of us travel. She
spoke in tongues: it was a jumble of irrational connections of words
and images, but after a while you understood. It was like listening to
someone speaking Spanish and every once in a while a word comes
out and you say, "Oh yeah." She reminded me of the sculptor John
Chamberlain who liked the sounds and the look of words but doesn't
care about the meaning of them. It was something like that—like
words put together for how they sound together but they might have

been in her imagination. Every once in a while she'd say these incredibly succinct things that cut right through everything, and the rest of the time there was this talking in tongues, this weird kind of chattering and clattering about. There were certain things she'd say when things had gotten out of hand and she was about to become dangerous. One of her famous phrases was, "There is a rat in the refrigerator." That meant some bad shit was about to happen, some real bad shit. I don't know if there ever actually was a rat that she'd found and put in the refrigerator or what, but she'd say that phrase and I'd think, Holy shit, what's going to come down now?

WALTER HOPPS: I was trying to go to school, so I would mostly do weekends and the graveyard shift at the Garland house. I'd come in at ten or eleven o'clock at night. That's what I did later when I worked at the UCLA medical unit, too. Oh, it was just hell, that's how you get addicted to speed because you gotta be at work at eleven o'clock at night and stay awake until seven in the morning. That was a real grind sometimes when you're there on a night run and you get off and you're heading right to school. I could fall asleep at the Garland house, but Jesus, she'd get up and roam the house at night. I'd be lying there having drifted off, but I'm not undressed and under the covers, right? You got your slacks on, the shoes handy, the shirt on, and you're ready to go. But then suddenly you open your eyes and her face is five inches from yours, staring at you, and then you have to get her back to bed.

Early one morning when I was sure Jane was still asleep, I took Grace Garland's new Edsel sedan out on PCH just to work off some tension and I ran the son of a bitch up as far as the speedometer would go, to where it says 120. I made sure the tires were good, which they were. I always made sure everything was shipshape on the car at the first gas station I'd get to, because you didn't want anything to go wrong when you were out with Jane.

ED MOSES: I had been going on these visits to the Garlands maybe
two days a week for maybe three months when they decided that I was
so successful that they wanted to increase it to three or four days a
week. They were looking for another person, so I mentioned Craig
Kauffman and another guy, Allen Lynch. The two of them had started
hinting around that they wouldn't mind having a gig like mine; they
liked that kind of bread. I asked them to apply. Craig lasted two visits,
Allen lasted one. Jane threw Allen out right away after one meeting.
She just didn't like him. Same thing with Craig. Craig actually took
her out two or three times. He was game because he was always inter-
ested in a few extra bucks. But Jane said, "Craig is crazier than I am."
And in a sense it's true. But he wasn't that kind of crazy.

CRAIG KAUFFMAN: Jane was a funny deal. We were really poor for a
long time. I mean, we got money from our parents. But, to do any-
thing else, we needed a little extra. So when we were still in college,
Jim Newman got Ed Moses and me involved in this thing with Jane.
And we would be on for—I don't know, twelve hours and then off, and
then on for twelve hours. And I didn't last very long. 'Cause it was
hard. She was a young woman and kind of attractive and she'd flirt
with everybody around when I took her out, particularly with motor-
cycle guys. She would always dress up in these designer dresses that
her mother got for her. Her mother had been a beauty queen when
she was younger and married to some movie mogul at one point. And
her mother was like this fading beauty, you know? One time I went
over there, there were some old silent movie stars, and they were all
playing bridge. It was creepy. Really creepy. Yeah, I think I actually
went down there one night when Buster Keaton was over playing
bridge or something.

 I'd go down to the big house on the beach in Malibu and pick Jane
up and take her out. We would go to all these restaurants for lunch
and have all this food and martinis and stuff. And she would get kind

Craig Kauffman,
1958.

of plastered and maybe do a cartwheel down the aisle. She'd pull tricks. Like, she'd break things and stuff. I never saw it really bad. But Ed and Walter did. And she would say, "There's mice in the icebox! There's mice in the icebox!" And then you knew that something bad was gonna happen. I didn't last very long. It was depressing for me, you know?

But Ed and Walter seemed to handle it pretty well. Walter was like the doctor. Walter was sort of always very analytical. You know? He told me one story that when he was making it with some girl, he was experimenting with himself. So he took his pulse. While he was doing it. I don't know whether that was a true story, but he told me that. You know what I mean, that aspect of Walter. That control, and analytical quality, slightly Zen-like.

ED MOSES: Walter could not take too much stress at all. He would just turn and go the other way or he'd go up to his room. Craig and I went

to pick Walter up at his home for lunch or breakfast one day. He had this little trunk in his room and he pulled out his shoes and there was this box of announcements for an exhibition that Craig and Wallace Berman had made—the announcements were about four or five inches high and about three and a half inches wide, with the picture of a beautiful little book printed on them. Walter was supposed to have mailed them, but he never did. Craig grabbed him by the throat and was going to throttle him. They'd spent about a week hand pressing all these things, and Walter just couldn't get it together.

WALTER HOPPS: I was very fond of Jane. Somewhere inside there was a really nice person and somebody who'd been very attractive once. I think Ed was fond of her, too, in a way, and he held up all right. But Ed was always interested in the dark stories. He lied about his age to enlist in the navy, you know. He even won a medal: he was on some beachhead in the South Pacific, where they went up the beach on those landing crafts, and the Japanese were just shooting everybody to ribbons. Ed came upon a doctor and saw him dead, and he was next to a guy whose lower body had been torn open. The intestines were all lying out and Ed was desperately trying to stick 'em back in and put the guy back together. Of course you get shell-shocked when everyone else is getting shot to pieces and you aren't—it's very hard on the psyche. You wonder why you haven't been killed. Ed just kind of went crazy— maybe he was hurt a little—and he was evacuated out with the wounded. So Ed woke up in the hospital in San Diego eventually with extreme trauma. But he survived.

Ed spent more time on the Garland case than I did and he managed to burrow out stories. We all just thought the mother was dreadful. When she had taken off in the past, she'd left Jane in the care of some kind of caretaker, and one of them turned out to be vicious. And that's part of why I think the doctors told us that she had a very difficult

time relating to women. This was all before our time, before we were onstage—Jane never mentioned the woman to me. Somehow Ed had ferreted out the information, and I'm sure it's true.

ED MOSES: For a while I didn't know what Jane's game was. She was so smart the way she played with you. Really smart, but really angry. She always made funny comments, but they were so oblique. It wasn't until I got to know her over a period of time that I could play back and forth with her. I couldn't figure out if her insanity was some genuine insanity that came about from a heavy-duty life situation, or if there was some genetic factor that had induced this schizophrenic behavior. Was she really blocked up and inside out, or had she gone through some heavy shit and had a low threshold for the shit? Or maybe the shit was so high that no matter what your threshold was you might have flipped out. I remember when I was in the service there were guys who couldn't take as much stress as other guys. Shell shock. She didn't seem like a straight schizophrenic to me. She was like this creature who had been mortally hurt. I heard one story that made me wonder.

The mother wasn't in Jane's life for a while. Jane must have demanded some independence. Grace Garland left her alone at the ranch with this gal named Helen who was a horse trainer who had come to watch over Jane and the horses while Jane's mother was off leading her own life. Grace Garland still had money, was socializing with her friends, showing off her diamonds, all that kind of stuff. She just parked Jane up in the mountains and then this caretaker and Jane took up together.

The woman had really taken her over and was trying to get papers signed over to her, bonds and stuff in her name, but Jane wasn't coughing up or doing what she was supposed to, so this woman just raised hell. This lesbian horse trainer took to tying Jane up and beating her. Then she set the horse barn on fire. It was really sort of a holocaust

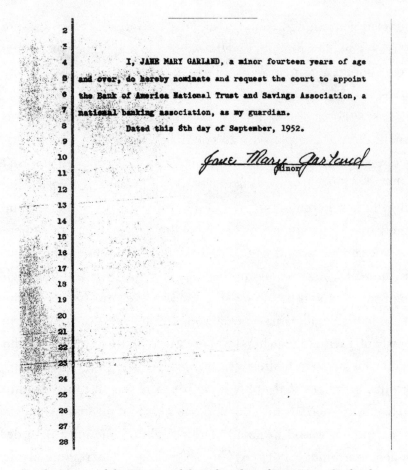

"In the Matter of the Estate and Guardianship of Jane Mary Garland, Minor," Superior Court of California, September 8, 1952.

with the horses. She either burned Jane or did some really horrendous thing, and the mother found out about it. The woman got thrown out, and she tried to sue, and Jane's mother tried to have her thrown in jail. This is conjecture because I heard only little bits and pieces, but I never really put it all together. Jane's mother talked to me about it a little bit from time to time because she wanted to get my confidence. Jane would talk about it, too, in her garble, and I also got some of it out of the shrink who followed Judd Marmor.

From "Petition for the Appointment of Guardian of
the Person and Guardian of the Estate and for
Order of Support," Superior Court of California,
June 18, 1954:

Grace Garland represents as follows:

Jane Mary Garland is incompetent by reason of the fact that
she is presently suffering from a schizophrenic reaction–mixed
type, and is unable, unassisted, properly to manage and take
care of her property or herself, and by reason thereof is likely to
be deceived and imposed upon by artful and designing persons,
and that it is necessary that a guardian of her person and estate
be appointed.

ED MOSES: I know there was a lot of bad feeling and a lot of shit going
on but I never paid much attention. You'd think now looking back,
Why didn't you pay more attention, Ed? I just didn't want to think
about it, I guess. Oh, those things were so horrific when they hap-
pened, and here was Jane totally short-circuited after that. That's when
she was brought into the hospital at UCLA. She never could get back
to herself—not while I was there. The mother hated this woman. Ac-
cording to her, Jane was fine before. But she would have said that be-
cause she wouldn't admit to anything that might indicate some kind of
underlying disturbance. She blamed it all on this other woman—she
thought that this woman had driven Jane nuts. We all have a potential
to snap, we just have to give it enough juice. It's about overload, and
different people have different overload sequences. Who knows?
Maybe Jane was a regular kid once.

DEBORAH JOWITT: I'll tell you a story. Beginning midway through my
third-grade year at school, I boarded five days a week at Marymount in

Los Angeles. Our dorm had just two adjoining rooms separated by a shared bathroom. The rooms were on the second floor and had very pretty, big French-door-type windows that looked out on the lawn. The rooms were simple, with two single beds with iron headboards. Each bed had a chair beside it, and at night you put your underpants on the chair beside your bed, and you put your dirty socks over them in the form of a cross.

I shared my room with a little girl my age named Leilani Owens, the daughter of Harry Owens, the bandleader. He wrote a popular song, a sort of pseudo-Hawaiian tune, "Sweet Leilani, Heavenly Flower." She was kind of a chubby, confident little girl. And I didn't care too much for her. In the other bedroom were two slightly older girls. One was a girl called Myra, and the other was Jane Garland.

The nuns used to bathe us together, the two roommates. You would be let into your little bathroom and told to sit down together in a tub of hot or warm water. Madame Brenda, who seemed to be on night duty, would come around and scrub you with a little scrub brush, quite roughly. She was small and ferret-like, with a red face, sharp little features, and black snapping eyes. And she had a thin but prominent nose. She was not unkind, but she scrubbed us hard. I don't remember how often we bathed, but it certainly wasn't every day. I do remember very clearly that we did not have individual baths. I don't know if Jane and Myra, being older, were bathed together.

The nuns were kind and wore an amazing habit. They dressed in a hood that covered their heads snugly, and over that a white, stiff, peaked triangular thing that fastened under their chin. And over that, a black veil that didn't cover their faces but came just under their chins. Their dresses were black with white collars. They were like blackbirds fluttering and swooping about, always hurrying and rushing, their skirts flowing behind, while the lightweight black veils, almost like a chiffon, flared out behind them.

Jane was larger than I was and quite developed, meaning she had

Jane Garland.

breasts, sort of, and was slightly chubby. She had a round face and very dark, reddish hair. And her skin was reddish and mottled, as if she had rosacea. It wasn't like acne, but her skin looked kind of coarse. Her features were very pretty, with a little mouth and big eyes. I didn't know her well, but I don't remember her as a person who had problems.

My mother would pick me up Friday afternoon, and I would go home for the weekend and come back Sunday evening. I remember one weekend, I was bored at home and asked to be taken back to school early. And the few other boarders, including Jane, were playing in an olive grove. I have a feeling that she did not go home on weekends. I never saw anybody come for her.

I remember her because of a very humiliating weird thing that hap-

pened to me but that didn't seem to discompose Jane at all. Our rooms were mirror images of each other, with the bathroom in between. I often had to get up in the night to use the bathroom, and it was, of course, very dark. One morning when I woke up, to my utter shock and horror, I was in bed with Jane. I had evidently turned the wrong way going out of the bathroom and gone to the bed that would have been mine, the left-hand bed. Jane seemed slightly amused about it, a little taken aback but quite friendly. She didn't say anything; she looked at me, kind of sleepy and bemused, like, "What's going on?" And I was like, "My god, what am I doing here? I'd better go back to my own bed." I got up quickly and went back to my room. The nuns found out about it and called my mother—whether they were asking if I was prone to sleepwalking or had lesbian tendencies, I don't know. As far as I know, Jane was completely unfazed by it. She seemed normal. Not overly exuberant, not overly friendly, but doing all the things we did.

LYLA HOYT: My husband, Warren, who shared the same mother with Jane—Grace Garland had him when she was only nineteen years old—always said that Jane's life was fairly normal until she fell into company with a cultlike group. She began drug use to some degree, with—or was given drugs by—several people who were questionable at the stable where her horse was kept.

I don't know quite how to identify them. They were several women who were very well schooled in how to develop guilt in teenage girls. I prefer not to say anything more about them. We always felt they used hallucinogenic drugs. And then during the time that she was under the influence of those drugs, they performed personal acts on her that left her with tremendous guilt. They used her because she had a sizable allowance from the bank, about $800 or $900 per month—approximately $6,500 to $7,500 today—before her trust funds came due. She had a new car then and a great deal of money for that period. After they had destroyed what semblance of hope she had of ever being

a normal person, they left her on the steps at St. John's hospital in Santa Monica. Destroyed her ego. Her person. I don't know how else to describe it. I think it was physical and I think it was sexual. That's who they were. Grace and Warren, Jane's mother and her brother, were denied access to her the entire time she was with these women. And when Grace and Warren finally did discover Jane's whereabouts, it was as I said. These women had left her totally incoherent, and I guess almost in a total kind of catatonic shock. As soon as she was twenty-one, they attempted to get hold of several hundred thousand dollars of her funds. They just lived a very high life until they could find their next victim.

When my husband approached the sheriff in Malibu, he was told that it would be very difficult to get anyone to testify against these people because there were other girls that were kind of in on parts of it, and the families didn't want their daughters implicated.

Grace Garland was from Cleveland. She lived next door or in the same neighborhood as the Hoyt family and grew up with Warren Hoyt, Sr., who became her first husband. Grace and Warren were married possibly for nineteen or twenty years; nothing is very clear. He was not well off, but he was knowledgeable in wood preservation. He went to mines all over and estimated what kind of timber should be used to truss them up. He lived a comfortable life, but he did not have money per se.

Suddenly Grace's mother passed away, and she was so stricken with grief she wasn't able to take care of herself and her son, named Warren after his father. Grace's sister, Jane, was married and living in Los Angeles at the time, and so she came and just picked up the two of them and moved them to an apartment in the Los Angeles area. Grace's husband followed later. And she healed there, got better, and met Bill Garland, I don't know how or when. Now, there was some confusion about exactly when she divorced Warren Hoyt and married Bill Garland. Nobody knows for sure why she went ahead and married again

before her divorce came through, but I think it was really because my father-in-law wasn't ready to give up his wife and son. He just didn't want to give her up.

Once Bill Garland discovered that Grace wasn't divorced from Warren Hoyt, he went to court to annul their marriage. At that point she divorced Hoyt, clearing the way for them—Garland and Grace—to remarry hardly a month later. Then in 1933 they built that house in Malibu. They took a great deal of pride in the way it was built, because it was one of those houses with a foundation of deep-sunk pilings, capable of handling any kind of storm activity from the ocean.

ALZOA GARLAND OTTO: My parents, William Joseph Garland and Alzoa Garland, his first wife, divorced when I was about ten years old, maybe a little younger, and it was very hard on me because I loved my father. He was adorable—but he had a temper. With my parents, it was a big fight all the time. They were married about ten years, and my mother tormented him. And my father was physically abusive. Once, he kicked her with his golf shoes on. I think that's very unfair when you do that with your golf shoes. That's just one incident. They were always in combat. I don't know what caused it. There were some couples that do that.

I thought it was a brilliant idea for my father to build that house in Malibu. It was a good place for a man to move to. I think he started building it while my parents were getting their divorce since he needed a place to live. Our nurse took us down there a few times and we swam in the ocean. The house was on the water. It had a big light on the top that told his friends where the house was, a light that they used for ships.

After the divorce, I didn't see him much growing up. Our chauffeur took us, my little brother and myself, over to his house a couple of times to see him, and he came to school once to see me, and that's

about the only time I saw him. He had another life and my mother had another life.

It was quite a scandal when Grace married my father, William Garland. I heard the gossip children listened to. I heard that he let her ex-husband live in an apartment downstairs while Daddy and she lived in an apartment above. I saw her one time. I was just a little child, ten years old, I think it was at the beach. She put her arms around him and kissed him, and I thought, Oh, you phony.

LYLA HOYT: Bill Garland died in 1940, when he was only forty-eight or forty-nine years old, from a kidney infection that led to uremic poisoning. This was before penicillin. He was wonderful to Grace. He was generous and they were very active socially and politically. Her life with Bill was something that we all would have liked to have lived.

ALZOA GARLAND OTTO: Women have to take care of their husbands. I felt that maybe that's why my father died so young. We were in Hawaii when it happened. I was about fifteen when we heard about it. I felt really bad, but you know, young kids when they haven't seen their father for years, they don't really have a connection. My mother just told us, "Your father died."

ED MOSES: Jane's mother was a hideous woman. Tough and opportunistic. She was very mercenary. She didn't have any values of any sort, or any intelligent stuff going on, just all the conservative clichés about minorities and the good old days. One of her heroes was General MacArthur, and she kept a framed photograph of him on the piano in the living room. William Garland had left all kinds of property to her and to Jane, including some huge ranch in Thousand Oaks somewhere; it was beautiful acreage. Apparently, he was originally in railroads and then diversified into real estate. I think he was in lumber, too. No refer-

ence was ever made to him. It was as if he hadn't existed, as if Jane was some kind of oblique incarnation of madness laid on this family.

LYLA HOYT: The movie director Gregory La Cava lived a few doors down the beach from the Garlands. I don't think it was a terribly long period of time after Bill Garland's death, maybe only about five months, when Grace married Greg and he moved into her home. La Cava, according to my husband, could have charmed any woman to do anything. Grace didn't even know she was breathing when she was with him—he had such an ability to hypnotize people around him to do whatever he wanted them to do.

Greg would have liked Grace to be an extra in a few of his movies, but I don't think he ever got her there. Jane was in one of his last movies, *Lady in a Jam.* She was about nine years old then.

Lady in a Jam: A SCREENPLAY BY EUGENE THACKREY,
FRANK COCKRELL, AND OTHO LOVERING;
PRODUCED AND DIRECTED BY GREGORY LA CAVA;
PRESENTED BY UNIVERSAL PICTURES.

Jane Palmer . . . Irene Dunne
Dr. Enright . . . Patric Knowles
Stanley . . . Ralph Bellamy
Mr. Billingsley . . . Eugene Pallette
Dr. Brewster . . . Samuel S. Hinds
Cactus Kate . . . Queenie Vassar
Strawberry . . . Jane Garland
Ground-Hog . . . Edward McWade
Faro Bill . . . Robert Homans

LYLA HOYT: W. C. Fields was one of Greg La Cava's buddies—they had made *So's Your Old Man* and *Running Wild* together. Fields came

to Grace Garland's house in Malibu fairly often, and my husband told me about having to take care of him. When he was ill, he was brought from his home in Hollywood to stay with Grace and Greg for several days. And according to my husband, he brought along a huge brandy snifter, because his doctors had told him he could only have one drink a day. We kept several letters from W. C. Fields that he wrote to Grace. In one of them he asked her, "Why did you marry that crazy dago?" or words to that effect. They didn't last long.

FROM THE PROPERTY SETTLEMENT AGREEMENT
BETWEEN GREGORY LA CAVA AND GRACE GARLAND,
DATED MAY 2, 1944: EXHIBIT A, "A PARTIAL LIST OF THE
SAID PERSONAL EFFECTS AND PERSONAL PROPERTY"
GRANTED TO LA CAVA:

Tools, saws, etc.
Wheelbarrow
Pool table, cues, balls, etc. (rack in closet)
Movie camera, projector and screen
Floodlight
Oil painting in living room (gift from Queenie Vassar)
Ping pong table (gift from Bill Fields)
Barbecue motor and equipment for barbecue
Miscellaneous clothing and personal effects
Suitcase
Cases of wine and various bottles of liquor
Deep freezer
Portable recording machine (gift)
Bone handled set from Lombard
Games (gifts of dominos, etc., from actors)
Punching bag and gloves
Bicycle (Ginger Rogers)

Silverware set (monogrammed)
Gold dishes (from Fields)
Keys to box, and other keys
Barbecue table, benches and cabinet
Colt automatic and ammunition (miscellaneous)
Electrolux vacuum cleaner
1 Coldspot (from bar)
Weighing Scales
Writing desk
Electric Roaster
Electric Bean pot

ED MOSES: After Grace Garland's divorce from Gregory La Cava, she married this guy Curly Lambeau, who was a football coach from some-place in Wisconsin. I saw a picture of him at the Malibu house—wide shoulders, a big guy probably. Looked like a real bullshitter.

As soon as they got together, they started pissing away as much of Jane's money as they could. By the time I was around I would say the mother looked like a typical sixty-five-year-old woman with dyed red hair and a face that had started to disintegrate, like all of us do. She kept herself relatively trim, but she had a tummy. She had one short leg, I don't know what it was from, but she had a limp. She might have fallen on her hip. Curly may have busted the leg in five places! When they split up there was a divorce settlement and he absconded with a good wad of property. I don't know how he did it but she was crazy for him, and he was a big tough son of a bitch. I think Curly got half the money and he hooked on to all the land he could get his hands on— whatever it was that she had. He took her to the cleaners.

LYLA HOYT: What's the story about Curly? The first time Grace met him was at the Roosevelt Hotel in Hollywood. She kept a room there

all the time, for when she was in town. If she were shopping or out for the night or something, she stayed there. She met him there, is my understanding, and he, too, had a way with women. After they married, Curly moved out to the Malibu house. But having one beautiful charming wife wasn't enough. Like the sailors, he had a lady in every place that the Green Bay Packers played football, which was something that Grace could not possibly tolerate. I think that was when Grace had to give up a lot of her money, in their divorce settlement. They had bought a great deal of undeveloped land together. Do you know where Lake Sherwood is out in Thousand Oaks? That will give you an indication of how he could persuade her to do things. He talked her into starting a chicken ranch out there. Yeah! For the sale of eggs! When they divorced, they divided that ranch in half, and his half was the one that was on the lakefront, with the buildings. I'm sure that it was profitable.

ED MOSES: There was still plenty of money left, but it had been mismanaged. Most of it was tied up in trusts, and that was the money the psychiatrists and all those people were tapping into. Now Grace Garland was real-estate poor—she had all this real estate, but not a lot of cash. She was like the overseer, but she couldn't get any bread out except for Jane's care and minimal housekeeping. There was enough to pay me and Walter, and she still had a little money to maintain the house in a minimal state. And she did have limited ability through the bank to get hold of a specific amount of funds that she might need for Jane's care. She couldn't go out anymore and buy fur coats and do all the shit she wanted to do with her friends. I think that was the problem: only Jane's money was left; Grace Garland was mad as a wet hen because there was all that gold out there and she couldn't get her mitts on it.

WALTER HOPPS: The mother always treated Jane in a kind of saccharine and ultimately condescending way. She just didn't understand

her daughter. Even if she was nuts, Jane was obviously smarter, poor thing, and that made it tough for both parties. I think Moses got it right: there were trusts in place to take care of the daughter, and the mother's hanging on for dear life. God, she just looked physically vulnerable all the time. She was a small, thin woman, and there was just a lot less physically to her than there was to Jane. She was a pretty woman who was under a lot of strain and kind of losing her looks but trying hard to hold on. In her prime, she might have looked like a starlet version of Gene Tierney. She looked scared. Thin and attractive and trying to hold it all together, and that was part of the sadness. She had essentially retreated to her room and was just hanging on.

ED MOSES: Jane hated her mother. She didn't trust her and would treat her badly, say bad things, and not pay any attention to her. She'd just walk away from her. When Jane got weird and said, "I'd like to kill her," the mother would get scared and run away from the house. I think Jane didn't really want to kill her. She was just mad enough to say it, not do it.

One day, the mother set it up for us to see the horses out at the Garlands' ranch. Jane got some carrots and she was feeding them to the horses. Then she stuck a carrot right up in the mouth of this one horse, Sweet Marie. The horse is chomping down on it and out of the blue Jane says, "Hey, that's not a carrot." Just casually like that, and nothing more. Finally she let out this yell—the horse had got ahold of her thumb and had bitten it all the way down to the core. She tried to pull out her hand, but not too hard, and then I yelled out and socked the horse alongside her head and she let go. She thought her thumb was a carrot and she was trying to snap that fucking carrot in half. I don't know shit about horses, I'm scared of them, but I whacked this horse on the side of her head the way I saw Gregory Peck do in *Duel in the Sun* with Jennifer Jones. That was a wild movie, a great movie. Anyway I got that fucker outta there and it was just sort of hanging by

a few threads. Her thumb was all torn up. The horse made these big indentations that broke the skin right down and it bled like crazy. I mean, oh my god.

Jane came to at that kind of funny moment, which is interesting— "That's not a carrot." I wrapped handkerchiefs around it and took her back to the hospital at UCLA. She's lucky she didn't lose her thumb. Her response to this horrendous thing that had happened was minimal. There wasn't a sound out of her the whole time. Nothing.

About the time of this incident, she started grabbing me on the inside of my thigh and I'd say, "Holy shit. What am I going to do now? Can't we just be friends?" No. She was a nut. She was obsessed and she was following me around and doing stuff all the time—playing with herself while we were riding in the car. She had sexual fantasies, was always hinting around, and she'd take your hand while you were driving and put it on her leg and take her knees and go back and forth. But it was not spastic, but, you know, driven. Askew. She was definitely askew.

WALTER HOPPS: When somebody dropped out, they'd try out a new person with her. One poor guy came out to the house and he was just a little too sure of himself. You know what I mean? Just a little too tight, and she could pick that up in an instant. All of a sudden she said, "The rats! The rats! The rats are coming! They're gonna get us!" She jumped up on the piano bench in her goddamned high-heeled shoes, went right up on top of the closed baby grand and pulled up her skirt and sort of danced around saying, "The rats! The rats!" So this poor slob jumped up and said, "I'll get 'em! I'll get 'em! I'll drive 'em away!" Jane suddenly stopped and said something like, "You fuckhead! There are no rats!" The guy just froze, and I thought, He's finished. You can't play into their games. When she had some crazy notion like, "We mustn't sit too close to those windows. The waves will get us," or something, you'd have to say, "They won't get us, Jane. The waves are gonna

stay out there where they are." You don't play into people's games like that or even their hallucinations. You reassure them. The whole point is that you're supposed to represent reality the best you can. So this guy was reported and we never saw him again. I think, sad to say, I was the one who reported him, because Jane just wasn't gonna relate to this guy. I reported to Jane's regular doctor. Judd Marmor was in the background overseeing the whole case.

I liked Jane. I actually cared about her. I think the relationship I had with her was like a cousin or something. The person she fell for was Ed Moses. He's what used to be called a dog. Ed was a good-looking guy in a curious kind of way. He looked like a devil; he always had a devilish smile. His hair wasn't gray then, he had dark, blackish, wavy hair. He had a way of putting his lower lip out at times. Ed used to be a real sporty dresser—most of us Southern Californian guys were.

ED MOSES: Jane sort of fixated on me, but I'm sure she fixated on Walter, too, because that was what she needed. There was a real heavy physical thing about her that always absolutely terrified me.

And then Judd Marmor dropped out of the picture. He suddenly realized it was a little too sticky. Marmor said, "I'm going to give somebody else this case. I'm overbooked right now and I can't really give it the kind of attention that it needs and besides she's a schizophrenic and they're very difficult." Judd couldn't deal with her. He would talk to her and there was no connection made. He was this rationalist who really didn't know how to deal with an insane person. Sometimes I would go to his sessions with her. There would be some trauma and he'd say to come over and we'd talk about it. I'd stand on the side and he would talk down to Jane, like she was a little child. She hated him—oh yes, she really didn't like him at all. I think Judd tried very hard but he wasn't the psychiatrist for her situation. I think he realized that and dropped out. My psychologist, Milton Wexler, knew how to deal with schizophrenics because he wasn't afraid of them. Wexler al-

ways said that they were the most difficult people to work with, but he had a certain kind of compassion for them so he did better than most. Milton said he couldn't work with somebody unless he really liked them. I think he would have done better with Jane.

Later on in the seventies I would see Marmor around. Once I said, "Judd, don't you remember me?" He said, "I do, but I'd rather not discuss it." I tried to talk to him about Jane but he wouldn't participate, he said he never talked about his patients. He let me know that it wasn't cricket for me to be asking, and he gave me the sly. I said, "Hey! Don't give me the sly, let's talk about it." I said, "It's long, long overdue, what the fuck do you care? Do you care about your reputation at this point in your life?" Uh-uh, he didn't want to be cornered. He said it was a very painful and tragic situation, and it was very difficult for him because there was nothing that could be really done.

I didn't think Jane was gonna last. I always thought she would either kill herself or set up a situation where she would be killed. She was miserable—miserable—but she still had some will to live. You were dealing with your own disturbed demons along with this person's. Like, "Are we just going to jump off this precipice together in fucking midair?"

The day finally came when I decided. No more. I can't do this, this is getting too fucking scary for me. I was on the brink several times of hoisting her skirt up and fucking the bejesus out of her. You can't tamper in that territory—you can create an explosion that you can't cope with. This was not the way it was supposed to be, you're the male nurse in a sense, and you don't fuck the nurse-ee. But at the same time, the doctor would say, "Whatever you do is okay." Not Judd Marmor, but the other guy he'd recommended to take his place. Judd kept it fairly strict and straight up, but this doctor was a sleazeball. He was absolutely willing to play ball. I think that doctor was just bought, because he would say shit to me and I'd want to say, "Come on, pal, I don't know that much about it but I know that's full of shit." But I never said

anything. He was in his fifties or late forties, I would say, slightly over-weight, puffy-faced, with a mustache and a syrupy manner. Slightly unctuous. I told him this was getting too heavy for me, and that's when he approached me about marrying Jane. He said, "It would be very lucrative for you, and your children would be taken care of for the rest of their lives." Our children? You go, "What?!" He says you'll be taken care of handsomely, you just have to marry this mad girl and every-thing will be hunky-dory. Mrs. Garland was there, too—the three of us in his office in Westwood somewhere. She didn't say anything that I remember, but she was all for it. I guess she thought that she could make some sort of alliance with me. I said, "Well, you know, that's a very interesting suggestion and I doubt if I could do it, but let me think about it." Of course I wasn't about to do it, but I was just trying to get off the hook with my life. I never talked with Walter about this, that I remember. I don't think they approached him with the same offer. Those people were scary. When millions of dollars are involved, peo-ple do weird things. They wanted to keep her out of the hospital be-cause she was so unhappy there, and they worried that if she went too far over the edge there would be no way to extract any money out of this situation. They were trying desperately to find a way to do it, but with somebody who was going to play ball with them.

We were all being invited out to spend the weekends. The idea was that one of these dumb little guys would get her pregnant. I don't know for sure, but I had that suspicion because of all the things that were offered. The mother would go to bed early and leave you with Jane, and she would start doing weird things. She kept getting weirder all the time. I was nervous. I knew I was gonna get fucked somewhere but I didn't know which orifice was gonna be penetrated, psychic or other-wise! And being the cheap moralist that I am, I just—well, it's not that I'm righteous or anything like that, it's just that I'm uncomfortable. Some things are just not my shtick. I like vanilla ice cream. But it was a good part-time job, it paid three times more than anything else I

might have found. I became dependent on it in a way. It was a fun adventure, but it got too heavy. It became one of those things that go bump in the night.

On what would be my last day, Jane was standing at the head of the stairs that go down to the living room. It was about three flights down. She was wearing a little cotton dress, standing with her hands behind her back. Her feet were spread apart, she was going up and down, rocking from one foot to the other. With a sort of smile on her face, she looks at me and says, "There's a rat in the refrigerator." I look down and dripping between her feet are drops of blood. Drop, drop, drop, drop—making a little pool there, and of course I started thinking the worst: Holy shit. She's jammed something up in her vagina, never dreaming what it actually was. She couldn't just be having her period, because she'd said there were rats in the refrigerator, right? She has both of her hands behind her back and I say, "What's in your hand, Jane?" She puts out her left hand and then puts it back again. So I said, "Let's see your other hand." She puts the same hand out again. "Let's see what's in your other hand, Jane." She smiled and she stuck it out. She had an ice pick pitted right down through the center of her wrist, straight through to the other side.

WALTER HOPPS: I don't know how Ed did it, but he had broken his arm. Jane noticed everything about him, and, despite our efforts to keep any dangerous objects away from her, she had somehow stashed an ice pick and apparently stabbed herself in the wrist, I guess it was with this ice pick. What a mess. They found her that way and had to take her to the hospital and fix her up. She ended up with a bandaged arm, she had a sling that looked just like Ed's arm.

ED MOSES: I thought I was on the verge of something when she stabbed the ice pick into herself. You know, maybe I was becoming an extension of her—I guess the potential was there for her to do some-

thing terrible. We got the doctor and then I retired. I had been involved with this for something like eight months or more. Everything felt real uncomfortable; I thought that I was going to be killed. Someone interviewed me once and said, "You don't look like you're afraid of anything." I said, "Well, you're wrong and you're right. I'm not afraid of anything, I'm terrified of everything." So terror was my constant companion. And Jane activated that terror because I used to have dreams as a kid—primarily my mother was always trying to strangle or kill me. In real life she would get me down and strangle me and beat the hell out of me and all that kind of stuff. We all have those stories.

Every Christmas, my mother made a big deal out of the tree. It was full of icicles coming down and the lights had to be just so. They looked beautiful. She would do a great thing in cotton underneath the base of the tree. She made a big deal picking out the tree, and she'd argue with the tree guys and try to get them down. She'd talk baby talk when she wanted things. I was so embarrassed when she was talking baby talk, trying to negotiate the price down with them, and she'd get mad when they wouldn't negotiate.

One Christmas when I was about eight years old, I was up on this little foot ladder putting the star at the top of the tree. I was leaning out over the very top and slipped. "Don't get up, don't do that, you boob," she said, I remember. "You're gonna fall on the tree." "No, I'm not, I can do this." "You can't get up there." So, I went up there and I slipped and fell right on top of it. She'd keep the Christmas balls year after year packed in boxes, and when I fell, everything was popping and cracking and lights were shorting out. Like lightning was going through the house. It was one of those moments. My mother totally went berserk. She cried and yelled and carried on and said the reason she did this tree every year was for me, to make me happy, and here I spoiled the whole thing. "You spoiled the whole Christmas," she said. I tried to help her pick it up and she took whacks at me. It was a total disaster.

I've noticed that people get very depressed at Christmas, all my

friends and everybody I know. They find it rather grim. I asked the shrink Milton Wexler, "What is your take on that?" He said it was because people have expectations about family, gifts, toys, about families getting together and everybody loving each other. And he said it's full of disappointments, with people arguing amongst themselves and then the gifts you get are not what you want—which is not really the point since what you really want is love and some kind of attention. But when that gets replaced with gifts, you feel unfulfilled. I know when I opened my gifts as a kid, I acted with enthusiasm, though actually I wasn't enthused. I knew what everything was, because I'd shaken all the boxes and figured out what was in them, so I'd have to fake surprise for the gifts: a knife, a top, a yo-yo. I got a bicycle once. And skates. You know, things like that. No teddy bears, no games, no books. I never received books as a kid. Never read books.

My mother's life never materialized, so she had to blame somebody, and I was the thorn in her side. The only way she could get alimony from my father was to let me live with her. All these guys would come by while I was growing up—they didn't want some woman with a little rat kid. I could have been a hermaphrodite. It was a fear when I was young because I developed so slowly that I didn't get a beard until I was twenty or twenty-one. I wanted to be a truck driver. I was a mean little bastard, but I was always instigating other people to do the fighting.

Anyway, there was something very ominous about Jane's situation that totally terrified me. I couldn't take it. But to Walter that was like fodder. He thought this incident was interesting. I think he continued on after I quit. There was also another guy for a while that they were really working on to marry her. He about freaked out when Jane set part of the house on fire.

WALTER HOPPS: By then I guess I had been working at the Garland house just inside a year. Christmas was a big thing for Mrs. Garland.

She got a Christmas tree and it was all decked out and she gave those of us who worked there little presents. I don't know, a necktie, god knows what. What she got for Jane turned out to be fancy lingerie and clothes that couldn't possibly fit her. She got stuff for the sort of person she hoped her daughter would be. Oh, it was just so perverse. It turned into a nightmare. Anyway, Jane, like a little girl, gets up early on Christmas morning, around six A.M., and goes down and rips open her presents. You always slept kind of lightly there and I just had a funny feeling, or heard something, you know, and I went down to see what was going on. It was just hell from then on out, just crazy. Jane was in one of her voluminous white nightgowns that flowed to the floor, and I can see she's obviously been weeping. She's managed somehow to set the Christmas tree on fire and smoke is filling up the house. I got her out onto this patio, it was the closest place I could get her outside. There was a fireplace out there and there were some cut logs, which I'd never seen used. Another guy was there, too, and we saw smoke piling up on the second floor where there were these stained-glass windows. He started trying to throw these little fireplace logs up there to break the windows and let the smoke out, and then one of the damn logs bounced off this window and came down and cut open his arm, so he's wounded now, right? Jane's in the worst shape we've ever seen her, she's screaming and out of it. It was such a holocaust that morning, I'll tell you. Mrs. Garland was trapped in her room, terrified. She got out, but she was just crazed and stunned. It was a nightmare. I called the fire department and I called Jane's doctor and he said, "Get her on into the hospital."

The fire engine, the police all arrived at the same time. I helped Jane into the back of a police car. She was absolutely quiet and I held her in my arms as tightly as I could and the two of us rode off to Cedars-Sinai Hospital together. Later I took a taxi back to Malibu to pick up my car and drove home to the Sawtelle area of L.A. I climbed into bed fully dressed—shoes and socks, trousers, jacket—and pulled the covers

over my head, just like a mummy. I was absolutely drained. I'll never forget that day.

The last I ever saw of Jane was when I turned her over to the doctors at the hospital. Never heard anything more except that she'd had to go back into the psychiatric ward at UCLA Hospital. I don't know what happened to the mother. I don't know what happened to any of them.

ED MOSES: I have no idea what happened to Jane. But one day about ten or fifteen years after I'd quit I thought I saw her walking through the Third Street mall in Santa Monica. I swear to god there she was wearing the same pair of red boots I'd gotten her umpteen years earlier. She didn't look whacked out, but she didn't look right. I think she was with some guy. I thought it was her—maybe I wanted it to be her. I did a double take—she had those little boots on but she was walking regularly. She wasn't doing the Jane Garland shuffle. She seemed functional in terms of getting from one side of the street to the other. I don't recall if she was talking. She just walked by and I was going in the opposite direction and I turned to look and she kept walking. Her head was the same shape but her hair was longer and she was walking normally. But she couldn't have been normal if she still had those red boots on. I walked toward her and the person she was with to get a closer look but they dodged into a building. I thought, Well, I hope that's her, and I walked away. I was afraid—I didn't want to generate any associations, particularly if she was with some guy, I didn't want her to feel disturbed. I think it was her—there was a presence. You know how you get a presence about a particular person, even if he's in disguise? I always wanted to have a gallery opening where everyone would wear paper bags and eyeholes so you could never recognize anybody by their faces. If a person walks up, does he have a presence that you can identify? With a painting, the presence is not what it means or what it looks like or what color it is or anything like that. The presence exists somewhere between the object in the painting and the

person viewing it, and there's a kind of energy field that goes back and forth. Some people pick it up and some people don't. You see a Rembrandt and it just resonates, you know? It vibrates with that kind of energy. I felt Jane's presence that day in Santa Monica, let's put it that way. I thought it was her.

One of the most interesting things Carlos Castaneda wrote about in his books was ghosts. He said that certain people have bodies, bodies that walk around, but they're not real people. And there was something about Jane like that. When my mother died, there was that point when there was a shift and the body continued but the person I knew was no longer there. She was sort of more and more a little child, but this child had lost its spirit. The person I saw walking through the mall had that same quality. There was just a little tinge of the memory of that former person.

IV

JENNIFER JONES

1400 Tower Grove Road, Beverly Hills

22400 Pacific Coast Highway, Malibu

22368 Pacific Coast Highway, Malibu

BOB WALKER: I have really lovely memories of my life as a child. In spite of all that went on, I cannot see how it could've been any better. That's me. I know that I am the sum of everything that's happened over the years, but I don't dwell on any of that. I feel very blessed. I don't think about my past very much, and I don't even think of myself that much, except in the feeling of being something planted and rooted in the earth, and in heaven.

I wish my brother, Michael, were here for you to meet. He was quite an interesting character. He carried enough darkness for the two of us. All through life he carried the dark stuff about Mom, and the only things I'm carrying now about Mom are the beautiful moments of her that I remember. Michael and our half sister, Mary Jennifer, probably had more troubles than I did—their ways of processing troubles were different from mine. It's just the luck of the draw that I've been blessed with the ability to allow my troubles to dissolve. I don't carry them with me. Have you heard that story about the two monks? Two monks come to the river, and they've sworn the highest vow that they won't touch women, and they aren't even supposed to look their way or entertain any thoughts about women whatsoever. So they're absolutely chaste. But they come to a river and this young lady is trying to get across, and she's got a jug of water, or some kind of burden. Well, one of the monks notices her predicament and picks her up immediately in his arms and puts her on the other side. The other monk is absolutely aghast but finally struggles across the stream and catches up to the other monk, who by now is far along, and says, "Tom," or whatever, "what happened? You know that we've taken these vows never to touch, much less look at a woman and never to speak to one, and what

have you done?" And Tom says, "What are you talking about? I left her behind an hour ago—you're still carrying her. You're still thinking about her." Tom knew this person needed help, and he did it without a thought, and he didn't carry it with him. He kept going, and he was able to carry on with his life. I'm like Tom. So when something bad happens, I never carry it with me. Like water hitting an electric stove, it just instantly turns to steam. I carry blithely on. But as Ram Dass once said, you know, if you think you're enlightened, go spend a weekend with your parents.

One memory I go back to a lot is when I was living up Trancas Canyon in the seventies with Ellie, my wife in those days. We were living in the bushes, on a stream, stark naked, like savages. When I met Ellie in New York she was smoking one Salem after another, wearing furs and high heels, and popping Dexedrine. Boy, I had her living in the woods, eating rattlesnakes and wild rice. I got a tent, but Ellie and my youngest child, Charlie, used to just sleep in the bushes. I had a two-year-old, and an eight- and nine-year-old, David and Michelle. I would bathe the kids in the stream in the morning, then send them off to school looking like they'd been chauffeured in from the Malibu Colony.

I remember my mother, Jennifer Jones, and her third husband, Norton Simon, coming down to check out our campsite and see how we were living. I don't know how they got down there. It was an hour hike into the canyon on a very rough, almost impassable dirt road, washed out in most places, with fissures. You really needed a four-wheel drive to get down there. And then you had to walk up the creek to get to our campsite. So it took some doing, I must say. Norton was in his best clothes, and Mother had on her perfect little Halston dress, her Hermès scarf, and Gucci shoes. I will never forget this, Mother standing on one of those beautiful rocks, head and shoulders above all of us, sunlight golden on the hills, and the trees are whispering in the

wind. Mother looks down and she says to me, "So, Robert, how long will you be living up shit creek?" I said, "Mom, maybe forever. Maybe forever."

Mom had come a long way from Oklahoma. Her previous husband, David Selznick, changed her name to Jennifer Jones soon after he met her because her real name, Phylis Isley, was not gonna cut it. I think in those days Jennifer wasn't such a common name, so Jennifer was for the exotic woman of mystery and Jones was for the plain girl that grew up in Tulsa. Jennifer Jones. It's a pretty good name, actually. But her dad always called her Phylis. Once Mother started to travel in the upper echelons, she became a little embarrassed of her parents, because she thought they were a little common. They were from Tulsa, Oklahoma, for crying out loud. A Southern town then in the sense that it had one of the worst race wars in history soon after Mom was born. Grandpa and Grandma Isley had tent shows. They were folks, just folks. But she loved them.

Her dad, Phil, had a traveling circus at one point early on. He had vaudeville houses, but not exactly vaudeville—stripper shows, burlesque. Later on, her dad had movie theaters here and there and a film exchange in Dallas that bought and sold films to the theaters. He was a self-made man who became an independent theater owner and a promoter of sorts. Grandpa Isley was a hearty kind of fella. When he came out to L.A., he would motor here all the time in these big cars, Packards from the forties, Chryslers, or Cadillacs. But he didn't drive. Chester Hill was the Isleys' black chauffeur. He was an all-around guy from back in the early days, 1937 on. He wore a uniform, just a dark suit, and a chauffeur's cap. He was a big influence in my life. He taught me how to walk in 1941, and I spent most of my time with him. They say I used to shuffle like Chester. I loved Chester. He was one of my mentors. I always felt more at home with the help.

Mother dropped out of college and left Tulsa for New York, where

she met my dad, Robert Walker, a youngster from a Mormon family coming out of Ogden, Utah. But it wasn't a loving family, and he didn't get along with his mother. Later, I found an interview that he had given to Hedda Hopper in which he admitted to always feeling like an outcast. He was very scrawny as a child and felt ignored by his class-mates. One day he couldn't stand it anymore and he ran amok, not knowing why, and raced screaming through the playground, kicking the other children. He was only six, but the school expelled him. "From childhood," he told Hedda Hopper, "I found myself up against mental walls. The maladjustments of that age grew and branched out all over the place. I was always trying to make an escape from life." Dad began running away from school when he was ten. He must have been a handful, full of the devil. I only heard about it in later years.

As soon as he could, he moved to New York, where he met my mother at the American Academy of Dramatic Arts, and on their wed-ding day he was so rattled that he forgot to kiss the bride. They must have been eighteen or nineteen. Then they went to Hollywood and both looked for work. Later they moved back to New York, and Mother had me when she was twenty-one while they were living in Jamaica, Long Island. And eleven months later she had my brother, Michael.

I think they call it "Irish twins." By then, back in 1941, Mom and Dad lived in a little rat-infested apartment in Greenwich Village, with the kitchen sink as our bathtub, having no money at all. They couldn't make a dime. Dad's first job in New York was as a script reader. It was done through Grandpa Isley. Dad was very proud and probably would have been hurt if he'd known, so he was led to believe he earned this job on his own. And Grandpa was instrumental in helping Mother also. Since he was a theater owner, he knew lots of people and was al-ways behind the scenes trying to make things happen. He was quite influential. So Mom always had somebody there trying to help her. Dad carried her bags and did pretty much everything for her because

Mother was helpless out in the world. I don't think she ever learned how to boil water and turn on the stove. I'm not exaggerating. She had had plenty of help when she was growing up. Her father doted on her. She always made men feel they needed to take care of her.

While they were living in New York, my mother signed with the legendary producer David Selznick. We all moved back to California, straight from a tiny apartment in New York to Bel Air, to this beautiful little house up on Perugia Way, off Bellagio Road. The four of us lived there for a few years. Dad got a series of movies, war pictures and comedies. And then Mother tested for and landed her first starring role in *The Song of Bernadette*. It was a Fox picture, and David Selznick knew that the movie would launch her career, so he was willing to lend her to the studio. His instinct was on the mark because Mother won the Academy Award for Best Actress in 1944. By then she was in the midst of acting with Dad in David Selznick's movie *Since You Went Away*.

The first day of filming, she told my dad that the marriage was over. And the next day they had to do a love scene, to act as if they were newly in love. I guess the magic had gone out of their marriage, but they were able to pull it off. I believe it was the first love scene that either of them had done in a movie. I don't think she left Dad for David Selznick. I think she left him, and then Selznick was there. But soon enough, she and David Selznick had fallen in love, although as far as I know she wouldn't live with him until they were married, which didn't happen until 1949.

Recognizing talent—that was the one thing David had. And he had it to the nth degree. He would see someone, and he would know right away if they had it. He had all these other women that he could have fallen in love with, you know? Ingrid Bergman, Dorothy McGuire. But it was Jennifer. He had a sort of Pygmalion relationship with her. He was responsible for changing her name and for her getting *The*

Song of Bernadette, Duel in the Sun, Portrait of Jennie, and so many other movies. He orchestrated the whole thing.

<div align="center">

MEMO FROM DAVID O. SELZNICK
TO KATHARINE BROWN, AUGUST 19, 1941:

</div>

To: Miss Katharine Brown
cc: Mr. D. T. O'Shea

. . . Today I chatted about the matter [the film *Claudia*] with Phylis Walker—for whom, incidentally, I have a great enthusiasm, in case you don't already know this. . . . I have told Walker that I wouldn't want to give her a big opportunity, and make her a star at the expense of the insurance policy that we might have by giving these opportunities to established stars, only to find out that we had difficulty later about her family being back East. She assured me that such would not be the case, and that she is prepared to move out here, her husband is quite prepared to move with the two children and settle permanently because they like California in any case.

Incidentally, what is the husband like? I wish you would interview him. And I wish you and Dan would discuss by mail, with copies by me, whether or not we shouldn't sign the husband as a measure of protection, either now or at such time as we decide to give her *Claudia,* if this comes about. It might be better to do it now, if we could make a brief initial deal, so that it doesn't look as though we are buying him subsequently just because we are giving her *Claudia.* We ought to preserve his pride. But if he is a good actor—wouldn't it be wonderful if he turned out to be good himself?

Memo from David O. Selznick to Whitney Bolton,
director of advertising and publicity
for Selznick, September 10, 1941:

To: Mr. Bolton

I would like to get a new name for Phylis Walker. I had a talk
with her and she was not averse to a change. Normally I don't
think names very important, but I do think Phylis Walker a
particularly undistinguished name. . . . I don't want anything
too fancy, and I would like to get at least a first name that isn't
carried by a dozen other girls in Hollywood. I would appreci-
ate suggestions.

Memo from David O. Selznick to
Katharine Brown and Whitney Bolton:

To: Miss Brown, Mr. Bolton, January 8, 1942

Where the hell is that new name for Phylis Walker? Personally,
I would like to decide on Jennifer and get a one syllable name
that has some rhythm to it and that is easy to remember. I
think the best synthetic name in pictures that has been re-
cently created is Veronica Lake.

BOB WALKER: In her later years, Mother would say to my brother,
Michael, and to me, about our dad, "Why in heavens name did I ever
leave that fellow?" But David had the keys to the kingdom, one that
Dad wasn't privy to. Mother was new and fresh and looking for other
adventures, and to her Dad was probably limited. Neither Mom nor
Dad were very worldly. But Selznick lived and breathed Hollywood

glamour, and the kings and queens of Hollywood bowed at his feet. After *Gone with the Wind*, there wasn't anybody who had more power in Hollywood. And he discovered a lot of glamorous women — or women that he helped make glamorous, or helped convince the public that they were glamorous.

DANIEL SELZNICK: S. N. Behrman said that every relationship my father had was a Pygmalion relationship. It was that way with Ingrid Bergman and Joan Fontaine and Rhonda Fleming and all the others. All you have to do is look at our home movies and see the shy, trembling, stuttering creature that he married. Each year Jennifer got a little more confidence. Each year she realized she was really naturally beautiful. She began to wear different kinds of clothes. She began to do her hair differently. She began to wear different kinds of jewelry. Slowly, Galatea emerges. But that was not the girl that my father married.

I was on the set of *Duel in the Sun* for the scene outside the McCanles Ranch at night, filmed on the soundstage at my father's studio in Culver City, with all these wonderful lanterns hanging outside the façade of the house. *Duel in the Sun* represents a kind of apotheosis of David's fantasy of Jennifer. At one point during the filming, he had her go to some place outside of Tucson and crawl across sharp pebbles so that her knees got completely bloodied. In a hundred and ten degree heat. And she was prepared to do whatever was required.

But Jennifer and David's relationship was very turbulent. Will we ever know how may suicide threats she made? Because if she left suicide notes, they would have been burned by you know who. He was protecting his own ass, if you will excuse the expression. If she killed herself, the headlines would have said she left a suicide note blaming David O. Selznick. Imagine his fears that this woman, whose life he had transformed for better or for worse, might take her own life.

BOB WALKER: Mom and David moved into the house at 1400 Tower Grove Road when he married Mom in 1949. The house has since been torn down, they've put up a monstrosity. It was a Spanish Mediterranean house. It was spectacular, because it wasn't too crazy, just tastefully done. There was a beautiful view of the valley, with Elizabeth Taylor's house on Beverly Estates down below to the right. That's the house Montgomery Clift was leaving the night he had his terrible car accident. John Barrymore had owned the house right down below to the left, but there were no houses built behind us yet. Just this old fairy tale water tower, and that's why they called it Tower Grove Road. The tower was so old it looked like Rapunzel was going to appear there at any moment and let her hair down.

The trees in our garden were a hundred feet tall. John, the gardener, had planted every one of them on the property. Even though he would refer to himself as "just the old lamplighter," you'd never seen a more elegant man in a wifebeater in your life. And he smoked a wonderful pipe, and he was always barefoot in the garden, with his pants tied around his ankles. He had been the gardener back in John Gilbert's days, when Gilbert lived in the house with Greta Garbo. Gilbert must have been quite a guy, because Garbo was no slouch. Our gardener told me how John Gilbert used to stand at the windows naked, overlooking Hollywood, with his arms out like a crucifix, yelling out in a drunken rant, "Hollywood, you have crucified me." This was after talkies, and Gilbert's voice was so high-pitched that it shattered his image. He slept with a gun under his pillow, a .38. He was very paranoid; who knows what kind of drugs he was doing.

The room that Michael and I lived in was the kids' room initially but eventually it became Mom's room after they remodeled it. There was an opening in the bottom of the closet. You could open it up and just disappear through there. It was kind of a secret passageway, and I was told that it had been an entrance or exit for Greta Garbo. It went into the cliff, then out and behind the house. It was a cave passageway

that was tunneled out to the road. That was where she apparently crawled through, back in the thirties, when she was having a romance with Gilbert and wanted to be more clandestine. They had paparazzi even in those days.

Our nanny moved with us to Tower Grove. Before us, she had worked for Leland Hayward and Margaret Sullavan. She had been Brooke, Bridget, and Bill Hayward's nanny. She was the biggest influence in my life. Her name was Emily Buck and she was from Nova Scotia. She first came to us in 1948 in a lumberjack shirt and Levi's like she had a gun on each hip. I thought she was great-looking. She was kinda rugged, not pretty in the ordinary sense. We were young monsters a lot of the time, my brother and I, but she could handle us, I'm telling you. She would put us both on the floor and sit on us: "You gonna behave?" She was blunt, frank, although she also had some diplomacy. She was just a straight shooter, straight, honest as the day is long. And kind, kind, kind. She was a happy woman. She loved to settle down with a cup of coffee in one hand and a Chesterfield in the other.

DANIEL SELZNICK: Emily Buck wasn't afraid to tell David Selznick or anybody else about what she thought was suitable for the children. She wore wire-rimmed glasses and had a lot of wrinkles in her face, and kind of short bobbed hair. Bobby and Michael adored her, my father adored her. She was completely dependable, and she was a voice of common sense in my stepmother's life. Whenever Jennifer had some kind of crazy idea of what to do with her children, Emily would say, "Mrs. Selznick, that's not appropriate. That wouldn't be suitable. I can't let you do that." She just put her foot down. She was this voice of clarity.

BOB WALKER: But while Mother was enjoying her garden parties and burgeoning career, thanks to her new husband, Dad was an alcoholic

and he was getting into trouble. In 1948 MGM sent him to the Menninger Clinic in Topeka, Kansas. He met Milton Wexler there. Milton was a young up-and-coming analyst at the time. Later on, when he moved to Hollywood, he became Mother's analyst for thirty-five years. Anyway, Dad was reluctant to cooperate with anybody at the clinic, but Milton kept at it, and finally Dad started opening up to him. Unfortunately, the studio decided after only four and a half months of treatment, "Nope, we've got to have him back to do this movie." Of course it was premature. When he returned from the clinic, I remember his hands on the steering wheel were all scarred. "What's all that, Dad?" and he said, "Oh, I was just hustling with some of the other inmates at Menninger, and my hands went through the window." Well, years later I saw pictures of him in a police station, with his hair all messed up and his tie askew and he'd been restrained. Apparently he'd knocked out all the windows at the police station, but he came back stronger than ever. Hollywood's always admired its outlaws.

MGM still wanted him to be the fair-haired boy so they could continue casting him in lover boy parts as the romantic lead. They put him in *Song of Love* and *One Touch of Venus*, which Gregory La Cava directed. It wasn't until he played Burt Lancaster's evil brother in 1950, in *Vengeance Valley*, that he played a villain. And then he played Bruno in *Strangers on a Train*. After that, he played Helen Hayes's son in *My Son John* in 1951. At that point, the studio felt that Dad's reputation was on the line, and it didn't want the public to react negatively to him. In the movie, the son had obviously become a communist, and that was the worst thing you could be in those days, next to being a homosexual. Leo McCarey, the director, wanted the son to recant at the end. Dad didn't feel it was in character or true to the original story. I remember Dad being disturbed by it, coming home and having a drink—a highball. He always came home and had a highball. He took it all so seriously. It worried me a great deal. I used to play with this

game made from a box with handles on each side, and you would use the handles to manipulate a steel ball through a labyrinth that had numbered holes along the path. The point was to keep the ball from falling in the hole. Less than a year before Dad died, I started playing the game as if it would determine how long he would live. If the ball fell in the hole marked thirty, then Dad had thirty days left to live. And I would dream at night that he was lying in a white coffin, all dressed in white. I would wake up and go check to see if he was okay, squeeze his feet.

Apparently Dad was in bed one afternoon and wasn't feeling all that great. Dad's shrink, Benjamin Hacker, came to see if he could help him calm down. The shrink gave him an injection of something like sodium amytal. It was an accident. In those days, I don't think they were trained enough to know that you don't give a serious depressant to someone dead drunk. He died in 1951. He was thirty-two.

That was it. Michael and I were instantly thrown into a black hole, into negative gravity, and we were just gone. Nothing worse could have happened. Michael was devastated by Dad's death. He didn't weather things well. He had a lot of Dad's troubled side, overthinking everything, carrying it around with him. He was afraid of his own shadow, and yet he had a temper, too. Dad was very lovable, but he was all twisted up, just like Michael. Whatever problems Dad and Michael developed in their youths tormented them their entire lives. They couldn't overcome whatever it was. They just got trapped in the vortex.

It's so bizarre that my father is buried in Utah between his parents, because he wouldn't have wanted that. I vaguely remember him saying he wanted to be cremated, but there wasn't anybody to stand up for him at the end. I was eleven years old and Michael and I weren't allowed to attend the funeral, if there was one. We were in a really vulnerable place, just an open wound really. After Dad died, Michael

and I were whisked away to Europe. Mom and David were doing the very best they could think to do with us, these two little hellions. My mother called me an angel with little red horns. I never felt abandoned, but I think my brother, Michael, had a more difficult time with it.

DANIEL SELZNICK: When Robert Walker died, the pressure grew because David suddenly had responsibility for the children of this woman that he'd fallen in love with. He did his best to keep the publicity down. He dealt with Dore Schary at MGM, who had once worked for him. Schary had just been appointed head of the studio after my grandfather Louis B. Mayer's reign. But to say that my father asserted himself to manage the public perception for the boys' sake is a cover to make him look good. I have no question about it. I'm not looking forward to seeing this in print, but it's the truth. Let's be honest with each other, it's horribly damning. He was so selfish, so needful to protect his own reputation.

LETTER FROM DAVID O. SELZNICK TO DORE SCHARY,
SEPTEMBER 1, 1951:

Dear Dore:

I am rushing this confidential letter to you by hand because it is urgent, because I hope (the MGM publicity department permitting!) we can get speedily and quietly out of town with the two Walker boys. . . . In every decision that has been made during these agonizing days, the welfare of the two boys has, of course, been the uppermost and dominating factor in the minds of everyone, including their mother, their grandparents

on both sides, their nurse, the doctors, and the psychiatrists. There has been meeting after meeting as to how to protect the children. I think the net result has been an extraordinarily good start toward their readjustment. But I am sorry to have to say that the biggest single factor that we have had to overcome has been the activity of the MGM Publicity Department, which I am sure has been well-meaning, but which certainly has portrayed a startling and depressing and even frightening ignorance of the most elementary knowledge of child psychology, and the most thoughtless attitude toward the welfare of these children. . . . We have had a terrible time for days now hiding every newspaper, both in my house and everywhere else the children went. Does this have to go on indefinitely while the MGM Publicity Department continues to feed out stories? Can't they, for heaven's sake, keep these children's names out of print? Can't they get busy on Esther Williams's cheesecake and leave this tragedy alone? I am sorry if I sound bitter, but I am bitter. I am after nothing for myself, and I'm trying to protect the two children.

We had decided to go very quietly to Europe. As I had obligations that made countless appointments in Venice, we were going to make this our first stop, especially since the children had been so eager to go to Venice for a long time, and it seemed an ideal way of distracting them, with gondolas and canals. . . . But there is no chance of our getting away on the plane without photographers, nor a chance of our landing in New York without them, nor of a chance of our landing in Rome, or any place else we go, without them — unless we completely change our itinerary and try desperately to keep our new plans a secret from MGM's Press Department. . . . Please, please Dore, give me your help on this, and immediately —

certainly not for my sake, since what I am doing is not for myself, but for the children and for Jennifer.

I know I can count upon you . . .

<div style="text-align: right">

Yours very sincerely,

David

</div>

BOB WALKER: While we were in Europe, Emily Buck sent a letter to Grandma and Grandpa Isley dated October 15, 1951, from the Hotel Lancaster in Paris.

Dear Mr. and Mrs. Isley,

Well, our jaunt over Europe is coming to a close. . . . It has been a wonderful trip, but going home is nice, too. We have really seen some wondrous sights, and it's been grand for the boys. It has taken their minds off their sorrow, and I think it was a very nice thing their mother did, taking them away from California and the surroundings that would remind them of their dad all the time. We talk about their dad a great deal. At first it was very hard on them when I mentioned his name, but now we laugh and talk about the things that happened at his house. . . . I'm sure when they get started in school and make new friends, their sorrow will lessen. Youth is so wonderful, they don't grieve like us adults. . . . Will tell you all about our trip when I see you in New York.

<div style="text-align: right">

Much love to you both,

as ever,

Em

</div>

BOB WALKER: When we came back from Italy, Mom ended up sending both Michael and me to Dad's shrink, Dr. Hacker, the man who

was responsible for Dad's death. I imagine she thought that he was the best person to counsel us since he was so intimately involved in the situation.

In the meantime, Mother and David were having weekend gatherings at the Chuck Walters house in Malibu, which they were renting at the time. Charlie Chaplin was a friend of theirs—this little guy that I didn't know from Adam. I hadn't been exposed to much in terms of film, and I wasn't interested. But this very slight older fellow came over and started talking to me, and I don't know if he saw a frown on my face or what, but he offered me this little bit of advice. He said, "You know, kid, whenever I need an adjustment, I just bend over like this." And he turned his back to the ocean, bent over, and looked out between his knees. He was just telling me that when he looks at the world upside down for a moment, everything gets straightened out. It stayed with me. Just look at the world for a moment from a different perspective. I'm guessing, but I think that was the message that he was giving me in a very lighthearted, throwaway line. A beautiful gift.

Mother's parties were quite the scene. Everybody was so erudite, and so witty, and so funny, and they were all so quick with the bon mot, the good word, the witticism. They just all knew what to say at the appropriate moment, and they were all drinking like fishes, just entertaining themselves and each other in such extravagant fashion. And there's no way I was going to live up to their expectations. I think Michael felt even less capable than I did. And at parties, we were brought in and expected somehow to perform in some way, to be these young, bright-eyed, bushy-tailed guys who could dazzle the crowd. But I would just very politely say hello and leave it at that. Except when I met Louis Jourdan's wife, Quique, at the house in Malibu. I had been out on the beach, where I had found a fish about seven inches long that I picked up to show my friends. I was hiding it behind my back when Mom stopped me in my tracks and said, "Say hello to Mrs. Jourdan." I was extremely shy and nervous, and suddenly there was this

vision before me, Quique Jourdan wearing a polka dot bikini. And I said, "I'm shy!" and I threw the fish at her.

Once I drank a bottle of Gordon's gin in about half an hour, just to see if I could walk a straight line. This was in Malibu, when I was about thirteen or fourteen years old. Mother and David were renting a little cottage for Grandma and Grandpa Isley next door to ours. I remember Mother was out having dinner with a shrink, discussing me while I was home drinking a bottle of gin. Grandma Selznick, Grandma Isley, and Grandpa Isley were all sitting at a card table playing canasta. I was in the kitchen drinking the gin and then went outside to walk the shuffleboard line, just to see if I could still do it. I seemed to be fine, so I walked straight to the living room, and said good night to everybody. "Good night, Grandma Selznick, good night, Grandma, good night, Grandpa," and paid my respects. And then I marched off to the bedroom and laid down on the bed and passed out. Nobody knew the difference. My mother came in later on looking for me and couldn't wake me. They were all terrified. They thought I had polio or something, and David Selznick's older son, Jeffrey, lifted me in his arms and carried me straight as a surfboard into the car and drove me to St. John's Hospital in Santa Monica. They did spinals on me, everything. That's how they found out I had more alcohol than water in my veins, I guess. When they let me go the next day, the nurses who were dressed in nuns' habits came in and wagged their fingers at me. They said, "Don't you ever do that again, young man. You came closer to dying of alcoholic poisoning than anybody we know." I couldn't walk for two days because of the spinal tap they'd given me. I was in terrible shape. This was the worst hangover of my life.

A Fourth of July party at Joe Cotten's house stands out to me. It was in Pacific Palisades. Everybody was in their finest clothes. There was a big swimming pool and I don't know what happened, but Mother either jumped into the pool or she was pushed in. She loved it, she

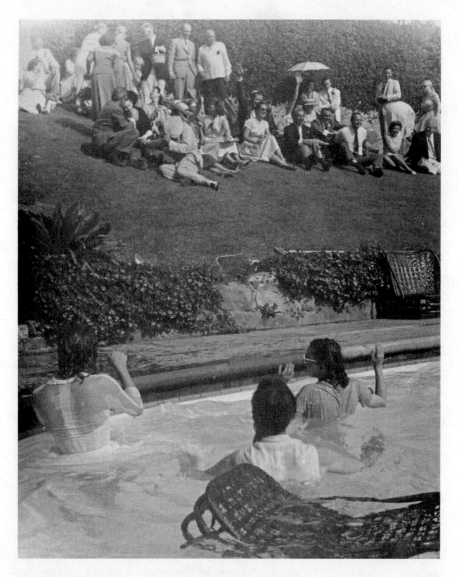

Jennifer Jones (center) on the Fourth of July at Joseph Cotten's home,
Pacific Palisades, 1955.

laughed and was swimming around there all by herself. And all of a
sudden other people were jumping in or being pushed in. I remember
somebody pushed in Joe Cotten, in all his finery, and apparently he
was not happy at all, but Mom just loved it. She was wearing some
flowing white thing, reminiscent of her costume in *Portrait of Jennie*.

Jean Howard took a great photograph of her that day. But I usually just couldn't wait to get the hell out of those parties and go up the hill, smoke Lucky Strikes, and play soldiers.

Michael and I went back to Italy with Mother on a summer vacation, at the time of filming *Beat the Devil* back in 1953. The movie was based on the novel by Claud Cockburn. It was made in a spontaneous way, making it up as they went along. Truman Capote, who got the screenwriting credit, wrote the script night by night, sometimes turning pages in at three in the morning. My introduction to him was in the Grand Hotel, or the Excelsior, one of those hotels in Rome. It was in the morning and I was having some breakfast, bacon and eggs. I heard this uncanny sound waxing poetic to my mother coming from the other room through the walls. And hearing his voice, I had to see where it was coming from. I went in, and there was the voice and the person. I mean it all worked. I wasn't disappointed. You can imagine what a young kid thought of this otherworldly creature, with an otherworldly voice and an otherworldly way of expressing himself. He just stopped my world in a sense. I didn't have any reference. I was just stunned to see somebody so real and so different. It was like a beautiful sunset or a freak wave in the ocean.

Initially, they were shooting in a little town called Ravello. John Huston was directing the movie, working with Oswald Morris, the great British cameraman. And there was Mom, Gina Lollobrigida, Humphrey Bogart, Peter Lorre, Robert Morley. It was such a cast of characters, it was so much fun being part of it. Peter Lorre was my favorite. You'd just look at him sitting there and start laughing because he'd move his eyes, just do something with his eyes, and you'd be on the floor. He was this divine wit and poet, imprisoned in this awkward little vegetable-like body, a little gnomelike creature with the capacity to make funny faces and whatever, but his nature was such that you could see occasionally through all of that, because he put on this clown persona, this mask, and shielded the real person. Robert Capa, who

was one of the photographers on the set, and David Seymour, whom we all called Chim, took me under their wing because I was really interested in cinematography.

Roberto Rossellini and Ingrid Bergman were also down there to do a movie, not that many miles away from us. At the time, I was madly in love with Ingrid Bergman. At some point during a break in the filming, we all went to Capri for a few days, and she was with us. I remember her lying above the blue grotto in this beautiful light blue bathing suit, and her blond Swedish hair blowing in the wind, looking absolutely gorgeous. I was probably all of thirteen then. I thought she was a vision of loveliness. Then we were all in Naples and heading to Rome, probably to do some more work for the film. I remember Mother got into a limo, but Michael and I ended up piling into Rossellini's red Ferrari convertible. We all had little goggles on, and those little cloth helmets that they used to wear to keep their hair in place. The Ferrari looked very racy and sporty and had a number on the side, I think. Rossellini was driving. We took off and must have been going a hundred and twenty miles an hour to Rome. I must have been in some kind of hog heaven, little kid heaven. I don't know why Mother let us get into the car with this maniac, but it was magical, the roof open so the Italian night was flying around our heads, all the little road markers and the trees. It was just heaven—faster, faster—I'm sure we were egging him on, and he's gearing down beautifully, and then gearing up beautifully. He's playing the thing like an instrument, and it's a Ferrari for crying out loud. The engine was like God was speaking. I remember the road. I remember the night.

STEPHEN SONDHEIM: I was traveling in Europe for the first time, and John Huston took pity on me and gave me the job of clapper boy on *Beat the Devil*. I was unpaid and thrilled with the experience, but I had to leave two weeks into the shooting when my money ran out. I knew

Jennifer Jones not at all, but I do recall her sitting at an umbrella table in the square of Ravello, rehearsing a scene with Edward Underdown, who played her husband. Above the surface of the table she was bantering blithely with him, but below it she was tearing her napkin into shreds. This was not in the script.

<p style="text-align:center">LETTER FROM JENNIFER JONES TO
DAVID SELZNICK, UNDATED:</p>

Darling,

It was stupid of me to make that fuss on the telephone and I'm terribly ashamed and sorry especially after all you've been through. It must have been dreadfully unpleasant all that business and certainly this is a poor time for Mrs. Jones to begin making demands but when I didn't hear from you I would only think you must have suddenly discovered your nurse was divine or a new secretary or maybe that fourth at Lenore's for canasta. Anyway I was wild with jealousy when I wasn't wild with rage at John of all of the stupidities of this silly way of making a picture. Your predictions have all come true—he just keeps ahead by minutes and in my case there is no question of performance—my job is solely to remember lines and positions rattle them off as quickly as possible never mind the meaning etc. etc. All the time I think it *must* be my fault, but really I know it isn't. John has just decided to make it a three ring circus with an assortment of types behaving in what he hopes is an untypical way but what seems to me only a sordid and completely unrelated one to the other way. Certainly my character has no reality of any kind and whether she is comedy, tragedy, or something "bourgeois" I haven't a no-

tion. Anyway in the last scene, still unwritten, (as is tomor-
row's scene, of course) John said that "they" should feel sorry
for her, this apropos of costume, but this is a confusing clue
because unless I appear in rags and tatters there has been
nothing in the script so far to indicate that she is anything but
a silly idiot and how I am to attract audience sympathy of any
sort is a source of great bewilderment to me. Surely they will
feel as I do at this point, that she needs a great solid kick on
the bottom. However lest I sound like another Norma Shearer
I hasten to add my complaints are not because she is defi-
nitely an unsympathetic character but because at least to me
she is completely un-understandable. I don't know what or
how to play and John has given for all practical purpose no
help whatsoever. There was one horrible night, a nightmare
of nightmares which shall remain in my memory the rest of
my days. It was a scene at the dock before boarding the boat
with Dannreuther. To be shot at night. I had received the
scene the night before. Carefully studied it . . . in Positano
where we had gone with the boys the day before. I arrived
home in Ravello the afternoon before the night's shooting to
be greeted with an almost entirely new scene which I quickly
learned—this was at three o'clock. At six o'clock we left for
Salerno where the scene was to be done, as I stepped into the
car another scene was handed to me, meaning changed—
some lines from the first version, some from the second which
I had just learned and then great long additional new ones.
It was dark and I couldn't study until we got to Salerno but
I thought oh well, it's a long scene, it was quite long, there
will be several angles, it will be broken up and even with ac-
cent problems I shall be all right. But when we arrived John
with his fetish for one angle, one take, etc. had arranged to do

it all in one. For the first time in my life, David, I couldn't re-
member the lines, I blew and blew and blew until 4:30 in the
morning. About 2:00 I said, John, please let's just let this be a
rehearsal tonight or break it up, John. I can't do it, I'm ex-
hausted, the lines are all confused, I need time to study the
scene properly, please don't humiliate me anymore in front of
the crew and other actors. Gina and Morley and Peter and all
the others were kept there all night because they walked
through the shot in the beginning with no lines and this was
most distressing to me. His answer was, forget the strain you
are under and act, remember you are *paid* to act. Said of
course with a grim smile and what passes for Huston *charm*.
At 4:30 completely paralyzed with shame and hating myself
for being so stupid, I actually couldn't remember the lines at
all, one time one line would be right and another wrong and
then another mixed up in a completely unreasonable way. Oh
David it was all my bad dreams in one. Anyway he finally re-
alized the senselessness of carrying on and we left for home.
The next night of course I was all right and went right
through it even though it had become a great stumbling block
but Bogie made a couple of mistakes and because the end of
the scene was not really good in that angle, John was forced
or rather decided to break it up, which if he had done the eve-
ning before there would have been no problem. Anyway, I felt
so badly, so ashamed and so much like an old actor who has
as you say learned all the parts of which he is capable that I
did a thing which you will probably hate me for and which in
retrospect I rather regret except that at the time of my abso-
lute dismay I couldn't help it. I told Bogie that, and this was
before the scene the second night when he was just barely
nodding good evening to me, that he needn't worry, I in-

tended to pay for the last night's work. Of course he said nonsense, don't worry about it, but I said that was my intention and then when I told Jack Clayton the same thing, he said not to say it to anyone else as some of the Italian partners might take me up. . . . Now I realize it was stupid but actually David I did cost them a whole night's work and in a way if we didn't need the money so badly I would like not to lose any salary for this silly picture. Because I know I have done a bad job even though I am not entirely to blame because circumstances have made it impossible, still as John says I do not understand the character and that is my fault. I would really feel much better about it if we didn't have to accept their money. Perhaps you don't understand this and perhaps I can explain it more clearly when I see you, the way I feel I mean. I am prepared for you to think I am the idiot child, but believe me David, whether all this is my fault or not, I am still not sure that I'm not the one to blame, at least I *know* I have mismanaged myself badly throughout the film, I allowed that stupid but not unkind or ungood Bogie, only rather cheap between you and me, to get under my skin and the foul mouthed Peter and the whole ratty group. Anyway scold me or if you think I am *too* silly and *too* stupid divorce me but don't hate me David. I have mixed up everything badly and for the first time in my life am working in a company, almost all of whom think me a *great* bitch I am certain. But I don't want to ruin your life and if you think I am awful too, please know that you are free absolutely and completely.

> If you still want it you
> have all my love,
> Jennifer

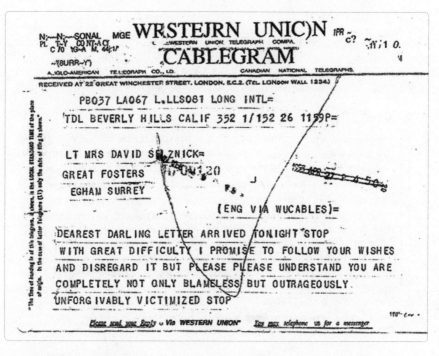

Western Union telegrams from David Selznick to Jennifer Jones, 1953.

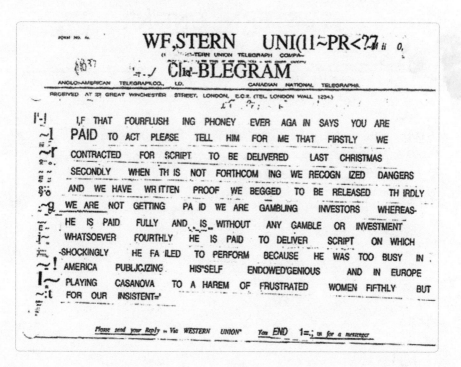

WESTERN UNION
CABLEGRAM

ANGLO-AMERICAN TELEGRAPH CO. LD. CANADIAN NATIONAL TELEGRAPHS

RECEIVED AT 22 GREAT WINCHESTER STREET, LONDON. E.C.2. (TEL. LONDON WALL 1234.)

L.LLS081 2/152=

SUGGESTION OF CAPOTE THEY WOULD NOW BE FACING COMPLETE
DISASTER SINCE TRUMAN IS DOING THE GENIUSES WORK FOR HIM
SIXTHLY NO ACTOR IN HISTORY HAS BEEN ASKED TO GO THROUGH
WHAT YOU HAVE ON THIS FILM BUT YOU WILL CONTINUE TO STRUGGLE
AND HOPE FOR BEST DESPITE INCREDIBLY AMATEUR CONDITIONS
SEVENTHLY AT THEIR URGENT REQUEST WE DONATED FIFTY THOUSAND
DOLLARS WORTH OF TIME FOR WHICH WE COULD HAVE HAD A LARGER
CLAIM ON THEM BUT WHICH WE REFUSED WHEN THEY SOUGHT FAVORS
FOR WHICH THEY EXPRESSED VERBAL GRATITUDE WHICH WE HAVE NOT
SEEN DEMONSTRATED IN THEIR BEHAVIOR
 PLEASE UNDER NO CIRCUMSTANCES AGAIN DEMEAN YOURSELF AND
DIGNIFY THESE FAKERS BY LETTING THEM GET YOU DOWN STOP YOU
SIMPLY MUST TOLERANTLY PATRONIZE THEM WHICH IS ONLY WAY TO

Please send your Reply "Via WESTERN UNION" You may telephone us for a messenger

WESTERN UNION
CABLEGRAM

ANGLO-AMERICAN TELEGRAPH CO. LD. CANADIAN NATIONAL TELEGRAPHS

RECEIVED AT 22 GREAT WINCHESTER STREET, LONDON. E.C.2. (TEL. LONDON WALL 1234.)

COPE WITH SUCH UNTALENTED PRETENSE STOP I ADORE YOU AND
HATE MYSELF FOR NOT BEING THERE TO TELL THEM OFF ALTHOUGH
I AM CERTAIN THESE GENTLEMEN=

```
        WESTERN     UNJ0~r\PR?7
             .IS WESTERN   UNION   TELEGRAPH   COMP~.   ")
  ,   -~ .   -CABLEGRAM
ANGLO-AMERICAN   TELEGRAPH   CO., LD.          "*   CANADIAN   NATIONAL   TELEGRAPHS.
:CEIVED AT 22 GREAT WINCHE     LrLLS081  3/48=  :.2. (TEL LONDON WALL 1234)

:HEROES  ARE  TOO  YELLOW  TO  BEHAVE  THAT  WAY  IF  I  WERE  THERE

WHICH-THANK   HEAVEN   J  SHALL  BE  SOON  STOP  KEEP  THIS  CABLE

WITH  YOU  TO  SHOW  WHENEVER  NECESSARY  OR  EVEN  WHEN  IT  CAN

SPARE  YOU  EITHER  SLIGHTEST  DJSTRESS  OR  SMALLEST  HUMILIATION

FROM  SUCH  IGNORANT  BRUTES  DEVOTEDLY.

        =DAV  I DO::
```

DANIEL SELZNICK: Jennifer felt that her marriage to my father hadn't, in some people's eyes, been validated, especially by David's mother, Florence Sachs Selznick, who was a tough, funny Jewish mother, maternal, quite loving, but very old-fashioned. She pressured David when he first separated from my mother, Irene, for Jennifer: "Are you considering marrying that shiksa? You're not really going to marry her, are you?" She absolutely adored my mother, and I'm sure that she told him, "Go have your fling, but for Christ's sakes, go back to your family." Jennifer was aware that Mother Selznick, which was what everyone called her, disapproved of her. Jennifer was highly sensitive and took it very personally. So one of the reasons she was so keen to get pregnant was to give Mother Selznick a new grandchild, to take the pressure off. I think Jennifer got pregnant twice and had two miscarriages. When Mary Jennifer was born in 1954, I think David's life became richer and sweeter. He watched her growing up with endless fascination and paternal love.

DON BACHARDY: Christopher Isherwood and I first met Jennifer in January 1955. We lived over on Mesa Road in Santa Monica, and Truman was staying with David and Jennifer. He came over for a long, long lunch and afterward suggested that I drive him to David and Jennifer's so that I could meet her. They were having work done to the Tower Grove house and were temporarily in Adrian and Janet Gaynor's house in Bel Air. So we went over, but Jennifer was at Fox making *Love Is a Many-Splendored Thing* and wasn't back yet. Truman said, "Well, we'll wait for her." So we did. Jennifer came home and wanted us to see her new baby, Mary Jennifer, in her crib.

BROOKE HAYWARD: You can see how Mary Jennifer might have ended up being disturbed. By the time she was seven, it seemed that Jennifer had lost interest in her.

I'd known Jennifer and David forever. In 1961, within several weeks of my marrying Dennis Hopper, our house in L.A. burned down, and the Selznicks took us in. Jennifer never, ever appeared before six o'clock at night. Almost every night we'd have dinner together up in the main house: David, me, the two children, maybe Dennis, and Mary Jennifer. And every single night, at six o'clock sharp, in would come Jennifer in her jodhpurs and riding boots and with a whip, having just walked up and down the hill in front of the house. And this was

*Mary Jennifer
Selznick and
Michael Walker.*

the first time she would see her daughter all day. Jennifer would appear for about ten minutes, swishing the whip against her boots, and then she would go upstairs. She never left the house during the day. She had yoga lessons, she had massages, she had her hair done every day, she had clothes brought and taken away. She never left the house until she took that walk at five in the afternoon and came to the children's table at six to see Mary Jennifer.

For years after we lived with David and Jennifer, Dennis and I would be invited to every single event they had at their house on Tower Grove. Dennis was not liked by the older generation in the industry, like Kirk Douglas and so on, who all thought he was a piece of shit. But David didn't. So we were invited to all their parties, which all of Hollywood attended. David and Jennifer had this bizarre but fabulous dining room and an enclosed porch that was sixty to seventy feet long and twenty to thirty feet wide. Three sides of the room were windows looking out on a beautiful vista, and underneath the windows were beautiful banquettes. The room held twenty or so small tables for no more than four people. On each table sat an absolutely gorgeous etched Italian wine dispenser, one half of which was for red wine and one half for white. The waiters filled and refilled them, and my jaw would drop. They were pouring the most expensive wine you could buy into them, and we were just guzzling it.

David would begin the evening by walking over to someone like me, for instance, and say, "All right, Brooke, you are the hostess of table number three, and here are the three guests that you have to take care of." And he'd name the people. He would do this to five or so different women. So I and these other women would have to find the three other people in time for dinner, line them up, and say, "Okay, we're table three." Then we'd sit down and dinner would begin. Finally Jennifer would appear for the first time, at least two and a half hours after dinner had started, in the most gorgeous evening dress

you've ever seen. She would walk the length of the room, go to every table, shake hands and kiss everybody, and then disappear. She would come back later in a second dress and then disappear again. She never sat down. We'd have coffee in the living room and she would appear in a third dress. She never wore fewer than three dresses in one evening. And every single year they gave a Fourth of July party, with races in the swimming pool. David would have a whistle around his neck to blow during races. I've never had such a good time.

DENNIS HOPPER: I have a very different take on David O. Selznick from the rest of the world. He was broke by then, which I didn't know till later. So he had a lot of time and he would spend a lot of it with me. He was a big man who was very funny and very quiet and chose his words very well. And he was very, very amenable. He wasn't an over-powering figure, you know, but somebody who really wanted to give advice and help me. Maybe he was always like that, maybe that's just the way he was. But he was really wonderful to me. I didn't know then

Mary Jennifer Selznick
in a home video by
Dennis Hopper.

what really hard times he was going through. Nobody would give him money anymore to make a movie, but you never saw that. And these were the first serious conversations I had with anybody in his kind of position. He would engage me in conversations: "So you want to make films? What kind of films?" Jennifer gave me a kind of legal pad for Christmas, and I'd write notes and notes. He gave me my first chance to direct. He gave me around five hundred dollars to do a little film of Mary Jennifer. We went down to the beach, as I remember, probably Malibu. It was about twenty minutes, maybe a half hour long, a film of Mary Jennifer at the beach, making a sand castle, playing in the water, somebody reading a story to Mary Jennifer. It was the first time I directed anything.

David did everything in his movies. I think he even talked to the actors. At that time the producer was much stronger than a director because the producer directed the directors. The director just shot the movie, didn't have anything to do with casting or with editing the movie. The producer had all the power. He's got final cut. He's gonna cast whomever he wants in the movie. He's supplying the money. He's the guy in charge. And the director is just for hire. Everybody's for hire. And that's why David usually had two or three directors. He'd just fire them and replace them with somebody else if he didn't like what he was seeing. That's it. He had all the power. Period. But it just takes a few mistakes and you're out of this game. It's a tough business.

From the time of *The Song of Bernadette* on, Jennifer was his property. That's what she was. She was his property. And then at the end she really let him down because she couldn't fulfill what he had in mind for her as an actress. She just wasn't that good. But he had made her such a great star that it didn't matter. That's reality.

LAUREN BACALL: I saw that Jennifer did not finally have the kind of marriage with David Selznick that she really expected. David did a lot for her, gave her parts that some directors did not want her for. She

wasn't a great actress. I remember there was a movie that David had bought for Jennifer, *Carrie*, based on the novel by Theodore Dreiser. I wanted a crack at that part, but I didn't know how to get it, and Bogie was not the kind of man to suggest that they cast me when they hadn't thought of it. I thought it was a part that I could really play well. I finally called the director, Willie Wyler, which of course was not a smart thing to do, and I said, "Willie, I don't know if they've cast this or not, but I would really like very much to try for it." And he said, "I would have loved to have had you in it, but it was decided at the beginning that it was for Jennifer." David had arranged all of it, so there was nothing Willie could do about it. David was always giving Jennifer the plum parts. Nobody else was getting them. And that's what she cared about more than anything. She wanted to be the one who was thought of the most, who was appreciated the most. Everything always had to reflect upon her—not her real life, but her. She had David doing everything to promote her, and she loved that. Unfortunately it didn't last.

BOB WALKER: There was a very shallow period in Mom's life where she spent a lot of time turning films down. I really believe David was responsible for that. Because he was always waiting for that great vehicle for her to be reintroduced. *Love Is a Many-Splendored Thing*, I think, was the last really big picture she did. She did a few things afterwards, but they were nothing noteworthy. I know projects came up all the time until people stopped asking, because David kept saying no. Nothing was ever good enough for her, I believe.

LAUREN BACALL: We were all crazy about Jennifer, but we saw the flaws. We always thought she was a little nutty. She was this beautiful and terrific person. She and David would have these enormous Sunday brunches, and of course David did all of it. Jennifer was busy doing her makeup and combing her hair and choosing her outfit. I will never

forget we were sitting around the house that they had rented in Malibu, and she said, "Oh, let's go for a swim!" She took a board, one of those little kickboards, and started running down to the water's edge and into the water and laughing. She was kind of playing her part. She was always trying to be noticed, to have people really care about her and be there for her. She wanted to be number one, to always win the award, the kudos.

I don't think I ever told her how to be a better wife or mother. She went through a period when she was in Switzerland, and with a shrink that she felt she needed, and this is all to do with her needs, her emotional needs, and it was quite obvious that she wasn't there for her children for a while. It became more than that. Dr. Meier, the guy who was her analyst, also became her lover. When David's mother died, she was in Switzerland and she did not come back. Knowing how close David was to his mother, you know, I felt that was a bad move. David really needed her and she wasn't there. So the fact is, she wasn't a wife. She had the role but refused to play the part.

<div align="center">

Letter from Jennifer Jones to
David Selznick, March 1959:

</div>

Dearest,

All goes well with me. I am getting terrific food and training from Bircher-Benner and what with Meier, at the end of two months I should come home like a lioness fit for a lion.

I love you and miss you and my little darling so much that I can't even talk about it and ironically the weather is great, but *great* now. Sunshine, full moon, the full treatment.

Hope you are well and the deal goes but most of all that you miss me a little. Betty Bogart came through from Klosters on her way to London with her two children in hand and she

told me I was pushing my luck. That you are a very attractive guy and in her words there are plenty of dames in wait for an attractive guy. I said I was less concerned since she had left California but I realized the danger, only I had to continue this work with Dr. Meier. Her reply was, if you can take it, exactly as follows. "F——— the Doctor, go home and get yourself l——— and you won't need doctors or diets. Greatest thing in the world for the complexion." So speaks the expert, the little mother.

> Adieu with xxxx's,
> Jennifer

BOB WALKER: What was the essence of David? He was such an accomplished fellow, and yet, physically, he was a basket case. I remember he did a little croquet and a little tennis, but always with a cigarette in his mouth. Between puffs he was hitting the tennis balls.

I guess Mother was trying to give me father figures here and there. She sent me to her psychiatrist, Dr. Meier, after she had seen him in 1958, when I was eighteen years old and going to a boarding school in Zurich. I remember the dust motes lingering in the light in the library like gold dust. He was Carl Jung's right-hand man and had the classic psychiatrist's face, with this wonderful beard and bushels of hair growing out of his ears, and he smoked a very romantic pipe with this great Dutch tobacco. He was very erudite, very Jungian. I did meet some wonderful people through her love affair with therapy.

As the sixties began, I was just turning twenty and back in Malibu. I was spending a lot of time with Dennis Hopper. We had been very close when we were younger and we hung out with the same people. He was constantly going to these art shows on La Cienega Boulevard and dragging me along. Dennis and I were both into photography and I made a series of pictures of him lighting up a cigarette by a Dr Pepper sign.

Dennis Hopper.

Dennis, Teri Garr, and Toni Basil had a happening in the parking lot right by the merry-go-round in Santa Monica. Ivan Moffat's mother, Iris Tree, had an apartment above the merry-go-round, and Claes Oldenburg also lived up there. The world was our oyster. We were like, "Look at that billboard, wow!" It was always, "Wow, look at that! Dennis, Dennis, oh, wow, did you see?" Everything was a "wow," everything was exciting, the atmosphere was just vibrating with potential. I

Bob Walker.

remember being wild and horny. I mean, just noticing all the girls and the crazy people, and probably the good smoke, and I felt like I was with my tribe, long-haired, bearded maybe, bead wearing, wild-eyed. And the merry-go-round was going, so that added to the excitement, the passion of those moments. Whenever I hear that carnival music, all I think about is my dad in *Strangers on a Train*. That music, it comes up in me a lot. There are certain things that become markers in life, and that's one of them for me. The scene at the carnival, as wild as that was, matched my father's psychic wildness. Dad gone wild.

Jane Fonda and Roger Vadim rented the house next door. They had this incredible Fourth of July party in 1963 where she invited the Byrds to play. It was wall-to-wall young and interesting people like Terry Southern, Jack Nicholson, Dennis Hopper, Peter Fonda, great writers, actors, directors, and artists. Bob Dylan's kids were always over. Richard Pryor's kids were friends with our kids, and so Ellie was friendly with Dylan's wife, Pryor's women, the whole thing. We were all drinking Lafite Rothschild 1959 by the caseload and smoking all the best Michoacán. Lafite Rothschild was twenty-six dollars a bottle in those days. Of course we wouldn't have known, everybody was so loaded they wouldn't have known if they had been drinking Gallo. Our house had a wonderful sloping shingled roof and at the intermission, the Byrds came over to hang out on the roof, along with Fonda and Hopper and whomever, puffing away, looking at the stars and enjoying life. We were all feeling celebratory, like cosmic warriors.

JANE FONDA: As I wrote in my memoir, I had a lot of time off during the filming of *The Chase* and decided I would throw a Fourth of July party on the beach. I had never given a big Hollywood party before, but as usual I took it on to full bore. I asked my brother, who unlike me was into the new music scene, what band I should hire. "The Byrds," he said without hesitation. The Byrds included David Crosby and Roger McGuinn, and there was an underground cult of Byrd Heads

who followed them from gig to gig. They were just about to hit big
with their version of Dylan's "Mr. Tambourine Man." Peter's instinct
was right on target; they were perfect. We put up an enormous tent
with a dance floor right on the beach. I invited Hollywood's old guard,
and Peter, wanting to make sure there'd be good dancing, got the word
out to assorted Byrd Heads. Think "Big Sur meets Jules Stein," "dread-
locks meet crew cut." Dad set up a spit, where he spent the evening
roasting and basting an entire pig, glowing in the attention his unusual
culinary skills brought him. It was called the party of the decade and
was talked about for a long time to come.

MARIN HOPPER: I would go with my parents every weekend to Jane
Fonda and Roger Vadim's house in Malibu. Malibu was so interesting.
It had a certain amount of glamour, because of the amount of money
and the kind of people that hung out there. But it's never been visually
that interesting. It's not like being in the Hamptons, where you have
this fabulous beach, with the sand dunes and the color of the sea, that
steel gray–blue as opposed to the Pacific, which is a lighter color. Mal-
ibu's a shantytown! A strip on the highway! It's a crappy beach with
shanty houses for the most wealthy, amazing, glamorous people in the
world. And the colony has the dirtiest beach in the world. So you're
swimming with sewage and you're living in little shanty houses. I just
remember that, even as a child. I thought, Yeah we're all here and
we're glad to be here, where are we exactly? Oh, right on the highway!

My parents would be invited to go to Larry Hagman's house in
Malibu on Sundays. I remember going there, and it was so strange,
because every Sunday he took a vow of silence, so he wouldn't speak
to anyone. I always saw him in some kind of caftan with a hood, and
he'd be marching in silence up and down the beach with a big flag and
then other people following him in a procession, walking silently with
different kinds of flags, medieval flags, flags with very splashy colors,
big flags. I think this was something that he would just do every Sun-

day, like a ritual. It didn't matter if all of us went with him or not! It was what was going on, it was very serious. He was very determined, very strong-minded in his thoughts. I don't remember him as a religious man. I didn't really ever understand it. It's something that his children probably grew up with, knowing that on Sundays he just didn't speak.

BOB WALKER: Around that time, my brother, Michael, showed up with this girl. He'd been through a lot by then. He'd already tried to commit suicide and been institutionalized a few times. He just didn't weather things well. Part of his way of dealing with life was not to take care of himself. I mean, he never saw a doctor, he never ate properly, he smoked cigarettes constantly, he just didn't lead a healthy lifestyle. He was living in Europe when he cracked up the first time. A farmer found him out in the country in France, bleeding at the wrists, near death out in some forlorn place. There happened to be a hospital nearby that could treat somebody near death from loss of blood.

He was brought back to the States, and he was in different institutions here, all trying to save him from himself. He had been at Yale, interested in archeology and anthropology. And then we both started doing some acting. I don't think he had ambitions to be an actor, really. I don't think he ever really enjoyed it. He went to a lot of acting classes, Strasberg and so on. He tried, you know, but he never felt comfortable doing it.

Then he got married to a sweet, wide-eyed little blond sprite named Jennifer Duteil, who was actually named after Jennifer Jones. They had a daughter, Amy. But the marriage didn't last long. After it broke up, Michael was really out there, drinking and carrying on. He gave up acting and just took jobs, whatever he could grab. He had major problems that prevented him from being a functioning human being, from being able to be places on time and hold a job. He just couldn't ever break out of his own mind. Michael just carried everything with him, mulled it over, digested it, regurgitated it, and digested it again. A

nightmare of cerebral mayhem. I just can't imagine. I know one thing that affected him very strongly was when he was three he walked in, unannounced, into Mother's bathroom when she was standing there unclothed, and she freaked and screamed and slammed the door in his face. You know, people weren't all that used to walking around naked in front of each other in those days. For Michael, that was quite a shock. Maybe he suffered the rest of his life from a little post-traumatic stress syndrome due to that one incident.

Maybe Michael felt that he was the second in Mother's esteem. Maybe he felt that he never quite measured up to whatever her expectations would be, or my expectations. See, I don't feel that there were any expectations that I had to live up to. But I'm sure that Michael felt criticized by Mother and David a lot, that they didn't support him. I think he was intimidated by the abilities and the intellect, for instance, of David. David was really smart. He could question you and talk you or anybody under the table.

DANIEL SELZNICK: My father got angrier as he grew older, because he was more and more frustrated by his inability to have the level of control over his own career that he used to have. Nothing was working for him. Fox bought him out of producing *Tender Is the Night* in 1962, and he was trying to dream up something. And he hid all this from Mary Jennifer.

Toward the end of my father's life, he managed to be in New York quite a bit of the time. He was living at the Waldorf Towers. Mary Jennifer was living with him, Emily Buck in tow. And Mary Jennifer was quite happy there. She and David had a very close relationship.

Meanwhile Jennifer was often in India on various spiritual journeys. The only person who talked to me about her spiritual journeys with any perception was Christopher Isherwood. Chris wrote a play with Don Bachardy adapted from his novel *A Meeting by the River* that James Bridges directed. It is about two English brothers going to India

and one of them becoming a monk. Jennifer, all her life, had sought spirituality.

My father was still on Benzedrine. He was addicted to it. And he was smoking three to four packs of Kent cigarettes a day. He was with his lawyer when he died in 1965. He had gone to his office to discuss a pending deal, I'm not sure for what. Producing new things, or distributing new things. His doctor later told me that he would have lived to be ninety, except that he damaged his heart through the smoking and the drugs. He was only sixty-three.

I flew the next day to L.A. to see Mary Jennifer at Tower Grove. She had no idea that David had any physical problems. I'd been talking with Jennifer for a couple of hours when Mary Jennifer came into the living room, her face so tear-stained. She had been given some sort of sedation, and she was almost unable to talk.

SUSAN SPIVAK: Jennifer was my friend and I represented her as a lawyer. I only remember one thing she told me about Mary Jennifer when she was young. She was in London with David Selznick, and she remembered him holding Mary Jennifer up to the window and saying, "See, Mary Jennifer, there's the moon. You want the moon? I'll get you the moon. There are the stars. Do you want the stars? I'll get you the stars."

BOB WALKER: After David died, my mom began an affair with another shrink. I think his last name was Newton. She called him Fig as a term of endearment. He would give her little frogs. That was their little totem together. I thought he was rather nondescript, could have been a Fuller Brush man, a vacuum cleaner salesman. He was a suit, you know? Short. He would just blend in with the scenery, but he must have had some charm, something that intrigued Mother. He was doing the classic no-no. You can't screw the crew. Don't have an affair with your patient. It may have been something there that went wrong that

caused her to go over the edge. Mother tried a couple of times to commit suicide. That time she was near Malibu at Point Dume, on the beach, but I don't remember the details.

DON BACHARDY: You know that attempt to drown herself in the ocean? Chris and I were very shocked and dismayed. Chris wrote her a charming postcard saying, "Jennifer dear, next time you go swimming, won't you invite us to go with you?" She loved that and immediately had us to dinner, to reassure us that she wasn't feeling suicidal. She was very embarrassed by all the fuss and the headlines. She wanted to assure us that she wouldn't be silly again. I think she just probably got depressed. As we all do.

DANIEL SELZNICK: For those of us who remember *A Star Is Born*, it was all so ironic. The front page of the *Los Angeles Times* had Jennifer walking into the sea, like Norman Maine in the film, one of David Selznick's most famous images.

I thought it ironically humorous, or humorously ironic, that the newspapers concluded that she was still mourning the loss of David Selznick, and that's why she did it. But she was mourning the loss of Fig Newton, who broke off their affair. I heard that she had walked into his dining room when he was sitting with his wife and children at dinner and said, "I've waited long enough. It's time you get up and leave this household." And he threw her out of the house. It's part of the family legend. You must be pretty confident as a woman if you think you can confront him and his wife and children. It was shocking. He must have promised her, as many men do when they're in extramarital relationships, "I'll leave my wife. Just wait for me." It does sound familiar. You can imagine how often David said that to her in the mid-1940s. Dr. Newton probably made these promises to her and wasn't keeping them. So not long after, she walked into the sea. Mary Jennifer, who was then about fourteen, knew the affair was going on. She said to me,

Floating Unconscious

JENNIFER JONES FOUND IN OCEAN

Deputies Haul Actress From Surf at Malibu Beach Cove

BY WILLIAM M. PHILLIPS
Times Staff Writer

Actress Jennifer Jones was found floating unconscious in the surf at the foot of a 1,000-foot cliff on the Malibu coastline Thursday night.

Hauled from the rocky cove by sheriff's deputies who had been searching for her for nearly an hour, the 49-year-old widow of producer David O. Selznick was revived by mouth-to-mouth resuscitation.

She was taken by ambulance to Malibu Emergency Hospital, where she was reportedly recovering "satisfactorily."

The hunt was touched off when a doctor, who said Miss Jones was his patient, told police she had called him from a Malibu telephone booth to say she had taken some sleeping pills and was going to take more.

The call from the actress was traced and at Point Dume, high above Westward Beach, Depu. Paul Piel and Eldon Luken found her 1965 Mustang parked.

On the rocky beach below, they found her sweater and white sandals, neatly placed side by side. Then, in the murky water, they saw her unconscious form.

"She had just taken off her things and waded in," said Piet.

They dragged the unconscious actress, who was dressed in tan slacks and a white blouse, to the beach and revived her with mouth-to-mouth resuscitation.

Please Turn to Page 20, Col. 1

Jennifer Jones

FOUND IN SURF—Actress Jennifer Jones is taken by ambulance to a hospital after being found floating unconscious in surf off Malibu.
Times photo by George R. Fry

Los Angeles Times, *November 10, 1967.*

"Did you notice that she managed to call her therapist just before she went into the water? Wasn't that clever of her?" Obviously Jennifer didn't entirely mean to be lost at sea.

Newton was intelligent, charismatic, and magnetic. He was very interested in the subject of multiple personalities. I heard he got Jennifer to donate a substantial amount of the money that she had inherited from my father's insurance policy for Fig's film documentation of multiple personalities. Pretty persuasive shrink. She had played Nicole in *Tender Is the Night*, which is the story of an analyst, Dick Diver, who is unfaithful to his wife, Nicole. The fact that she would now live out

the Dick Diver story from Scott Fitzgerald was completely spooky. She was very good in *Tender Is the Night,* very convincing as a psychiatric patient.

SALLY KELLERMAN: Jennifer told me stories—later on, not when she was seeing him—about this guy, a therapist named Fig Newton. The impression I got from her was that he was short and not very attractive. When I asked her what he looked like, she said, "Well, he is no Cary Grant." But she was completely enamored of him. She would have picnics in his office. She'd bring lovely things to eat and then have a session with him. You know she would. Right? Oh my god! Oh my stars! One time she went to his house and climbed over his fence in order to spy on him. She was a little rascal. I mean she really was. Remember her in *Duel in the Sun?* That's all I gotta say. I just have this image of her crawling up the side of the mountain. You know, nothing would have stopped her. She had a passionate affair with him.

ALICE WEXLER: My father became Jennifer's analyst around 1967 and remained so for forty years. I was kind of horrified by the story of her coming to Dad to get his approval of Norton Simon before she married him. I wouldn't ask my therapist about things like that. And that he would make the decision for her, he had an arrogance about him. People called my dad "the guru." He was very courtly, Dad was. And very gracious. Although he could be very stern and very tough, very angry. Oh, we had many battles. He stood up to Norton Simon, I remember. I know that he disagreed with Norton about some issues. And told him so. Norton was a tough customer. Dad could match him. He was pretty fearless. I mean, Dad had a lot of self-confidence, and he was not easily intimidated. And I think he sometimes felt that he was the wisest, or he was going to save the world, or save other people. And he didn't have a good sense of limits. Dad was kind of unconventional in terms of his relationships with some people. There were a few pa-

tients that he became friends with. You're not supposed to do that. He could be cavalier about that, in my opinion. I think he rationalized that it was good for the patient, when maybe it was good for him.

"LOVE AT FIRST ANALYSIS TURNS TO CHARITY,"
Los Angeles Herald Examiner:

When Norton Simon met Jennifer Jones, it was their mutual "profound involvement" in psychiatry that attracted them to one another—rather than her obvious beauty and fame, or his obvious wealth. They "didn't connect" on the first date, at a small Los Angeles party, she recalls, because "Norton was pre-occupied with his art project." A renowned collector, Simon founded the Norton Simon Museum of Art in Pasadena. "On the second date, however, I brought along my psychoanalyst, Milton Wexler, to look him over," she says with a grin. "I was gold-digging for a project I was working on, [Wexler's] Heredi-tary Disease Foundation." Later, Simon brought his own psy-choanalyst into the budding romance, to assess Jennifer. They were married three weeks later—with a prenuptial agreement. "Norton said to me, 'I'm a crook and you're a crook. What do you want?'" Both smile. "So he gave a sum to the Hereditary Disease Foundation and didn't get much from me but a dowry of chipped china and worn Porthault sheets." "Oh yes, I did," Norton says softly. "We had a lot in common."

WALTER HOPPS: When Jennifer Jones and Norton Simon were mar-ried in 1971 they immediately established a new residence at 22400 Pacific Coast Highway, just south of the Malibu Colony, in a contem-porary house with the ocean lapping against the sand.

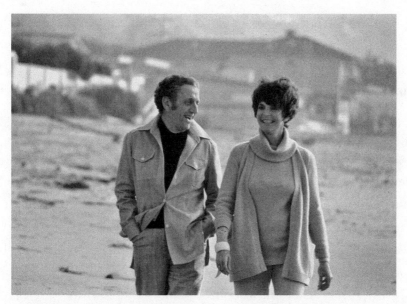

Norton Simon and Jennifer Jones Simon on the beach near their home
in Malibu, California, 1974.

Norton's was a whole modern mythology, dependent on will and a kind of irrational act in the face of total absurdity and nothingness. But eventually style and gesture and how things were seen to be done became a concern of his. So the notions associated with the voracious and megamaniacal willfulness of the earlier robber barons—Mellon, Carnegie, Frick, Rockefeller—hooked up with Simon so that he was both something new and a reincarnation of something old. He also seemed to be thrashing about trying to tackle what Stanford, Hopkins, Crocker, and Huntington did out west. But unlike those men, he used this philosophical stance as a rationale for his tremendous ambivalence about making a lasting mark in society. He had some kind of terribly deep ambivalence that prevented him from settling down, that certainly characterized the way he talked about objects he presumably liked, if not cherished. It was all for sale.

Simon had relaxed, if one could call it that, when he took his second wife, Jennifer Jones. Her style began to pervade that of this self-

made tycoon, generally characterized as ruthless by outsiders. Simon himself had always characterized his stance in life as that of an "existential businessman." His very words. What it seemed to mean with Simon was, "Don't guess what I'm going to do next." That's a key to him. He fancied himself the sort who looked at totally contradictory opinions and acted in ways logic didn't dictate.

But whatever he meant by "existential businessman," it made his face anguished and pinched—I don't think I'd ever seen him smile prior to his marriage to Jennifer Jones. After his marriage, his hair grew longer and he began, at least at home, to wear open shirts or turtleneck sweaters and slacks, kind of tailored leisure clothes. Before Jennifer, he only wore severe ordinary suits.

Norton Simon began to collect paintings around the mid-fifties, and by the late sixties had spent maybe sixty-five million dollars in cash. He'd exceeded the compulsive collecting of Chester Dale and Andrew Carnegie, rivaled that of Andrew Mellon, superseded perhaps any American collector in terms of the number of works he'd acquired. The collection was nineteenth century at the core but ranged backward into baroque art and even earlier. The house he'd lived in prior to marrying Jennifer Jones was a relatively nondescript modern home in Hancock Park. Fine woods, plain but rich beige textures, massive furniture of a bland modern character. A few good antiques and very great paintings indeed. The house lacked style, if anything. All the focus was on the art objects, whether a golden Egyptian cat with an earring or Simon's beloved Cézannes, Pissarros, Matisses, or Manets.

A simple life as far as style: plain. His business life, though, was byzantine and complex, very guarded and international by then. But it was styleless, too: there was no color or elaborate paraphernalia or friends or social occasions. He entered UC Berkeley in the 1920s but dropped out after only a month and a half, a nobody. He began empire building in the 1930s with a little cannery in Fullerton, and by the 1940s he controlled Hunt's Foods. By the 1970s, many millions later,

he had acquired an extraordinary art collection—and Jennifer Jones was a prize possession indeed.

TOMOYUKI "YUKI" TAKEI: I met Jennifer Jones when I was twenty-six or twenty-seven. I did her makeup and hair, and I traveled everywhere with her. I spent more time with her than anybody else, more than Norton. I had seen her in *Love Is a Many-Splendored Thing*, which was very popular in Japan, and so I wondered, Who is Jennifer Jones? It turned out that she liked Japanese things, anything Asian or Indian, like meditation and yoga. She was very Japanese in some ways. Good manners, you know? We talked about culture and Japanese history. She told me once, "I think my earlier incarnation was Asian. I'm an Okie, but my real background is part Indian, part Native American, and part Asian." She said, "I'm an Okie, but I hated it there. I couldn't wait to get out."

It would take four hours to do her hair and makeup. And it was all for Norton: hair, makeup, beautiful dresses. The point was not to go out and show other people. Everything was for Norton. "Norton deserves for me to be beautiful." And he was paying. I did her hair every day, an incredible cost. For the cost of the whole year, you could buy a house in the Valley. And I did it for her for more than thirty years, every day, sometimes morning and night. And she didn't take off her makeup at night. She'd leave it on until I arrived. When she went to bed, she was all made up. Do you know why? This was not for Norton, this was for herself. She said it was "in case I get sick at night and have to go to the hospital. Somebody's going to take a picture of me, and I don't want to be without makeup." She did this every night.

WALTER HOPPS: Norton and Jennifer started a tradition of annual holiday parties on Christmas Eve. I was at their first or second party. Jennifer had set her sights on changing Norton's style, a change which prior to this Christmas party I hadn't seen. It was a shock. The interior

of the house was done in the most lavish and expensive fashion, a consummate act of conspicuous consumption of taste and fantasy one could describe as, let's say, rich California beatnik. It seemed in keeping with the style that the entrance hall should feature an upright Egyptian sarcophagus. At the time, a certain kind of woven straw mat had become high fashion, and Jennifer used it throughout. Rich fabrics covered the walls. The influence of Jennifer's decorator, Tony Duquette, was very much in evidence. And flowers. I don't ever remember seeing fresh flowers in Simon's previous house, but this place was lush: orchids and tuberous begonias and ferns. This was how Jennifer set out to rival the intensity of the paintings.

The cast of characters surrounding Norton had changed with his new status. Simon had become acceptable indeed as a multimillionaire in the movie social world. He was no longer the outsider. I remember running into Dr. Franklin Murphy that evening. Murphy wore many hats: ex-chancellor of UCLA, chairman of the board of the *Los Angeles Times*, board member of many cultural institutions from Kress to the Los Angeles County Museum. Murphy was one to drink a little, and curiously it was he who reminded me—suddenly and in a startling way late in the evening—of the occasion for the festivities. He was lolling and swaying a bit near a makeshift little bar set up at the edge of Simon's most inner sanctum, his private study. Well, study meant an enormous stack of books ready to be read piled up against one wall, a locked file cabinet, and a bare desk with enough phones to suggest at least a small-time bookie. In that setting, I noticed Franklin Murphy miss a step, sway slightly, and bump a painting, which for the remainder of the evening hung askew. The painting was a delicate picture of the Madonna with the newborn Christ child by Hans Memling, which in a funny way brought the occasion into a kind of groggy focus. I said to Murphy, "Well, it's his party, isn't it?" And he said, "Whose party? Norton's party?" And I said, "No, it's *his* party," pointing at the painting. I don't think he got it.

DAVID GEFFEN: My relationship with Norton really developed when we became neighbors at Carbon Beach in Malibu. He encouraged me to collect art. The first painting I bought was a Monet water lily. I called up Norton, and I said, "Norton, I bought this beautiful water lily, and I'd love for you to come over and take a look." So he came over, looked at the painting, and said, "David, it's an absolutely fantastic water lily. It's just great. I really have to have it for the collection. What do you want for it?" I said, "Norton, I don't want to sell it to you, I just got it." He said, "I have to have it." So I said, "Well, if you have to have it I'll sell it to you for what I paid for it." I mean, he was a good friend. So he bought it. Years later I was walking down the street with John Landau, Bruce Springsteen's manager, and we go into Wildenstein's gallery. One of the Wildensteins said to me, "Oh, we have a beautiful picture, I'd love to show it to you. It's a water lily." I said, "Oh, I love water lilies." So I see it and it's a gorgeous water lily. I said, "I think I've seen it before." He said, "You may have. It was at the Norton Simon Museum." It was the picture I had sold Norton, and Wildenstein's was selling it for many multiples of the amount I had sold it for to Norton. I think I paid something like four to six hundred thousand dollars for it and they had it priced in the millions. So I called Norton and said, "Norton, I was at Wildenstein's today and saw this beautiful painting. My water lily." He said, "You mean, my water lily." And he was right, it was his water lily.

He always made an effort to teach me how to make money. Years later, after he retired, I remember walking down the beach and passing the house they had bought from John Frankenheimer. It had that bay window in the bedroom, and Norton had a desk there, and I saw him with a phone at each ear. I called him later and said, "Norton, I thought you were retired?" He said, "I am retired." I said, "I saw you in the window and you had a phone in each ear." He said, "Oh, I was trading currencies." I said, "That's hardly retired," and he said, "Oh no, to me trading currencies is tennis."

MARTIN SUMMERS: I moved to the Lefevre gallery in 1967, and Norton started to ring me in London about things. It was at Lefevre that we found the great models of Degas sculptures. We had the entire collection including the famous fourteen-year-old girl, which we bought for a million dollars. We were going to sell them, and the first person I thought of was Norton. We thought what we had was an unauthorized although genuine cast of the set. What we had not realized was that this was the original set from which all others were cast, making it the most important set of Degas bronzes that exists. But there they were, we got them over to London, and I remember polishing them lovingly one at a time. I'm a Degas fan and to be able to handle every single one of them was magnificent. I called Norton and said, "We've got an extraordinary story, and you should buy them." He said, "I'm interested. Have you got bronze number thirty-three [*Grand Arabesque, First Time*]?" I said, "Of course we have bronze number thirty-three." He said he'd call me back.

The next morning he called at dawn and said, "There's a plane leaving London today at eight fifteen A.M. Bring that bronze." I grabbed the bronze, wrapped it up in a blanket, put it in a grip bag, and rushed to the airport. I carried it on the plane. You didn't need an export license in those days. It was sitting right above me, up in the rack. I arrived in Los Angeles, got in a taxi, and was about twenty minutes late for our rendezvous at the Polo Lounge in the Beverly Hills Hotel. I remember combing my hair, looking a little bedraggled, and carrying the bronze statue that I had removed from the grip bag. I grasped it firmly and walked into the Polo Lounge to see Norton sitting there with his assistant, Darryl Isley. In the middle of the round table in a booth was his bronze. It was like some high noon, you know? I sat down and clunked my bronze number thirty-three on the table, too. He grabbed mine, and I grabbed his. He said, "Yours is a fake." It was his first comment. Darryl intervened and said, "Norton, I wouldn't pursue that line." I was looking at Norton's bronze, which was a third-

generation cast, all soapy and soft. You could see the incisions in the plastic, which were very crisp in the models set. I said to Norton — I didn't say his was a fake — but I said, "I do hope whoever sold you this will take it back, because you shouldn't have it in your collection." I thought that was the politest way of saying it. Eventually he came to London, saw the whole collection, and bought it. The set together cost two million dollars; today it would be forty million dollars.

JUDY SIMON: Norton was very competitive by nature. He was very critical all the time of his two sons, Bob and Don. Don, whom I later married, said it wasn't bad until they came into adulthood. He saw the boys as competitors, not sons. Which was bizarre, because they were so far from being competitors: one, Bob, was a poet who always carried a volume of Emily Dickinson with him, and Don, his interest was in international relations. Norton wanted Don to drop out of Berkeley his first semester, because he himself had dropped out of Berkeley after the first six weeks. And then when they went to work for Hunt's Foods, he put them in minor jobs, had them supervised and just discouraged them. This powerful father continually told them that they were worthless and stupid.

Don and Bob both came into a tremendous amount of money when they turned twenty-one years old. They inherited stock in Norton's company from their grandfather, Myer Simon. Norton demanded it back. He said, "You didn't earn this money, you don't deserve it. I want it back, all of it." Bob was going to sign over everything, but Don was very strong, and he said, "I'll give you back half, but I'm not giving you everything." Don had the strength to gut it out, but Bob really was too sensitive to have a father that powerful.

JOAN WILLENS BEERMAN: Bob shot himself in the closet above the bedroom of where he and his wife, Sylvia, slept. Blood began dripping

down on the bed and that's how she found him. She told me herself. She was nine months pregnant. It was so sad. He was about twenty-eight, maybe thirty. I felt terribly guilty that I had missed cues. He got into deep depressive episodes. At one point he had a gun and they took it away from him. He went out and bought another one right away. He felt that he couldn't be the kind of father to this child that he wanted to be. He felt he was unequipped, that he was so defective that he would damage this child. That's the legacy of Norton. Both the boys were so sweet. Two guys with a sensibility that wasn't equipped to take his berating. They were so demeaned by him.

JUDY SIMON: On the day we buried Bob, Norton was utterly, utterly distraught, but he didn't talk about his guilt. At the funeral, and at the luncheon, he was crying. Bob was his favorite child. And then he started confronting Don, fighting with Don right at the lunch. I don't remember the exact words he said, but he was having nasty exchanges with his only surviving son on the day of the funeral. And Don was outraged because his father had kept it to himself when he found out that Bob had had a gun. Norton had taken the gun away and put Bob in the UCLA mental hospital, but Bob got ahold of another gun. None of us had a clue that he was in this kind of depression. Norton said, "I believe there are brain disorders, and that's why I have invested in the PET scan." For him everything was cerebral.

SALLY KELLERMAN: I didn't have a real intimate relationship with Norton, although he was always very kind to me. I mostly saw him when he and Jennifer would entertain. He did speak to me once about his son killing himself. It was at a dinner at the house in Malibu. He told me, "I figured if he was willing to take that step, then I could have the courage to walk away from my marriage."

JOAN WILLENS BEERMAN: When Bob killed himself there was money left in the will to set up a foundation. It was really a tax ploy, and it was a very small amount, but it turned out that the will was incorrectly written, and in order to avoid huge amounts of taxes, the attorneys made a deal to establish a larger foundation. So more money went to the foundation, a sort of forced foundation. Bob's widow, Sylvia, asked if I would be a trustee of that foundation.

Norton always felt the money was his. It was a control issue. I was like in my twenties, just a young kid, so he would call me and say, "I want the money this year to go to this place." And I would say, "Norton, I'll bring it up at our next trustee meeting." He would get angrier and angrier. By then he'd divorced his first wife and married Jennifer, who then took up the cause and was very angry with me, too. Finally she called and said, "We have to meet. We're going to meet at a neutral site, at Hedda Bolgar's office." She was this fabulous woman who was Norton's therapist and my mentor for a time. But as Norton's analyst, she stepped way over the boundaries. He gave the funds to start an institution in her name, the Wright Institute Hedda Bolgar Psychotherapy Clinic. He bought the building or something like that. So we met there. Jennifer started right in defending Norton, yelling at me, saying, "How dare you make him crawl to you and beg you for this money." And you know, it couldn't have been very much, maybe a hundred thousand dollars a year, or something like that. So it wasn't about the money, it was about control, power. I just sort of sat there, and she was saying, "You shouldn't have anything to do with this, you're only on it because of Sylvia, and Norton should be on the foundation." He's sitting there rather quietly, actually, while she's yelling at me. Finally I said, "It's not his money anymore." And he then said, "I knew it, I knew that's what you thought." So he went storming out, and she went out after him. That was the end of our communication. Jennifer was really a bitch, and I didn't

like her. Her agenda was to prove how loyal she was and how much she could take on for him. They were among the few people I never got along with. Sylvia moved away soon after. She took the money and left.

MARIN HOPPER: The first time I visited Jennifer after her marriage to Norton, I was ten or eleven years old. On our way to Malibu my mother said, "You know, he makes Hunt's ketchup," and, "He's made a fortune from ketchup and tomatoes." And I was like, "Wow, really? Jennifer who had been married to David Selznick is now married to this tomato person?" I just couldn't put it together at all. I said, "Why would she want to do that?" And my mother said, "Well, you know he's very well-off, and he's got an incredible art collection. Marin, you might want to comment on his art, maybe you can ask him questions about it, because I know you like art."

A few years later, I remember my uncle Bill Hayward came to Norton's house to visit once when I was staying with Norton and Jennifer for the summer. One night, Bill had a long conversation with Norton about tomatoes and tomato farming. Only Bill could have a conversation about tomatoes. Everyone else said, "Oh, Norton Simon, the great art collector!" The tomatoes were not something anyone else dared bring up with Norton. I remember thinking, Oh, here we are, finally! We're having the tomato conversation. There was a big scandal at the time. They were gassing the tomatoes to turn them red in the supermarkets. Norton was very upset, because it affected the taste. And Bill was very up to date on his tomato information, the canning process, Norton's canneries, how he made ketchup, all of that. Bill obviously had done all this studying about tomatoes. It would have been just like him to one day decide that he needed to know all about tomatoes. Or he had done homework in order to have dinner with Norton. Really impressive!

FABIENNE GUERIN: There were always people for cocktails, people for dinner at big parties, like Lauren Bacall. I'd always seen her in movies as this beautiful classy woman, but she had a mouth like a truck driver. I was shocked that she used the f word. With a scotch and a cigarette in her mouth, she was not at all the classy, cool lady from the movies. But Jennifer Jones was always classy, dressed impeccably. She was such a beauty. I spent a lot of time with Mary Jennifer over the years. Or Jennifer as she wanted to be known. If you were talking about her, you said Mary Jennifer, but it was Jennifer when you talked to her. So Jennifer Jones became big Jennifer and Mary Jennifer became little Jennifer. Mary Jennifer never felt that she herself was beautiful.

But her mother was a vision. One that didn't wear panties. That was her thing. I don't think she ever wore them. Her maids told us that they would wash all her bras, but there were no panties. And she didn't wear pantyhose either. And she wore dresses. When she'd sit down on a chair, she'd sit like riding sidesaddle. She'd cross her legs, and I always thought, What a weird thing. I don't remember if Mary Jennifer and I ever talked about it. We just knew that her mother didn't wear panties.

MARIN HOPPER: When I came with my mom to visit Norton and Jennifer's house in Malibu, I remember seeing Mary Jennifer. I knew her very well from when I was a child. I looked up to her. I'd always admired her just because she was older than me and she seemed cool. Her bedroom was right on the left when you walked into the house. I thought Mary Jennifer was so great and her room was so great, so I wanted to see everything. It was all black lacquer with mirrors and a bathroom with more mirrors. I wanted her to open all the cabinets and she'd show me everything. I was going to say, "Hey, you're here in your new house, your mom just got married, you know, starting over." And then I just saw that she was covered in these thorns, and I thought,

Wow. When you're a child, you don't know why, but you sense disaster. And she was completely unraveled. She was wearing a black cashmere sweater, jeans, and these really divine cashmere socks. It was all black. Her hair matched, the dark hair with the very thickly piled black cashmere turtleneck. It was all very soft, because I gave her a hug, and she gave a feeling that was so soft. I remember touching her feet because I thought her socks looked so fabulously soft. But she had those stickers that you get from a plant, like donkey's tails, the little buds that get stuck—thorns, I guess. She was covered in them. And I thought, Are you all right? Is everything okay? And she said, "I've had this terrible day, I've had, oh my god, I've had this terrible day. I haven't been feeling well." She had gone on a walk in the hills. I said, "Were you walking without your shoes?" and she said, "I went hiking without shoes."

Mary Jennifer Selznick, approximately eighteen years old.

She had taken her shoes off to go hiking in the mountains. I said, "You've got this stuff in your socks, and they're so beautiful, the socks! Why would you want to walk without your shoes and ruin your socks?" And she said, "I'm very angry with my mother." And I remember not really understanding how anybody could be angry at Jennifer.

FABIENNE GUERIN: I'd never seen anybody fight with their mother the way they did. I mean, I'd lip off, and my mother would whack me, or I'd get a spanking for being naughty. But Mary Jennifer would disappear into her room with claw marks on her from Jennifer. And big Jennifer often wouldn't come to dinner because she had battle scars. I mean, they were at each other physically. I never saw it happening, I just saw the aftermath. I'd sit in Mary Jennifer's room waiting for her to come back from her mother's room. She'd come back out, and her hair would be all disheveled, and then we wouldn't see Jennifer that night for dinner. She'd have invited people for dinner, they'd arrive, and she wouldn't come out. I discovered years later that before little Jennifer was born, David idolized big Jennifer. She was the ultimate, she was everything for him, and he worshipped her, loved her, adored her. Everything was for her. Then Mary Jennifer was born, and the love shifted. He was taking Mary Jennifer to Cannes and to New York, he was bringing her presents back, and big Jennifer was just not around. So I think Jennifer loathed Mary Jennifer, because Mary Jennifer took away her husband.

BRODRICK DUNLAP: Mary Jennifer was pretty from what I can remember, kind of thin, sexy. I was ten or twelve and I remember looking at her, going, man, she's kind of sexy, but she's weird. She was timid, very quiet, secretive. At their house, they had all these art crates stacked in the back, I'm talking like ten feet high, a bunch of wooden crates. And Mary Jennifer had taken a tarp, like one of those cheap little tapestries, and made a big tent outside, like her own boudoir. She had all this

hippie stuff, and I think she liked to smoke pot there. Back then every-one was doing that, but the Simons looked down on that kind of thing. So she had this little tent area that she created, and one day Jim, Si-mon's houseman, hired my friend Stuart to help take down all those packing cases, all that tent stuff. Mary Jennifer came home and had an absolute meltdown. She began screaming, yelling, saying they had to reconstruct the thing. She had a boyfriend and she may have been sleeping with him out in this tent thing. It was kind of her romantic hideaway, and when it disappeared it flipped her out. I think Jennifer later on figured that out and there was some brouhaha about it. But Mary Jennifer was crazy, she was weird. But she was strikingly beauti-ful, very thin, very troubled, drugged.

BOB WALKER: I think Mary Jennifer had very high expectations, just like a lot of people, but I think her life just turned into a huge disap-pointment and frustration. She was, you know, so enamored of her mother, and so in awe of her mother, and wanted to be like her. David and Mother, they both treated her like a princess. She was brought up in that way. I think being out in the world, and seeing what life really was, it probably took its toll on her. Mary Jennifer, like Michael, was filled with envy, greed, jealousy, love, hate, fear. Enormous fear.

I remember one time Norton and Jennifer decided to take a six-week trip to the Far East. Norton said to Mary Jennifer, "I think it'd be wonderful for you to stay at our place and look after the collection for us while we're away." Mary Jennifer said, "Well, I don't know very much about art, Norton, and I don't know if you should give me this responsibility." Now from his point of view, that was sort of wonderful, an interesting, challenging thing to do to her, to say, "Okay, live here, take this responsibility for something other than yourself." She told me about this herself. She said, "I'm going to try and do this." And then for weeks she was waking up every morning around all that expensive art. And one day she said, "What am I doing here?" It frightened her. She

didn't know how to deal with all these masterpieces. It was too awesome a responsibility. So she swallowed a bottle of aspirin or something. She just couldn't handle it. Somebody called Norton and Jennifer in Thailand or wherever they were, and they flew back immediately.

She was a very pretty girl, but not movie star pretty. Nowadays, she'd be hired because they hire people that look real. But I think there was some disappointment with it. She magnified it to the point where she got very self-destructive. She couldn't handle being young and almost beautiful. That was the second time she took a lot of pills. She must have been about twenty or twenty-one. She wasn't passing out, but she wanted to go to sleep, so we kept her going. My girlfriend and I had to walk her for hours on the beach so she would get this out of her system, lots of coffee. Nowadays you'd call 911.

RICHARD WEISMAN: I ran into Mary Jennifer in New York sometime in 1973 or 1974, maybe at Studio 54. She had moved there briefly to take acting classes. I might have said, "If you're ever around, give me a call. We should get together," because I remembered her when she was a little girl. Now she was attractive, very much like her mother. Long hair, not too dark, very pretty. She might have been nineteen years old. So one evening, not late, when I had five or six people at my apartment, she just showed up. She rang from downstairs. So I open the door and give her a hug. "Hi, how are you?" And she starts to gasp and completely passes out. In my front hallway. I think she was really wasted, or that's how it appeared. And now I have like four or five people over, and the two couples said, "You know, maybe we ought to . . ." You know, they left. And this one friend of mine and I, we kind of got her up and helped her upstairs. I had a duplex with three bedrooms upstairs. And I let her lie down in the middle bedroom. So this guy leaves, I come back to the bedroom, and she's standing in the doorway. I say, "You feeling better?" "Oh, I'm fine. I just wanted to get

rid of those people. So, how about let's get a little sex going." I mean, you have to understand we just had laid her down on the bed and she could hardly walk. And now she's standing up saying, "I just wanted to get rid of 'em. Now, come on, take your clothes off. Let's go." I was kind of shocked, A, that she was okay, and B, that she would say this. And her dress was off and her top was off. I'm like, "Mary Jennifer, this is not gonna happen. Okay? This is not gonna happen." "What do you mean? I don't turn you on? Is that why it's not gonna happen? Believe me, I can turn you on. I know how to turn you on. Don't worry about that."

But I got her a cab to send her to her apartment. I said, "Please, Mary Jennifer, listen to me. I want to be there for you, but not that way. I'm not going to sleep with you. We're never gonna have sex. Okay? So you gotta get that through your mind. Okay? And it has nothing to do with how you look because you are a very hot looking girl. But I know your family and your brothers, and besides, your mother is married to my uncle, so it's just, like, weird. So this is just not gonna happen. So look at it this way: my loss, I lose out here. Okay?" So then she says she's okay. "But you know something, we could have a great time. No one has to know. No one ever has to know." And I said, "It's just not gonna happen." I mean, just think, what do you do after that? That's only trouble. I called later to see if she was okay. I said, "Are you okay?" She says, "Yeah, I'm okay. I guess you did the right thing. But I just wanted to stay with you. I wasn't gonna do anything." I said, "Mary Jennifer, you gotta take care of yourself."

DR. BEATRIZ FOSTER: Mary Jennifer came to me through Jennifer's therapist, Milton Wexler. Milton was my friend, although I didn't agree with his mixing of social and professional life, which I think had a lot to do with the breakup of his marriage. When Mary Jennifer turned out to be very crazy, he sent her to me. I can't tell you everything because it would be a conflict of patient-client privilege. I am

very strict in that sense. I'm the opposite of Milton, I keep things very much inside. I also have reservations talking about somebody who was as close to me as she was. I care about my patients, and I also cared a lot about Jennifer and Norton, and I hated to see what they had to go through.

Mary Jennifer was with me for two and a half years, and she was a real spoiled brat. She got everything she wanted, and she was a very unhappy child. I think she was very bipolar. I never knew whether or not she was going to come for her appointment. If she was close to anybody, it was Jennifer. She and Jennifer came once or twice to the office together. Her relationship with Jennifer was very frail. It's one thing to want to have a relationship and another thing to be able to have one. Mary Jennifer wanted more than anything to have a relationship with Jennifer, but there was a lot of competitiveness there and that didn't make it easy. I remember that once, as Mary Jennifer was leaving the office, I said something about her father being a big director. She turned on me and said, "He was no director, he was a producer!" I didn't even know the difference. I said to her, "So who the hell cares?" She said, "I do, and you should, too." It was very important to her to remember that he was a producer, not a director. But of course he had died and then Norton came, who was also a powerful person, and that didn't fit very well.

She had this habit of going to high-rises, even walking on the roof, and together we tried to figure out her obsession with high places. As a psychiatrist, I've known a lot of people who go up onto roofs. It's a way of contemplating the idea of death. I said to Mary Jennifer, "One day the wind is going to be very hard and it will throw you over," but she said, "I'm a very strong woman."

Once her brother called me when he thought that she was going to kill herself, to dump herself in the ocean. Jennifer and Norton were away, and this guy didn't know what to do. So I got into the car and went to Malibu. Mary Jennifer was running along the sand on the

beach, and I said to her, "Enough already. I want you to stop this." I caught her by one arm and said, "You're coming home with me." I don't remember where I put her, but I got her out of the sun and got some sanity in her, because she was all riled up. She said she was going to drown herself. But all it took was for me to grab her by her hand and say, "Listen, this is the end of this, you're going to sleep." And she did.

At one point, I had to give a paper in Norway or someplace, and I put her into Cedars-Sinai Hospital before I left. I wanted her in a safe place while I was gone. Everything she did was iffy: you never knew what she was going to do next. I couldn't leave the country with that on my mind, so I said to Mary Jennifer, "I'm going on a trip, and you're going to be here. We're not all going to be nuts, so you're going to the hospital." And she agreed. When I came back, I didn't think it was good for her to live alone. Norton and Jennifer had a life of their own, and Mary Jennifer didn't fit there at that time. I decided she would be better off living with another family. Somebody referred a family, the Persells, to me, and she did very well with them. She began doing things like cooking and making her bed, which was sort of extraordinary for her. She spent a lot of time with them as a family. She used to bring me a rose, and raspberries and tarts that she'd baked. She learned from the Persells. These tarts were the first things she'd baked in her life. She brought this big package one day, and I said, "You're giving one to me, and you're taking one to your parents." She was not supposed to be in touch with Jennifer much during that period, but they did see each other occasionally. So off she went to Malibu with the tarts, and Norton and Jennifer looked at her as if she'd climbed out of a tree. But they ate the tarts and enjoyed them. I was glad about that.

THE RIGHT REVEREND WILLIAM PERSELL: I was rector at St. John's Episcopal Church on West Adams Boulevard by USC, a beautiful Italian church. We had parishioners who were in a program which assigned people to live with them through the mental health organization.

The parishioners knew we had lots of room in our house in Pasadena, and so they suggested the idea to us, and we said we would do it. Mary Jennifer was the first and only person we ever took in through this program, although we always had lots of people living with us. We have six children, most of whom spent time as exchange students overseas, so we always had exchange students living with us for various periods of time.

We called her Jennifer, which she'd asked us to do. She was taking one or two courses at Occidental College, just to sort of have something to do. Once she was panicked about a course she was taking. She would not get out of bed and go to school, and I went up and said, "You've got to get up, and you've got to go to school." And she got an A in the class. But we just sort of pushed her to go to school. There were some days that were pretty hairy, actually, when she would then be totally uncooperative. You just had to be insistent. "No, you're not gonna do that. You're doing this." And so that was hard. She had her own car and she smoked a lot. Our second to youngest daughter, Lisa, said that Jennifer was like a big sister to her, even making comments to Lisa like, "Look at your boobs. You have such big boobs, and you're only thirteen. And I'm twenty-one, and look at my flat chest."

Some days she was attractive and normal, happy and talkative. And other days, you could really see the trouble in her eyes and face. But she didn't talk about her problems much. She was seeing her therapist every day, so I didn't see that as our role. Our role was just to create a home and environment where she could interact with normal people. She would sit down and talk to me about anything, theology or the church politics. But I didn't talk with her much about her family, and she was not supposed to have contact with them through this period, according to her therapist. I don't think she got letters from her family. It's hard for us to tell if she missed her mother and any of them at all. Before she came to us, she got pregnant while she was living in New York, and she rushed to David Selznick's first wife, Irene, who lived

there. I don't know when this was, but she was pregnant at one point and had an abortion. And she got in touch with Irene, not with Jennifer.

Mary Jennifer liked our church, the racial diversity of it. She felt it was a good thing. She came to church on occasion, certainly on Easter. She was with us for Christmas as well. She told us she was not Jewish, and I don't know what she really was.

The day Mary Jennifer was picked up by the police in Beverly Hills for walking around on rooftops, we were all tied up at the church. Our daughter Karen went over and picked her up and drove her back. Once she told my wife, Nancy, that she wanted to kill herself. She threatened suicide a couple times, but she didn't do anything in our home to act on that. I think she thought of Nancy more as her mother than she did me as her father. Once she gave Nancy a T-shirt that said "World's Best Mom." She killed herself two days before what would have been David Selznick's seventy-fourth birthday.

DR. BEATRIZ FOSTER: One very stormy day, after I'd gotten back from a vacation, Mary Jennifer didn't come to her hour. And the next thing I knew I had a call from the morgue. Mary Jennifer's mother was in Dallas because her father was dying in a hospital there. I called Norton and said to him, "There's a mess here. The people from the morgue called me and told me she's dead." And Norton said, "Beatriz, don't take this personally. You're talking to somebody who had a son that did the same thing." I said, "But I take it very personally." He said, "I don't want you to do anything with the morgue today. I'm going to take a plane to Texas right now." So he went to Dallas. He found Jennifer at her hotel. Jennifer's father was not expected to live long, and when Jennifer saw Norton she said, "Oh, don't tell me, it's happened." He said to her, "Yes, but not what you think. It's not your father." At about three or four in the morning, Jennifer called and said, "Oh my god, Beatriz, what you must be going through." And then we talked for a

Jennifer Jones' Daughter
Falls 22 Floors to Death

[Newspaper article text largely illegible]

Los Angeles Times,
May 20, 1976.

while. The fact that she would think about me in a situation like that, I'll never forget that.

I remember calling the morgue and asking if could I view the body. The guy said to me, "Lady, wake up. She fell twenty-two stories, how much do you think we have?" It was horrible. I had to go through all her clothes and all her stuff. I took them to my house, where Norton and Jennifer collected everything. I found her diary. Mary Jennifer had very specifically written that diary for me. I told Jennifer that I'd torn it up, and she took it very well.

I remember how windy it was the day Mary Jennifer died. When I'd seen that her time for the appointment had come and she wasn't there, I looked out and saw the wind and thought to myself, "There goes Mary Jennifer." Those California winds, they'll blow you away.

MARIN HOPPER: Soon after Mary Jennifer's death, at the end of my first school year in Arizona with Michelle, Bob Walker's daughter, Jennifer called. "You must come stay the summer at our house, because Norton and I are in Malibu." So we got on a plane back to Los Angeles and it was all very happy. I think I had my fourteenth birthday at that time. Michelle and I stayed in the room that Mary Jennifer had stayed in. It had two twin beds. I would eat breakfast in the kitchen in the mornings with Michelle and Jennifer's other grandchild, David. It was very seventies Beverly Hills feeling, casual in nature but sort of uptight. They had an eat-in kitchen facing the beach, and we'd all be there and suddenly Bobby would show up. He had kayaked in from Catalina Island, having conversations with the sea lions. Bobby was doing a lot of coke then. He was always very fit and doing lots of things, but he was not really present.

DENNIS HOPPER: It might have been a fantasy, but I seem to remember that Bobby Walker had a one-man submarine, and he decided to take it alone from Malibu to Catalina. He was later found three hours past Catalina. I don't know how they found him. He must have surfaced or something, figured, I must be a little past it. I should have hit that place three hours ago. Anyway, he missed Catalina and was headed toward Hawaii in his one-man submarine. When they found him by helicopter, finally got him and turned him around and got him back to Catalina, he called me and he said, "Dennis, I'm gonna get a two-man submarine, and I want you to go with me." I said, "Bobby, don't waste your money. I don't think I'm really gonna—" "No, no, you're gonna love it. Listen man, I just had a little miscalculation. That's all. Don't worry, we'll hit it this time. You'll be with me." And I said, "Bobby, I don't really think I'll be going on this trip."

BRODRICK DUNLAP: Between our house and the Simons' house was a walkway, and we had an outside bathroom, a beach bathroom, with

louvered windows. One day one of their kids opened up the louvered window by taking one of the louvers out and then filled the toilet with buckets of sand brought through the window, just being kids, mischievous, you know. So I open the door and here's all of this sand filling our toilet, and I go, what? I look down the beach and I see these footprints going back over to the Simons' house. So I knock on the door and tell Jim, their houseman, "The grandchildren just filled our bathroom with sand." Mrs. Simon was there, opening some new art, but when she hears me complaining about the grandchildren, she runs in and says, "How dare you say that my grandchildren would do that!" And I say, "I want someone to come and clean it up." So she rushes into the packing room, or whatever, picks up a claw hammer, and starts coming at me with it. Jim, the houseman, jumps between us and says, "Rick, it's time for you to go home, you better get out of here."

We had a big storm once, and a bunch of debris washed up on the beach. A dead dolphin had washed in, and Norton walked out to see it. And then I got a call from one of his house people, saying, "Will you meet Mr. Simon on the beach? He wants to ask you a question." So I say okay, whatever, and I walk over and he's standing there and he says, "Is that a shark or a dolphin? Is that a shark?" I go, "No, it's a dolphin." He says, "How do you tell?" And I said, "Because it's got a long nose, and . . . well, it's got a lot of teeth. It's a dolphin." A dead animal was on the beach, and he wanted to make sure it was a dolphin, not a shark.

MARIN HOPPER: One night Michelle and I were having dinner with Jennifer and I said, "Michelle and I are taking tennis lessons, and we have a crush on this tennis pro." We were sort of giggling about it at dinner. And Jennifer said, "Well, girls, I have an idea. It's going to be hard for me to do, because you know I see my therapist Milton Wexler every single day, but I've thought a lot about it, I think I'm going to

give Michelle and you one session out of my week with him, and in that session, you girls are going to talk to him about sexual education. Milton is going to explain everything to you, sexual, everything, because I'm not going to explain it to you. Everything you want to know, you're going to talk to Milton about, but not to me, to Milton." I was so excited. Jennifer said, "Marin, I'm going to call your mother, Brooke, and make sure she knows that I'm going to send you for one session." I was so excited and thrilled to be taking up an hour of Jennifer's time with Milton. Jennifer had told me how much Milton meant to her. I'd heard how she had seen him for years and years. I knew that we, Michelle and I, had to get the most out of it. I was deeply curious as to what we were going to talk about. I couldn't wait to hear his stories.

Jennifer got up a little earlier that day Michelle and I had the appointment with Milton so she could drive us there. It was a big deal because you normally never saw Jennifer before eight o'clock at night. It was her hour with Milton, which she had never given up to anyone. Michelle and I dressed up. Jennifer was famous for getting to Milton without her hair done. She would go covered in a scarf with dark glasses. The valet would take her car downstairs in the dark parking lot and she'd take the elevator straight up to his office so she didn't have to be seen. But that day she also got dressed up and waited downstairs in her little Mercedes coupe, the car still running.

I asked Milton a lot of questions, and he said, "Well, first of all, let me tell you, this is how you get a man. I just want you to know about Pamela Harriman." He was very up-front. I don't think you gave names, even in those days. He said, "Jennifer Jones was once in a restaurant with her husband, David Selznick. This was in the 1940s or 1950s. And Pamela walked in with someone very handsome and very promising. Jennifer felt very naïve and said to David, 'Well, gee, you know she's always with the most handsome and the most dashing and attractive

men, and yet she's not that beautiful, and she's not a movie star, she doesn't have that kind of beauty, David. What is it about that woman that she can get any man she wants?' And he said, 'She doesn't take her eyes off of him the entire time she's with him. She looks at him the entire time. She orders for them both and takes total care of them, but never takes her eyes off of him.'" That was Milton's big story for me.

Then I got a little racy and I said to him things like, "Well, what do you do in bed?" And he's like, "Well, there are three kinds of women. One is a policewoman who tells the man exactly what he should be doing: a little here, a little there. She's very controlling. And you definitely don't want to be like that!" I remember I was like, "Okay, don't be too bossy in bed." And I said, "Well, tell me about a man's penis." Michelle was in a coma. I think she was in such shock that her grandmother had brought her to this man. He said, "Okay," and he drew us a diagram! He showed us the most sensitive points, where to touch exactly. He was very instructive, very medical about it. And I remember saying, "Tell me exactly where that is." And he showed us on the diagram. Michelle was so embarrassed. I was asking so many questions, and I said, "Thank you very much. It's been wonderful talking with you." And I left with that diagram in my bag. I don't know if I showed it to Jennifer or not but I think I took it home.

BOB WALKER: Marin Hopper and Michelle were early teenagers when Mom sent them to see Milton to have a talk about sex. So Milton said to Mother, "I'll see them on condition you don't ask me any questions afterwards." And of course, she couldn't help it. She started digging. She was bursting at the seams to know what they were told. "What did they talk about?" But Milton said, "They knew more about this subject than I ever will know."

I think Mom needed Milton. And she loved him. At some point, Frank Gehry, Julie Andrews, Blake Edwards, Sally Kellerman, Bud

Cort, and Mom, among others, were all in group therapy with Milton. Mother used to say to him, "Milton, I'm your only patient that never graduated."

MILTON WEXLER: People in the film world gravitated to me one way or another. I don't have a clue as to how it mounted, but gradually I started meeting directors and actors and some of them joined my group. A lot of them, you know, were fairly well known. So the whole thing started to spread. And then they began to put stuff in the newspaper that was irritating to me. "Analyst to the stars" and crap like that. I wasn't an analyst to the stars. There were a couple people that were star quality, I guess, but you know, it wasn't as if the stars in Hollywood were flocking to me.

I found the group sessions quite extraordinary. I knew nothing about it all when I organized my first group with painters and sculptors and people like that. I had successfully treated John Altoon for schizophrenia because of my research on that sickness at Menninger's, so I suddenly had a reputation in the art world. The trouble was artists don't pay their bills, and I was becoming bankrupt. So I said, "Fellas, I can't do this anymore. We've got to do something different. We've got to form a group." I created my own process, my own techniques, my own everything. I was quite flabbergasted by the results. The artists were such fun. Even though everybody loved everybody, they were scathingly critical of each other. There was something about their warring that seemed to produce some kind of creativity. At one point I said to them, "The competition is so keen that you're all paranoid killers." The dynamic was extraordinary. I would allow anything in group—yes, I would allow anything. But then of course in that kind of group, no matter whether an attack was justified or cruel, the attacker would be immediately attacked back. And I would make sure to call on somebody who would take up the cudgel to say this kind of cruelty was not

acceptable. I did not have to become a participant. It was a wonderful laboratory to observe human behavior and the human interactions.

BOB WALKER: I remember at one of those sessions at Milton's office on Roxbury Drive, a man came in with a gun. Half of Hollywood, old Hollywood, is sitting there. The man didn't bother Mom, didn't ask for her rings or anything, but he robbed the other folks. She remembered that she tried not to stare at him. She never made eye contact. She became invisible and extremely cool. She said she'd remembered something that I had said: "I'm in the ocean, in my kayak, but I'm not worried about the sharks 'cause I can neutralize them." Somehow she got that into her head, and so she was just in there thinking, What would Bobby do in this situation? He would neutralize the shark. So she became extremely calm and got through it fine. But that's not what I meant. Neutralizing the shark is about coming to terms with the fear that's within you. That's actually the shark you want to neutralize, the shark of fear. And the way to do that is to embrace it. I'm sure Milton was a picture of calm and reason. He was that kind of person.

SALLY KELLERMAN: There were twelve or so of us, and we'd meet for about two hours at around seven at night on Thursdays. I remember I had on a pink off-the-shoulder sundress because when I walked into group, and everybody said, "Oh, you look so beautiful tonight. Oh my gosh, Sally, you really look great."

Ira Barmak, a producer, was there that night, just back from Mexico. He was talking about his moon ring, which had something to do with some guy that he was seeing. And he also had a loaner watch, because his watch was being repaired and there was some problem. So there was a lot of discussion about all this. And suddenly there's a knock at the door. Milton says just, "I'll be right back," and he goes out to this little anteroom outside. He's gone for several minutes, and we're

all laughing, making comments about why he was taking so long. And somebody says, "Maybe it's a robbery." And then Milton comes back into the room with a brand-new briefcase. He puts it on a table in the middle of the room, and he says very calmly, "Put all of your money and your wallets in there." I'm thinking to myself, What are you up to now, Milton? What are we gonna learn from this now? And suddenly a guy whirls around the open door with a gun that looked huge. In my mind, I see him wearing a three-colored hat, like a beanie, from the Middle East. He was black and dressed all in black. And he says, "Put every dollar and penny you have in that bag. If I find one penny on you, you're dead." I dug through the bottom of my purse, ripping out the lining and taking every penny. And I never looked up, because I thought I was looking so beautiful that night that if I looked up, that he would kill me. One person took off their ring and sat on it. Somebody else took a hundred dollars out of their wallet and did something similar. In those situations, you don't really think you're going to be the one to be shot. I was sure that I was going to lose some friends that night. It was really scary. After I had thrown everything in, I just sat there.

Ira Barmak, the guy with the moon ring, decided to stare him down. So the mugger says, "You. Get up here. Give me that ring and that watch." Now remember, we had Donna O'Neill there, whose husband owned all of Orange County. We had Jennifer Selznick Simon. And people actually risked their lives to sit on a hundred-dollar bill or a ring. I was just amazed. We're all sitting there sure that someone's going be shot. And then the mugger says, "Okay, I'm gonna go now. And you don't move out of this room or I'll kill you." And Milton says, very calmly, "Well, how long should we wait?" The guy whirls the gun around to Milton, and he says, "Are you fucking kidding? You want me to shoot you or something?" And Milton goes, "No, I just—" "Well, you better shut up." I was sure he was going to kill Milton. And he left the room. It was so scary. But that evening sure cured us. Nothing bothered us anymore. The moon ring, the watch—all those seemingly

important issues weren't so important anymore. We sat there for the longest time, chagrined at the shallowness with which we'd been dealing that night with our lives.

The next night, all of us met at a hotel to talk about everything. Everybody had something different they were feeling and saying. Milton was intrigued by people's reactions. What I remember most was Jennifer saying, teary eyed, that she had nothing to give the robber. She had no jewels and no money in her purse. She had nothing to give the robber. And that worried her.

We all had to give our reports to the police. I reported seeing a three-colored hat, but other people didn't see a hat at all. They never found the guy, but it did get in the press. And here's what it said: "Ninety-eight dollars' worth of jewelry was taken." I think if the guy ever found out who was really there, he would have shot himself to think of what he could have walked away with.

BUD CORT: Milton was like a myth in Hollywood. I don't know how Jennifer met up with him, but she covered the waterfront and it wouldn't have taken her long to figure out who was the guru of whatever she was investigating. The first time I met her was at one of Milton's various benefits for his Hereditary Disease Foundation. *The Song of Bernadette* had been a seminal movie for me. And then the more I watched Jennifer's work, the more I realized that she had a divine madness. You could see what a tender, vulnerable creature she was onscreen. Being her friend was like being friends with a unicorn. And to be in the movie business, it's completely schizophrenic. Every second you're on the set, you're touched, you're mauled. It's like a molestation. We ended up in Milton's group together. Milton was a doll. He filled a gaping hole in my being. I'm an actor. You know what I mean?

I didn't know Norton that well at all. But I remember sitting down next to him at a dinner one night at his home in Malibu. He said, "What are you doing sitting next to me? This is supposed to be boy-girl,

boy-girl." And I said, "You're just being a fuddy-duddy." I'd never had a father, so I wasn't too great with guys. Bob Altman heard our exchange and said to me, "Don't you know there's a secret to getting along with everybody? You just make believe that they're all on acid. Then it's easy not to take anything too personally." Norton and I ended up talking, and I thought he was great.

WALTER HOPPS: Several years after Jennifer and Norton had bought John Frankenheimer's house, they decided to buy the house next door, at 22368 Pacific Coast Highway. The Garland house. Norton totally redid it. There were some really grand houses built there in Malibu, most not enormously grand, but this was a three-story house. It's so crazy to have seen the house in the context of the Garland family—old man Garland long dead—and then to see that Norton and Jennifer had fixed up that same house for an additional beach house, you know? Same damn house. Lord knows who has it now. Serious enough house that it wouldn't have been torn down, I don't think.

BRODRICK DUNLAP: After Grace Garland left the house and before the Simons moved in, it sat empty for eight or nine months. People vandalized that house like you wouldn't believe. We used to shoot into it, *boom, boom, boom,* blow the windows out. And we'd go in like it was a haunted house and creep around at night. It sure had a strange history. Both Jane Garland and Mary Jennifer were definitely touched. In the evenings we'd go over there and skateboard in the pool.

FRANK GEHRY: When Norton Simon asked me to do his second house in Malibu, I showed him my sketches and he said, "This looks like it's your unfinished symphony." I said, "But Norton, Schubert died, and I'm still going strong." So he said fine. He liked it. I started making it, and I didn't know how to do it, so I did one layer at a time. I got the first

layer down and I was just starting the second layer and he stopped me. He wouldn't let me do more. So that's why it stopped there. The budget wasn't even a million dollars, just two or three hundred thousand.

Norton was difficult. He was really controlling. He wanted to control me, control the price, the costs. He was a control freak. He wanted to control how much he paid me, or didn't pay me. If you think about it, it was abusive, I guess. And he was very tricky, because he gave me a budget and then wouldn't pay for all the additional changes. He called me one day and said, "Jennifer thinks the tile looks bad, what can you do about it?" The tile roof on this house was old Spanish tile, like all the houses around it, and Jennifer one day looked at it and said, "This looks like an old gas station." She hated it. I said, "Well, there's lots of tile, you can replace it." Norton said, "Can you show me what you can do?" So I found the best tile made, it was made in the Midwest, and I showed it to him. He liked it. He said, "Can I order that?" I said, "Well, it's a different shape, you'll have to redo the roof, different weight. You'll have to pay me for doing it." He said, "I hired you to do my house." So he didn't want to pay for the change, the detailing. We ordered the tile and they'd agreed to a certain date. But they missed the date, and he got pissed off. Norton called the company and got the name of the president and then he went out and bought the company and fired the president. Pretty good, huh? So he was a ruthless little motherfucker.

WALTER HOPPS: Unlike the industrial tycoons from the past, Norton had a deep ambivalence about making a lasting mark in society as a monument builder. It wasn't until 1974 when the Pasadena Museum found itself in dire straits that he negotiated a deal to house his collection. Men of potency with a lot of social power and ambition have to really worry about death. Let's accept the sophistry that those with exceptional skills, drives, and resources face the question: "By god, something will stand to outlive me."

HAL GLICKSMAN: My position at the Pasadena Art Museum was pre-parator. I hung the pictures. The trustees didn't have enough money to keep it going. Simon didn't come in through the basement and sabo-tage the thing. It was headed for the rocks when he got it, just months away from closing its doors. And Simon got it for absolutely nothing. What he did was really high-handed. The trustees came to him time and time again to help them and to bail them out, and do a partner-ship, or anything he wanted, and he kept saying no until he saw that this thing was absolutely on the rocks, and he could get it for next to nothing. He just reveled in, you know, humiliating people and making them grovel and making them jump and everything else. Ruthless. A shonda for the goyim. Until Milken came along, Norton Simon was probably the most hated Jew in America.

BOB WALKER: When Norton developed Guillain-Barré syndrome, he and Mother moved to the Beverly Hills Hotel for a few years. For the rest of his life he had twenty-four-hour nursing, but I saw how his mind still worked fine. He said once to one of his nurses that he would give away his entire fortune, every dime he'd ever made, if he could just stand again for five minutes and feel the earth beneath his feet. I re-member when he was walking on the beach, the joy he got out of walk-ing and being in nature, I mean what for him was nature was the beach.

He was a rare bird, an odd bird. If you had to be in business with him, I think he could have been pretty difficult. But I never asked him for advice. I'm like a knife through butter, going through life avoiding the hard edges. He was always probing and asking questions about my situation. He was always interested in what my second wife, Judy, and I were doing and how we were getting along. I did have a confrontation with him one time when he was trying to convince me that I should declare bankruptcy for Tops in 1990. Tops was the art gallery I'd started with Judy. Business wasn't great. We were trying to

make a little money doing it. I found myself raising my voice trying to explain to him, "Norton, I love this business." I finally yelled, "We're not gonna go that way." Here I am yelling down at this man who's totally paralyzed in a wheelchair. I remember feeling rather uncomfortable, kind of standing up that much higher than him. Tentatively I decided it was time to be on my way. The next thing I knew, he was chasing me down the hallway of the hotel in his wheelchair. And he's barking at me like a wild German shepherd. I couldn't believe it. He had me cornered. He was ferocious in his desire that I understand. He had me against the wall, but I refused to give up the gallery.

Later on they moved together to a house in Bel Air, but the next year, in 1993, he died. We all went to distribute Norton's ashes in San Pedro Bay, at the entrance of the Los Angeles harbor. I had arranged it. I rented a boat from this guy that I'd found in the Yellow Pages. The boat was rather large, maybe seventy-five feet long with one open deck, but you couldn't go down inside. We were quite a few of us. There was the whole damn family. It was quite a scene. We all stood on this deck in the windy afternoon, on this funky old wooden ship, motoring out into the San Pedro harbor with Norton's ashes. And these people were not seagoing people. These were the people in high heels and bouffant hairdos that you would have seen at Norton's eighty-fifth birthday party at the Norton Simon Museum, holding cocktail glasses. They looked like they'd never been south of Doheny Drive.

JUDY SIMON: When my father-in-law died, Jennifer called my husband and said, "Would you like to see his body? It will be taken away soon." And Don said, "Yes, I think I'm going to come over. I want to make sure he's dead."

FRANK GEHRY: Two years after Norton died, Jennifer called me and said, "The Zurbarán painting doesn't look as good as it did when Nor-

ton was here. Would you come and look at it and tell me what's wrong?"
I went and looked at it, and I said, "Well, the color they painted the
walls is problematic." Sara Campbell, who was the museum's curator,
started painting the walls of the museum after Norton died. It was all
white before. It's not that you can't paint walls to put paintings on, it's
being done all the time, it can look good, but you have to be careful
what colors. And whoever was picking the colors wasn't cool about it.
And it became clear that what Sara had done was to display the paint-
ings in some kind of academic fashion. She put them all in chrono-
logical order, equally spaced around the room. It was sweet, but it lost
the power of the work.

Jennifer put me on the board of the museum, and the other mem-
bers said they wouldn't spend any money. I talked to Jennifer, and I
said, "Look, I'm not an expert on nineteenth-century French paint-
ings, but John Walsh is in town, can I bring him out?" So I brought
him out and he looked at it, and he wrote me a note. I had said to him,
"Give me ten commandments." I got Carter Brown to do the same. I
got Seymour Sly to do the same. I got Wolf Deeterduva, from Ger-
many, and then Irving Lavin from Princeton. They gave me the ten
commandments. The first on everybody's list was to tear the building
down and build a new one. I think they were just being nice to me.
Then they said that the show was arranged too academically. The rela-
tionships between periods weren't carefully done, the way it should be,
with that quality of work. The rooms were hard to hang because of the
curved walls. The lighting wasn't working. There was a problem with
the continuity of the galleries, 'cause they were designed for contem-
porary work, so they didn't have rooms, so you couldn't define periods.
I had each one of them meet with Jennifer. And we talked it all
through, and she asked me to do a study for free. I was on the board, so
I couldn't turn it down. I did the whole thing, showed them how to do
it, within budget, leaving the curved walls in, trying to just do a few

skylights, reorganizing. We said we would do it, 'cause we didn't want to close the museum down. And I said to my wife, when I was doing it, "Norton would roll over in his grave if he knew I was redoing his museum." My wife said, "Frank, stop it. Norton planned it this way. How much are you getting paid for doing it?" I said, "Nothing." We did the first five galleries and found asbestos. Those five galleries were shut off, the asbestos guys came in, they had to take out the ceiling. When they took out the ceiling they found asbestos had gone down behind the walls, they had to take out the walls. I was adding a couple skylights, so they had to cut holes when they took out the ceiling. They cut the hole for the skylight, and it rained and the floor, the parquet floor buckled. So they had to take out the floor. I said to Jennifer, "I didn't do that on purpose, but here's where we are, it's all stripped down to concrete, and it doesn't make sense to put back the curving walls like they were." Now this is ironic. Me, who does curvy walls, was trying to straighten everything out. She agreed with me. So we rebuilt the five galleries the way they are now. Very fine.

We had a board meeting. Gregory Peck came, and Milton Wexler came, and Jennifer and the lawyer Matt Byrne, and the Ann Landers advice columnist, Eppie Lederer. We had set up lunch in the main gallery, which was all new, all changed from what they saw, rehung with all the paintings. It looked drop-dead gorgeous. And all of them sat in the room, had the lunch, nobody commented, anything on anything, zero. At the end of the meeting, I think Eppie turned to the chairman and said, "When are you going to start remodeling?" And Milton was semi-blind by this time and he was the only one who knew. He had leaned over to me and said, "This is gorgeous." He barely could see it! So when Eppie said that, Milton had a cow. He said to all of them, "You're sitting in it, you idiots." So we did finish the museum. We did it for under six million dollars, all of it. I got the garden changed, it was a million out there. I wanted to redo the auditorium, and they

wouldn't let me, they didn't have any money, and I wanted to put a sound wall in the garden, because when you go out, all you hear is traffic. And Jennifer wanted me to do a teahouse in the garden. I started designing it, and I actually got into it with her. Her fantasy was Arabian nights, you know, Jennifer had this thing about the knight on the horse coming and carrying her off to a tent, ravishing her. She used to talk about it all the time. I decided to make her that fantasy in her garden, I was getting close to it. So I've done all this other stuff for free, but I can't afford to keep doing this. I was getting engineers and stuff. And at the board meeting, Frank Rothman, the lawyer for the museum, turned to me and said, "Oh, we can get a USC student, to do it cheaper." So that was insulting. But Jennifer was in cuckoo land by then, and she didn't know that I was being insulted. She got it into her head that I was being paid the four and a half million dollars, the price of the interior remodeling. She called me and started screaming at me, "We paid you all this money!" I said, "Jennifer, I did everything for free."

BOB WALKER: Into his late nineties Milton was still giving Mom her two-hour sessions at his apartment on Ocean Avenue, where he lived by then. She would come see him at his home three times a week if not every day. Once when she came to see him for her session, some people found her lying on the floor in the lobby, in front of the eleva-tors. She must have had a dizzy spell and just fallen, but they didn't know what had happened. She was somewhat incoherent. She could've broken something or she could have hit her head. She was very disoriented. Her balance was getting really bad and she was walk-ing with a cane, an elegant white cane I gave her from Tops. They called up Milton, he was on the eighth floor and came down to see if she was all right. But what could he do, he was using a walker himself, he was probably ninety-seven. He just said, "Let's call 911." She was

taken to the hospital for all kinds of tests but they couldn't find any-
thing wrong with her. She had to stay there and be "re-electrified."
One day she just took off from the hospital, marched out and walked
over to Westwood. They found her at some hotel over there just sitting
in the lobby. We finally had a bracelet made for her, a beautiful gold
bracelet, so she would know her name and her telephone number. We
tried to make her believe that Milton had given it to her so she would
wear it.

DAWN WALKER: I knew Jennifer was in the throes of dementia when I
married Bob. One day she left her handbag at Milton's. She was still
going to see him every other day. He was a port in a storm, but that day
her defiance reared its head. She had been driven to Milton's by her
assistant, Paul, who had originally been Norton's runner or gofer. Her
session finished, and she came down by herself, and Paul met her in
the lobby. Milton came down after her and said, "Oh, Jennifer, here's
your handbag." She had left it behind from the previous session a cou-
ple of days earlier. And she said, "No, I'm not taking it. It doesn't match
my outfit. I'll send a messenger. I'm sorry to bother you with it, but I'm
not taking it, I'm going somewhere." So Milton said, "Take your hand-
bag! Jennifer, you're losing your money. Be realistic. They're telling
you your money's not gonna last. This is ridiculous, spending sixty dol-
lars to send a messenger to me. You're here right now. Take it. Paul can
carry it or put it in the car. Your handbag's holding you hostage. Don't
you see it?" And what's in the handbag? A mirror, a comb, lipstick.
That's all she ever carried. But she absolutely refused, and so she sent
a messenger because it didn't match her outfit.

BOB WALKER: We didn't go to Milton's funeral service, it was probably
only family members. Mom did make the memorial service at Carrie
Fisher's place. She managed that. It was a major, major party. Every-

body she'd ever seen in her life was there, but a lot of the time she wasn't aware of what was going on. It was impossible to get up to the house somewhere off Coldwater Canyon Drive. Mom had to be in a wheelchair, so we had to go up this dirt path that was behind the tennis courts. It was crazy. All the best doctors, all the best analysts and scientists were there. It was an incredible get-together. Mom wasn't sure if Milton had been her husband. She'd talk about him: "I miss him, were we ever married?" "No, Mom, he was your analyst." But she knew he was someone really close to her.

I never saw Milton as a patient, and neither did my brother, Michael. I'm sure Mother would have been happy if we had; Mother was happy when everybody was in therapy. For the last thirty years of Michael's life, he was living in a small apartment in the Valley, on Victory Boulevard in Van Nuys. At one point he worked at a gas station across the street from Whiskey A Go Go. He had been a bouncer and he'd worked at a clothing store and on a kibbutz and at a funeral home. He even volunteered at a 7-Eleven to help the night managers stock the shelves. He got robbed one night. The robber chased him through the store and put the gun to his head, but it misfired. I mean he'd done everything. I have visions of him with a yarmulke on his head, careening through the streets in a hearse at seventy miles an hour, stoned, like in a Hunter Thompson nightmare. And then during the funeral, he managed to tip over the coffin, ingloriously or gloriously, and out tumbled the remains of old Uncle Herman in front of the assembled multitudes. Since Uncle Herman was in the coffin, nobody felt they had to put pants on him, for god's sake. Of course, Michael couldn't continue working there after that.

At some point, he quit drinking and started attending AA and other kinds of meetings. He called me one morning and said, "Bob, I'm sorry, I really have to apologize to you. I think I've done you a great disservice." And I said, "What could you possibly have done?" And he said, "I go to all of these meetings, and one of the meetings I go to is

Survivors of Incest Anonymous." And I said, "Really? Wow, that's inter-
esting." And he said, "I got up at the meeting, and I don't know why I
said it, but I said that I was a victim. When they asked me who the
perpetrator was, I said it was you, Bob. I'm so sorry." I said, "Really?
Me? That's fascinating, Michael." He said, "But it's just a matter of
time. This is supposed to be anonymous, but since our parents are
people of note, it's just a matter of time before people find out, and
you're going to be accused." I said, "Well, how old were we at the
time?" "Three and four." I said, "But you don't remember any specific
incident?" He said no. He was obsessed about it for months, and I tried
to joke him out of it. I'd be very interested to know what I did when I
was four years old. I said, "Michael, set your heart at ease, please. You
have probably done me the greatest favor that anyone has ever done for
me in my life. If this gets out, I'll probably never stop working in this
town again." This town loves scandals, you know.

DAWN WALKER: I had never had a migraine headache until the first
time I met Michael. He was such a tortured soul, and it was so appar-
ent. Poor thing, he could overthink everything. Whatever life brings
us, Bobby's attitude was process it and move on, and Michael's was
hang on to it at all cost. I personally can't imagine spending that
amount of energy in misery on purpose. But I did see his brilliance
even in the craziness. I thought he was terribly funny, and his cos-
tumes never ceased to amaze me. When one was expected to turn up
looking somewhat dressed, Michael would want to turn up just the
opposite, just for the shock value. We'd be meeting at the Bel-Air Hotel
for lunch with Jennifer on Father's Day or something, and Michael
would show up in a baseball cap and his plastic bag from the 99 Cent
Store in his hands, and his jeans all torn up, and all sweaty from chas-
ing the bus because he wouldn't let anybody pick him up. He didn't
want to bother us.

Jennifer described the two brothers as Nickel Pickle and the Joy

Boy, because Michael was always a little bit of a sourpuss, and Bobby was just always on to the next thing. Michael idolized Bobby. Bobby was his hero. And when their dad died, Bobby really became his everything. He really loved him. Like, I would never say this to Michael's daughter, Amy, but the only thing Michael ever loved was Bobby.

BOB WALKER: All those years in the Valley, Michael really lived the life of a recluse. A good part of Michael's time was spent in an apartment closed in with his demons. His mind was always racing a million miles a minute, navigating emotional labyrinths with minefields everywhere. It was a horror in a way. I can see how you would feed on that and begin to identify with your pain and your suffering so much that you don't want it to go away. You want to have these problems, because they are who you are. For instance, long ago Michael shaved his head. He did it to bug Mother, who loved his long hair. And he used to cut his eyelashes. He had long, long eyelashes, and he thought they were girl's eyelashes. People always commented about how beautiful they were, but he thought they were making fun of him. So he used to cut those, too.

He was most comfortable with street people and people he'd meet at AA meetings and other self-help groups. He was like a professional goer to these self-help groups. And it kept him sober. He was uncomfortable with the educated, I think, even though he'd had an education and he was very smart.

AMY WALKER WAGNER: My dad had the money to take care of himself. He had insurance. He chose the way he lived, and he chose the way he took care of himself. I mean, he had money to pay for his apartment but he lived very modestly, and he didn't have a lot of things and didn't want a lot of things. But he had enough money to pay for his living expenses. And I've always felt that if he didn't have that, he probably would have been homeless. I could see the mental state that he

was in, at times, and he couldn't have taken care of himself. Fortunately he had a lot of financial sense, and he was very good at saving money. It was funny. On his death certificate, Dawn had to fill in something for occupation. Dad never liked to be associated with acting as his occupation. So she put down "finance."

BOB WALKER: Eventually his body started breaking down. One day the phone rang and it was Michael calling from the hospital, saying, "They told me I should call somebody in my family because they are going to operate tomorrow." He had been in the hospital ten days and didn't call us. He had collapsed in the courtyard of his apartment, and the neighbors had taken him to the hospital. The neighbors told me they wanted to call us, but Michael said, "No, don't call them, don't bother them." Like Mother, he didn't want to bother anybody. He had been really sick, and he was trying to self-medicate. He thought he just had a cold, but his lungs had collapsed. And he had severe emphysema and severe osteoporosis. He was all bent over towards the end, just terrible.

We brought him home after he left the hospital. But he just wasn't able to abide by our one rule: be kind to Mom. He was aware that she was descending more and more into dementia, and that might have depressed him. And maybe he felt that now he'd never be able to make his peace with her.

We went through a lot with her dementia, but we were able to handle it all, because we all felt a lot of love for her. And even though we wanted to have Michael at our home, he wasn't able to be kind to her. If she would say, "Hey, Michael, how are you?" he would ignore her completely. He just would almost freeze in place and not react. And while Mom wasn't aware of Michael's illness, she was aware that he was being rude to her. At one point she said, "Don't talk to your mother like that." So I finally told him that this kind of behavior was not acceptable. He was sick, in really bad shape, but when I said that,

he marched out of the house. He must have felt like he was a kid again, back fifty years, being controlled and judged by Mom, under her scrutiny, or maybe even not being loved as much as I was. I followed him out and said, "I appreciate your problems, and I'll talk to you as much as you wanna talk about it. But we have to be kind to one another and acknowledge one another as being part of this experiment here." But he kept on walking and somehow got a bus to take him back to his apartment. This was a man on his last legs. He lived probably another year afterwards in that hovel.

I don't think he ever had a moment's peace, even after he moved to the assisted living home. The angst and the worry and the anxiety and the fears were all there. And memories. The last time I saw him he was lying on his back, looked near death even then, although I was in denial. His arms were literally thinner than a banana. And every day he seemed to get weaker and weaker. He was eating properly at last, but for years he had been malnourished. I remember him sitting at the table on Thanksgiving a year earlier and what teeth he had starting to crumble in his mouth. He sat there with his teeth in his hands and a look on his face like "What's happening to me?" He had smoked three, four packs of cigarettes a day, and at the end he started popping cough drops instead of smoking cigarettes. And he lost weight every day. It finally got to the point where he didn't even have the strength to lift a spoon to feed himself.

We got a call at three in the morning. He must have felt a heart attack coming and reached for the cord to call someone and tumbled out of bed. He must have gone right away. It suddenly hit him. He just got so weak that he just couldn't go on anymore. I think he had a serious infection. He'd had all his teeth pulled three weeks earlier, all twenty-three of his teeth, because he hadn't seen a dentist in forty years. And then he just seemed slowly to go down, down, down, down, down. I was with him two days before he died. One of the last things

he said to me, tongue in cheek, was, "This has got to be my punishment for being a lapsed Catholic."

But now he's free. After he died, we scattered his ashes on a hill at Point Dume overlooking the ocean. It's so peaceful. And he is there with the lizards and the wind and the breezes and the rain and the crows calling.

One of my best memories of Michael is from when we were traveling up to Utah. I was coming down off of I don't know what, I was getting sober again, one of my Robert Downey episodes. I went up there to rehab myself. I don't know what Michael was doing. He was probably sober. But I remember there was this wonderful hot spring on the Virgin River up in Utah in a town called Hurricane. Pah Tempe Hot Springs. The water was just the right temperature. We painted ourselves with mud there, me and Michael, and this was the most natural, the most real, probably one of the best times of his whole life, I think. He went out painted with mud and walked in the hills with a stick.

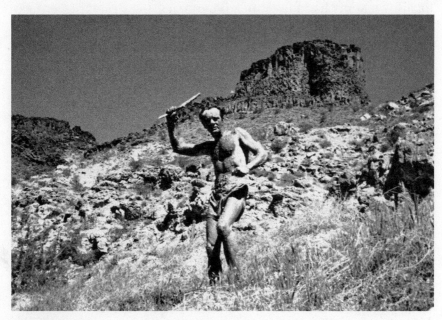

Michael Walker.

Then he came running down the hill like something out of one million B.C. It was almost like you expected dinosaurs to crest the ridge behind him. Like he was running from the cave bears. He came down like such a wonderful savage.

Two years after Michael's death, Mother was near the end of her life. It was costing five hundred dollars a month to get her Porthault sheets ironed and pressed. We finally set up a table in the garage, where Dawn ironed sheets. But eventually even the last remaining sheets didn't get ironed. Mom was way beyond that.

For three days just before she passed, she lay there with her eyes closed. She'd seen enough in her ninety, almost ninety-one years. She'd taken enough in and she was finished. She was even finished with eating, she just didn't want to eat anymore. So she just breathed and listened to the kirtan music and to us. About fifteen minutes before she left, her breathing got more gentle. She'd been breathing rapidly for about three days, but then it slowed, and then her eyes opened finally. I had my hand underneath her hand. I was right by her head and she just passed in this gentle beauty. We'll always carry that with us. Her breath just slowed to a gentle, soft whisper, and then no more breath, no more breathing, and that flutter in her wrist like a butterfly.

Colleen, her nurse, and Dawn dressed her in white and put little white flower petals in her hair, just gorgeous. Bud Cort had given her a rosary, which she was wearing, and some water from Lourdes and a silly ten-inch plastic Jesus that changed colors.

DAWN WALKER: I made arrangements at a little place called Conejo Mountain Funeral Home in Camarillo. They sent a van to pick up Jennifer, and they took care of all the paperwork that goes along with cremation. They called me when things were ready, and Colleen and I went there. While they were getting everything ready, we waited in a little room next door. We made a little altar on which we put roses, chocolates, photographs of Michael and Bobby and Jennifer's parents,

one of Bobby's purple handkerchiefs, the water from Lourdes, and candles. Before they sent her into the oven, we wrapped her in beautiful red cashmere blankets and we put a Virgin of Guadalupe pillow next to her. We took the water from Lourdes, two bottles, and we poured it on her, along with rose and lavender water. We kissed her, told her we loved her, and we sent her in. While we waited, we had a little kirtan music going in the background on an iPhone, and we talked about all of the events of the last six years. They brought us her ashes in a bag. I had brought the box that had held Michael's ashes. It had his name on one end of the box and hers on the other.

BRODRICK DUNLAP: Norton's first house is owned now by Arnon Milchan, a big wheel in financing in Hollywood. Haim Saban is next door, in the Garland house. He turned it into a fortress. Malibu today is no longer the town that I grew up in. In the old Malibu, we had a hardware store, we had a lumberyard, we knew the doctor, everyone in town knew each other. If I walked down the street and my car broke down, someone would pull over and pick me up. I'd go to the shopping center for lunch, and I'd know everybody there. They'd know my kids and everyone would say hello. We all rode our motorcycles up and down the beach, and no one cared. The beach was so very different back then.

WALTER HOPPS: I would be remiss if I didn't recount the surreal twist of fate having to do with the last day of Bobby Kennedy's life, which he spent in Malibu. A few years before the Frankenheimers sold their beach house to Norton Simon, they volunteered it to Bobby Kennedy toward the end of his campaign. That afternoon, one of the Kennedy children got caught in the surf—it was rough out there—and Bobby went in to save him and scraped his forehead a little bit. So Mr. Frankenheimer got some of his wife's makeup and fixed it so it wouldn't show when he gave his speech later that evening.

As the story goes, after the Kennedy boy was pulled from the surf, Grace Garland invited the children to swim in her pool next door. Before leaving for the Ambassador Hotel, Bobby and Ethel Kennedy went over to thank Grace, and she, knowing that they had a menagerie of pets at their house in Virginia, gave them a monkey, a spider monkey named Mr. Magoo. The monkey had belonged to Jane Garland. It was an impossible, miserable critter to give to anyone, and Grace gave it to the Kennedys.

BRODRICK DUNLAP: The Kennedys went off to the speech and never came back. Everyone was gone. They left behind a little spider monkey with a rope stretched between two trees so it could go back and forth. I remember seeing the monkey in the tree for a couple of days. And then one day the monkey was gone.

V

THE STEINS

1330 Angelo Drive, Beverly Hills

The entrance to Misty Mountain.

JEAN STEIN: I still remember listening at night to the cries of coyotes around our family house, which was known as Misty Mountain. It was built by Wallace Neff during Prohibition for Fred Niblo, the director of the first *Ben-Hur*. Its site high up in Beverly Hills led me to imagine as a child that we were far removed from town. Even then I had the sense that my world was make-believe. I recall my mother boasting that Orson Welles had come to the house with Dolores del Rio and praised it by saying, "This place reminds me of Berchtesgaden." In the mid-thirties when Katharine Hepburn lived there, she had to fend off snakes in the living room — or so I was told.

FIONA SHAW: Up there, you couldn't believe you were in Los Angeles; you were in Connecticut, or wherever you wanted to be. But of course as soon as you came out on the patio behind the house and looked down at the city, you thought you were in heaven, looking down at earth. Because it certainly had nothing to do with whatever was happening down there. And it was weirdly human scale. It was kind of a villa more than a castle. And there were a few castles around. You looked out the windows, there was a castle over here and a castle over there. And if you looked down from the house, it was two minutes as the crow flies to where the Sharon Tate house was. That's a dubious bit of history: "Sharon Tate was murdered just over there." Then the neighbors were worried about their dogs because they'd be eaten by mountain lions. So it was like, "Mountain lion over here, Sharon Tate over there."

It was a Spanish crescent house. Semicircular. And it looked deceptively low-rise. There was a floor underground, and as I understand,

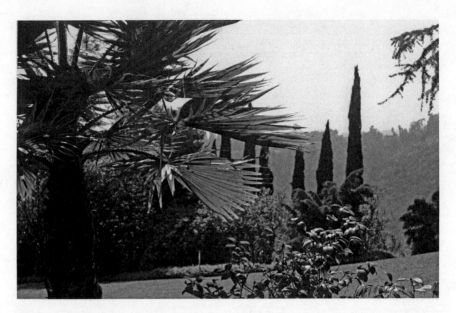

The view from Misty Mountain.

after dinner the guests would go downstairs, where there was a screen-
ing room and a bar. Much of the entertaining went on down there.
And then outside, it had hedged square gardens, which is my idea of
complete heaven. I want to die in a walled garden.

And then beyond the gardens there was a tennis court, surrounded
only by canyons. You know, you could sort of feel Katharine Hepburn
wearing some marvelous flannels, going *ping* with her racket.

I saw photographs of Jean's parents, and—you know, Bette Davis,
whoever was at the parties on certain evenings. There were more pho-
tographs of all of them downstairs in the bar adjoining the playroom
looking absolutely gorgeous, these women wearing tiny threaded fab-
rics with very scooped fretwork on their evening dresses, so that you
realize when they said, "Come to a party and hang out," that they were
having these incredibly stylish parties on a Friday or Saturday night.

Very exciting that the level of evening dress was early nineteenth
century right into the twentieth century. It wasn't just people in flan-
nels doing a lot of hands in pockets. People were really stylishly dressed.

Bette Davis and newsman Harry Crocker in the living room.

From left to right: Frances Goldwyn (Mrs. Sam Goldwyn), Mary Lee Fairbanks (Mrs. Douglas Fairbanks), Jules Stein, and Kitty Miller (Mrs. Gilbert Miller) in the screening room downstairs in the 1940s.

Of course, they all had martinis coming out of their ears. And then beyond the bar, there was a door that led to an exit for a fast escape in case of a raid.

JEAN STEIN: During the Second World War, my parents set up the secret room behind the bar as a kind of bunker, a bomb shelter, in case the Nazis . . .

FIONA SHAW: Came and got them. You'd grab a bottle of whiskey and just go behind your door, and you'd be gone. The bar had this high, high red leather back, sort of like being in a railroad station bar of the 1930s. And it was a tiny bar, and you know, it was a place where you'd just sit and you'd drink. Obviously top secret, or whatever you wanted to be.

DAVID "PREACHER" EWING: You remember before the house was sold you asked if I'd take pictures in the abandoned pavilion? By then it was in ruins, with vines growing in through the broken windows. This place, just ten feet away from the manicured lawn, was all withered so it was like the lost childhood. I had the feeling, like, did some horrible event take place there that everyone wanted to forget about? I mean, did somebody catch somebody having an affair there? Like, we don't talk about this, we don't think about this; we don't tear it down because it doesn't exist.

JEAN STEIN: I preferred it as a ruin. One of Preacher's photographs showed a rusty Electrolux vacuum cleaner laid to rest behind the soda fountain.

I asked Father one day why he didn't keep up the pavilion. It was just the two of us sitting on the patio. He looked far off into the distance, and he said, "Well, the children grew up and went away."

After my parents died, my half brother had the pavilion torn down

one day when I was away, because he thought its condition would hurt the real estate value of the property.

BARBARA WARNER HOWARD: I remember walking up to the lawn that led to the pool with the carousel horses. I used to adore the ice cream parlor. I loved the pavilion. I remember meeting Elizabeth Taylor there once as a little girl. We were sitting on the lawn. And she'd just done *National Velvet*.

WILLIAM EGGLESTON: I was wandering around the gardens. Didn't know where I was either. I didn't know the place—you led me around, you were my guide. I remember one beautiful night. I stayed late at the house, 'cause I think I'd had a couple of drinks. And I was probably waiting on Barney, the houseman, to take me back to the Chateau Marmont. It is a beautiful memory. You wanted to take a dip. So, next thing I knew I was in a lounge chair out there looking over the pool, you know? And you appeared wet in this—you were really good looking in this bathing suit. I don't know where we ended up that night. It might have been the night when I was going with you to Joan Didion's.

Walter Hopps had called me earlier. He described the house and said you hoped that I would be willing to photograph it. He said, "You've been to Graceland, right? Well, this is on about that scale but completely different." And I said, "Well, I'll do it for Jean." So I think I called you right away and said, "I'll be there." And that was the end of it until we started working. Those are some of my best memories, our working together out there. I loved that house. Whereas I hated Graceland.

That was a hard job, photographing Misty Mountain. I didn't know what to think the first time I saw it. I just attacked it like an attack. I did the best I could as a good soldier would.

The remains of the pavilion.

I didn't think the house was pretentious. It wasn't my style. But who cares? Mostly I remember Barney eating in the kitchen. Which is so funny. I took a picture of it. That's my favorite picture of the whole damn thing is Barney—your servant's fixin' a meal for himself. He's chowing down. It's like he's completely disrobed. He would certainly sit down at the table and help himself. I liked him very much. Barney reminded me of the kind of young man who would have landed in Iwo Jima or Normandy. You get me? I think he would follow orders.

JOAN DIDION: I remember making our way to the pool. That was the last night you would have possession of the house. It was quite dark. And exotic. I had not even known this pool was there, ever. And then I remember you ran into the house and got a memento for me.

JEAN STEIN: A huge bottle of perfume from Mother's mirrored bathroom.

JOAN DIDION: Which was Tabu. I still have it in the guest bathroom in New York.

MURRAY SCHUMACH (FROM HIS UNPUBLISHED BIOGRAPHY OF JULES STEIN): Born in Chicago in 1924, in this stewpot of crime, political corruption, dance bands, jazz and radio, was a little agency devoted to making money by booking bands in various parts of the Midwest, and by representing them for a commission. The company, with the grandiose name of Music Corporation of America, operated out of a

Jean Stein.

two-room office in a grimy building in the Loop. It was founded by Jules Stein, a dapper twenty-eight-year-old ophthalmologist, who had worked his way through college and medical school by playing the violin and saxophone in dance bands; by leading bands, and then by booking them while still doing his internship and residency in Cook County Hospital, Chicago, and while practicing ophthalmology in that city with one of the leading oculists in the nation, Dr. Harry Gradle.

The young doctor with a square jaw and lithe build abandoned a potentially lucrative medical career because he found booking bands more exciting and was convinced it would prove a quicker path to a Rolls-Royce, a seat on the New York Stock Exchange, and other luxuries that seemed so terribly prestigious to the son of Lithuanian immigrants who never owned more than a dry goods store in South Bend, Indiana, where he was born.

RUTH COGAN: The home I grew up in with Jules and my other brothers and sister was an ordinary house. Ugly, very ugly. We definitely lived on the wrong side of the railroad tracks. We lived next to our store. My father worked hard in the store. They sold notions and shoes and clothing to the farmers. Once in a while, they would trade a pair of shoes for whatever the farmers brought in as produce.

It was not a happy home. It was a kosher home. We had two pantries. There was a synagogue in South Bend, a very Orthodox one. The women sat upstairs and the men downstairs. I would say about forty families. It was quite a Catholic town. There was a lot of friction there. I would go down the street and they would call me "sheeny." My younger brother, David, too. I didn't like it, but I knew I was Jewish.

JULES STEIN (FROM HIS UNPUBLISHED BIOGRAPHY BY MURRAY SCHUMACH): I remember I used to go into my mother's room and put

all of this paraphernalia on me, read the Torah or the scripts or whatever it was, and I remember so distinctly my rebellion. It was too much for me. My parents had not outgrown the old ways. They were still the same. I was going to this Hebrew school and I had no idea what I was reading. And I thought I was a little above that. I just couldn't take it anymore.

I knew I wanted to go away. It wasn't that I wanted to get away from home, but I wanted to go someplace. I was expansive in my thinking, I suppose, even as a child. I was conscious, even then, that there were more important things going on outside South Bend.

During my high school days, I enrolled for a summer course at Winona Academy, at Winona Lake, which was known mostly for being the summer home of the evangelist Billy Sunday. I was using these extra credits to shorten my high school term. I was always urgent about everything. Time was always the most costly thing to me. This terrible loss of time seemed to me to be something I would never be able to recover.

It was my first time away from home, and I got so lonesome I almost went back to South Bend. However, Warsaw, Indiana, was only four miles away, and since this was a resort town, I got the bright idea of looking for a dance hall there in which I could promote Saturday night dances for the students of Winona Lake, which was also the location of the Indiana University summer school. I found a second-floor hall and made arrangements for the interurban streetcar line to run a special car from Warsaw back to Winona Lake at midnight. I printed postcards announcing these Saturday night dances and sent them to all the students in town. This was my first dance promotion.

RUTH COGAN: My mother was a strong, determined woman. And very ambitious for the children. Education was important to her. She encouraged your dad, my brother Jules, to go away to college. It was not a happy marriage with my mother and father. There was no love there.

They were just stuck with each other. Divorce didn't exist at that time. I think it was an arranged marriage. My father had already been living in South Bend and they wrote to Europe to send a bride. She was a very beautiful woman. Her name was Rosa.

Jules went to study at the University of Chicago. He graduated there, then he went to Vienna to study ophthalmology. When he came back he practiced with Dr. Gradle in Chicago. At the same time, he started this little band-booking business at 32 W. Randolph Street in Chicago with Billy Goodheart. It did very well. In fact, it did so well that he took a leave of absence from Dr. Gradle to start the Music Corporation of America business.

JULES STEIN (FROM HIS UNPUBLISHED BIOGRAPHY BY MURRAY SCHUMACH): When I got the charter for MCA, it was just a name. I didn't look upon it as a major decision of my life. It was a routine thing. I needed a corporate name. By 1925, I was getting bored with medical practice because 90 percent of it was just fitting glasses. Finally, one day I went to Dr. Gradle and asked for a leave of absence so that I could get my business organized. He agreed. For a couple of years after he still kept my name on the door of his offices. He was a wonderful man. I offered him 25 percent of my business for nothing. He wouldn't take it. I think that deep down when I asked Dr. Gradle for a leave of absence, I knew I would never come back.

RUTH COGAN: My oldest brother, Billy, and Jules moved us all to the Piccadilly Hotel in Chicago. But my father was left behind. My mother was very strong, and my father was, I would say, on the weak side. I think my younger brother, David, identified with my father, who was a weak person, because he knew he, too, was weak.

JEAN STEIN: I have a distinct memory of meeting my grandfather, Father's father, one day when I was six years old. We were in the garden

outside our house, and Uncle David came by with an old man in a big felt hat. Father really loved and admired his mother, but he had no admiration for his father. I think Uncle David identified with his father because they had both sort of failed in life. So there I was in the garden, looking at this man I was told was my grandfather and wondering why he was wearing a big felt hat. I'd never seen such a hat, and I thought he must have been awfully hot wearing it in the sun like that. It really baffled me. Later, of course, I learned that he wore it because he was an Orthodox Jew.

DAVID STEIN: My mother always thought Jules was going to be the bright star of the family. My father was less imaginative. But he was a worker who built up his department store next to the house where we lived. And he was very much, I think, the follower of my mother's desires, in creating an atmosphere for the children.

When MCA started, I was doing jobbing dates, playing in Chicago with all the bands from the time I was about sixteen years old. I was having a good life. I was a member of the union and playing in orchestras. I loved to play the saxophone. And your father gave me my first saxophone lessons. My mother was very anxious that the boys— meaning Billy and Jules—should advance and not stay in South Bend. And should go on their own as fast as they could. Which they did.

My mother got Parkinson's and died. And my father died a lonely man. Lost, cast off to the side. My oldest brother, Bill Stein, who was a few years older than Jules, had a weak heart. He was a very bon vivant character. He loved show business. He was a good-looking man. Very artistic. He followed show people, and he was very involved with the beginnings of MCA. He died too young. We had a lot of tragedy in our family.

RUTH COGAN: Billy went to Notre Dame in South Bend. He always had one shiksa after another. He screwed around quite a bit. God for-

bid, never Jewish. Maybe he was trying to project himself in a new image. He had a heart problem. He ended up with an amputated leg.

Early on Billy was in business with your father for a little while. I think he's the one that discovered Lew Wasserman. He was an usher in Cleveland and Billy brought him to Chicago.

LEW WASSERMAN: Jules Stein created a whole industry. I don't think people realize that but he certainly created the traveling band, which in those days never existed. And he certainly had the vision in the area of the one-nighters where he took bands to towns. Isham Jones told me the story about how your father signed him up. He was playing at the Hotel Sherman. He was getting twenty-five hundred dollars a week, which was an incredible sum of money, and he said that this young man came up to him, admired his playing, and told him he wanted to talk to him about going on the road. And Isham Jones said to the young man, "Do you know how much money I make? Twenty five hundred dollars a week. The only way you can get me to leave is if I get a certified check for ten thousand dollars for four weeks and a Pierce-Arrow bus," which was the biggest bus of all. And he forgot about it. Four or five days later, your father came back with a certified check for ten thousand dollars. Jones didn't realize that when he went out for the trip he got the ten thousand dollars by getting deposits from the places where he was going to play. And your dad made thirty to forty thousand dollars on the tour, and that started a company. No one had ever done it before. Your dad, because he had played Kansas City, knew there was a lot of money out in America in the early twenties.

JULES STEIN (FROM HIS UNPUBLISHED BIOGRAPHY BY MURRAY SCHUMACH): There was a time when I probably knew just about every town in the Midwest with a dance floor and its train connections. We

had contacted the headquarters of Western Union and we told them: "You could do a lot more business if you were to get the local offices to check out their areas and tell us where all the dance floors and promoters are located. In turn we will use your offices to make sales for playing dates on tours." They agreed and out of this we prepared a fantastic working list of dance floors and operators.

The one-night stands were where the money was. We got 20 percent for the one-nighters, compared to 10 percent for booking an orchestra into a longer engagement. The main reason we wanted to get a radio broadcast from a hotel or nightclub where we had a band with a long engagement was so that the band would become better known and it would make it easier for us to book it for one-night tours. The important thing was to have the band working seven nights a week.

From 1929 to 1937 we spent most of our time in Chicago, commuting to New York about twice a month with occasional trips to London and Los Angeles, where I had established branch offices, primarily to book dance bands. In the depths of the Depression, 1929 to 1932, MCA was enjoying great success and profitability since people wished to escape from their problems and difficulties, and seemingly the popular dance bands gave them this satisfaction. I was aware that this craze would not continue forever, so I sought diversification in representation by adding the management of singers, dance teams, and other talent the public would patronize. Radio was becoming an important part of public entertainment, so we lost no time in representing artists for this blossoming new field. During this time, my wife, Doris, was making friends with scores of new people, many of them within the industry, and entertaining artists and clients wherever she could be of help.

I first met Doris when she was a few months short of fifteen while I had my own orchestra during the opening year of the Muehlebach Hotel in Kansas City. I thought she was very pretty, even though I was

interested in another Kansas City girl who was several years older. I distinctly remember the spring of 1917 when I was sporting a two-seater yellow Stutz Bearcat automobile and taking Doris and other girls of her group for short rides on the south side of the city. In fact, I still possess a photograph with Doris at the wheel. The spring of 1917 was one of the most interesting of my youthful days. I had my own orchestra of five musicians at the hotel. I was netting over one hundred dollars a week including a fine room; I had not reached my twenty-first birthday; I had a Stutz Bearcat for which I paid nine hundred dollars to Mrs. Morton of the salt company.

GERALD OPPENHEIMER: Doris had got to know Jules through the Jewish community at the dances he would organize at the Muehlebach Hotel in Kansas City. Every Sunday afternoon, you'd go down there and dance and listen to orchestras. Jules was the leader of the orchestras. And he was like a Sinatra. He had a raccoon coat and a Stutz Bearcat car.

In the meantime, my mother married my father, Harold, when she was sixteen, and then she had me and my older brother, Larry. My father was very unsuccessful. He took over his family's liquor business, and then Prohibition came and knocked him out. After about seven years, she got a divorce.

Doris saw Jules again at a New Year's Eve party. That's about the time that Doris decided she wanted to go to live in New York, which I think was a good thing for her. She wanted a career. And Kansas City, for divorcées in those days, was not the best place to be. In New York, she got a job at Bergdorf Goodman. And that's when Jules started dating her. And she dated other people, too, as I understand. She would come back to Kansas City once a month or so to see my brother and me, which was a big deal because we didn't have airplanes in those days. Well, once every three months. And she'd telephone every week.

GILLIAN WALKER: Bergdorf Goodman was a heaven, and the women who worked there were known as Angels. Angels knew how to help men who came into the store to buy that little special something, which would allay the suspicions of girlfriends or wives at home. In the course of such counseling, an Angel just might meet a man, divorced or bored with his marriage, and fly him off his feet. As an Angel, your mother never took her eyes off the prize. She came for and indeed wooed and won your father with amazing efficiency.

GERALD OPPENHEIMER: I understand Jules proposed over the telephone. He married Mother despite her being a divorcée and having two children. He softened up a bit when you and Susan came along. But he was a relatively cold individual, actually.

LEW WASSERMAN: I first met your father in his office in Chicago, and I never got my coat off. He looked at me and said, "I hear from my brother Bill that you're very good at something. If Bill wants you, it's okay with me." Your father wore those clip-on glasses and had a big, big office. He was truly the only so-called business executive I had ever come in contact with. They offered me a job as national director of advertising at the enormous salary of sixty dollars a week. I was making a hundred dollars a week before where I was working. So I went back to Edie—we'd just been married. You know, we got married in July of '36 and this must have been September. I told Edie that I was going to take this job. She said, "Why? We just got married, we don't know a soul in Chicago." We had no money to speak of. We had a two-door Chevrolet an uncle of Edie's had given us for three hundred dollars. I said, "There's got to be a great future in this company." She asked, "Why?" I said, "The man who owns it is very old."

ARTHUR PARKS: I don't know if you knew this or not, but during Prohibition, when Karl Kramer was in charge of the one-nighter cards—

posters which he'd have printed up and sent out to the promoters—he was also in charge of buying the liquor, because there were only speak-easies in those days.

LOUISE MILLS: My father, Karl Kramer, knew Jules Stein when he was a bandleader, and he recalled that your father knew Mae West when she was a brunette. My father had been doing publicity for the Or-pheum Circuit, the vaudeville chain, and he had an offer to join the newly formed company Music Corporation of America. My mother said, "Oh, do you really want to give up this known job for a new ven-ture?" And I guess he did. Your father was the one who hired him. He became the treasurer of MCA. He kept the books. If you're the trea-surer of an organization, you know everything about the organization.

MCA was providing everything for the clubs. In Chicago, and then later when they would send the bands on tours, they would make agreements with the nightclubs. They provided the noisemakers, the funny hats, the booze. This was during Prohibition. I was born in 1929, and I think my father was working for MCA then. I don't know whether it was Capone's gang, but there was some kind of mob involvement. The mob element controlled the liquor industry, and in order to book the bands and handle all of these arrangements, you had to cooperate with the people who were the bosses. So I think they worked out some kind of arrangement.

MURRAY SCHUMACH (FROM HIS UNPUBLISHED BIOGRAPHY OF JULES STEIN): In September of 1933, Stein, with incredible aplomb, took what may have been the biggest chance of his life. In that month, when gangsters were becoming particularly unruly because Prohibi-tion had ended that year and they were worried about new sources of revenue, James C. Petrillo, then head of the Chicago local of the American Federation of Musicians, telephoned Stein and urged him

to come over to his office "right away." Stein, who had dealt many times with Petrillo on union matters, trusted the union leader and knew that if Petrillo said this was an emergency, it could not wait.

So the economy-minded Stein decided to take a cab the mile or so to Petrillo's office. When he entered the mahogany-paneled office, with its bulletproof windows one floor above the street, the burly union leader immediately closed the heavy wooden door to prevent eavesdropping. Then he sat at his desk in a far corner of the room, out of range of the sidewalk, and in his gravelly voice said, "Your name is on the list. Better get a bodyguard."

This meant that Stein was marked for kidnapping. He was astounded. He asked Petrillo how he knew this, but Petrillo refused to tell him. Stein knew that Petrillo, who had frequently risked his life to keep gangsters out of the union, had excellent underworld sources.

Not until 1975, when Petrillo was in his eighties, limping on a cane, did he feel he could finally discuss the event. By then he was living in a luxury apartment building in Chicago, and he proudly showed me a photograph on the wall of himself with President Truman, Petrillo blowing a trumpet and the president playing the piano.

The tip, Petrillo said, while sipping brandy, had come from George E. Browne, who, with Willie Bioff, headed the International Alliance of Theatrical Stage Employees. Bioff and Browne were more than officials of the stagehands union. Federal investigators sent both to jail for extortion in 1941. The union was dominated by Al Capone and his associates, with Bioff as front man. During the 1930s, it extorted millions from the mightiest bosses of Hollywood studios, sometimes as much as fifty thousand dollars and one hundred thousand dollars at a clip.

JAMES PETRILLO (FROM MURRAY SCHUMACH'S UNPUBLISHED BIOGRAPHY OF JULES STEIN): George Browne was a good labor leader. He

was a guy that never stole any money. But he loved to hang around with gangsters. I don't know why. But if you go to bed with lice, you get lousy. Anyhow, he liked me and he trusted me. If he didn't, he wouldn't come to me with the story about Jules.

George says to me: "What do you know about this guy, Jules Stein?"

I tell him, "He's a good guy."

Then George gives me the word. He says the snatch will be for fifty thousand dollars.

So I called Jules and told him to come to the office. That is natural. It's not something you discuss on the phone. Jules asks me how I know. I wasn't going to tell Jules. How can I? What happens to George if that gets known? He gets killed. I was in the middle. I had to protect both of them. I never knew for sure which mob it was. People always like to say it was Capone. Why say Capone? It could be O'Banion. It could be Touhy.

People don't realize what it was like in those days. Yeah, I know they've seen a lot of movies about Chicago gangsters. But that's not the same. It's almost impossible for an outsider to realize that in those days if a guy sneezed everybody went for his gun. It was a son of a bitch. Guys would come to you to buy tickets and say: "Al sent me." Or: "Touhy sent me." Then they would send someone around a few days later and he'd tell you: "Everybody's paying. So you pay, too." There was lots of that. Nobody was bluffing in those days. If a guy said he would shoot you, you could bet on it. You would be shot.

Well, I give the news to Jules. He is cool. That's Jules. He just sits and bites his fingernails, the way he does when he's excited.

JULES STEIN (FROM HIS UNPUBLISHED BIOGRAPHY BY MURRAY SCHUMACH): The next day, I took out a kidnapping insurance policy for seventy-five thousand dollars. I'd always known that Lloyd's gave insurance on chancy things—like the weather. So I decided they would

do this. I didn't know who else to go to. I was pretty sure the Touhy gang was behind it. And the big gangsters in Chicago in those days, they had deals with the politicians and the police and the judges. I figured there was no sense going to the cops. Petrillo kept telling me, "Get out of town. Get out of town." I refused to get out of town. I guess I was fool-ish. But I figured they just wouldn't go after legitimate businesspeople.

I had the guts of a fool. Since then I've seen lots of those movies about Chicago and the gangsters. An awful lot of ketchup has been poured in those movies. But the funny part is that when you're living right in the midst of all this stuff, it doesn't seem as important. I had no fear. I don't know why. I was either too dumb or something. I walked around the streets of Chicago and I did my business the same as ever. But at the same time, before I'd get into the car, I'd look in the back to make sure there was nobody hiding there who could knock us on the head.

OSCAR COHEN: And who owned Petrillo? There were ten guys in Chi-cago who owned him.

JEAN STEIN: And those would have been from the Capone mob?

OSCAR COHEN: I guess the bad boys. I don't know. I don't think you could have been the head of a union, and not be, you know . . . any union. I mean, the American Federation of Musicians was out of Chi-cago. I was a kid. I couldn't fathom all of the things that were going on. And I said to myself, maybe I just shouldn't pay attention to it, because it can't be true what's going on.

JULES STEIN (FROM HIS UNPUBLISHED BIOGRAPHY BY MURRAY SCHUMACH): The relationship between Jimmy Petrillo and myself became a very close one over the years and it was because he found me honest. And I found that he was honest. When I made a request, there

was a reason for it. If he told me, "I don't want you to do this because it will embarrass me," I wouldn't do it. If I wanted to bring an orchestra into his local, for instance, and he said, "This is a tough time for me to swallow; you will have to forget it," I forgot it. I knew Jimmy had special problems of a different sort. He was running his local with an iron hand in Chicago. And he was running up against gangsters who tried to take over his union. But he never let them do it. You never fight unions. You outthink them.

In the early days, there were people who believed I was being backed by mobsters. But these people never realized that my medical background gave me a strong sense of ethics. Basically, medicine is an ethical profession. All my life, I never wanted to be associated in any way with anything that would tarnish my medical background.

FROM *Collier's*, MARCH 10, 1934:

In the lobby of the building wherein Doc Stein holds forth in Chicago, Mr. Joe Kospar of East St. Louis was trying to buck up his two jaded companions. He spoke in a loud Mississippi River dialect. Many years of side-show barking and tent spieling had robbed Mr. Kospar of whatever native ability he may have had to speak in conventional conversational tones. Besides, it was six o'clock in the evening and the nightfall roar of the Loop, to say nothing of the bleating crowd in the lobby, gave him tough competition. . . .

"There's the Doc now," said Mr. Kospar, breaking through the crowd toward a smallish, dapper man with cold, direct eyes. "Hey, Doc. Doc, just a minute. Listen."

But somebody with the adroitness of one much practiced shouldered Joe Kospar of East St. Louis aside, and a second blocker completed the shunting by depositing Mr. Kospar back where he had come from. Doc Jules C. Stein—who manages

the affairs of more than ninety per cent of the country's dance bands, the Big He of the night club floor shows in Chicago, strode on uninterrupted, surrounded by celebrity. He was not going to a night club. Night clubs to Doc Stein are a business. He wouldn't go to one unless business expediency commanded. It seldom does. . . .

Doc Stein practiced medicine for two years before diverting his talents to public amusement. Under his energetic direction, there arose what his puny rivals called the band trust—the Music Corporation of America, which as I told you, manages, books, routes and dictates the engagements of more than ninety per cent of the dance bands in America.

To sum it up, if you want a nicely polished dance orchestra guaranteed to produce no sour notes you see Doc Stein, whether it's for the coming out party of your daughter Mary or for a movie, radio or a high-hat reception.

LEW WASSERMAN: I literally didn't see your father again until I came to Los Angeles in the early part of '37 and MCA had just moved into the Beverly Hills building. Your father and mother were renting Douglas Fairbanks's home in Santa Monica. I was staying at the Beverly Hills Hotel, and your father picked me up Sunday morning in a yellow Rolls-Royce convertible and drove me to the beach. It was a beautiful home. And a beautiful white sand beach. Not a soul, no people in those days. I borrowed some trunks, got a towel, and started walking to the beach. And your father said, "Where are you going? We don't swim in the ocean, we have a swimming pool." I had never seen a swimming pool before. I'll never forget that.

We were not doing much in the movie business when I came out here. I became a good friend of this gentleman named Nat Deverich, who was Leland Hayward's partner. They had originally both worked for Myron Selznick and William Morris. They owned the town. One

day Deverich had me come to the office. Hayward was on the couch, his shoes off, his tie open, no jacket. He was sprawled out having a drink. And he never got up. We never shook hands. He said, "Nat Deverich thinks you're very bright. Why don't you come over here? We'll give you a third of the company and you run it." So Leland Hayward said, "Well, I hate being in this business. My wife doesn't like me being in it. I'm bored with it." So I said, "If you feel that way, why don't you sell it to us? To MCA?" Your father was in Asia, so I spent a week with Nat working out a deal. We bought the business. Now, the war was on and Gene Kelly, Jimmy Stewart, and David Niven, all these people were off in the service. When they came back, that was really the big explosion for MCA. We went from a nonentity to the number-one company in the United States.

I let Hayward pick out any office he wanted, except your father's and Taft Schreiber's. The office he picked had beautiful French wallpaper and he hated French wallpaper. I said, "I'll take it off. Anything to make the deal." He put up a picture by Paul Klee—you know, one of those half faces with a dot in the middle. And your father came storming into my office: "This crazy painting ," he said. "I'm gonna talk to him." "Whatever you do, Jules, don't upset him." A few days later, your father came in and said, "I worked it out. He's very happy." Jules had the French wallpaper taken down and paneled the whole office. It cost about forty thousand dollars. And the painting stayed up.

I started buying the lots behind the MCA building for seven to nine thousand dollars each. And your father said, "What the hell do you keep buying these lots for?" I said, "Someday, we'll need expansion. The war'll be over."

Jules kicked me upstairs in '46 and I became CEO. He owned the entire company. He said to me, "You run it. I'm going to devote the rest of my life to medicine." He said that at the suggestion of your

mother. From that day to the day he died, we had only one disagree-
ment. And he never once said to me, "Why didn't you do it that way?"
He never second-guessed. From '46 till '54, when they distributed
shares to the executives, he owned the whole company. And I bought,
I don't know, a dozen more talent agencies all over the world. We had
offices in Germany, France, Italy, England—we had a monopoly. I
made twenty-seven trips in one year before there were jets from here to
England.

JIM MURRAY: The relationship among us at MCA was a caste system.
Lew Wasserman was on the moon. I couldn't tell you what your father
did, because it was unknown to us as linemen, me being a line agent.
Like Taft Schreiber. If you asked me what Schreiber did, I couldn't tell
you, but you knew that he was very, very big. It went down the caste
and there was the Picture Department, the Television Department,
and the Personal Appearance Department. We were considered the
lowest, and yet we generated an awful lot of money, we found a lot of
unknown talent that became motion picture stars, but we were in that
caste down there. The Picture Department were all snobs, very snob-
bish. When I say snobs, they didn't make fun of us or anything, we
were just beneath them.

I've got to say this to you, in the twenty years I was at MCA, none of
what we're talking about with the boys with the crooked noses, or the
mobsters, was visible. None was. You couldn't say these guys were con-
nected with the mob. It was so classy, and so clean, and professional,
that for me, all those years, I did not see it. I knew it, but I didn't see it.
That's how I feel MCA operated in the day of your dad. They were all
in shirts and jackets. The mob affiliation was kept really top secret.
MCA was too classy to be involved with that kind of a story.

My name was changed from Murray Fusco to Jim Murray when I
became an agent. MCA did not give business cards that easily. They

had to make sure that you looked like an agent, acted like an agent, and then they'd give you a business card. So in those days when people asked me for my business card, I'd say, "Oh, I forgot it." So I'd write it out on napkins.

There was an agent by the name of John Dugan. He was an Irishman. He looked like the actor James Cagney, he was that small, and he called me into his office, and he says, "Murray, we've got to change your name." I said, "Why do we have to change my name?" He said, "Because it doesn't make sense. It doesn't sound right, so we're going to give you a new name." I said, "What's my name?" He said, "Jim Murray." So my first name became my last name. He made an Irishman out of me. I loved it, because I was getting a business card. How many times can you write your name on a napkin?

We had an act called Divina. She was a girl that swam in a tank nude. Nude. She worked out of a tank that was maybe eight feet square, and we would book the act in bars, and they would have to tear the walls down to get the tank in and then put the walls back up.

JEAN STEIN: What did Divina look like?

JIM MURRAY: Oh, we had a different one every week. It didn't matter. You didn't have to be anything but a stripper. We even had one in Staten Island. We had five or six units.

I went through three years in Chicago. When Dean Martin and Jerry Lewis split, I got Jerry the first job at Chez Paree. So I book him, and I go to the opening at the Chez, and the line was around the block. I knew they were all gangsters. Everybody at the Chez was gangsters. That was the start of Jerry Lewis's career alone, without Dean, and he did very well at the Chez.

Later, when I was working in Vegas, Woody Allen, a nice man, arrived at the airport. I pick him up. I picked up all the stars. I pick him

up and he's got a little case that he's carrying his clarinet in and a carry-on on his arm, a very small piece of luggage. He had one sports jacket that he did the entire show with, every show, a brown tweed sports jacket. And I booked him with Petula Clark. Petula was basically the star of the show. It was a fantastic show. It did so much business you can't believe it. My selfish thought was that I want to separate them now. By separating them I got two deals, right, so I split them up. She comes in, does a big, big job. Now he arrives, with the clarinet, same thing, and he dies, no business at all. Had him there for three weeks. First week he says, "Jim, I don't want my check, I don't deserve to get paid." So he had me go to the crooked noses and say, "He wants you to keep the check." "Absolutely not! He gets the check whether he likes it or not." He wouldn't take it. He's the only one I ever heard of that wanted to give seventy-five thousand back to Caesars Palace. His act was very dry. It wasn't the kind of comedy you could listen to and drink and smoke.

I was transferred to the Miami office in '58 because I was supposed to be the agent for Cuba based on my expertise in the nightclub business. My function would be to book acts there and in Miami. I went twice to Cuba, and once I introduced myself to George Raft at the Capri. I was amazed to see the shows after going to Vegas. There were more showgirls, not as staged as they were in Vegas, and they had a lot of big-boob girls dancing. But it all came to a dead end one day when one of the agents in the Miami office came to me and said, "Jim, it's not going to work for you. Cuba is dead, Castro's there. What are you going to do now?" I said, "What do you want me to do? I'll clean swimming pools."

CONNIE BRUCK: Lew Wasserman was good at navigating private deals seamlessly and untraceably, so Ronald Reagan's reputation somehow emerged unscathed from the corruption, but it was no secret that the

relationship between Reagan and MCA went beyond the usual sym-biosis of agent and client. In 1941, for example, Wasserman sought to extend Reagan's deferment from active military duty by writing a letter for Jack Warner to sign, then made him the biggest deal in the agency's history. Wasserman tripled Reagan's salary, and by adding a few extra weeks to the seven-year contract, made it an even one million dollars. As the two men got closer, Wasserman guided Reagan through the political thickets of Hollywood. Sidney Korshak was close with the actor, too. Much attention has been paid to Reagan's appearance as a friendly witness before the House Un-American Activities Committee in 1947, but Reagan made his political debut before that, taking the side of the studios—and the mob—in a critical episode in Hollywood's long-running, violent labor wars. His 1946 presentation in front of the Screen Actors Guild during that battle probably paved the way for his election as SAG president the following year. It was from this position that Reagan and Wasserman, by then MCA's president and CEO, really got into business together.

As SAG president, Reagan granted MCA a blanket waiver that per-mitted the company to operate a talent agency, MCA Artists, and also a new television production company, Revue Productions. This was otherwise prohibited because of the inherent conflict of interest in si-multaneously being agent and employer. A few years later Reagan be-came the host, program supervisor, and star of a Revue production called *General Electric Theater*. The role resurrected his acting career and got him into the home of every American that owned a TV. By the end of the 1950s, MCA produced or co-produced more television se-ries than any other company, and it got some cut from about 45 per-cent of all TV network evening shows. That's how powerful the blanket waiver was: MCA could make up the rules because no one in the commercial world was strong enough to challenge them. It wouldn't have been possible without Reagan's waiver.

By 1961 it was evident to Wasserman and Stein that time was run-

ning out for them, as both producers and agents. Their monopoly was too blatant. And if they had to choose, they would clearly take the production business and cast the agency business aside. Leonard Posner, a lawyer from the Justice Department's Antitrust Division, was rapidly uncovering many aspects of MCA's antitrust violations and some evidence of the secret dealings between MCA and Reagan. But what he was really looking for, as far as Reagan went, was evidence that he had been bribed by MCA to give the waiver. In 1962 Reagan was interviewed before a grand jury in L.A., and he claimed he couldn't remember any of the details of any dealings with MCA while he was SAG president. With John F. Kennedy in the White House, and Robert Kennedy as attorney general, MCA and its subsidiaries were finally charged with violating the Sherman Antitrust Act, and SAG was named as co-conspirators. In a settlement Wasserman negotiated with the government, MCA agreed to dissolve its agency business but preserved its ability to become a full-scale entertainment conglomerate—MCA Universal.

Not long after that, Reagan's political career got under way. Father George Dunne, a Jesuit professor of political science at Loyola University, said in an interview very early in Reagan's political rise, "This is a dangerous man, because he is so articulate, and he's sharp. But he can also be very ignorant, as he clearly was, in my judgment, interpreting everything in terms of the communist threat." Taft Schreiber, the MCA executive who was very close to Stein and Wasserman's die-hard adversary, joined a group of wealthy Republicans to support Reagan when he ran for governor of California. Soon, Schreiber was Reagan's chief fundraiser and campaign co-chair. Stein was heavily involved in the campaign financially, too.

GORE VIDAL: Jules and I would talk politics, and that's how we got on so well. He wanted the dish on the leaders of the country. I would tell him what they were like, and he was eager to find out. Good

agent. One day, they might be useful, you know. And I very much enjoyed him. And apparently he enjoyed talking to me, which was a wonder since he thought my mother was the devil—the mad shiksa who must have been married with a stake in her heart. Jules got very Old Testament around her. She was a drunk. He didn't feel that Doris needed any encouragement along those lines. But my mother's influence was negligible. It was basically Johnnie Walker who got there first.

My mother, Nina, had married her third husband, General Olds, and headed out to drink her way through the war at the Beverly Hills Hotel. That was my mother—this deranged flapper. She moved into Bungalow 1, and she had a double bungalow so she could have the nanny at one end, and at the other end Mrs. Olds held court with her lady-in-waiting, Mrs. Stein. They didn't do much waiting, those girls. They just started right in. The early dawn would see them mixing the first martini. My mother and yours held really strategic conferences in the Polo Lounge. Yeah, right around noon, they would check in, and that's where they conducted the Second World War and that's how we won. Nina and Doris were just in charge of everything, until Doris fell into a rosebush on one side, and then Nina on the other side. Dorothy Earl, their good friend from Santa Barbara, who was six feet tall, just plucked both ladies by the nape of the neck out of the rose-bushes, the way you do with kittens, and steered them into another drink.

My mother had previously been Mrs. Hugh D. Auchincloss from Newport, Rhode Island. In those days, those names were titles. Instead of being the duchess of Devonshire, you were Mrs. Hugh D. Auchin-closs. Brits would ask me, "Why don't you people have proper titles?" Because we have names. Everybody knew who you were when they heard your name. Doris wanted to hop over into shiksaland. And that's how my mother entered your mother's life.

Nina and Doris were happy drunks together and they had lots of secrets. They were constantly whispering to each other about this and that. Oh, there were men drifting in and out, you know. They were good-looking women. I mean, neither one was disgusting-looking. You didn't wanna run away. People came around. Your mother was raised in a much crasser world. Mine was raised to be a lady. It didn't take. The very thought of art just gave her chills. Hated it. At least your mother liked furniture. Your mother had showgirl values. She knew a good rock when she saw one.

LOUIS BLAU: When your parents were traveling around South America, your mother took her jewelry case. It was big. And it was loaded. "Hang on to that and don't let anybody touch it," I told your mother. We never got out of the Guatemala airport with that. The Guatemalans thought maybe she was going to start a revolution, she was going to hire the army with all the jewelry. I told them, "She is very well known in the United States, and she will do a lot of entertaining when she's in Latin America. And this is all part of her costume for entertaining." "Well, no, no, no, no. No one can have anything like this. You have more inside your case than they have in the treasury of Guatemala." And they had the minister of the interior come from downtown Guatemala City out to the airport to look this thing over. And finally, they assured me, first place, they weren't going to let these go out of the airport. And they let me lock them up in a safe place in the airport. We retrieved the jewels when we went on from Guatemala. I think we flew next to Argentina.

JEAN STEIN: Mother claimed that Evita Perón admired the brooch she was wearing during their audience with the president's wife. It seems the custom was to offer her anything she desired, but Mother had no intention of handing over her pin.

GORE VIDAL: My mother gave away my clothes and books after I'd left for the army, all my possessions to the Salvation Army on the grounds that I wasn't coming back. She was one of the most horrible people that ever lived. All I wanted to do was murder her and I never got around to it. My half sister, Nini, had a nervous interior. She tried to be a good girl and she'd get knocked across the room, you know, teeth falling out.

NINA AUCHINCLOSS STRAIGHT: I remember all the furs that our mothers wore, with the animals biting one another, and they'd sling them around their necks, you know. And the tails would wag. If you saw a tail swinging, it was either gonna be Mrs. Stein or Mom.

Everybody wore hats in those days. Day jewels, and afternoon jewels. And evening jewels, and hats to go with them. The casual aquamarine that covered somebody's whole wrist. But your mother had the hair and the face and everything, so there must not have been much of an effort. The hairdos out in L.A. at that time were worthy of the eighteenth century. They made Marie Antoinette look like a biker.

The last time I saw your mother, she had just gotten the most incredible square-cut diamond ring anybody'd ever seen. I just adored it. I meant to write you to say, "Please don't sell it. I need to have somebody who owns that ring. It just gives me such a kick." She said her friend Frances Goldwyn had seen the ring and said, "Doris, I didn't think you needed that sort of thing." It looked like the Rockefeller ice rink, open for summer practice.

Our mothers together were like two guys looking for more guys. For prey. For my mother, it was an excuse to get out of bed and get dressed. I can't even remember her kissing me or hugging me or anything. There are pictures of her being nice to me as a baby. But she just said she didn't like girls. I was not a most fetching child, I must admit. I looked like Orson Welles's moonchild.

I can remember you wearing these great, incredible Scarlett O'Hara skirts to school. You could barely get through the door. We'd have to push you through with your petticoat. Going to your house for a party was quite an occasion. First you walked into that huge dollhouse upstairs. Loved it. Loved all the rooms. Wanted to live in it. My ambition as a little kid was to grow up and live in a bassinet. So cozy-looking, and all the silk and lace and everything. So, I thought the dollhouse was even better.

I remember somebody very stern wondering why I was in your mother's hat closet—that must have been your governess, Miss Hirschberg. But I was not talking. I had friends in the closet. The iconography of those hats alone would tell the entire history of the movies. Nowadays, nobody gets dolled up. Back then, everybody had waistlines and really pulled themselves together.

GORE VIDAL: Your mother was so funny. I really liked her. Nobody likes mothers as mothers. She always referred to faggots as "our feathered friends." It took me a long time to figure out she wasn't going out with parakeets.

JEAN STEIN: Walter Hopps always said that my sister, Susan, and I were like props. When the stars came to the house, we'd be brought down to curtsy like little dolls in our silk dressing gowns. Our social life was carefully regulated, but I didn't feel at ease with those Hollywood kids. Father didn't much care to be with people, but Mother went out almost every night. She loved being with people. She was open with everybody, very flirtatious. But that was just her exterior. When she was at home alone with us, it was a different story.

EARL MCGRATH: Doris would always have a drink in her hand, you know. When her glass was getting low, she'd look at the butler, Charles

Harris, and she would sort of look over at the shelf there. And she would look at Charles again, and look in the direction of one of the guests, then look at the shelf again, and Charles would pour another drink and put it over on the shelf. She'd put her old drink down and she'd go, "Oh, hello, how are you? Nice to see you." And she would pick up the new drink that Charles had left for her. In this way, she would never have to finish a drink.

CHARLES HARRIS: I remember the first time I met your parents. They were in the dining room when I went in and introduced myself. I don't know if I was just too damn lazy to go out and look for another job or just that it was easier to stay there and forget what was down below. Because all the jobs are the same, you know, when you get into domestics. You can't improve yourself too much. You can do better on your job, but your wages are all more or less stabilized. You're not going to get any raises or anything. They tell you to wait until they die and then they'll leave you something. They'll put you in the will.

The Steins were in South America at the time I came. Misty Mountain was 1,000 percent different from the Hearst Castle. There was absolutely no comparison. With Mr. Hearst, when I went to work up there, he had forty-five thousand acres. And your dad only had nine acres and most of them were on the hillside. Mr. Hearst lived like a king. And your dad lived like a pauper. Although your dad probably had more money than Mr. Hearst did.

JOAN DIDION: I couldn't fathom the moment when we would become close, your parents and I. I became close to your father, because he was fascinated by taxes and money. I was close to your mother because she was somewhat fun, and she'd pick me as the person who she could send to the bar to get a drink and wouldn't embarrass her. I was taking Charles's place.

JEAN STEIN: I'll never understand what motivated Mother exactly. I remember her taking me for an interview to a private high school called Westlake. On the way, she said, "You probably won't get in because you're Jewish." And I wasn't accepted. I didn't even know we were Jewish until I was six. The Second World War had started by then. Father came into our bedroom one night with Mother, and he told my sister and me that if anyone ever insulted us, it was because we were Jewish. I remember asking, "What is that?"

I was apolitical until I was about sixteen, when my father's lawyer, Edwin Weisl, tried to set me up with a young attorney. I suppose my father trusted Weisl's judgment; he was a close confidant to several powerful men, including Lyndon Johnson, and he could be counted on as a fixer whenever needed. Of course, at sixteen I had very little idea of what all that meant. In any case, Weisl claimed that he had the perfect person for me to meet, and he took me down to the courthouse in New York where a trial was in progress. This was during the black-listing period, and William Remington had been accused of being a communist. It turned out that the young attorney I was to meet was Roy Cohn, the venomous mastermind behind the prosecution. I sat and watched the proceedings, and within minutes my sympathies were with the victim. This was a pivotal awakening for me as a young person. Remington was a distinguished man, and he was tragically murdered in prison. Roy Cohn went on to become a henchman for Joseph McCarthy. The dark irony of Cohn's career is that he headed up the witch hunt against homosexuals working in the U.S. government while he himself was one of them, something he denied until the day he died of AIDS.

My parents were ambitious for me to marry someone from a noble family. It was like a Henry James novel set in Hollywood. Gore Vidal's family represented American aristocracy to my mother, so she approved of our relationship when we became close friends. Gore

took me under his wing like a surrogate older brother. I was his eager student as he sought to broaden my horizons, giving me introductions to friends of his like Paul and Jane Bowles when I went to Tangier. Many of the friends I had when I moved to New York were through Gore. He provided a sanctuary when I started to rebel against my parents.

GORE VIDAL: You were around and somewhat unfocused, not terribly interested in the academic world to which you had been committed at Wellesley, like a nunnery. There you were in your nun's gown. I said, "Meet some more interesting people." So I took you to one or two literary things. I don't usually recommend anybody to go to such things, but if you haven't seen one, you have no idea. And as I've told everybody, I didn't see her for six months, and the next time I did, she was with Faulkner.

JEAN STEIN: The year I lived in Paris at the home of my uncle David, I did an interview with William Faulkner for *The Paris Review*. I was twenty. I had met Faulkner at the Palace Hotel in St. Moritz of all places. He was doing a favor for his longtime friend the director Howard Hawks, who had helped him out years earlier in Hollywood with screenwriting projects when Faulkner was down and out. Hawks was preparing to make a film called *Land of the Pharaohs* and had commissioned Faulkner and Harry Kurnitz to write the script. St. Moritz was a stopover on the way to Egypt, where Hawks planned to shoot the film. So there they were with Robert Capa and Charles Feldman and his wife, Jean Howard, whom I had known through my parents. They invited me to join them and introduced me to Faulkner. The film turned out to be a disaster, and he didn't seem to recall much about his time in Egypt when I asked him about it later. During the interview I did with him, he described the inane mechanics of the Hollywood system in a story about getting hired to write the dialogue for an MGM

film set in New Orleans, which never got made. He called it all "foolish and incomprehensible activity." Having grown up in that world, I thought that was rather apt.

Meanwhile, my parents were still hoping I'd marry a prince. I gave in to them at one point and married William vanden Heuvel. We had two children—Katrina and Wendy. Bill represented respectability to my parents. He was actually from an immigrant family. His father had worked in a mustard factory in Rochester and his mother ran a boardinghouse. My parents were perfectly happy for me to marry someone in the Catholic Church. I had to take lessons about how to bring your children up as Catholics. I let them be baptized and have Communion, but I had no intention of raising them in the church.

Years later, not long after Bill and I were divorced, I told my parents that I was going to take back my maiden name. My mother said, "That is the stupidest thing you've ever done." I was shocked to hear her say that in front of my father.

WENDY VANDEN HEUVEL: We were living in a different world than my grandparents. I was probably about eight when Nonnie, Popop, Mommy, Katrina, and I went to Disneyland. Popop always spoke of Walt Disney with great respect. He had a lifetime pass to Disneyland. It was gold, like a credit card. Our guide was a blonde from Orange County, an Anita Bryant type, dressed in a blue guide uniform made out of some synthetic material with a little red-and-blue polka-dotted scarf. A woman walked by in hot pants, platform shoes, and a halter top. No brassiere. It was pure seventies. The guide was taken aback. The woman was ejected from the park. Mommy asked, "What was wrong with that woman?" The guide said, "If visitors see people like that, they will no longer believe in Mickey Mouse."

Then Mommy asked the guide if there were any black people working at Disneyland. She looked very embarrassed and said there were two. It turned out that they worked the submarine ride. Next we

went to a special exhibit about progress through history, sponsored by General Electric. Nonnie was talking about how great it was, and Mommy said, "This sucks." Nonnie looked at her and said, "There is something wrong with you." We drove back, and no one was speaking to Mommy. She knew it was time for her to leave for New York. That night Katrina and I had dinner with Nonnie and Popop, and Katrina said she didn't understand what was wrong with people wearing hot pants. Popop turned on her and said, "You stay out of this. Your mother is a troublemaker. She's a Commie."

JEAN STEIN: In the summer of the Watergate hearings, Walter Hopps and I were sharing a house out in Trancas on the cliffs beyond Malibu. Dennis Hopper had introduced us, and we were kindred spirits, you could say. One night we decided to have friends over. Walter had many gifted California artists in his orbit. Ed Ruscha, Ed Moses, Larry Bell, and Billy Al Bengston were all there. I recall that when my parents walked in, my father took one look at the guests and said, "Oh my god, who are all these people?" I didn't hear my father describe my friends as "riffraff," but I'm sure that's how he viewed them. He was even more shocked when in walked Jennifer Jones and Norton Simon. At one point the art dealer Nick Wilder sauntered up to Norton and said, "Norton, baby, I'll suck you off whenever you want." That was the night when Tom Wicker, the editorial columnist of *The New York Times*, had a discussion with Father about the Watergate hearings. Father had given a large contribution of approximately $160,000 to Nixon's reelection campaign, but it looked as though Nixon was going to hell in a bucket. Father was heard saying, "How can I get my money back?" It seems that one of Father's top executives, Taft Schreiber, had engineered for Hollywood to get a great tax break. Later in the evening, Bill Eggleston arrived from Memphis with a briefcase full of drugs. The next day when he came to, he believed he was out

at sea on an ocean liner. "Where are we?" he asked. That was a good question.

A year or so later, during the Pentagon Papers trial, I invited the defendants and their lawyers to a screening at our house. I'd gotten to know them by helping to raise funds for the defense. The trial had caused a serious rift between generations in the Hollywood community. Those who had lived through the blacklisting period felt very threatened by the issues that were at stake. After the guests departed, my father informed me that he didn't want those people in his home ever again. I sensed something primitive in his attitude, as though the pogrom could return to get him.

Even though we were often at odds, I was always terrified of angering my father. I went to great lengths to avoid getting on his bad side. Once I was in Paris and needed to get back to New York in time for a screening of *The Miracle Worker* that my father had organized to benefit his foundation, Research to Prevent Blindness. I got to the airport late and was told the plane was already taxiing. So I ran out on the airfield and stood in front of the plane. The Air France pilot must have thought I was a crazed American, but he stopped the plane, lowered the stairs, and let me board.

WENDY VANDEN HEUVEL: When I was about seventeen or eighteen, I wanted to get an agent. My mother called me and said that she had spoken to her friend Nancy Dowd, who had a possible movie role that I could try out for. So I called Nancy, and she gave me the name of the agent. I called Popop to tell him, and he said that he wanted to see me as soon as possible.

When I walked in Nonnie looked extremely worried and said, "Where have you been? Come in here, sit down. Your grandfather has something very important to talk to you about."

They were in their bedroom, and I sat myself down, poured myself

Wendy vanden Heuvel.

a glass of water. I had no idea what this was about. Maybe they had found the speed that I'd stolen. Popop looked very worried, and he said, "Young lady, have you ever heard of white slavery?" And I said, "What? What are you talking about?" "Well, young girls come to Hollywood in the hope of being movie stars, and they get kidnapped and drugged, and they're sent overseas in Chinese boats and used as slaves. No one ever hears about them again."

I said, "Okay, but what does that have to do with me?"

"Well, this agent you're going to see, I want his name. I don't know who he is. He could be a white slaver. No one knows."

He was kind of hedging about what exactly would happen, but it seemed like a prostitution ring. It reminded me of those Lily Tang movies from the forties. All I knew about prostitution was from old

movies I'd seen on television. While he was speaking, I fantasized I was going to be abducted to Shanghai on a Chinese bark, with all the smoke and opium, and then taken down to the Lower East Side in some brothel, never to be found again. I had a vision of being chained to a rickshaw and whipped.

I finally said, "What are you talking about? This is Mommy's friend."

He said, "Look. Just tell them that Jules Stein is your grandfather and I am in control of your career. I just want their name."

I just said, "You're crazy." If I was going to tell them that, I might as well not go. What's the use of getting a part if you're going to say that? They'd think I was really strange. So finally we left it that I'd be careful and they shouldn't worry about me.

Popop was lying on his bed. No shoes, just a shirt, pants, and tie. He had a little push-button control on the side, and as he was telling me about white slavery, he was pushing the button and gradually rising up as if to take control of me. It was very funny; I had to hold in my laughter. I felt that I had just been speaking with an extremely paranoid man. It was almost like dealing with a delusional king.

WARREN BEATTY: I knew him pretty well, you know. Anytime someone needed medical advice, I would call your father and he would leap to it as if it were the only thing on his agenda. I remember sitting with your father on the terrace at Misty Mountain when he was really sick. He was a tough guy. Do you remember when he had that thing about boysenberry? It was the only flavor that appealed to him. I remember his telling me he thought Ronald Reagan could become the president of the United States and my wondering if that just signaled an end to his clear thinking. It reminded me of a conversation I had with Sam Goldwyn when he was speculating about who the next president would be back in '68. I was working for Bobby Kennedy then. Sam said, "What is his name, he came to see me the other day," and

he couldn't remember the person but finally he said, "Nixon, Richard Nixon." I thought, Well, Sam thinks Richard Nixon could become president. I guess that shows what kind of shape he's in.

And then the same thing happened with Jules. He said, "We have a guy out here we think would make a hell of a president." He was sitting there eating boysenberry sorbet. I said, "Who's that?" And he said, "Ronnie Reagan," and I thought, Ohhhhhhh, well, that's it for Jules.

JEAN STEIN: Even though Warren thought Father was at the end of his rope, he still devoted his time and energy to the Jules Stein Eye Institute, which he had founded. He wanted to be remembered for his contributions to the preservation of sight rather than for his business endeavors.

Late in his life, my father enjoyed reading obituaries. He read them not to see who had died, but to see whom he'd outlived. Men like my father rarely have friends. He didn't care much for most of my friends either. Walter Hopps came by one New Year's Day, while Father was watching the Rose Bowl. Walter politely asked Father who was winning. And Father turned on him and said sternly, "It's not who's winning that counts, but who's losing."

WENDY VANDEN HEUVEL: In 1981 we found out that Popop had metastasized bone cancer, and Mommy, Katrina, and I went over to the hospital together to see him. He was in his bed and he looked really depressed. He said, "You know I love you," and then he said, "Oh, I don't know what kind of world this is going to be for you two girls. This is an awful world. I don't know what's happening out there, I don't understand it anymore."

Then he turned to Katrina and he said, "I know that you'll do great things. You'll do wonderful things. I have complete faith in you." Mommy stood up for me, and she said, "And Wendy, too!" He said, "No, not Wendy. You, Katrina." I backed up about ten feet away from

Wendy (left) and Katrina vanden Heuvel.

his bed, in slow motion, till I had my back to the wall, trying to get out. I was trying to hold in my tears as much as I could. Finally he said, "Well, you girls go. Come kiss me goodbye." I was like, Oh, the fucking asshole. But I went over and kissed him goodbye and we left, and all the way downtown in the taxi I was crying, telling Katrina that I was no good and that I was never going to be anything. I really believed it. It was mean of him. It still stays with me.

JEAN STEIN: I remember we were all standing around in the entrance hall at Misty Mountain before we left for Father's burial at Forest

Lawn, and I heard Edie Wasserman say to Lew, "Well, it's about time." Even though I was distraught, I thought, Now that's too good to be true. Edie was wearing a diamond pin that said "Love."

WENDY VANDEN HEUVEL: Popop is buried at Forest Lawn next to Mary Pickford because he wanted to be able to come up at night and dance with her. He talked to her about it before she died.

CHARLES HARRIS: You know, after they closed your dad's coffin, I said he should have been holding *The Wall Street Journal* and have his other hand propped up with his magnifying glass on it. But they got the casket closed too quick. I was there in the slumber room with him before his burial. It was little whispers going on all over, little tears here and there. But I think the tears were mostly dried. Swanee, who had always worked as a laundress for them, was the only one who was hysterical. And I think it was real, too, it came from the heart. I thought it was Wasserman who went over and grabbed Swanee, but it may not have been. I heard that your dad's former secretary, Glenda, watched the whole thing from up in a tree. She hadn't been invited to the funeral. If I wrote about my time with the Steins, it would only be funny to the few people who would know who I'm talking about. In Iowa or Kentucky, Jules Stein would only be a Jew. But in Beverly Hills they actually would think it was funny.

WENDY VANDEN HEUVEL: Right after Popop's funeral, I wanted to have certain mementos of him. So I went into his closet and got one of his tuxedos. I tried on the jacket and it fit me perfectly, because Popop was such a small man: five foot seven or five foot eight. He actually had six or seven tuxedos, and I think I may have taken two or three. I also took a bunch of old Persian-tailored jackets because I was a teenager then, and it was a cool thing to wear to school. I think I was eighteen

at the time. I thought, Nobody is going to know that I took these, there are so many of them. Popop had sixty or seventy jackets: he had three closets full of them. Most of them were made in Paris, because they had Paris labels, but they were all tailor-made. The fabrics were so beautiful: linens, silks. They were beautiful colors, too. There were also tweeds, but I didn't want the tweeds.

I took the tuxedos and jackets into my room and hid them in my cupboard. I wasn't going to wear these clothes anywhere until I got to New York and then I was going to flaunt them all over town. But it wasn't as easy as I thought to take them. Either Nonnie was going around in my drawers, or one of the maids was putting away some clothes and said something. All I know is that I was in the bathroom, blow-drying my hair before I went out, and Nonnie started pounding on the bathroom door and saying, "Come out here. Come out here, you naughty girl." I came out, with my hair wet, and she had one of the tuxedos in her hands. I literally froze.

She said, "What is this? What is this? Where did you get this?"

I said, "I don't know." I didn't know what to say. "I just wanted to have something to remember Popop by. That's all." I was half crying to get out of it.

She said, "I know what you are up to. I know why women wear these kind of clothes. Young ladies should not wear pants. If you wear these kind of clothes, you must be a lesbian! I know about Marlene Dietrich. I know about these things."

I said, "Listen, I just like to wear jackets and things, and I wanted some clothes of Popop's. It is what everyone is wearing, and I'm not a lesbian!" Then I got angry at her. I was so terrified that I had been caught. She was a little hysterical, I think, because of the funeral. What happened eventually is that she let me keep one of the jackets but I wasn't allowed to keep any of the pants. I have one tuxedo jacket, and I still wear it sometimes.

Nonnie was as social as ever after Popop died. She was always either getting driven to a cocktail party or hosting one at the house.

JEAN STEIN: My half brothers, Larry and Jerry, paid Richard Gully—do you remember him?—to organize movie parties at the house for Mother. That was just one of various ways in which everything was propped up for her at the end.

WENDY VANDEN HEUVEL: I went out to visit Nonnie just to try to get closer to her in some way. She had just turned eighty. I was sitting in her mirrored bathroom, which was a bad replica of the hall at Versailles, and she was putting on her makeup, and I thought to myself, God, this is so weird. She must have been doing this every night for sixty years or more. And I thought how bizarre it was to have this ritual of putting on your makeup every night. It affected me a lot to see her so old and out of control of herself more than usual.

She looked like a painted doll with all that caked-on makeup: she put on huge amounts of foundation and rouge. Her eyeliner would be askew because her hand trembled. I remember standing next to her at these cocktail parties when I was sixteen or eighteen and thinking, You have got to be kidding! She was like something out of Madame Tussauds—it was a little scary. Then there were the black lace girdles that she wore to shape her figure under some boxlike dress. I remember her standing in front of the mirrors in her bathroom where you could see your reflection from every angle. That bathroom was phenomenal. I think there was even a mirror on the ceiling above the tub. She'd stand there in a black girdle with her silver-white hair, applying makeup. Last came the lipstick, always red—red, red, red lipstick. It was just an amazing ritual for her—the preparation, the makeup, the dress, the shoes.

In the last years of her life, Nonnie had a woman in the house who

would help her dress and apply her makeup. She'd prop Nonnie up in a chair like a little doll, ready for the evening's activity. There was something vacant about her. I remember her having to ask, "Where am I going tonight?" She reminded me of Billie Whitelaw in Beckett's *Rockaby*—an elderly woman sitting there in a rocking chair living in the past, existing only in her memories.

DOROTHY STEVENS: I was very fond of your mother and I think we worked well together. I was her social secretary and I think your mother had quite a great deal of confidence in me, I felt that she did. She would ask me to write letters for her, and I would ask if she would like to dictate something. "Oh no, no, you write it." I picked up some of her little regular sayings, like "I must say," and put them in so it sounded like she herself, of course. On some of them when I thought it might be necessary, I would take a rough draft in and read it to her or ask her to read it. I'd say, "There might be something you would like to add." Very seldom was there a change. "No, that's fine, that's fine." Then I'd go back and put it on her stationery.

 Things weren't all happy, you know? But she handled things so well. I tried to help her all I could. She'd sometimes ask me to come down and sit in the library with her, especially after your father passed on. I knew she was terribly lonely. Yet your mother was one who didn't want to let her feelings out. She didn't want anyone even to indicate that they may have known her loneliness, so I never did. I felt great sympathy for her, but I never talked about it with her.

 Then when your mother got really sick near the end and had to go to the hospital, I went to see her very, very often. I was at the hospital when she died. I was holding her hand. And she was holding mine.

BETTY BREITHAUPT: Your mother really pushed your father to keep going into the office towards the end of his life. I credit her for being

responsible for a lot of his success, only because she kept pushing him. She would call in the morning and say, "He's on his way. He didn't want to come, but I told him he had to. He has to make his presence known." I sometimes felt like saying, "You know what he does when he gets here? He sits in his chair and sleeps." I was your father's secretary for many years, and after he died, I went to work for Mr. Wasserman, who was not very friendly. The MCA men all might have been that way when they were agents, but as they got older they kind of mellowed a little. Wasserman never mellowed. He was a big yeller. There was one fellow who left his office after being yelled at and went home and had a heart attack. It was a high-stress work environment. I was still working there in 1993 when a former employee fired shots at the building. I was sitting at my desk on the sixteenth floor outside of your father's old office. The shooter was in the park across the street with a rifle. I just remember we heard a *ping*, and then, you know, a bullet came through the window right behind me. We were told to crawl on the floor towards the center of the building and lie there until the police came. Several people got hit.

I remember when Matsushita bought MCA in 1990, Wasserman thought he ought to show his Japanese side, so he decided to put in a big koi pond at his house. Wasserman fed the fish every day, but they had such trouble with the fish, and the fish were dying, and they had to actually call SeaWorld to help them get his pond up and running again.

WENDY VANDEN HEUVEL: Wasserman told me a story once about poverty. We were out on the street waiting for a car to come, and I asked him, "Did you always want to do this? What is it for you? What do you love about it? Did you always want to make movies, Lew?" He said, "No, but I always knew that I wanted to have money." He told me how he had been a movie usher for years in Cleveland. "Once you taste poverty, you know that you want money, and I didn't want to live that

way anymore." That was very clear to him. I wanted to know what his passion was, basically. Why was he so passionate about what he did? And that was the answer I got, basically: power and money. I was kind of interested by that. To think that would drive a man to where he was today, that kind of motivation. But I don't think he was really fessing up. I think on some level he meant what he said, for sure, but I would be curious to know what his real passion was. But, maybe it was the money and the power. He was definitely into a whole king trip over there.

I didn't really know Mr. Wasserman, to tell you the truth, but I remember being at a meeting at Universal and looking out the window and thinking, Oh my god, this place is a kingdom. You are on top of this black tower looking out, and it is a very powerful feeling. And I got it. Lew Wasserman sat at the end of that table, holding court, and I looked at him and thought, This guy thinks he's a king; this is what this is all about. I had just gone to see the Dalai Lama recently. The Dalai Lama is also known in the world of Tibetan Buddhism as a king, but in a completely different direction. In Buddhism they talk a lot about illusion, and how basically we are living with illusions all the time and we get lost in our illusions, our samsara. We don't live in the truth, and that is our problem, that is why we keep bumping up against things. And here were these two kings from two different kingdoms: one is the king of creating illusion on top of illusion, and the other king—the Dalai Lama—is about breaking through the illusion. It was like a revelation. Hollywood is very powerful, and very real. No matter how make-believe it is, it is real, and it moves and shakes and it is not something to mess around with. It is a real force. But it was like in *Star Wars*, where the forces of light and dark come together and fight. You could see Lew Wasserman and the Dalai Lama facing off.

BETTY BREITHAUPT: I think the last time I saw Mr. Wasserman was in 1998, and he was in the commissary, and you could see that his mental

capabilities were diminished. He smiled a lot then. I had never seen him smile. The girls would always have to find somebody for him to have lunch with. And he had his table in the commissary, and a certain waitress, Anne. He always ate the same thing, I think.

WENDY VANDEN HEUVEL: I went back to Misty Mountain years later to see what artifacts I could find. Sneaking around when no one was around in the basement, I felt a little like a scavenger. I found these trunks from old Hollywood full of top hats, photos, dresses, and boas. The trunks had stamps on the outside from all the places that my grandparents had traveled: Paris, London, Madrid, Buenos Aires. It was like being transported back to a different time. That time had elegance, class, very remote from the Hollywood of today. There was an artistry and a beauty to it. Beaded ball gowns, tails, spats, dickeys, monocles. Imagine Rita Hayworth, Ava Gardner, Ginger Rogers, Fred Astaire.

I found one of Nonnie's hats that had twelve skunks smelling roses on top of it, with a black lace veil hanging down the front. It was hysterical. She also had these very classic pillbox hats, and the floppy ones with a flower on the side—what I imagine the ladies wore to the racetrack. There were photos of her and her friends dressed for masquerade balls or just laughing, smoking, drinking, having a good time. The stuff in the trunks had this musty mothball odor like it hadn't been opened for a very long time. Actually the whole basement spooked me. It was a screening room and recreation area with a pool table in a side room. It was all done up to entertain, but nobody was there to entertain. It felt so empty, ghostly. I could hear the silence and little creaks as I walked. I had my memories of what it had been like—light coming from the projector, Popop on the phone telling the projectionist to start the movie, screams from the scary pictures, the pool balls clacking, my friends joking around. We saw *Great Expectations* in that room, you know the old one in black and white. That room was very Miss Havisham, only scarier.

DOROTHY STEVENS: Sometime after your mother died, I was upstairs in my office one afternoon when the big bell rang. I answered the gate phone, and this very crackling voice said, "May I speak to Mrs. Stein?" And I thought to myself, This is strange, and I said, "Well, Mrs. Stein isn't here. I'm the secretary, may I help you, please?" And she said, "I'm Katharine Hepburn, and I want to come in. I just want to walk all around the back of the property." "Just a moment, please, I will call my security man to come down to open the gate." Because I was very careful about whom I let in, and especially since she wished to speak to Mrs. Stein, I became more cautious. This was during the time when Miss Hepburn was here in Los Angeles doing a tribute to Spencer Tracy for MGM TV.

So I rang the phone to Barney's room, and I said, "Barney, there's someone speaking down there with a very crackling voice, and uh, she says she's Katharine Hepburn. I hesitated to open the gate, I certainly don't want to insult this lady, so will you go down, and if it is Katharine Hepburn, by all means let her come in."

So Barney jumped up and went down the long curving driveway. He told me later that as he got in sight of the gate, he saw Katharine Hepburn hanging on to the rails of the gate peeking through like a little squirrel. So he opened the gate. And Barney told me that he walked up with her and she had such a fast stride that big Barney, who was well over six feet, could hardly keep up with this little lady.

I did go downstairs, and yes, there was Miss Hepburn, dressed in her usual wear—a pair of slacks much too large, a very large pair of walking shoes which flapped along as she walked, a topcoat, also large, a sweater, hanging on her back and tied around the front, with the two sleeves knotted under her chin. Her hair was done in the usual Katharine Hepburn style, pulled up in a little knob on the top of her head. And I said, "Well, good afternoon, Miss Hepburn. I'm sorry I had to keep you waiting at the gate." "Oh no, no," she said, "I know that you can't just let any old riffraff in." And I said, "Well, Miss Hepburn, I

would hardly consider you riffraff. The next time you come visit us, just say 'Golden Pond,' and the gate will open all by itself." She laughed and said, "I'll do that, I just will do that."

She was reminiscing as we went through the entire home. It turned out that she had rented it for a short time in 1935 just prior to the time when Mr. and Mrs. Stein purchased it. But she loved the place. We were in the living room, and she said, "Do you ever see any snakes in here?" And I said, "Snakes. Oh no." "Oh yes," she said, "when I lived here, every once in a while a little snake would come crawling out." And I said, "Oh my goodness, what did you do?" She said, "Oh, I just grabbed my little rifle and went *boof, boof,* and I shot him." She told us that it was really way, way out in the country then, and quite wild. She said she would sit out on the patio and have her tea, and the deer would come right up and almost eat out of her hand.

Marvelous lady. I just couldn't believe this crackling little voice down there, you know. I later heard she had tried to get into the house other times, when no one was home. You have to be extra cautious here. There's so many people who play tricks on homes. They might say they're going to deliver flowers and they have a gun in the bouquet, you know. That's a very common trick here in Los Angeles.

JEAN STEIN: When I visited the house a few years after the estate sold it to Rupert Murdoch, it was a shock to discover nothing had changed. The Murdochs had even put up family photographs of parties at the house from the forties and fifties on the wall leading down to the screening room. I felt like an apparition as I described the cast of characters to Murdoch's estate manager, William Scheetz.

WILLIAM SCHEETZ: Mr. Murdoch just moved right in, and everything kind of stayed. I'd go to cook something, and I'd look for a recipe, and the first book I pulled down, it had your mother's name inside, Doris

Stein, and her favorite recipes circled, with little notes. And we ate with the same utensils, and cooked with the same pots and pans.

I was the one who thought of putting up your father's photos. Well, I was the one who found the photos. And I showed them to Mister, and he said, "These have quite an interesting history. We could make this into a coffee table book somehow." He does own HarperCollins, you know. You couldn't get the guests down the staircase because they'd be staring at the pictures. "Where could you buy this kind of thing, you know? Wherever could you find decorations like this, which are so unique to the house?" I also saw the pictures of your coming-out party.

JEAN STEIN: That was from another lifetime. Judy Garland sang "Over the Rainbow."

DAVID "PREACHER" EWING: I just came along for the ride. It was like you were at an exhibition. I mean, it's like being dead and coming back and seeing somebody occupying your life. I thought it was amazing that William Scheetz opened up every nook and cranny, like, you know, the china closet, and it was, "Here's your mother's china." It was almost like he was going to open up her lingerie drawer and pull out her corsets. They had this DirecTV dish, 'cause at one point Murdoch owned DirecTV, right? The dish was up on the roof, and right next to it the old TV antenna, old style from the fifties, and William Scheetz said, "I don't know why they left that up there." And I said, "Because it was the Steins'."

FIONA SHAW: There were many remarkable elements inside the house. On the piano in the living room, there was a photo of Rupert Murdoch and his family, which was surreal, obviously, for an outsider. I didn't even let my eyes look at the photograph, I was so embarrassed. I was thinking, Oh, it's Rupert Murdoch—oh, and his family.

And then the house manager, William Scheetz. I felt that as soon as the Murdochs were gone, it was his house. He ruled it. I got this terrifying view that he danced around, you know, a bit like a toy coming alive at night. And he was obsessed with the history of the house and obsessed with the people who were in it. And obsessed with Jean and her father and mother. But I did feel your father and mother in it, and a chaotic daughter running around.

William Scheetz kept taunting you, saying, "Do you know how much this is worth?" He was very cross at you for leaving it all behind. He couldn't resist telling you the price of everything, which he knew because Christie's had come in to appraise the furniture. "These chairs are worth two and a half million dollars each," and, you know, "This dust is worth twenty dollars." We should have just looted the house and filled up the rental car.

WILLIAM SCHEETZ: I was more the decorator of the house, you know. Mr. Murdoch doesn't worry about anything tangible in his environment. You can put him in a garage with a telephone and a chair, and he'd spend the day and do his normal thing. Give him a pencil and a pad of paper, and he's happy as can be. He doesn't care where he works. I think everything's in his head. And I think that was the reason why a lot of things never changed in the house, because he had no reason to change anything. He appreciates things the way they are. And he'd get lots of compliments on the house, so many.

JEAN STEIN: Lew Wasserman had told Rupert Murdoch that all the possessions in the house would be his when he purchased it. I thought he was supposed to be negotiating for my family.

JOAN DIDION: Your father's partner, old Mr. Wasserman. Of course he was negotiating for Mr. Murdoch. Of course he was. Of course he was.

BARRY DILLER: I bought the house for Rupert Murdoch a few months after Doris died. Rupert was looking for a house in California. He went up and saw the property and then he went off to Australia. Lew and I talked, and Lew said to me, "I think it's going to go quickly, so if Murdoch wants it, you should do something." So I called Rupert in Australia, and we talked about it, and he said, "Yes, I don't want to lose it." I said, "Well okay, if you're serious" He said, "I'm serious. If you can get it, get it for me." So I called Lew back, and I think, if I'm not mistaken, the price was six-two or six-seven, something like that, and I asked him if they could keep whatever furniture that belonged in the house. And Lew said fine, and we closed the deal. And I called up Rupert and I said, "You bought the house. It is amazing." That dining room that I had lunch and dinner in plenty of times when your parents were alive was exactly the same. The silver, I think, was the same. I bought the silver as part of the house price. I negotiated the deal with Lew.

It was much less than the forty-seven million that David Geffen gave for the Jack Warner house, but what nobody knows about is that he bought the house with every single, literally, every single thing. He said to Barbara Warner, he said, "I don't want to negotiate with you about anything. I want everything, everything, everything that's in the house is mine." Later he sold much of that to Time Warner for an awful lot of money, 'cause the house had all of Jack Warner's memorabilia, his archives, essentially. His Academy Awards, all sorts of stuff. David did very well on that. But anyway, there was a big difference between the price he paid and the price Rupert paid.

DAVID "PREACHER" EWING: The best part with William Scheetz was when we were outside the house and I asked him, "Do you have a gun?" And he said something like, "I pack one in the house because of what happened down there in New Orleans after Hurricane Katrina. I could just see the hordes coming up the mountain, like the pillagers

in *Frankenstein*." My other favorite thing was when I found Howard
Zinn's book *A People's History* in the guest room downstairs, and
Scheetz said Murdoch had read it from cover to cover.

WILLIAM SCHEETZ: A friend gave me a copy of *The Nation* because
one of his clients subscribes to it. I showed it to Mister. It was a full-
page ad for *The Nation* itself. And in one corner it had a picture of your
daughter. And it said, "Katrina vanden Heuvel, editor and publisher of
The Nation." And then in the opposite corner there was a picture of
Mr. Murdoch. And it said, "Owner of practically everything else." And
down in the center of the ad it said, "Subscribe now to help with the
de-Murdochization of the world," or whatever. Yes. I showed it to Ru-
pert. "That's Jean Stein's daughter." "Really?" And I said, "And look at
what it says about you: Owner of practically everything else." "I wish I
was," he said.

KATRINA VANDEN HEUVEL: The ad had a picture of me and a picture
of Murdoch as if it was a prizefight—and it was an announcement of
independence: "The antidote to Murdochization—Give friends and
relations *The Nation* this holiday season. Independent since 1865."
 There was a background to the ad because *The Nation*'s first ever
glossy centerfold was in 1996, and it was the National Entertainment
Complex, five octopi, and one of the five octopi was News Corp. And
with Murdoch, it wasn't only because of his right-wing views, but the
sense that he was this octopus engulfing the world with his ideas and
his power and his money. And I did see in it the irony of my grandfa-
ther, because in the 1940s *The Saturday Evening Post* had called his
company MCA "the star-spangled octopus." And now Murdoch owned
a piece of our family history. It's like *The Ghost Goes West*, right? Re-
member that great movie? I remember seeing it in my grandparents'
screening room. I loved that movie. Murdoch literally bought the

bricks, mortars, even the photographs, in order to give himself the ca-
chet that Popop had, right? Sure, he paid for the house, but in a way
he seized bits of property that would make him feel like the Hollywood
mogul. It's so eerie, because it's like a ghost movie or a haunted house,
where the former inhabitants are on the walls having a grand old time.
To me, Misty Mountain now doesn't have the sense of mystery or the
Hollywood glamour that it used to have. The house is supposed to be
in perfect condition, but all the stuffing in those outdoor patio chairs
had been ripped out. A big great horned owl had chewed up eight of
them in the course of a few minutes. Maybe it was angry. Angry at
Rupert Murdoch. It flew down to attack and made a big racket. Ac-
cording to William Scheetz, you could hear it out there like a monster.
I remember my grandmother, always going crazy about the deer eating
her roses, you know? And then my grandparents would just have more
fences built.

JOE JOHNSTON: I was a gardener for the Steins, and I stayed on when
Rupert Murdoch bought the property. One time when the Steins still
lived here, I came down to the pool and there was a black guy there.
And he says, "Get off my property." This man, this stranger, says to me,
"Get off my property." And I says, "This is not your property. What are
you doing here?" So he walked away, and I went to find Charles, the
butler, and I says, "You better lock the doors and everything. You got a
stranger on this property." And then Charles told Mister, and Mister
was inside. In the house. We had a .22 rifle there that we used to shoot
squirrels with when they'd knock all the nuts down and demolish
things. And I grabbed that thing. And then I found the guy sitting on a
seat up on the top porch, you know, where Mister had his office. So I
says, "You better get out of here right now." And he didn't. Anyway I
ran downstairs and as soon as I got in the driveway I hear this person
saying to me, "Drop the gun." And I turn around and there's the LAPD

officers. And then they ended up grabbing this guy up on the porch and they brought him downstairs, and that's when your dad comes out through the kitchen. And your dad says, "This is not your property. I am putting you under a citizen's arrest." And they took him away. I don't know who this guy was. He wasn't a bum. Just a regular guy, a stranger.

WILLIAM SCHEETZ: There were homeless people living in the hillside right under the property. And they had all their little possessions, books and food, but stuff that wasn't old and it was all organized, maybe a blanket or something to sit on or sleep on. And we think that they were sneaking into the greenhouses on the cold nights to get warm. They had been drinking water but then not closing the tap all the way. And then the gardeners would say, "Wait a minute, this was closed yesterday. Why is it running now?" We locked the greenhouses and changed the locks and moved their piles of stuff, and then it stopped.

The neighbors to the south put up a fifteen-foot-high fence separating our two properties, because of the mountain lions. And within the first two weeks an animal coming in with its cub jumped on it and bent the top of the fence trying to get in. And now they have security full-time in their backyard at night and cameras and some kind of contraption that sprays water if it senses movement, big jets of spray. It's a humane thing. So in the meantime our Rhodesian ridgeback went to live back in New York because that was the one who was the hunter and was chasing it. Lucy, she's the one who got in a fight with the mountain lion. I remember it was thousands of dollars to have her fixed up.

Then those neighbors wanted the fence eighteen foot. I made them stop at fifteen, 'cause I was afraid it was going to look like the Great Wall of China back there. They sent me a packet of all kinds of information on mountain lions and their patterns. It's supposed to be unusual that they would go into a residential area. The gardeners there work seven days a week. They put in the flowers, and then three weeks

later they rip out the flowers, and then they put in new flowers. And then they rip out those flowers.

Our gardeners would often find rattlesnake nests on the property. Once a year when they did the brush clearance, they'd find these nests. And they would fight between themselves for who got to take the rattlers home to eat them.

GENE BARNETT KERR: I can't imagine why anybody would want to interview a security guard. When most people look at a security guard all they see is a uniform: they don't really see a face. A security guard could go home, change, and talk to someone he had talked to only a couple hours before but not be recognized. I don't know why that is, but I do know it happens.

Working at Misty Mountain was the easiest job I'd ever had in my entire life, without question. After the house had been sold, the Stein guards got worried. No one knew what was going to become of their jobs. The help inside worried about whether Murdoch would keep them. He could have security if he wanted it. Well, we didn't know what kind of person he was. You can see how the guards hated to see it end—I know I did. You could walk around outside, be your own boss. I started about a week before Mrs. Stein passed away. I saw her one time on her way down the driveway, and right after that she passed away. I saw her smile just once.

Nobody had lived there for a while before Murdoch bought the property. I used to wander around up there by the old pool and the bathhouses wondering about all the old Hollywood people who'd been there in the past. I imagine there were quite a few. I think that was the one spot that had some mystique for me. I felt bad when they tore down the pavilion.

We didn't work for the studio; we just worked for a security company that had a contract to supply guards to the studio. The studio absorbed the cost. As to what the security company made, I can only

guess. Everybody wished they worked for the studio. In fact, I'd never seen so many Hollywood hopefuls in my life as seemed to go through our guard force. I think the agents sent them over to get jobs as guards at the studio so they could get some exposure. A lot of the guards were interested in the movies—or I should say they were interested in Hollywood. I suppose some of them would have been happy with just one word with Mr. Wasserman, or one word from Mr. Stein. Most Hollywood hopefuls will never make it here because they don't have the right agent or the right contact. They come and go. I'm sure there's thousands that come and go.

They say security is one of the fastest-growing industries in the United States. More people out here have security guards than I would have thought. Perhaps it has more to do with prestige than security. It seems like our jobs are more about answering the gate and checking people in and out. On my side of town no one can afford security guards. I've watched as people in my neighborhood have started leaving their lights on all night, and more and more houses have bars on their windows. That's what they have to do—they can't afford to hire security guards or services like on the Westside or in Bel Air. I'm way over in El Monte. I keep having trouble down there: people taking things out of my yard and so forth. They take anything that's not nailed down. My idea of security might be completely different than yours. I feel like I belong down at my place guarding my own house, not up here in the hills. Nothing ever happens up here.

BIOGRAPHICAL NOTES

LAUREN BACALL was a film actress. Her movies include *To Have and Have Not*, *The Big Sleep*, and *Key Largo*. She wrote two autobiographies, *By Myself* and *Now*.

DON BACHARDY is a visual artist. His books of portraits include *October* (in collaboration with Christopher Isherwood), *One Hundred Drawings*, *Drawings of the Male Nude*, *Last Drawings of Christopher Isherwood*, and *Hollywood*.

WARREN BEATTY is an actor and director. His films include *Splendor in the Grass*, *Bonnie and Clyde*, *Shampoo*, *Heaven Can Wait*, *Reds*, *Dick Tracy*, *Bugsy*, and *Bulworth*.

JOAN WILLENS BEERMAN is an analyst. She serves on the California Committee South of Human Rights Watch.

ANN SMITH BLACK's aunt was Lucy Smith Doheny.

LOUIS BLAU was a lawyer.

MARYANN BONINO is a professor and musicologist and the curator of the Doheny Mansion.

BETTY BREITHAUPT has served as a secretary to Jules Stein and, later, to Lew Wasserman.

ROY BREWER was the Hollywood representative of the International Alliance of Theatrical Stage Employees and Motion Picture Machine Operators.

HARRY JOE "COCO" BROWN, JR., was a childhood friend of Barbara Warner Howard's.

CONNIE BRUCK is a *New Yorker* staff writer and the author of several books, including *Predators' Ball* and *When Hollywood Had a King*.

GAYLE CHELGREN is the niece of Hugh Plunkett.

RUTH COGAN was the sister of Jules Stein.

OSCAR COHEN was an executive producer and president of Associated Booking Corporation.

BUD CORT is a film and stage actor. He starred in *Brewster McCloud* and *Harold and Maude*.

JOHN CREEL is the founder and CEO of corporations specializing in international marketing, design, and product development. He is the stepson of Robert Plunkett, the brother of Hugh Plunkett.

MIKE DAVIS is a writer, historian, and political activist. His books include *City of Quartz: Excavating the Future in Los Angeles*, *Ecology of Fear: Los Angeles and the Imagination of Disaster*, and *Planet of Slums*. He received a MacArthur Fellowship in 1998.

JOAN DIDION is an essayist and novelist. Her books include *Slouching Towards Bethlehem*, *Play It as It Lays*, *A Book of Common Prayer*, *The White Album*, *Political Fictions*, *Where I Was From*, *The Year of Magical Thinking*, and *Blue Nights*.

BARRY DILLER is the chairman and senior executive of IAC and the chairman and senior executive of Expedia, Inc. He was formerly chairman of Fox, Inc., under Rupert Murdoch.

CAROLE WELLS DOHENY is an actress. She was married to Edward L. Doheny IV, the great-grandson of Edward L. Doheny.

PATRICK "NED" DOHENY is a musician and the great-grandson of Edward L. Doheny.

TOPSY DOHENY is the widow of Timothy Doheny, a son of Edward L. Doheny, Jr.

BRODRICK DUNLAP is a real estate agent at Coldwell Banker Residential Brokerage.

PHILIP DUNNE was a screenwriter, film director, and producer.

WILLIAM EGGLESTON is a photographer. His books and portfolios include

Los Alamos, Election Eve, William Eggleston's Graceland, The Democratic Forest, Faulkner's Mississippi, and *Ancient and Modern.*

DAVID "PREACHER" EWING is a writer and occasional filmmaker in California working on a nonfiction book.

JANE FONDA is a film actress. Her films include *Walk on the Wild Side; Barbarella; They Shoot Horses, Don't They?; Klute; Coming Home;* and *On Golden Pond.* Her books include *My Life So Far* and *Prime Time.*

BEATRIZ FOSTER was a psychiatrist.

PATRICK FOULK was a close friend of Ann Warner's.

DAVID GEFFEN is a philanthropist and art collector. He was a producer and a film studio and record company executive.

FRANK GEHRY is an architect. His buildings include the Guggenheim Museum Bilbao, Walt Disney Concert Hall in Los Angeles, the Fondation Louis Vuitton art museum in Paris, and the Pierre Boulez Hall in the Barenboim-Said Akademie in Berlin.

HAL GLICKSMAN served as a preparator at the Pasadena Art Museum and later as the director of the Pomona College Museum of Art.

FABIENNE GUERIN was a friend of Mary Jennifer Selznick's. She is married to J. P. "Rick" Guerin.

RICHARD GULLY was the chief of protocol to Jack Warner.

CHARLES HARRIS was the butler to Jules and Doris Stein.

BROOKE HAYWARD is the author of *Haywire* and the daughter of Leland Hayward and Margaret Sullavan.

DENNIS HOPPER was a film actor and director. His movies include *Easy Rider, The Last Movie, Apocalypse Now,* and *Blue Velvet.*

MARIN HOPPER is a designer and the daughter of Dennis Hopper and Brooke Hayward.

WALTER HOPPS was an art curator, museum director, and art dealer.

BARBARA WARNER HOWARD is the daughter of Jack and Ann Warner. She serves as the chair of the New York Theatre Workshop board of trustees.

CY HOWARD was a screenwriter, director, and film producer and the third husband of Barbara Warner Howard.

JEAN HOWARD was a photographer and the wife of the agent Charles Feldman.

LYLA HOYT married Warren Hoyt, the first child of Grace Garland.

MARSHA HUNT has been a film, theater, and television actress.

JAN IVAL was the butler and chauffeur for Ann Warner.

JOE JOHNSTON has served as a gardener to Jules Stein and as the landscape consultant at Misty Mountain under Rupert Murdoch's ownership.

DEBORAH JOWITT is a dance critic. She was a classmate of Jane Garland's at Marymount.

CRAIG KAUFFMAN was a visual artist.

SALLY KELLERMAN is a film actress. Her movies include *M*A*S*H*, *Brewster McCloud*, and *Foxes*.

GENE BARNETT KERR was a security guard at Misty Mountain.

NAOMI KLEIN is a writer and social activist. Her books include *No Logo: Taking Aim at the Brand Bullies*, *The Shock Doctrine: The Rise of Disaster Capitalism*, and *This Changes Everything: Capitalism vs. the Climate*. She serves on the board of directors of the climate activist group 350.org.

RING LARDNER, JR., was a screenwriter, novelist, and journalist. His films include *Woman of the Year*, *Laura*, and *M*A*S*H*. He wrote the novel *The Ecstasy of Owen Muir*.

ANSON LISK's aunt, Lucy Marceline Smith Doheny, was the first wife of Edward L. Doheny, Jr.

EARL MCGRATH is a man of letters, a former gallery owner, and the former head of Rolling Stones Records.

ARTHUR MILLER was a playwright, screenwriter, and author. His plays include *All My Sons*, *Death of a Salesman*, *The Crucible*, *A View from the Bridge*, and *After the Fall*. His screenplays include *The Misfits*.

LOUISE MILLS's father was Karl Kramer, an executive at MCA.

ED MOSES is a visual artist. He had a retrospective exhibition at MOCA in 1996.

JIM MURRAY was an executive at MCA.

WALLACE NEFF, JR., is the son of the architect Wallace Neff.

JIM NEWMAN co-founded Syndell Studio in Los Angeles with Walter Hopps and Craig Kauffman.

LARRY NIVEN is a science fiction writer and the son of Lucy Estelle Doheny ("Dickie Dell"). He is the grandson of Edward L. Doheny, Jr.

GERALD OPPENHEIMER was the son of Doris Stein from her first marriage.

GREGORY ORR is the son of Joy and Bill Orr and the grandson of Ann Warner and her first husband, Don Page.

JOY ORR was the daughter of Ann Warner and her first husband, Don Page.

ALZOA GARLAND OTTO's mother was Alzoa Garland, the first wife of William Joseph Garland.

JACKIE PARK was a close friend of Jack Warner's.

ARTHUR PARKS was an executive at MCA.

THE RIGHT REVEREND WILLIAM PERSELL is a bishop who served as the rector of St. John's Episcopal Church in Los Angeles.

JAMES PETRILLO was the president of the American Federation of Musicians.

ABRAHAM POLONSKY was a screenwriter, film director, and novelist.

RICHARD RAYNER is an English writer and historian who has lived in Los Angeles for twenty-five years. His books include *The Blue Suit* and *A Bright and Guilty Place*.

SETH ROSENFELD is the author of *Subversives: The FBI's War on Student Radicals, and Reagan's Rise to Power*. As an independent journalist based in San Francisco, he has written for *The New York Times*, the *Los Angeles Times*, and *Harper's Magazine*.

LARRAINE ROSNER is the widow of Louis Rosner.

LOUIS ROSNER was a neurologist and one of Jack Warner's doctors.

WILLIAM SCHEETZ is the personal/estate manager for Rupert Murdoch.

MURRAY SCHUMACH was a journalist at *The New York Times* for forty-eight years. He also wrote several books, including *The Face on the Cutting*

Room Floor: The Story of Movie and Television Censorship and *The Diamond People.*

DANIEL SELZNICK is a producer and the son of David and Irene Selznick.

FIONA SHAW is a stage and film actress and an opera director. She has starred in many plays, including *Medea* and *The Testament of Mary.* She has also directed several operas, including Benjamin Britten's *The Rape of Lucretia* for Glyndebourne.

BETTY WARNER SHEINBAUM is a visual artist and the daughter of Harry and Rea Warner.

JUDY SIMON is the wife of Donald Simon, Norton Simon's son from his first marriage.

TOM SITTON is an author and historian. His books include *Grand Ventures: The Banning Family and the Shaping of Southern California.*

STEPHEN SONDHEIM is a composer and lyricist. His work includes *West Side Story, A Little Night Music, Sweeney Todd, Sunday in the Park with George,* and *Into the Woods.*

HERBERT SORRELL was the head of the Conference of Studio Unions.

SUSAN SPIVAK is an attorney.

DAVID STEIN was the younger brother of Jules Stein.

JULES STEIN was the founder of Music Corporation of America and the Jules Stein Eye Institute.

DOROTHY STEVENS was Doris Stein's social secretary.

NINA AUCHINCLOSS STRAIGHT is a writer and the half sister of Gore Vidal.

MARTIN SUMMERS is an art dealer and private consultant.

TOMOYUKI "YUKI" TAKEI is a hairstylist and former salon owner.

ANNE TERRAIL is the daughter of Barbara Warner Howard and Claude Terrail.

KATRINA VANDEN HEUVEL is the editor and publisher of *The Nation* and the daughter of Jean Stein.

WENDY VANDEN HEUVEL is an actress, a teacher, a producer, the director

of the nonprofit theater company piece by piece productions, and the daughter of Jean Stein.

GORE VIDAL was an essayist, novelist, and playwright. He was the author of numerous books, including *Julian, Burr, United States: Essays 1952–1992,* and *Palimpsest: A Memoir.*

AMY WALKER WAGNER is an attorney and the daughter of Michael Walker, Bob Walker's younger brother.

BOB WALKER is a photographer and the son of Jennifer Jones and Robert Walker.

DAWN WALKER is the wife of Bob Walker.

GILLIAN WALKER is a psychotherapist in private practice and on the psychiatry faculty at NYU Medical School, teaching family and couples therapy.

JACK WARNER, JR., was a film producer and the son of Jack Warner and his first wife, Irma Solomon.

LEW WASSERMAN was the former chairman and chief executive of Music Corporation of America and, later, of MCA Universal.

RICHARD WEISMAN is an art collector. His mother was Marcia Weisman, the sister of Norton Simon.

STEFANIA PIGNATELLI WERNER is an interior designer.

ALICE WEXLER is a historian whose books include *Mapping Fate: A Memoir of Family, Risk, and Genetic Research* and *The Woman Who Walked into the Sea: Huntington's and the Making of a Genetic Disease.* She is the daughter of Milton Wexler.

MILTON WEXLER was an analyst and the founder of the Hereditary Disease Foundation.

ACKNOWLEDGMENTS

To Bill Clegg for his editorial advice, and for his friendship and dedication to this book.

To David Ebershoff, who has been an incredibly caring editor and who has advised me with grace and kindness.

To the gifted Scottish poet and editor Robin Robertson, with gratitude for his belief in this book.

To Ed Ruscha, who has always been a gracious friend. He has generously contributed the iconic image on the jacket cover.

To Ottessa Moshfegh, a brilliant editor who has been involved with every aspect of this book. She is a loyal friend.

To Webster Younce, to whom I am indebted for his sensitive editing, and for caring deeply about this project.

To Marie Jager, who was an intrepid and dedicated researcher of unwavering spirit.

To Mary Blume, Kennedy Fraser, and Fiona Shaw, constant friends whose love and kindness have supported me throughout this project.

I am especially grateful to the following people for their generosity and advice: Mike Davis, William Eggleston, David "Preacher" Ewing, Dennis Hopper, Walter Hopps, Barbara Howard, Diane Keaton, Brigitte Lacombe, Ed Moses, Richard Rayner, Deborah Treisman, William Vollmann, Bob Walker, and Dawn Walker.

For their encouragement and support, I wish to thank Hilton Als,

Richard Axel, Jack Bankowsky, Cori Bargmann, Peter Bogdanovich, Natasha Parry Brook, Peter Brook, Connie Bruck, Elizabeth Coll, Mary Dean, Angie Dickinson, Joan Didion, Carole Wells Doheny, Brodrick Dunlap, Winston Eggleston, Jodie Evans, Susan Feldman, Harry Gamboa, Jr., Silvia Gaspardo Moro, Gronk, Tom Hayden, Jim Heimann, Willie Herrón III, Marin Hopper, Caroline Huber Hopps, Janet Johnson, Robert "Cyclona" Legorreta, Norman Lloyd, H. W. MacDonald, Earl McGrath, Kristine McKenna, Alessandra Moctezuma, Chon A. Noriega, Ethan Nosowsky, Gail Oppenheimer, Gerald Oppenheimer, Dr. Pratapaditya Pal, Grace Pollak, Karen Ranucci, Michael Ratner, Charles Ray, Danna Ruscha, Mariam Said, Robert Scheer, William Scheetz, Daniel Selznick, Betty Sheinbaum, Stanley Sheinbaum, Sid Sheinberg, Alexandra Shiva, Patssi Valdez, Jataun Valentine, Gillian Walker, Sam Watters, Vivien Lesnik Weisman, Drenka Willen, Barbara Williams, JoAnn Wypijewski, and Narda Zacchino.

Special credit is due to the valiant transcribers, Ian Hassett and Joanna Parsons.

I wish to thank David Ebershoff's colleagues at Random House: Barbara Bachman, Susan Kamil, Beth Pearson, Tom Perry, Robbin Schiff, and Amelia Zalcman, and Caitlin McKenna, to whom I am particularly indebted.

I would also like to thank Bill Clegg's colleagues at the Clegg Agency: Jillian Buckley, Chris Clemans, Henry Rabinowitz, Kirsten Wolf, and Drew Zagami.

I owe special thanks to the following people: Molly Jean Bennett, Rachel Cole Dalamangas, Al Davidian, Adam Figueroa, Gloria Gomez, Paul Hassett, Mercedes Marcial, Marina Parulava, Kaitlin Phillips, and Amy Ryan.

Finally, I am especially grateful to Katrina and Wendy vanden Heuvel, who have always been there for me and to whom this book is dedicated.

TEXT CREDITS

Grateful acknowledgment is made to the following for permission to reprint the material noted below:

AVALON, A MEMBER OF THE PERSEUS BOOKS GROUP AND THE ESTATE OF DIANA COOPER: Excerpt from *Diana Cooper: Autobiography by Diana Cooper,* copyright © 1985. Reprinted by permission of Avalon, a member of The Perseus Books Group and the Estate of Diana Cooper.

GLOBAL MULTIMEDIA PARTNERS, INC.: Excerpt from *Collier's* magazine. Reprinted by permission of Global Multimedia Partners, Inc.

HARRY RANSOM CENTER AT THE UNIVERSITY OF TEXAS AT AUSTIN AND DANIEL SELZNICK: Four Western Union Bank telegrams from David O. Selznick to Jennifer Jones; memo from David O. Selznick to Katharine Brown and D. T. O'Shea dated August 19, 1941; memo to Whitney Bolton, director of advertising and publicity for David O. Selznick, from David O. Selznick dated September 10, 1941; memo from David O. Selznick to Katharine Brown and Whitney Bolton dated January 8, 1942; and letter from David O. Selznick to Dore Schary dated September 1, 1951, all housed in the David O. Selznick Collection, Harry Ransom Center, The University of Texas at Austin. Used by permission of Harry Ransom Center at The University of Texas at Austin and Daniel Selznick.

HEARST COMMUNICATIONS, INC.: Excerpt from "Love at First Analysis Turns to Charity" from the *Los Angeles Herald Examiner*, June 25, 1980. Reprinted by permission of Hearst Communications, Inc.

MARSHA HUNT: Quote attributed to Marsha Hunt. Used by permission.

CHRISTOPHER MOUNT: Excerpts from an unpublished biography of Jules Stein by Murray Schumach. Used by permission of Christopher Mount.

SETH ROSENFELD: Quote attributed to Seth Rosenfeld. Used by permission.

BOB WALKER: Undated letter from Jennifer Jones to David O. Selznick; letter from Jennifer Jones to David O. Selznick dated March 1959. Used by permission.

PHOTOGRAPH CREDITS

195–97 Courtesy of the David O. Selznick Collection, Harry Ransom Center, University of Texas at Austin. Courtesy of Daniel Selznick.

198 Courtesy of Bob Walker

200 Courtesy of the Dennis Hopper Art Trust

205 Top and bottom: Courtesy of Bob Walker

212 Courtesy of William Phillips and the *Los Angeles Times* staff. Copyright © 1967 Los Angeles Times. Reprinted with permission.

215 Courtesy of the Norton Simon Museum Archives

226 Courtesy of Bob Walker

235 Courtesy of the *Los Angeles Times* staff. Copyright © 1976 Los Angeles Times. Reprinted with permission.

257 Courtesy of Bob Walker

262 Courtesy of Jean Stein

264 Courtesy of William Eggleston, Eggleston Artistic Trust

265 Courtesy of Jean Stein

265 Courtesy of Jean Stein

268 Courtesy of David "Preacher" Ewing

269 Courtesy of Inge Morath@Inge Morath Foundation/Magnum

300 Courtesy of Langdon Clay

303 Courtesy of Laura McPhee

The longtime editor of *Grand Street* magazine and a former editor at *The Paris Review,* JEAN STEIN is the author of *American Journey: The Times of Robert Kennedy,* an oral history with interviews by Stein and edited by George Plimpton. She is also the author of *Edie: American Girl,* which was edited with Plimpton. Originally from Los Angeles, Stein lives in New York City.

ABOUT THE TYPE

This book was set in Electra, a typeface designed for Linotype by renowned type designer W. A. Dwiggins (1880–1956). Electra is a fluid typeface, avoiding the contrasts of thick and thin strokes that are prevalent in most modern typefaces.